INSIDE THE ART & VISUAL EFFECTS

JEFF BOND & GENE KOZICKI

STAR TREK THE MOTION PICTURE:
INSIDE THE ART AND VISUAL EFFECTS

ISBN: 9781789091991

Published by
Titan Books
A division of Titan Publishing Group Ltd
144 Southwark St
London
SE1 0UP

WWW.TITANBOOKS.COM

First edition: July 2020

10 9 8 7 6 5 4 3 2 1

To receive advance information, news,
competitions, and exclusive offers online, please
sign up for the Titan newsletter on our website:
www.titanbooks.com

Did you enjoy this book? We love to hear from our
readers. Please e-mail us at: readerfeedback@
titanemail.com or write to Reader Feedback at the
above address.

A CIP catalogue record for this title is available from the
British Library.

Printed and bound in China.

STAR TREK
THE MOTION PICTURE ™
INSIDE THE ART & VISUAL EFFECTS

JEFF BOND & GENE KOZICKI

TITAN BOOKS

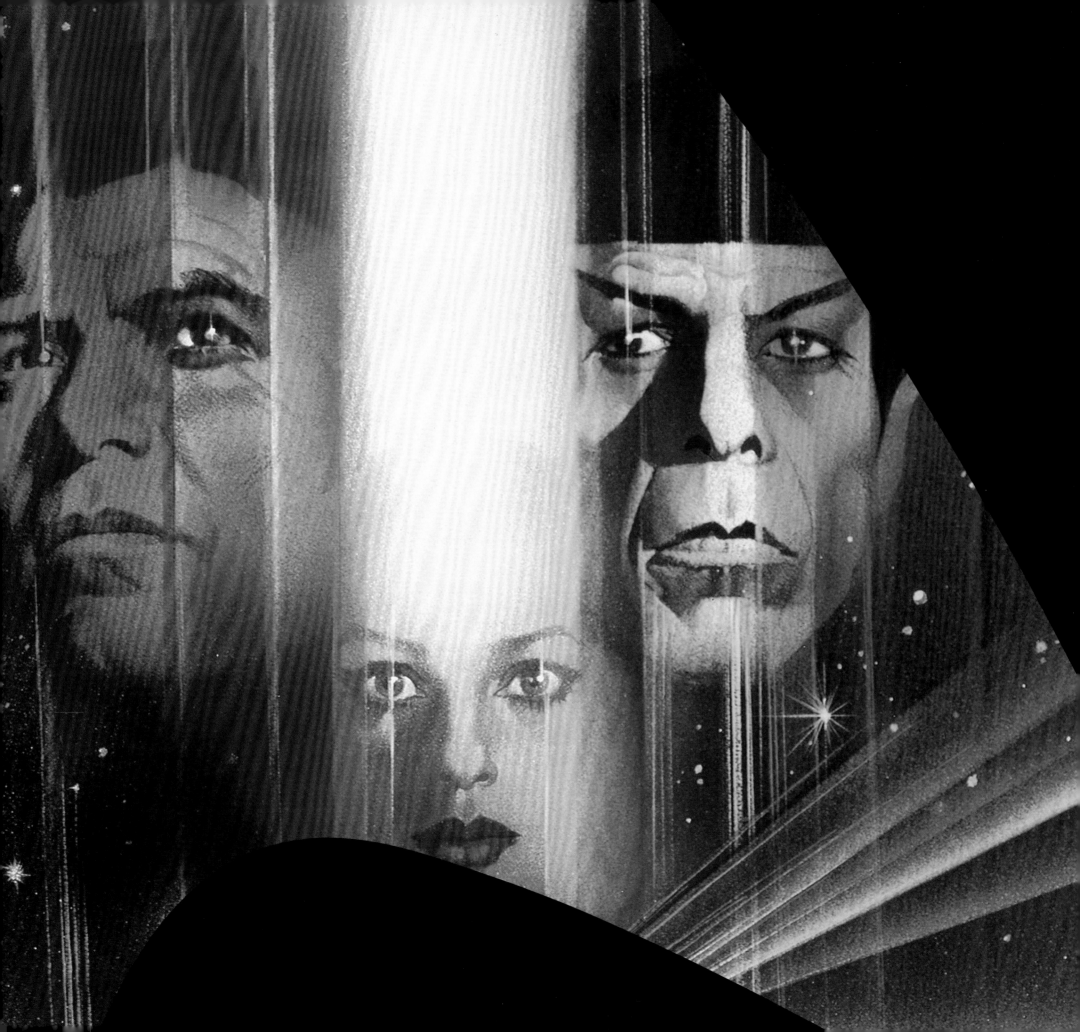

CONTENTS

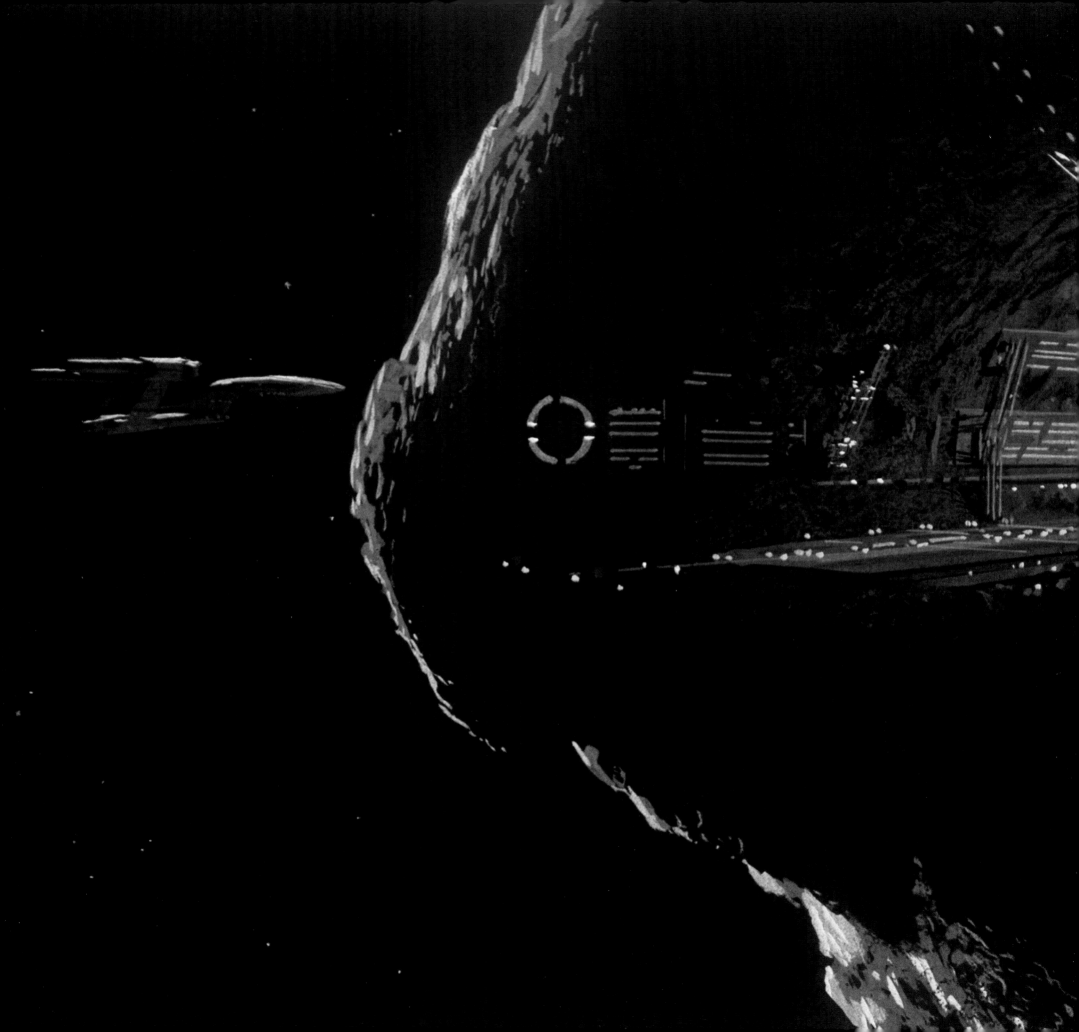

JEFF BOND AND GENE KOZICKI

FOREWORD

This is an impossible book, because *Star Trek: The Motion Picture* was an impossible movie. How do you turn a TV series into a movie? How do you redesign the most famous spaceship in cultural history? How do you design something no one has ever seen before—something orders of magnitude larger than anything human beings have ever constructed? How do you visualize a 'living machine'?

Add to that, how do you create special visual effects that everyone expects to be better than the ones that just blew them away in *Star Wars* and *Close Encounters of the Third Kind*, and do it in ten months, starting from scratch, because your original visual effects creator just got fired?

The answer is, you hire all the best people available and make them work twenty-four hours a day, seven days a week, and you just barely get it done.

Our impossible task with this book is to condense that monumental task into a few hundred pages and a few hundred images. We pitched this book idea to Titan several years ago—it was a no-brainer with the fortieth anniversary of the movie's release coming up. And we had formed friendships and relationships with a number of the incredible artists and craftsmen who had worked on *Star Trek: The Motion Picture* among dozens of other amazing projects—

people like Douglas Trumbull, Richard Taylor, and model makers and effects artists Greg Jein, Bill George, and Pat McClung, among others.

Adding to our challenges, the events discussed in this book happened four decades ago. Individuals have their own memories and opinions about what happened during the *Star Trek* movie's production, and others are no longer with us. For those—chiefly Robert Wise, Harold Michelson, Mike Minor, Robert Fletcher, and Fred Phillips—we've quoted (with permission) from Preston Neal Jones' excellent oral history of the project, *Return to Tomorrow*. We have worked to interview, acknowledge, or at least mention all the major artists who contributed to *Star Trek: The Motion Picture*, but watch the movie's credits sometime—a massive army of talented, hardworking pros worked on the 1979 movie, and every single one of them contributed something important.

One thing we wanted to do was, to the extent that we could, rehabilitate some of the reputation of Robert Abel & Associates. Abel and his company are now, at least as far as *Star Trek* fans are concerned, chiefly remembered for dropping the ball and not delivering on the *Star Trek* movie's visual effects—which is true. But what's not often noted is how much of the design influence of Abel and his art director Richard Taylor still looms over the film, particularly in

the look of the *Starship Enterprise* 'refit' as it was evolved by The Original Series art director Matt Jefferies, Richard Taylor, Andrew Probert, and finally by model maker Jim Dow and his team at Magicam. Abel and his team designed many of the iconic effects sequences in the movie, which were then executed—brilliantly, given the conditions they were working under—by Douglas Trumbull's Entertainment Effects Group and John Dykstra's Apogee Inc., with both Trumbull and Dykstra adding their own stunning touches and sequences, and Dykstra adding another whole layer of visual mystery and awe to the production by hiring 'visual futurist' Syd Mead to design V'Ger.

Drop any of these people (and let's not forget space artist Bob McCall, hired by Doug Trumbull to visualize Trumbull's trippy 'Spock Walk' sequence) and *Star Trek: The Motion Picture* doesn't get made. Drop Lee Cole and you don't have controls for the *Enterprise*. Drop Mike Minor and you don't have whole sections of sickbay and Vulcan. Drop Harold Michelson and you don't have sets that can actually be built for a major movie production. And on and on. So if we left you or your favorite artist or technician out, we feel you. So here's a salute to everyone who worked on the picture, from Robert Wise and William Shatner to the lowliest extras on Epsilon IX. You made it happen.

OPPOSITE: Ralph McQuarrie concept painting of a redesigned *Enterprise* approaching a spacedock built into an asteroid for *Planet of the Titans*, the first *Star Trek* feature film to go into pre-production in 1976. Although the film was cancelled before it went into production, some concepts survived in *Star Trek: The Motion Picture*.

ABORTED LAUNCH

PLANET OF THE TITANS

AND

STAR TREK: PHASE II

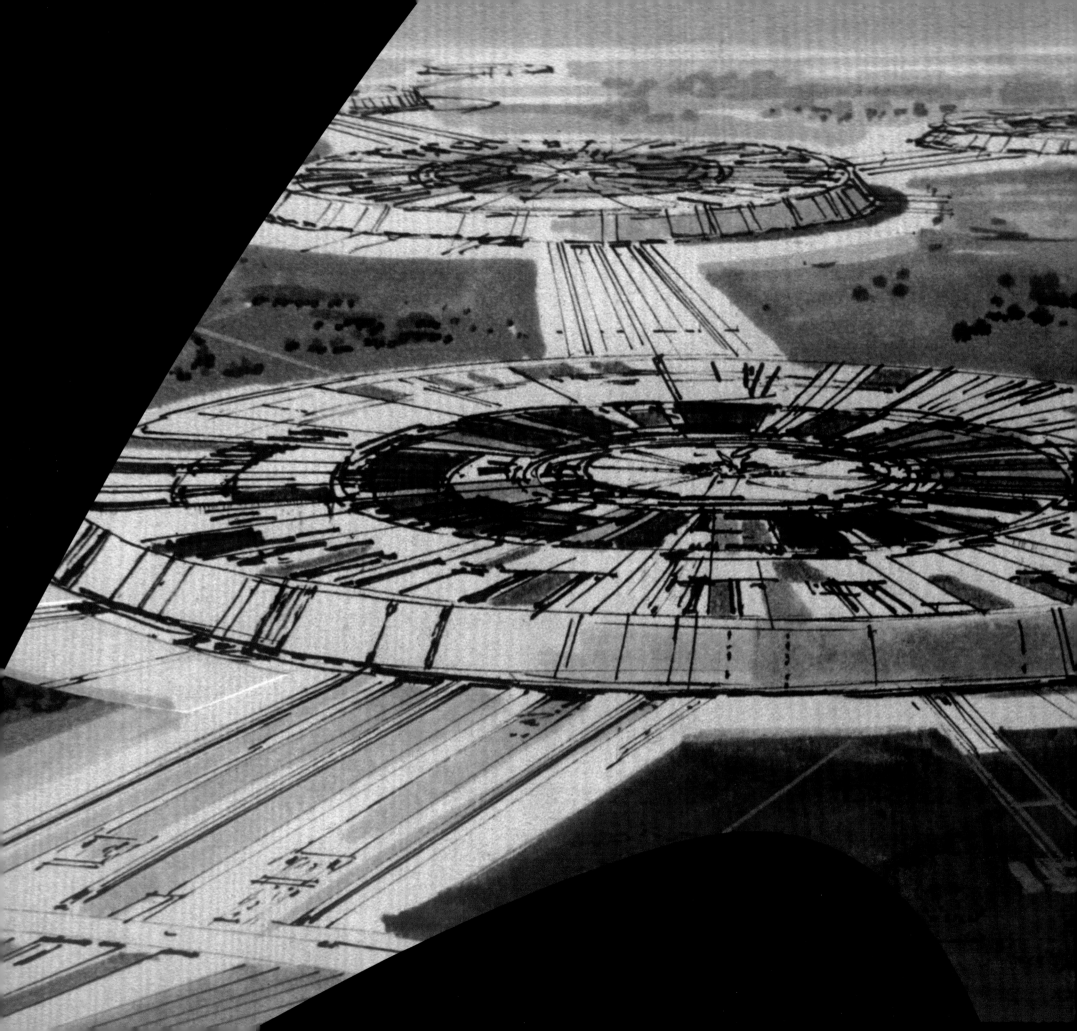

ABORTED LAUNCH

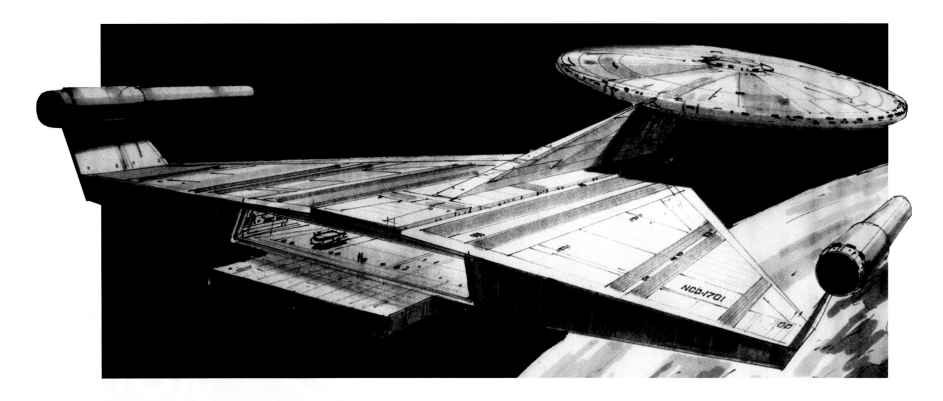

ABOVE: Ralph McQuarrie rendering of production designer Ken Adam's concept for the *Enterprise*, seemingly with an influence from *Star Wars*—but done well before *Star Wars* would hit theaters in 1977.

The first *Star Trek* movie remains unique in a franchise that has produced more than a dozen feature films. With a story that favored philosophical ideas about artificial intelligence and human evolution over action, the film embraced the loftiest ideals of the original television series while giving it a sprawling scope and an immersive, moody atmosphere that has rarely been matched since. Merely completing the movie to meet its release date proved to be a herculean undertaking, requiring a momentous team-up of some of the most legendary visual effects and conceptual artists in the film industry, ultimately working almost twenty-four hours

a day to bring the film to movie screens. Once released, the film's visual conception of the *U.S.S. Enterprise*, Starfleet, alien worlds, and its awe-inspiring central mystery, V'Ger, would set the stage for and profoundly influence the look of *Star Trek* through all of the feature films and hundreds of hours of television productions that would follow.

Creating the 1979 film's visual effects involved hiring—and in one case, firing—some of the most respected and forward-thinking artists and visual effects companies in Hollywood. These included a burgeoning subsidiary of Paramount called Magicam; an award-winning company called Robert Abel & Associates, run by

filmmaker Robert Abel; Douglas Trumbull, the man behind many of the awe-inspiring effects seen in Stanley Kubrick's *2001: A Space Odyssey*; and John Dykstra, visual effects director for *Star Wars*. Richard Winn Taylor III, Andrew Probert, art director Harold Michelson, astronomical artist Rick Sternbach, miniatures art director Jim Dow, and visual futurist Syd Mead, along with the other artists and technicians who worked for Paramount, Magicam, Abel's, Trumbull's, and Dykstra's group together would develop the look of what would become one of the most visually ambitious science-fiction films ever made. In a way, *Star Trek* was always destined for the big screen. Gene Roddenberry's concept of a faster-

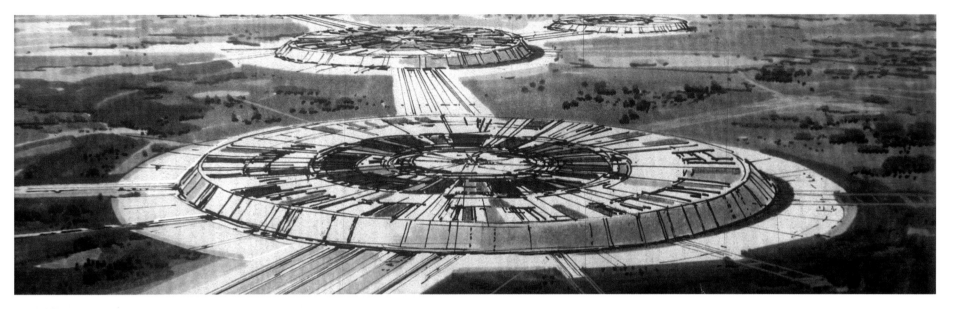

THIS PAGE: Ralph McQuarrie concept art for Federation headquarters structures on Earth for *Planet of the Titans*. The movie would have been directed by Philip Kaufman, who would later hire Leonard Nimoy for a well-regarded remake of *Invasion of the Body Snatchers* and earn critical acclaim for the fact-based astronaut drama *The Right Stuff*.

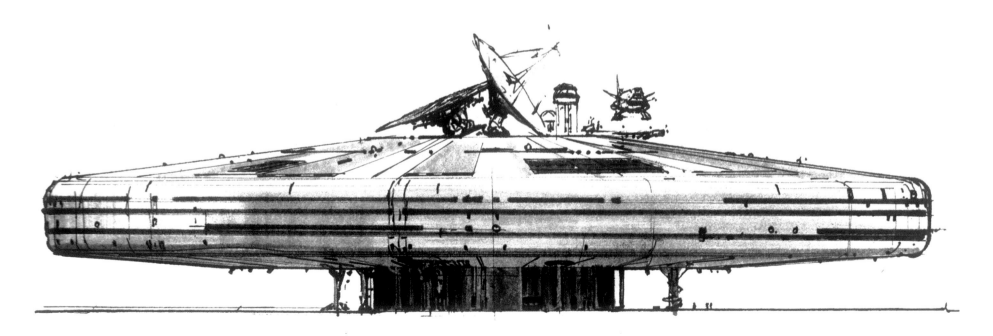

BELOW LEFT:

Interior angle of Ralph McQuarrie's asteroid space dock. McQuarrie created the asteroid space base concept for an earlier project—and would continue to use it on projects after he left *Planet of the Titans*.

BELOW RIGHT:

Alternate McQuarrie concepts for Starfleet space stations.

than-light starship with a crew of 400 people, operating in a future where whole swaths of the galaxy have been colonized by humans and aliens, had an epic scope unlike anything that had ever been produced on television. The show's distinctive characters—*U.S.S. Enterprise* captain James T. Kirk (William Shatner), Vulcan science officer Spock (Leonard Nimoy), ship's surgeon Dr. Leonard 'Bones' McCoy (DeForest Kelley), chief engineer Montgomery Scott (James Doohan), communications officer Lt. Uhura (Nichelle Nichols), helmsman Lt. Sulu (George Takei), and navigator Pavel Chekov (Walter Koenig)—and thoughtful, optimistic storytelling quickly made the show a hit with viewers, even if it had always struggled with network television ratings. Roddenberry had discussed the idea of making a theatrical *Star Trek* movie in the midst of the show's three-year run, back when the concept of a movie *Trek* was strictly pie-in-the-sky wishful thinking.

Yet when The Original Series disappeared from the network airwaves in 1969, its cultural impact quickly snowballed as daily airings in syndication gave the show an audience far larger than it had ever commanded on NBC. Roddenberry and the original cast reunited in 1973 for a highly lauded Saturday morning animation revival; tens of thousands of fans began swamping *Star Trek* conventions across the country, and *Star Trek* merchandise in the form of model kits, paperback novels, and blueprints proved that *Star Trek* was a popular and profitable pop-culture phenomenon.

In May 1975, after continuing discussions with Paramount Pictures about a possible live-action revival of the series, Gene Roddenberry set up offices at the studio with the idea of making a small-scale *Star Trek* movie for around $2–3 million. But determining exactly how to bring back the crew of the *Enterprise* would prove to be a tremendous challenge, with

potential storylines taking numerous forms. "There were a bunch of early experiments, kind of getting their feet wet with this feature film," notes legendary visual effects artist Douglas Trumbull. "The story I was hearing was that they were terrified to be the first people to turn a television series into a feature film. That was just the weirdest idea at the time. There were other people who'd done passes of it, who'd shot sizzle reels. There were several false starts, two or three different productions."

Roddenberry's first script, *The God Thing*, was written in treatment form between May and July 1975, and had Kirk and his crew confronting God—who turns out to be the Devil, an idea that would have to wait for a later *Star Trek* movie. When the studio rejected that idea in August 1975, a host of science-fiction writers (including *Star Trek* vets Theodore Sturgeon and Harlan Ellison, as well as Ray Bradbury and Robert Silverberg) were brought in over the next year

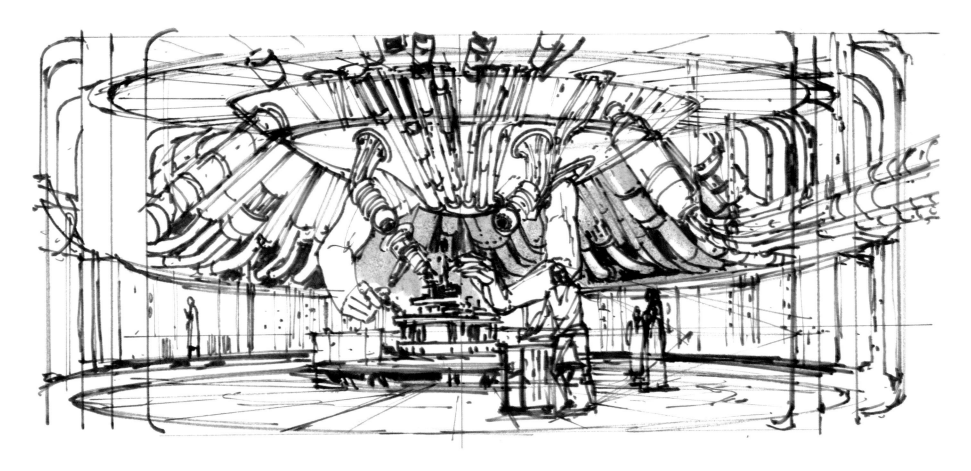

to pitch ideas, each more cosmic than the last. Roddenberry and writer Jon Povill collaborated on a time-travel story that famously incorporated the death of U.S. president Robert F. Kennedy.

In July 1976, the project moved forward with British screenwriters Alan Scott and Chris Bryant, and director Philip Kaufman. *Star Trek: Planet of the Titans* developed into a thematically ambitious tale that involved the future evolution of humanity, a black hole, time travel, and an ambiguous, spider-like nemesis.

Planet of the Titans would be no low-budget *Trek*. Kaufman and his screenwriters envisioned a $7–8 million movie with elements of horror and even eroticism, a distinctly adult and challenging thriller. In early 1977, to visualize the movie and update the look of the *Enterprise*, Kaufman brought onboard legendary production designer Ken Adam, famous for creating the look of the James Bond thrillers and for designing Stanley Kubrick's Cold War black comedy *Dr. Strangelove or: How I Learned to Stop Worrying and Love the Bomb.*

Another artist beamed onboard the project was less well-known at the time, but would soon become famed in his own right: Ralph McQuarrie, a painter and illustrator who had done work for the aerospace industry as well as another space project being developed by the director of *American Graffiti*, George Lucas.

THIS PAGE: (TOP) McQuarrie concept for an alien 'brain complex'—a permutation of the hyper-evolved, spider-like creatures at the center of *Planet of the Titans*' plot; (RIGHT) Concepts for the shuttles.

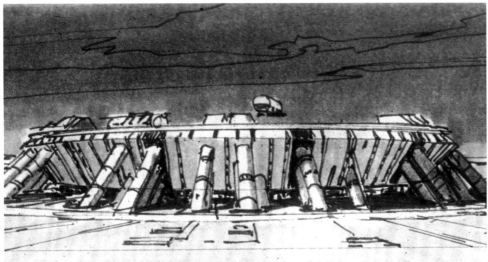

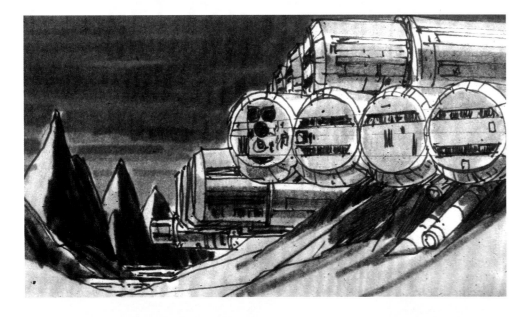

Adam came up with a radical new look for the *Enterprise*, altering the ship's cigar-shaped engineering section into a flattened, triangular shape with its warp pylons and nacelles positioned at the trailing edges of the triangle (in Philip Kaufman's treatment, the crew gains mysterious mental abilities after a journey into a black hole, and Scotty and his engineers update the *Enterprise* with what seems to be future technology). Adam generated charcoal sketches of the new *Enterprise* and McQuarrie rendered full-color paintings of the ship in a Starfleet base constructed inside an asteroid, a concept that he had developed for earlier projects and would continue to pitch on later ones. McQuarrie also created concepts for shuttlecraft and other vehicles, as well as exteriors for Earth and Spock's world of Vulcan, depicted as an industrialized, polluted planet. Adam and McQuarrie also sketched concepts for an alien 'brain center' and the story's giant, biomechanical spider creature, described as "part electrical, part animal, part plant." Kaufman's treatment contained other elements that now sound familiar—the *Enterprise* in drydock for a futuristic refit; an opening battle involving the Klingons; a special effects light show as the *Enterprise* enters a black hole, described as "a bombardment of light and sound"; Spock returning to Vulcan to 'exorcise' his human half; a semi-psychic, counselor-like female character, Dr. Riva, who senses the approach of the black hole as it heads toward Earth under alien control; and Spock and Riva joining together with the film's spider-beast—revealed to be a future evolution of humankind—and agreeing to become a new Adam and Eve as part of the reinvention of humanity.

Planet of the Titans had the potential to be the most ambitious space epic since *2001: A Space Odyssey*. Philip Kaufman would later bring Leonard Nimoy onboard a critically praised remake of the paranoia chiller *Invasion of the Body Snatchers*, and direct literary adaptations of *The Right Stuff* and *The Unbearable Lightness of Being*. He also gave Indiana Jones his first MacGuffin when he suggested to George Lucas and Steven Spielberg that the adventurous archeologist should be pursuing the Ark of the Covenant in *Raiders of the Lost Ark*. In addition to Ken Adam and art director Charles Bishop, veteran miniature effects artist Derek Meddings, who had worked on Gerry Anderson's Supermarionation TV shows *Thunderbirds* and *Captain Scarlet*, as well as several James Bond features, worked on concepts for *Planet of the Titans*.

Executing a screenplay that pleased everyone proved an insurmountable challenge and, in May 1977—just weeks before the opening of *Star Wars*—Paramount shut the project down, with studio heads believing there was no future in science fiction. Adam, Bishop, and Derek Meddings all eventually moved on to another spacecraft-heavy production, the James Bond adventure *Moonraker*.

LEFT: Ralph McQuarrie sketches for an interior corridor and exterior concepts for Vulcan, depicted as a highly industrialized, polluted planet in the *Planet of the Titans* script.

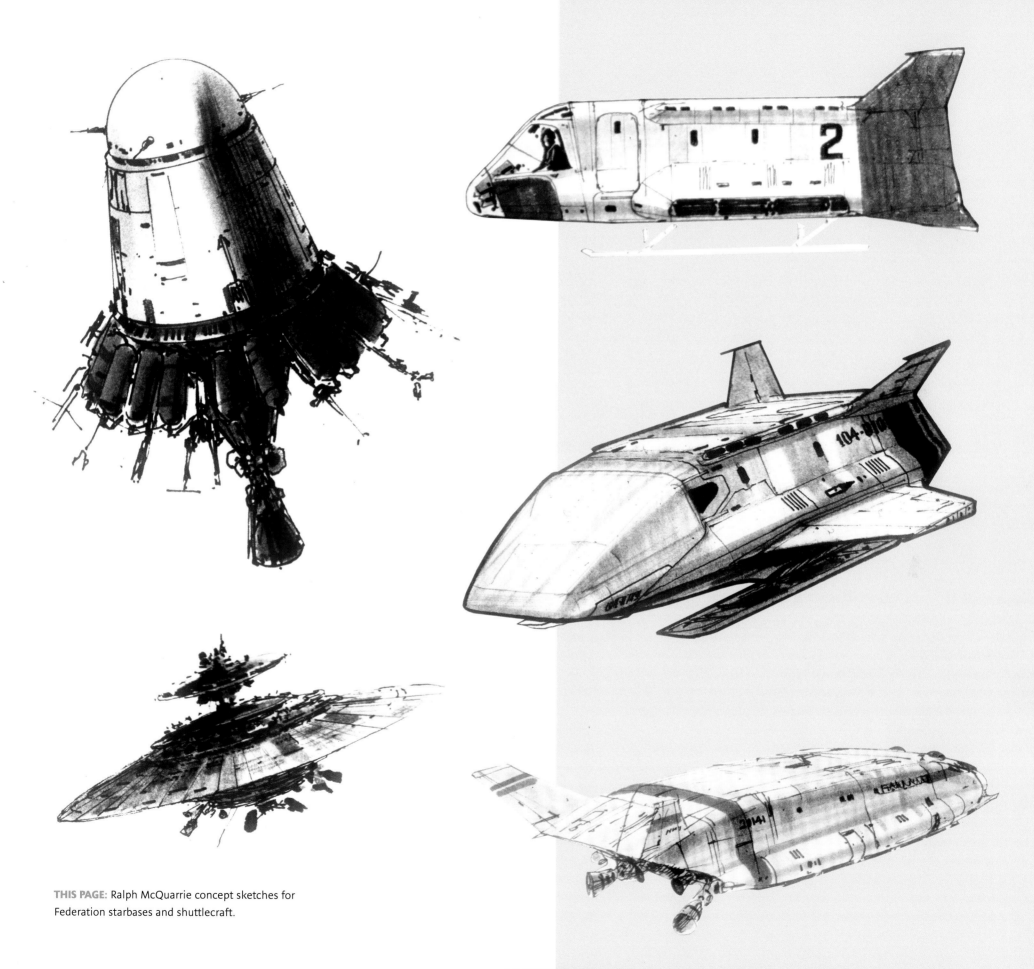

THIS PAGE: Ralph McQuarrie concept sketches for Federation starbases and shuttlecraft.

BELOW: McQuarrie front angle study of the *Enterprise*. In Philip Kaufman's treatment, the starship would have been augmented with far future technology after an encounter with a black hole created distortions in time and human evolution.

Star Trek was far from dead, however, and efforts quickly shifted to bringing the show back as a TV series that would anchor a new 'fourth network' owned by Paramount to compete with the established 'Big Three': NBC, ABC, and CBS. Gene Roddenberry assembled a staff of writers and around a dozen stories, and recruited William Shatner and most of the original cast, with one major exception. Leonard Nimoy was reluctant to return to the demands of portraying Mr. Spock in another weekly TV series, so Roddenberry and his staff created a younger generation of characters, including a younger, full Vulcan named Xon as science officer, as well as a first officer named Willard Decker, and an alien 'Deltan' named Ilia, all adding dimension to the crew as they would perform alongside the familiar faces from the original show.

Star Trek: Phase II, as the new series would be known, was planned to launch as a two-hour TV movie that would establish the new characters and concept for the show. In the intervening years between the cancellation of *Star Trek* and the launch of the movie project, Roddenberry had been involved in several pilots for new science-fiction series, including *Genesis II*, set on a post-apocalyptic Earth. One script for *Genesis II* was 'Robot's Return,' about a space probe returning to Earth after encountering superior alien technology, and Roddenberry chose a similar story to form the basis for the *Star Trek: Phase II* pilot. Roddenberry hired science-fiction writer Alan Dean Foster, author of several novel-length adaptations of stories from the *Star Trek* animated series, to write the story, which would be entitled 'In Thy Image.'

Star Trek's original art director, Matt Jefferies, joined the production as a consultant and contributed an updated design for the *Enterprise* with swept-back, angular warp nacelle pylons,

a recessed parabolic navigational deflector, and slab-shaped warp engines replacing the simple tube shapes of the original starship. Series veterans Joe Jennings and artist Mike Minor (who had earned an Emmy nomination for his effects design and work on the episode 'The Tholian Web') returned to the series and began set construction for the *Enterprise*'s interiors, updating the bridge into a more complex and technologically advanced appearance. Jennings and his staff also finalized Jefferies' design for the *Enterprise*.

At the time, the options for the kind of ambitious visual effects work the show required were limited. Long-standing optical houses like the ones run by Lynwood Dunn and Howard A. Anderson were the obvious choices, but Paramount also had its own subsidiary, an upcoming outfit called Magicam, which had developed a method of video compositing that

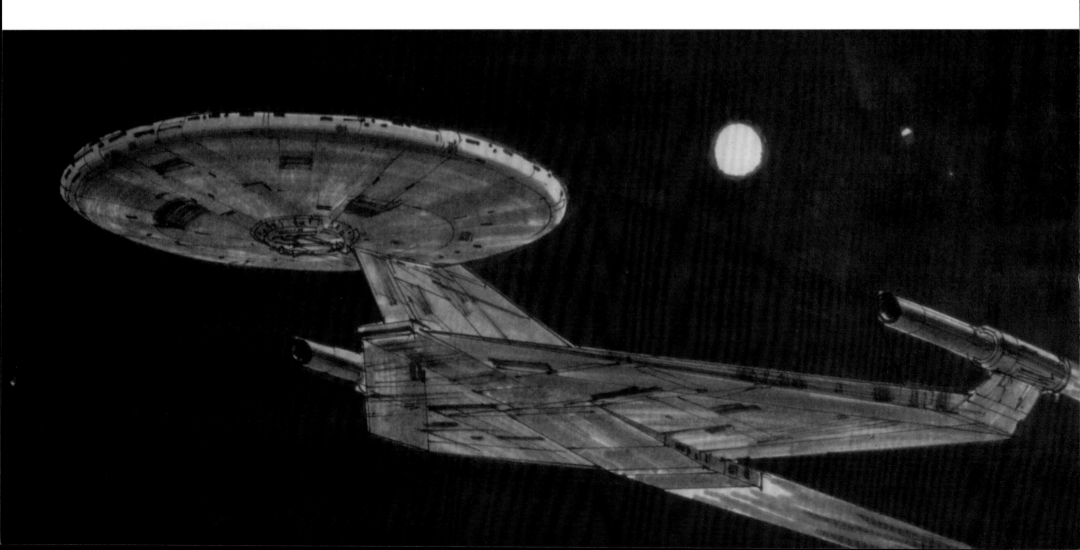

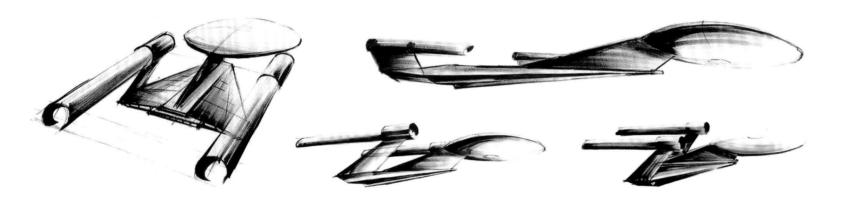

ABOVE: McQuarrie rough sketches of the asteroid drydock scene.

held great promise for the series. The company also specialized in miniature construction and, in September 1977, it was put to work building several important models for the production under the direction of Jim Dow. These included test reproductions of the original *Star Trek*'s Klingon ship, and early versions of the drydock and an Earth-orbit 'office complex' designed by Mike Minor. For research purposes, the production had been loaned one of the original Klingon ship miniatures and a small model of the *Enterprise*, likely the 33-inch version sparingly used for just a few shots on the original show. "Mike Minor was on the lot at Paramount," Dow says. "We weren't working

on the [feature] *Enterprise* at all at that point; we had a very rough TV model—not the one at the Smithsonian, but a smaller one—and that set the scale. I told them that even that model was meant for distance shots and it wasn't going to work for close-ups, so we were going to have to build one." Dow and his Magicam crew would eventually build their own *Enterprise* miniature—but not for *Star Trek: Phase II*.

One reason the *Planet of the Titans* movie project had been cancelled was the belief that there was no market for a big space movie. That, and the desire by Paramount to be a player in the television network, led them to green-light a television reboot. But while *Star Trek: Phase II*

was gearing up during the summer of 1977, George Lucas' space fantasy *Star Wars* was slaying box-office records, and Paramount's fourth network plans began to unravel. With advance buzz about Steven Spielberg's soon-to-be-released *Close Encounters of the Third Kind* starting to grow, studios could see that *Star Wars* had changed the landscape for science-fiction films. Paramount executives realized that they had an advantage in having a space franchise that predated *Star Wars* just waiting to be exploited. A *Star Trek* for movie screens became a priority once again, and 'In Thy Image' would become *Star Trek: The Motion Picture*.

CENTER: Ken Adam's sketches for his *Enterprise* redesign. Adams was the Oscar-winning production designer behind Stanley Kubrick's *Dr. Strangelove* and *Barry Lyndon*, as well as the James Bond films.

WARP EXPERIMENT

BOB ABEL & ASSOCIATES

WARP EXPERIMENT

THIS SPREAD: Some of the cutting edge imagery designed and executed by Robert Abel & Associates that brought the company to the attention of *Star Trek*'s producers.

Despite the fact that, by the latter part of the summer of 1977, it was clear to upper management at Paramount that *Star Trek: Phase II* would never air and would be replaced by *Star Trek: The Motion Picture*, work continued on the sets and models for the television reboot. By the late fall of 1977, it had become obvious to those involved that they needed to start thinking about the big screen, not the small one. This limbo period would last for several months. *Star Trek: The Motion Picture* was officially announced at a March 1978 press conference featuring director Robert Wise (of *The Sound of Music* and science-fiction movies *The Day the Earth Stood Still* and *The Andromeda Strain*) and the entire original cast. Initially

budgeted at $15 million, the film would feature a music score by Jerry Goldsmith, whose work included *Planet of the Apes, Patton, Chinatown,* and *Logan's Run.*

With *Star Trek* hitting the big screen as a major production, its visual impact became one of the first orders of business for the project. Prior to *Star Wars,* big-budget special effects movies were products of the studios and their veteran technicians and special effects departments. Stanley Kubrick's *2001: A Space Odyssey* had briefly challenged this model, and still stood—almost a decade after its 1968 release—as the unbeatable standard for visual effects in movies. But making space movies was still considered a gamble,

and films like *Silent Running* (the directorial debut of *2001*'s effects supervisor Douglas Trumbull), and *Journey to the Far Side of the Sun* (a Gerry Anderson production), were relatively low-budget exceptions. Even big-budget movies, mired in the disaster-movie cycle of the 1970s, boasted largely traditional visual effects, with matte paintings and miniatures bringing to life natural disasters (*Earthquake*), 1930s airships (*The Hindenburg*), rampaging giant apes (the 1976 remake of *King Kong*), and futuristic cities (*Logan's Run*). While all were well done, none of these Oscar-winning effects films truly dazzled the eye. If a *Star Trek* movie was to break new ground, it needed a different approach.

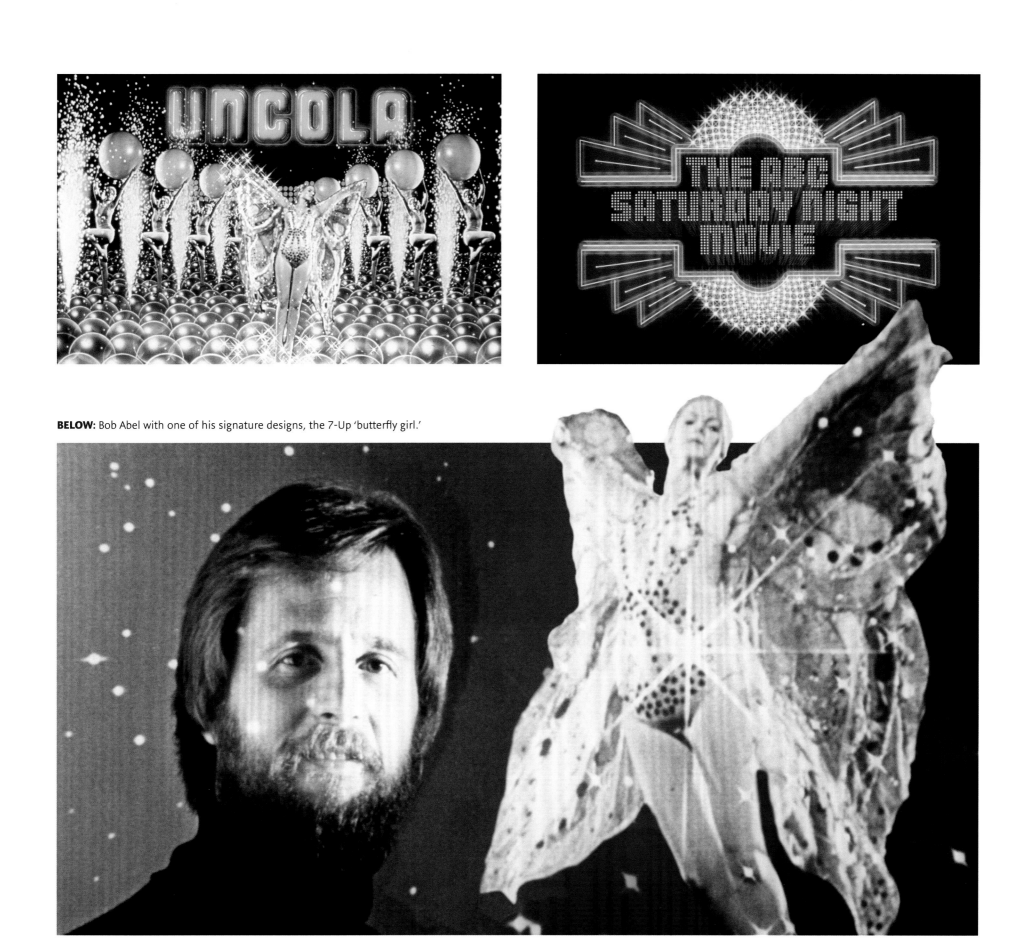

BELOW: Bob Abel with one of his signature designs, the 7-Up 'butterfly girl.'

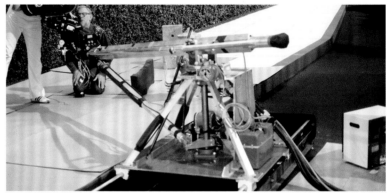

By the mid-1970s, most of the large studios had divested themselves of their visual effects departments as a cost-savings measure. While many of the former studio employees had started their own facilities in Hollywood and the San Fernando Valley, by the time the early planning for *Star Trek: The Motion Picture* began in the early fall of 1977, there were only a handful of facilities capable of pulling off the big-screen spectacle a *Star Trek* film demanded. Chief among those facilities were ILM, established by George Lucas for *Star Wars*, and Future General, headed by Douglas Trumbull. Future General was a subsidiary of Paramount Pictures, in a deal with Doug Trumbull to head up an R&D lab looking into advances in theatrical presentations. The visual effects in *Star Wars* created a lot of press, and John Dykstra and his crew were quickly commissioned to provide visual effects and design services for *Battlestar Galactica*, thus rendering them unavailable for *Star Trek*. Similarly, Doug Trumbull and Future General were committed to finishing the visual effects work on *Close Encounters* and were likewise unavailable. With the two newest cutting-edge facilities unavailable, it was time to think outside the established box.

At the time, the place for truly mind-boggling visual effects was in television commercials. And the facility at the cutting edge of those commercial visual effects was a company based in Hollywood, just down the road from the Paramount lot: Robert Abel & Associates. Robert Abel had been a documentary filmmaker in the 1960s but had worked in primitive computer animation as early as the 1950s with animator John Whitney, who had generated the arresting title sequence for Alfred Hitchcock's *Vertigo*, based on Saul Bass's design. In 1971, in the wake of *2001: A Space Odyssey*, Abel formed Robert Abel & Associates with Con Pederson, who had worked on the immersive, first-person POV slit-scan 'stargate' sequence in *2001*. The two men adapted the *2001* slit-scan processes (which involved filming the patterns of light created when abstract artwork was moved between a light source and a narrow 'slit' aperture in front of the camera) for use in a series of title sequences for ABC television, as well as commercials for Whirlpool and eventually ads for Levi Jeans and 7-Up. These commercials featured dazzling, hallucinogenic imagery far in advance of anything audiences were seeing on movie screens. Abel himself was a master salesman

THIS PAGE: Early motion-control equipment was hand-built and customized for the job at hand. 'State-of-the-art' often meant large bundles of wires. This was likely the system that Paul Rabwin saw prior to bringing Robert Abel in as a consultant.

> "I went over and looked at what he was doing...he had this [motion-control camera] rig. I had never seen anything like it."
>
> Paul Rabwin *postproduction supervisor*

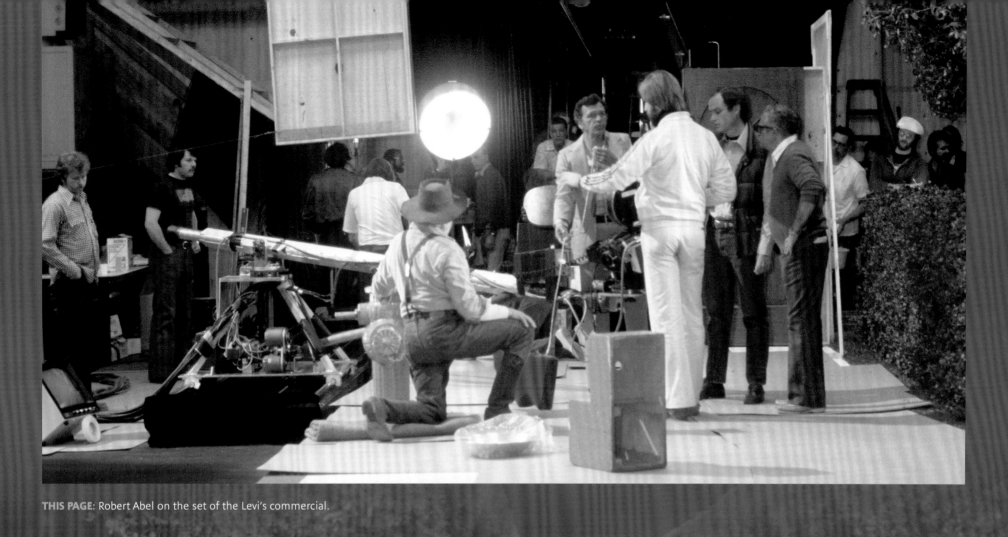

THIS PAGE: Robert Abel on the set of the Levi's commercial.

who could generate exciting ideas on the fly and would often dive into groundbreaking—and expensive—research and development, and was keen to push burgeoning computer technology to advance the art of visual effects.

Since visual effects work usually takes place after the live action has been filmed, it is generally the responsibility of the associate producer/postproduction supervisor to find and work with a visual effects facility. On *Star Trek: Phase II*, that job belonged to Paul Rabwin. A veteran of numerous Quinn Martin productions of the early 70s, Rabwin had limited experience with visual effects, but had heard about the new technology that had been developed for *Star Wars*: motion control. "I hadn't had any experience with motion control, but I had done some reading about it and talked to a few people," Rabwin recalls. Both Bruce Logan, director of photography for the *Phase II* pilot, and his camera assistant/ operator had recently worked at Robert Abel & Associates. "We were chatting, and he was saying 'Have you ever seen his system?' I said 'No'. He said 'There are really two real motion-control systems in town: ILM, which we're not going to get access to; and Robert Abel...So I went over and looked around and saw what he had been doing...He had this [motion-control camera] rig, I had never seen anything like it." Intrigued by what he saw at Abel's, Rabwin set up a meeting at Paramount. "Obviously, this is something they should know about," remembered Rabwin. "This was a big investment for Paramount."

Looking back, Rabwin reflects, "When I presented the idea [of Robert Abel], I said, 'The reason I'm presenting this is because there really isn't another working motion-control rig in the city. His work has always been exemplary, Richard Taylor is extremely talented. We should explore this.' I was presenting this as having our visual effects supervisor work with the equipment rather than Abel coming in as a supervisor. It was really about making a deal with him to get the hardware."

Robert Abel, not seeing his company as an equipment or rental facility, wanted to have some sort of creative control. Abel & Associates seemed the perfect fit for *Phase II*, particularly as the production began developing ambitious ideas for the story's central threat: a gigantic 'living machine' that would be called V'Ger— something unlike anything seen on film before. "Abel was a perfectly respectable place," Douglas Trumbull recalls of his reaction to the news that Abel's group would be handling effects for the *Star Trek* movie. "I thought 'Okay, they're good, Con Pederson is there', and he had worked on *2001* and knew how to organize this stuff. They were legitimately at the frontier of bringing CGI and computers into the mainstream. I thought it was visionary and there was no reason to expect that it wouldn't work until it didn't."

"We knew about his commercials," says Jon Povill who, by the time of *Phase II*, had been promoted to a producer working with Gene Roddenberry. "In particular the Levi's commercial, which was brilliant. Bob was a great salesman who had a great dog and pony show, complete with a number of dazzling conceptual drawings...[They were using] equipment he (and his staff) had never used before, so there was a serious learning curve. Remember, we're talking about computers in the late 70s, not Apple, not plug and play. Rather, endless tiresome configuration and matching of drivers with storage on floppies. Basically, a nightmare."

Despite some reservations, but taking the overall situation into account—the desire to create something spectacular, and the lack of availability of other companies that could do similar work—and given the quality of their demo reel and sales pitch, Robert Abel and his team were hired by Paramount late in 1977, initially as consultants. Soon after they began working with postproduction supervisor Paul Rabwin, when it became clear that *Star Trek* was destined for the big screen, Robert Abel pursued the overall visual effects contract for his company.

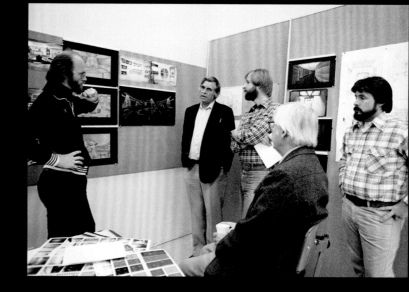

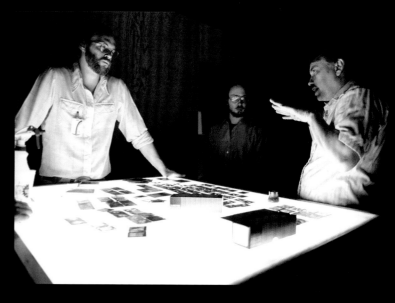

Richard Yuricich, who had worked with Trumbull on *2001*, *Silent Running*, and *Close Encounters*, was brought in by Paramount as a consultant just prior to the start of principal photography. "George Lucas, Bob Abel, and Doug Trumbull are kind of the fountainhead of contemporary, modern special effects," Yuricich says. "The 7-Up commercial and the girl, the logo, the Levi stuff, was all laborious, and they were going to do some of that for *Star Trek*, which was very time consuming and very expensive." Robert Abel & Associates was a great incubator of talent. Bruce Logan, who had also worked on *2001*, shot several commercials for Abel before being selected as the director of photography for the *Phase II* pilot. Richard Edlund would leave Abel's company to accept a position with ILM on *Star Wars*, effectively launching his spectacular career. Many others would pass through Abel's doors on their way to help create the VFX/CGI industry of the 1980s and '90s. "He was tremendously talented," says matte painter Rocco Gioffre of Abel, who was

brought onto the production by veteran matte painter Matthew Yuricich (Richard's older brother). "The crew that he had working with him in those days included many people who came over and became Douglas Trumbull's crew. Dave Stewart, who wound up being the motion-control photographer, came from the 7-Up commercials, and so on. Robert Abel & Associates had a very good reputation for artistry, primarily for television stuff."

Today, Abel is primarily remembered for being dismissed from the *Star Trek* production after failing to generate sufficient usable footage for director Robert Wise—a situation that set the production back months while Wise and company were facing an immovable deadline to get the film to theaters by December 7, 1979. Besides storyboarding most of the visual effects sequences for the film, Abel and his team did provide some effects for the film, including filming the live-action footage of the brilliantly illuminated V'Ger probe exploring the *Enterprise* bridge. The technique for the interior scenes of

the bridge crew in the wormhole was also worked out and executed by Abel's crew. The movie is more influenced by the signature look of Abel's commercial work than many people realize, due to the contribution of Abel's art department and sense of style.

Visual effects art director Richard Taylor, one of the key artists behind the 7-Up spot and other commercials, had joined Abel's company in the early 1970s after years of producing elaborate, projected light shows for rock concerts. Taylor had seen the slit-scan effects work Abel had done for ABC—glowing versions of the network's *ABC Sunday Night Movie* and *Tuesday Movie of the Week* logos that seemed to form illuminated landscapes sliding underneath or over viewers' heads, very much like segments of the famous *2001* 'stargate' sequence. "The Abel Studio started to evolve its own language and it was painting with light—painting by numbers with light, if you want to think of it that way," Taylor says. "I brought to it technology that had never been done because I was inventing it."

Taylor began to experiment with animation stands, rear-projected light sources, color filters, diffusion, and multiple passes to create a unique, gleaming, glowing look on film. "I started figuring out a way to sandwich stuff together [to] get interior glows and exterior glows. That technique I was doing started being called Candy Apple Neon, and then there was streak photography—we started combining those two, and that really began about 1974–75 with the *ABC Sunday Night Movie* marquee." The mid-70s *ABC Sunday Night Movie* opening was Taylor's elaborate revamp of the simple slit-scan logo effects done at the beginning of the decade—a brilliantly colorful, moving movie marquee with spinning stars, neon-lit letters, and illuminated, art deco framing.

As 'In Thy Image' evolved into *Star Trek: The Motion Picture*, visualizing the alien space probe V'Ger remained the key challenge. But the story also required an updated look at the *Enterprise*, updated Starfleet technology and spacecraft, Earth, Vulcan, and even the Klingons. The abstract, hallucinogenic look of much of Abel's work had made him a perfect candidate to realize the mind-boggling subject of V'Ger, but

ultimately that aspect would be finalized by other artists at other VFX facilities.

Just as Ken Adam had hired Ralph McQuarrie to generate spacecraft and hardware designs for *Planet of the Titans*, Abel and his team hired a young artist named Andrew Probert, who would evolve the look of the *Enterprise* and the Starfleet space stations and vehicles seen in the film. "I was studying industrial design at Art Center [College of Design] and, at that time, *Star Wars* was being advertised as this big space movie coming out," Probert recalls. "All the advertising featured art by Ralph McQuarrie, and the ads referenced 'LA-based artist Ralph McQuarrie' and I thought 'I really want to meet this guy'. I looked him up in the phone book and gave him a call and said I'd like to interview him for my school newspaper. That was kind of my foot in the door." Probert showed McQuarrie his portfolio and impressed the veteran aerospace artist. McQuarrie had become a hot property after *Star Wars*, and was at work on something called *Star World*, whose visual effects were being created by John Dykstra of *Star Wars*. After *Star World* was deemed too similar a title to *Star Wars*, it was changed to *Battlestar Galactica*. McQuarrie

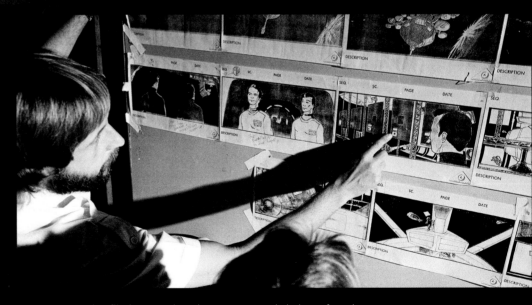

THIS PAGE: During filming, storyboards were constantly being referred to on set.

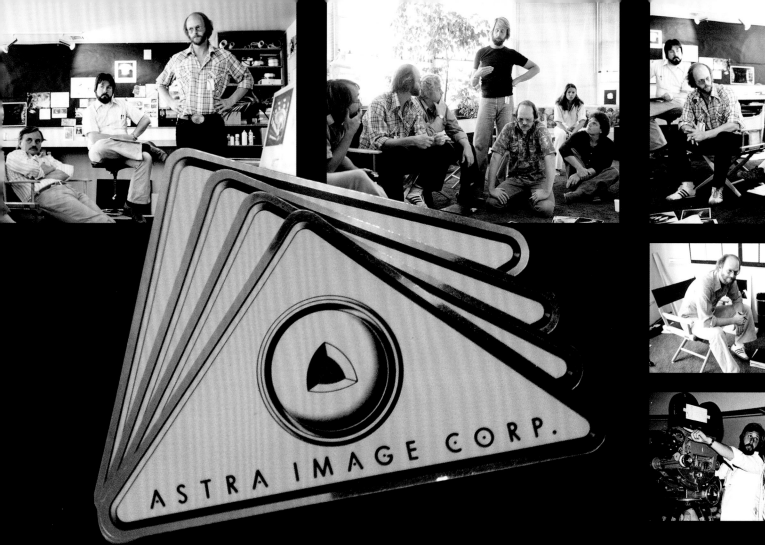
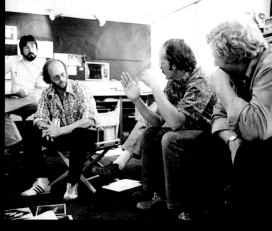

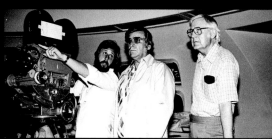

ent Andrew Probert to meet with Dykstra, and Probert was hired on *Galactica*. "They had me working on these robot helmets and then the full robots and, when they changed of the name of the show to *Battlestar Galactica*, those robots became the Cylons. So I designed the Cylons, the landing bay for the *Galactica* that you see when the Vipers come in for a landing, and the Cylon Basestar and some other things that weren't used."

McQuarrie had been hired to work on the *Planet of the Titans* movie before anyone knew what a massive hit *Star Wars* would be. After *Star Wars'* success, McQuarrie was re-approached for the new *Star Trek* movie production, but

had already been recruited by George Lucas to work on the *Star Wars* sequel, *The Empire Strikes Back*. McQuarrie suggested Probert as a concept artist, and Probert, an enthusiastic fan of the original *Star Trek*, eagerly took on the job. "Richard Taylor was my art director, and Richard said, 'Okay, I want you to design all of the Earth-based hardware—that will give those designs continuity because it will all be coming out of your head.' I got all my input from Gene because he would come into our office. Robert Wise would be there on occasion and we were all talking about what they wanted to see."

One casualty of the decision to switch to a feature film and give more responsibility to

Abel & Associates was Magicam—at least as far as visual effects production was concerned. "Because Magicam was a video composite system, initially we were contracted to do the television series," says Jim Dow, who was in charge of miniature construction at Magicam. "When they made the decision to finally go to a motion picture, they didn't know what our capabilities were. I'd already done *Close Encounters* and *Silent Running*, hundreds of things, and my purpose for developing the miniature shop at Magicam was that we could develop the highest quality miniatures that had ever been done for motion pictures—nothing had been done the way I wanted it to be done.

CLOCKWISE FROM TOP LEFT: Con Pederson, Andy Probert, and Richard Taylor in the ASTRA Art Dept; Robert Abel confers with his art dept and Jim Dow of Magicam (kneeling); Richard Taylor and Robert Abel; Abel confers with Roddenberry and Robert Wise on the bridge set during the filming of the wormhole sequence

BELOW: In December 1977, a meeting was held at Magicam's model facility to review all the miniatures built to date. During this meeting, it was decided that virtually all the miniatures seen here would have to be scrapped.

All of a sudden, when they went to film, they started looking at other people and we were in jeopardy of losing the project because our system was only video. I had to convince them that we were capable and set up for motion picture special effects." Despite the fact that Magicam was the de facto in-house VFX facility for Paramount, it was ultimately decided to award the contract for the visual effects to Robert Abel & Associates, but with Magicam providing the miniatures.

Abel and Richard Taylor met with Magicam's team in December 1977 to review their progress on *Star Trek*'s miniatures and determine whether the models would stand up to scrutiny on the big screen. At the time, Jim Dow and Magicam had constructed models of the drydock and space office complex miniatures based on designs by Mike Minor, while Don

Loos—one of the builders of the 11-ft miniature of the *Enterprise* used on the original series—and Brick Price had constructed a 6-ft model of Matt Jefferies' and Joe Jennings' new *Enterprise* design.

Richard Taylor quickly determined that the *Phase II* miniatures would have to be redone. While this high-pressure situation had the potential to create a rift between Abel's crew and Magicam, Jim Dow recalls that both groups quickly agreed on the goal of creating better-quality models for the motion picture production. "Richard Taylor came over and he was going to take over essentially what I was doing and there was a little bit of professional rivalry at that point," Dow says. "We proved to him that we were on the same page, and Richard and I became really good friends and worked well together."

Taylor oversaw design work on the *Enterprise* and Starfleet elements being generated by Andrew Probert, with Jim Dow overseeing the model construction. Over this process, design elements were refined and finalized as the construction processes and the needs of shooting evolved, with numerous artists contributing to the final looks of the miniatures. Eventually Abel's group, in their location just down the street from Magicam, began to staff their own model shop, one which would eventually employ some model makers from Magicam. One of them was Mark Stetson, who would work on the final finishing of the *Enterprise* model. Stetson says that the Seward model shop wasn't designed to compete with Magicam's so much as to help maintain and troubleshoot the *Star Trek* miniatures for filming. "They weren't planning

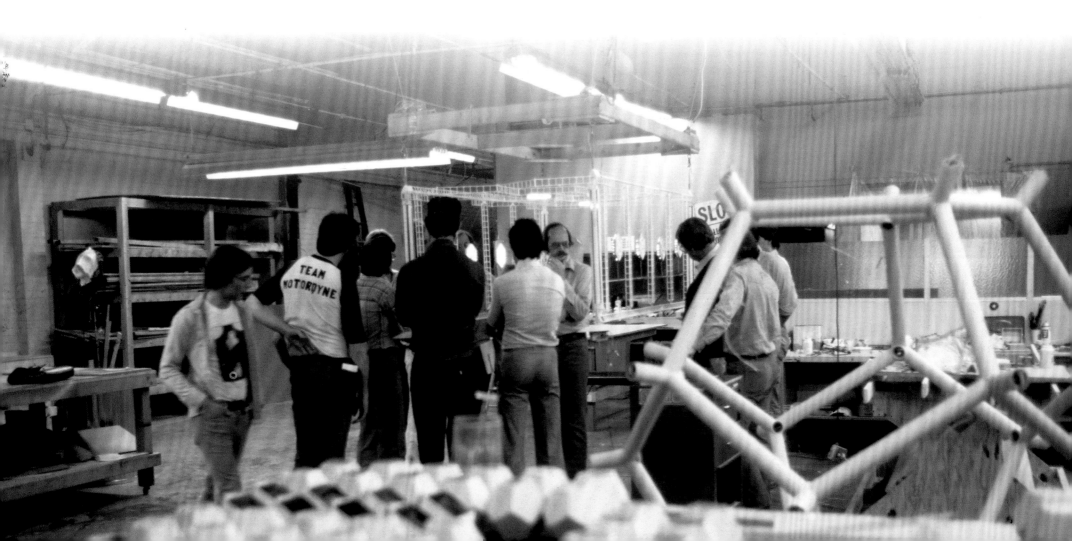

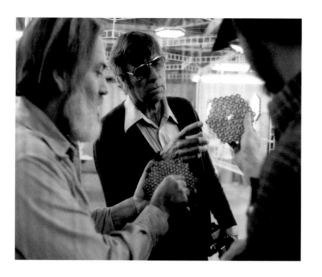 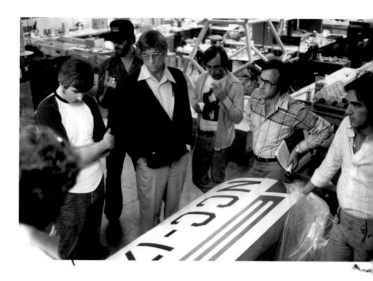

ABOVE: (LEFT)
Gene Roddenberry
discusses one of the
drydock spotlights
with Paul Turner of
Magicam; (MIDDLE)
The *Phase II* drydock
featured a much
simpler and more
open frame design.
The only design
element that would
survive was the
hexagonal spotlight;
(RIGHT) Magicam
also built a closeup
section of the *Phase
II Enterprise*'s hull.
Note the striping
reminiscent of The
Original Series.

to do much building; they were maintaining the models. All models need to be maintained while they're being shot because cameras crash into them, different needs come up, camera moves get too close to the models and detail has to continue and be revised. Abel hired Dick Singleton to put together a small crew that included Dennis Schultz and Chris Elliott, and Zusanna Swansea, who started at Magicam and moved to Abel's before I did. Joe Garlington and I joined them working for Dick. The way it all evolved was in fact the correct way to do it. You can't have a model in a model shop completed to the extent that you're going to fill all the requirements of shooting, because you can't anticipate all that stuff. So that's what Dick Singleton's role was at Seward—standby builder."

The Abel group, by this time dubbed ASTRA (for 'A Star Trek Robert Abel'), wasn't just involved in building miniatures and visual effects. Robert Abel's ability to sell his group's capabilities eventually led ASTRA into involvement with some important live-action sequences in the film, including the 'wormhole' sequence in which a flaw in the *Enterprise*'s warp drive technology creates a dangerous space phenomena that envelopes the starship, and a sequence in which the *Enterprise* bridge is invaded by a brilliantly

illuminated energy probe sent by V'Ger. "To me, it was a no-brainer as to why Robert Abel & Associates was hired to do visual effects, because they were absolutely bleeding edge in their visuals," Andrew Probert says. "Richard and all of these guys had all these Clios and other awards for these commercials which were just jaw-dropping, and Paramount said 'Okay, that's what we want to do for our effects.' Robert Abel and Richard, and all of these guys were just killing themselves trying to come up with visual effects that had never been done before, and that requires a lot of R&D, a lot of time, and a lot of advance thinking, because they wanted this film to look like no other science-fiction film had ever looked."

Probert cites the bridge probe sequence as an example. Abel and his team had devised a 'light wand' that would be operated by a technician on the bridge to provide practical, interactive lighting for the scene. "The tests were amazing, but that happened right at the time when Paramount said, 'Okay, you guys, we have a date and you have to produce these effects no matter what.' They were developing all this amazing stuff and, because of this release date, they were caught short. Robert Abel did not have the time to develop all the stuff they were working on."

In January, Abel had been called in by Robert

Wise to screen what visual effects footage his team had produced. Abel's ambitions for the film's effects and his team's heavy involvement in set design, on-set effects, and even costume and props (like a glowing pink sensor affixed to the neck of performer Persis Khambatta, playing a V'Ger-created reproduction of *Enterprise* navigator Ilia) had slowed ASTRA's output to a crawl.

"Abel was able to keep the production demands at bay with his endless song and dance that he'd be up and running in one more month," producer Jon Povill recalls. "Oh, and he just needed this one more piece of equipment—but look at this great drawing of what we're going to do as soon as you buy us this new stuff. After thirteen months on the production, Abel finally screened his first thirty seconds of test footage for Robert Wise. I wasn't in the room, but I happened to see Bob [Wise] as he was leaving the screening room. I'd never seen him that angry or close to exploding. He was half muttering to himself, half talking to whoever was next to him. 'I want that guy off the show. I never want to see or talk to him again.' I think it's safe to say that whatever he saw in there, it didn't exactly dazzle like the Levi's commercial. So it was eleven months before our locked-in release date, and we no longer had a specia effects house."

REFIT

DOUGLAS TRUMBULL
AND
JOHN DYKSTRA

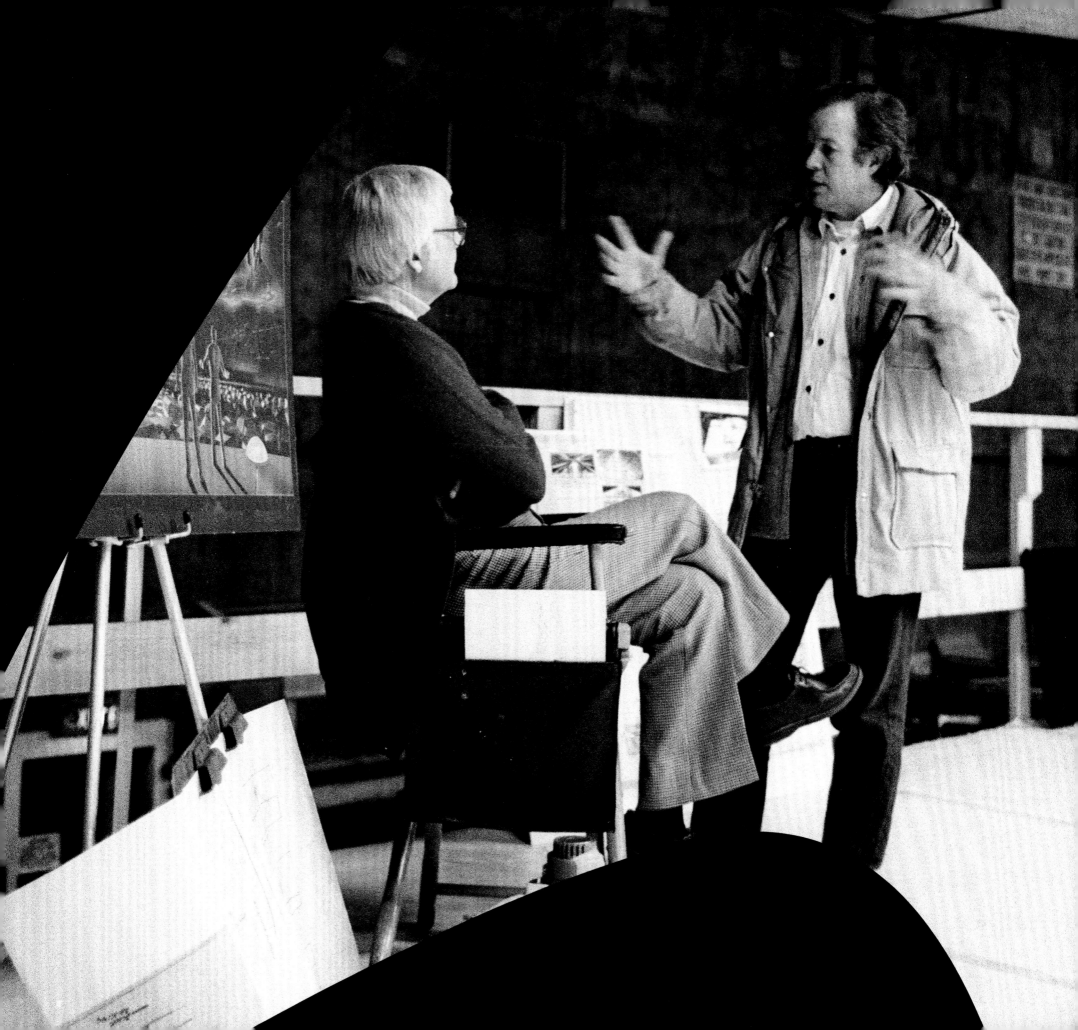

REFIT

PREVIOUS SPREAD:
Doug Trumbull talks
to Robert Wise.

BELOW: Doug
Trumbull with
art director
Harold Michelson
and director of
photography
Robert Klein on
the *Enterprise* set.

obert Abel's departure from *Star Trek: The Motion Picture* would turn an already technically challenging production into a headlong race against time as the cast and crew faced an immovable premiere date.

Richard Yuricich, who had been monitoring Abel's progress as a consultant, felt that ASTRA could have delivered impressive effects given a longer schedule, but that was out of the question. "I ended up the producer on the effects—I was offered the job to take over, which I did not take. I said I was ten percent of what they needed—'You've got a lot of great art here, but you need an artist.' All that art was there, it was just a matter of time and Abel & Associates, ASTRA, they were just so totally optimistic but they were correct about everything they were doing. Time was what the problem was. There was no way they could do this stuff with all the pre-actual, usable digital pipeline."

Despite some reservations during pre-production, ASTRA continued to be the main VFX supplier after filming began in early August of 1978. To ease the workload on Abel, one of Yuricich's early suggestions was hiring a matte painting unit—something Robert Abel's team completely lacked—to begin executing some shots. Yuricich's older brother Matthew was an experienced and sought-after matte painter who had worked on *Close Encounters of the Third Kind* along with Rocco Gioffre, and Richard Yuricich brought both men onto the *Star Trek* feature.

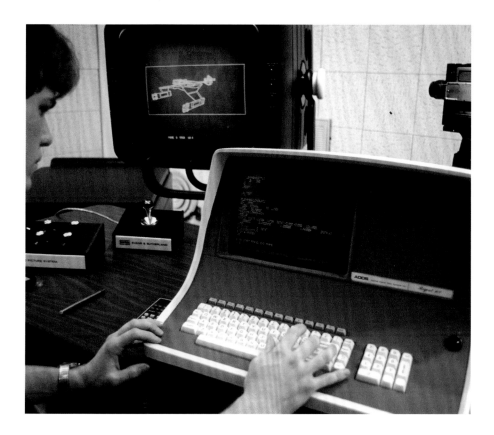
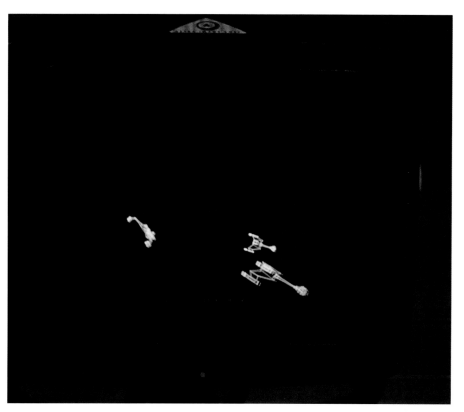

Ultimately, this would be a case of 'too little, too late' and the relationship between Robert Abel and the studio began to rapidly deteriorate. By December of 1978, after four months of principal photography, and with the filming of the Memory Wall sequence not showing promising results, the relationship had gotten so bad that Paramount began actively courting Doug Trumbull again.

Fortuitously for Paramount, by that time Doug Trumbull had finished up work on *Close Encounters of the Third Kind*, as well as an R&D project exploring high frame rates. After some meetings and a review of the design work done to date, Doug Trumbull decided to step in as visua effects supervisor and replace Robert Abel and some of his crew. After first asking about the possibility of moving the film's release date and being told that that was impossible due to contractual obligations between Paramount and the theater owners, Doug Trumbull decided to split up the workload with John Dykstra's company, Apogee.

Dykstra had helped revolutionize outer space visual effects with his motion-control Dykstraflex camera and its applications on *Star Wars*. And while Apogee was unavailable to work on *Star Trek* the first time due to *Battlestar Galactica*, by early 1979 they were available again when Ken Russell's *Altered States*, for which Apogee was to provide visual effects, was suddenly put on hold.

After Abel's firing, Trumbull and Dykstra became more than just ideal possibilities for the *Star Trek* film's visual effects—their hiring was now essential to the film meeting its release date. "The first films that really established the need for tight integration between the visual effects crews and the director were *Star Wars* and *Close Encounters*," Trumbull says. "At the time, no studio was able to understand that that's the way it had to be to work effectively." Trumbull himself was impressed by some of the technical innovations that Abel and his team were trying to achieve and integrate into *Star*

Trek: The Motion Picture, including what may have been the invention of the modern system of pre-visualization using computer-generated imagery to plan out shots. Abel was using vector or 'wireframe' graphics to choreograph potential shots of spaceships, but the system had its own limitations. "The big argument that I had when I saw some of the first pre-vis they did with wireframe (because that was the idea, to pre-vis shots) [was that] I said with wireframe I have no sense of scale—there's no guidelines for how fast the camera should move or how to make it look big or whatever, and I had this complete suspicion that wireframe was a huge mistake of judgment to assume that it would guide you through the shooting. And then they made these other mistakes, which were that the processes they were using didn't take into account that there was a thousand-foot magazine on top of the camera and it would bang into stuff. There were fundamental flaws in the whole approach."

ABOVE: Scott Squires works at ASTRA's Evans & Sutherland computer terminal, working out the flight paths of the Klingon ships. This data was to be transferred to the motion control camera system when the miniature was filmed.

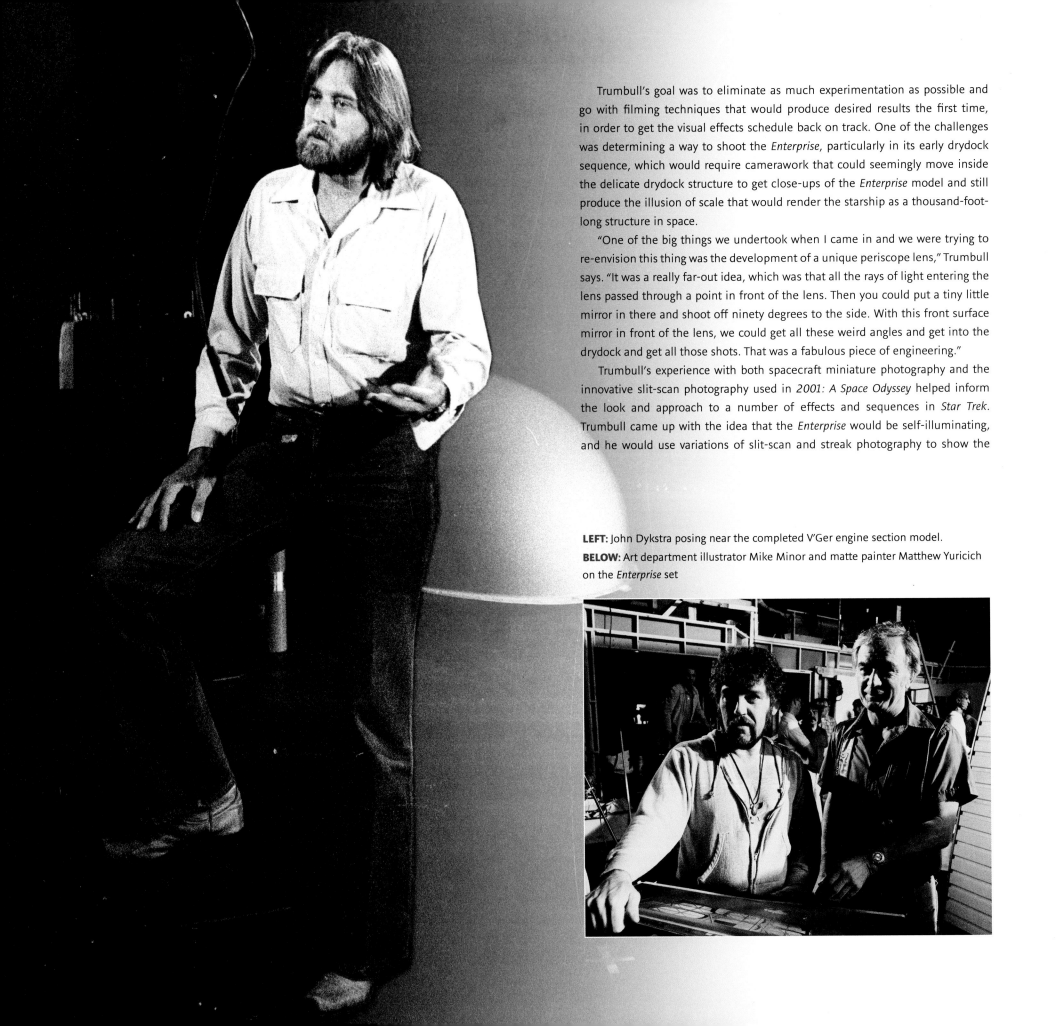

Trumbull's goal was to eliminate as much experimentation as possible and go with filming techniques that would produce desired results the first time, in order to get the visual effects schedule back on track. One of the challenges was determining a way to shoot the *Enterprise*, particularly in its early drydock sequence, which would require camerawork that could seemingly move inside the delicate drydock structure to get close-ups of the *Enterprise* model and still produce the illusion of scale that would render the starship as a thousand-foot-long structure in space.

"One of the big things we undertook when I came in and we were trying to re-envision this thing was the development of a unique periscope lens," Trumbull says. "It was a really far-out idea, which was that all the rays of light entering the lens passed through a point in front of the lens. Then you could put a tiny little mirror in there and shoot off ninety degrees to the side. With this front surface mirror in front of the lens, we could get all these weird angles and get into the drydock and get all those shots. That was a fabulous piece of engineering."

Trumbull's experience with both spacecraft miniature photography and the innovative slit-scan photography used in *2001: A Space Odyssey* helped inform the look and approach to a number of effects and sequences in *Star Trek*. Trumbull came up with the idea that the *Enterprise* would be self-illuminating, and he would use variations of slit-scan and streak photography to show the

LEFT: John Dykstra posing near the completed V'Ger engine section model.
BELOW: Art department illustrator Mike Minor and matte painter Matthew Yuricich on the *Enterprise* set

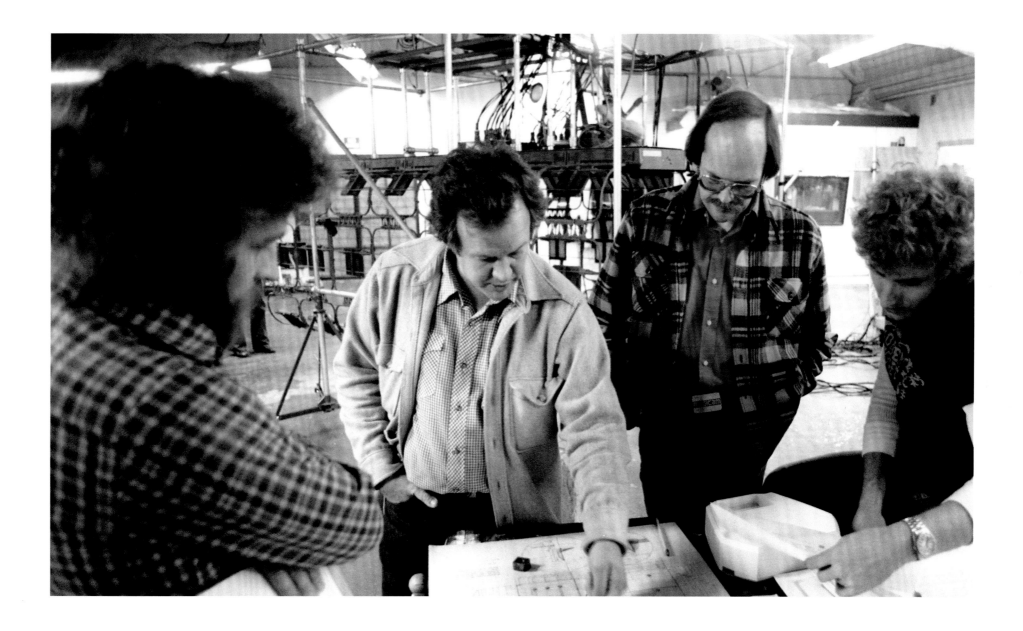

Enterprise seeming to stretch and fly through a tunnel of rainbow-like light effects as it went into warp drive. ASTRA's Richard Taylor had done initial research into what the ship would look like moving faster than light. "We called MIT and started asking if there was anybody who'd tried to visualize what it would look like to go forward at the speed of light, and they sent some film they'd done with some kind of CG in some way and it started to stretch and got spectral, something like that, and I brought in these drawings of how the *Enterprise* could jump to light speed."

Trumbull also used his own filmmaking experience and more slit-scan photography variations to create entirely new sequences, like Spock's late-in-the-game journey through V'Ger's memory core. Trumbull's group used lasers to create a vivid new look for the sparkling photon torpedoes invented for the TV series—a blue torpedo is shown destroying an asteroid during the wormhole sequence (Apogee would film red torpedoes for the film's opening Klingon sequence). Robert Swarthe had created a 2D streaking effect using animation stands and hand-drawn holdout mattes for the live-action

footage of the wormhole sequence, to show the *Enterprise* bridge crew buffeted by distortions of time and space created by the wormhole. Since the sequence was proceeding well at the time, and given Doug Trumbull's prior experience working with Swarthe on *Close Encounters*, it was decided to let that unit proceed intact with their work—the only visual effects work in the film that was started by ASTRA that would be completed. It fell to Trumbull to complete the sequence and depict the exterior shots of the wormhole itself, and the *Enterprise* being blurred as it streaked through the space phenomenon.

ABOVE: Doug Trumbull (pointing) confers with (L-R) Jim Hilton, Jim Dow, and Chris Crump at Magicam.

"One of the most challenging things was the wormhole," Trumbull says. "The idea was to take slit-scan to a new level by scanning a laser onto a rear-projection card and accumulating that as a volumetric thing because it was still pre-CGI. You could do that with a couple of mouse clicks today, but that was a very complicated bit of action to do then because every frame had to be the next iteration from the previous frame. I had to make all kinds of judgment calls on what I felt would be reliable and work, and get something on the first take instead of a nightmare of months of experimentation. There was no room for that. So that was my own call about how to do the wormhole as an extrapolation of slit-scan. You

had to have guys like Scott Squires, who was an electronical equivalent to [miniature director of photography] Dave Stewart—someone who could be counted on to spot something that was going wrong during the shoot and make sure they didn't screw it up."

Trumbull and John Dykstra's Apogee Inc. would eventually divide the work of photographing V'Ger, the film's central story element, with Trumbull using the smoke environment photography he had employed so successfully to bring scale and realism to the UFOs in *Close Encounters*, this time to create the sense of a vast interior environment for V'Ger. Dykstra's group would film V'Ger's exterior, using a combination of a seventy-

foot miniature and additional, oversized set pieces, shot with smoke and incorporating lasers scattered through smoke layers to create a background environment, an effect similar to one often used in rock concerts at the time.

With both Trumbull's Entertainment Effects Group and Apogee shooting material almost twenty-four hours a day, the goal of hitting the film's release date began to seem achievable. " It made a certain kind of sense, but I think it was really kind of sad that the whole movie as a vision had gotten so badly derailed that it was impossible to get back," Trumbull says. "The whole thing never achieved its goals and was never able to be what it could have been if everything had gone well from the get-go."

OPPOSITE: PR shot of Apogee's version of V'Ger.

BELOW: (LEFT) A digital model of the *Enterprise* was created by ASTRA to aid in the planning of camera moves; (RIGHT) VFX Slate from *Close Encounters* displaying the strange relationship between Columbia Pictures, Future General, and Paramount Pictures.

"I had to make all kinds of judgment calls on what I felt would be reliable and work, and get something on the first take instead of a nightmare of months of experimentation."

Doug Trumbull
special photographic effects director

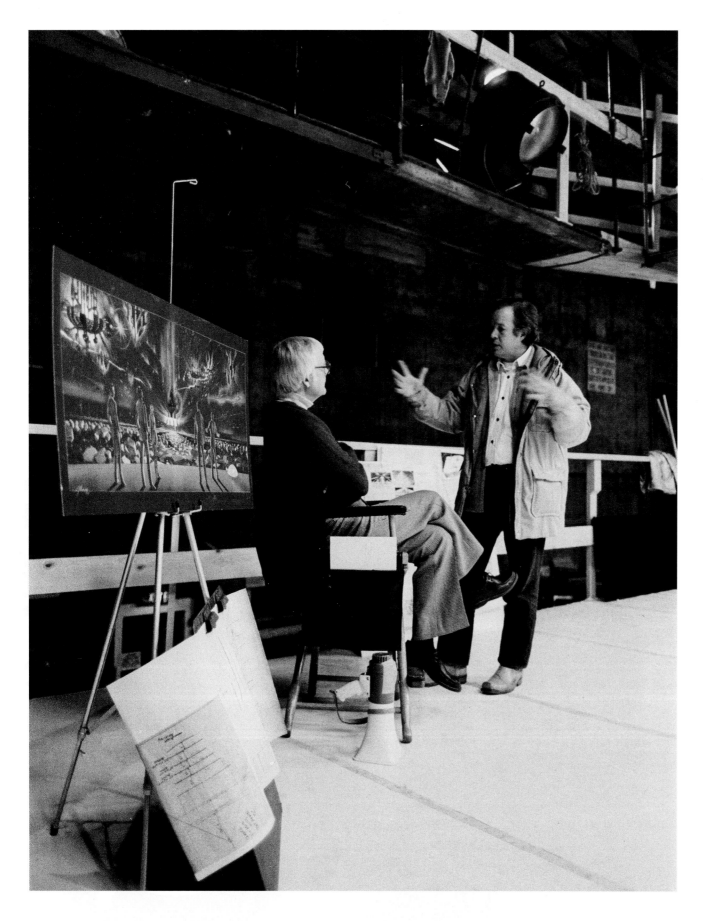

"The decision to hire Bob Abel was, in my opinion, the single worst decision that was made during my time on *Trek*," Jon Povill says. "It vastly impacted the number and quality of the special effects shots that we could use in the film. It drastically impacted the edit, as every week [editor] Todd Ramsay would get a new list of FX shots that would not be ready in time. And it drastically impacted the budget as we had both Dykstra and Trumbull's companies working golden time shifts twenty-four seven, trying to get as much footage as possible ready for the release."

Yet despite Abel's departure, some of ASTRA's effects would make it into the film. The spaceships they designed, and many of the sequences they storyboarded, would be filmed by Entertainment Effects Group and Apogee. *Star Trek: The Motion Picture* would ultimately make it to the big screen as a fusion of the creative vision and technique of ASTRA, EEG, and Apogee—compromised by a crushing schedule, but still showcasing dazzling, Academy Award-worthy visual effects.

The film's critical visual elements—the *Enterprise* and Starfleet, aliens like the Vulcans and Klingons and, of course, V'Ger itself—all evolved as they were conceptualized, built, and filmed by different artists and effects groups, from Magicam to Robert Abel's team, and finally Douglas Trumbull and John Dykstra's groups.

LEFT: This photo was taken as Doug Trumbull was being courted to take over the VFX duties. Note the large concept painting of the wing walk sequence.

OPPOSITE: The V'Ger model is filmed on Apogee's stage.

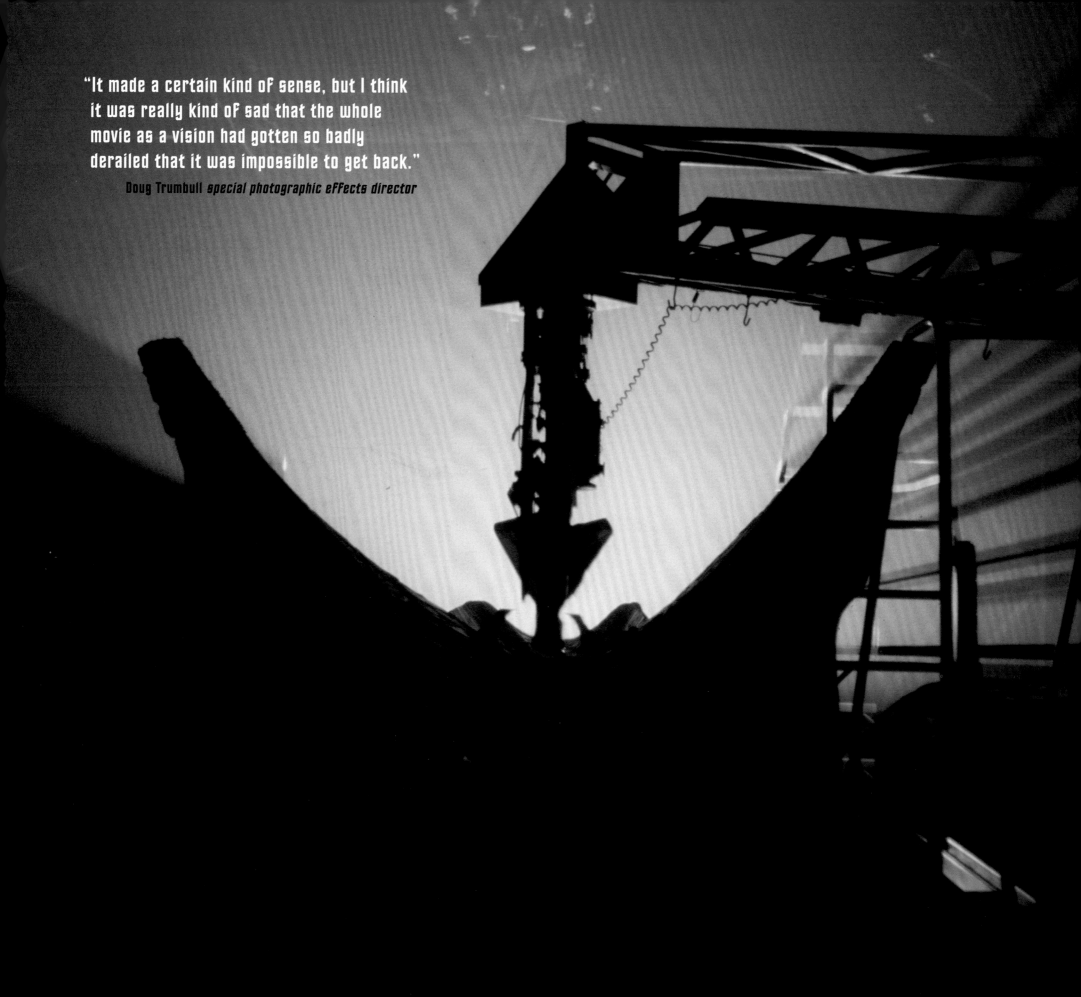

"It made a certain kind of sense, but I think it was really kind of sad that the whole movie as a vision had gotten so badly derailed that it was impossible to get back."

Doug Trumbull *special photographic effects director*

CHAPTER THREE

THE *U.S.S. ENTERPRISE*

EVOLVING THE CLASSIC STARSHIP

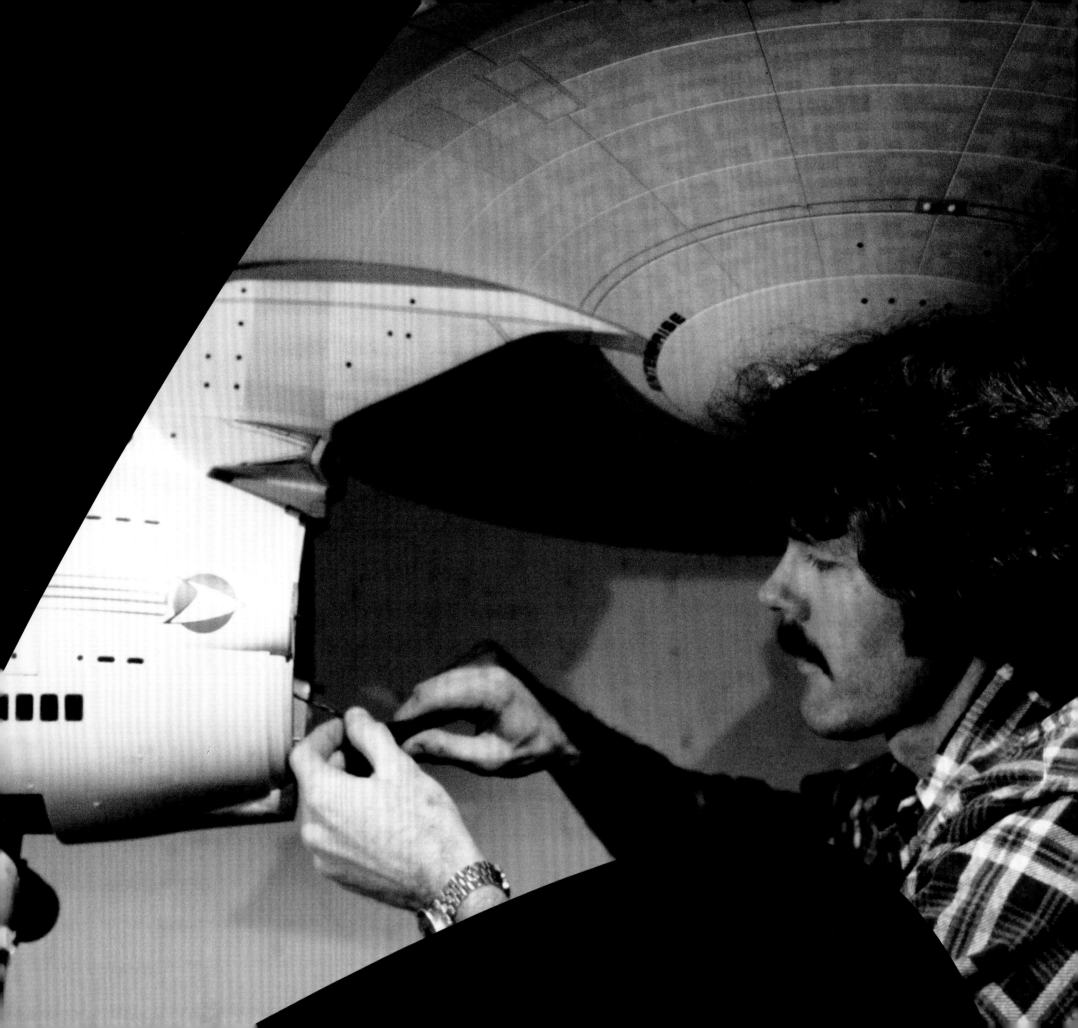

THE *U.S.S. ENTERPRISE*

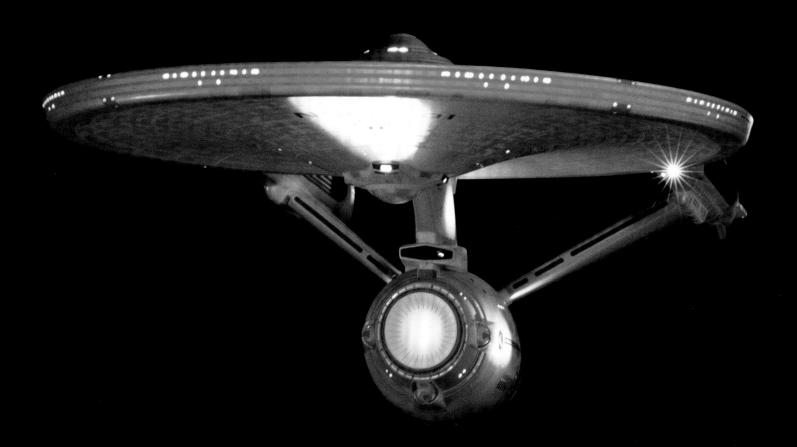

A decade after its debut on network television, the *Starship Enterprise* had evolved into a cultural icon reproduced on bumper stickers, as model kits (AMT's kit of the *Enterprise* was at one time the best-selling model kit of all time), on posters and paperback book covers, and even detailed in a bestselling set of official blueprints and the *Starfleet Technical Manual* just like the kind seen being pored over by Scotty on the TV series. As Gene Roddenberry would point out to more than one artist working on the developing *Star Trek* movie, the *Enterprise* was more than a spaceship—it was a character, perhaps the most important one in *Star Trek*.

The spacecraft's profile—its saucer-shaped primary hull, the cylindrical lower engineering hull, and the upper, dual warp nacelles—was instantly recognizable, and any artist prepared to update the starship's design strayed from that iconic look at their peril.

At the same time, certain aspects of the ship's look had been limited by 1960s materials and research, as well as the show's budget. Model builders Brick Price and Don Loos had begun the process of updating the *Enterprise*'s design based on sketches provided by Matt Jefferies, who had designed the ship for the original series and had been recruited by Roddenberry during the production of *Star Trek:*

Phase II. "Matt had already started changing it—he swept back the pylons and started changing the engines to more of a rectilinear shape instead of the circular tube profile it was originally," Richard Taylor says. But Jefferies had also gotten involved in Michael Landon's TV series *Little House on the Prairie*, a job the art director genuinely loved, and reluctantly withdrew from *Star Trek* after making a few sketches and diagrams of the *Enterprise*. Joe Jennings and Mike Minor, who had both worked on The Original Series, remained on the production as it began to transition from the *Phase II* television pilot 'In Thy Image' to a theatrical movie.

Price and Loos' version of the *Phase II Enterprise* was 6 ft long, just over half the size of the original, 11-ft *Enterprise* constructed by Richard Datin for the first *Star Trek* pilot in 1964. The 6-ft miniature incorporated a number of features that would remain on the design, including its swept-back warp engine pylons, rectilinear engines, a photon torpedo tube located at the base of the 'dorsal' pylon connecting the saucer to the engineering hull, and prominent, circular docking hatches on the engineering hull and behind the bridge dome.

At the same time, Paramount had its in-house vendor Magicam and miniature expert Jim Dow building the *Phase II* pilot's other miniatures, including a large close-up section of the *Enterprise* engineering hull and a hatch for a docking sequence, and versions of an orbital drydock and space office complex, all based on geometric designs generated by Mike Minor. But as the production evolved from the *Phase II* television series to a feature

film, Robert Abel and his art director Richard Taylor were asked to evaluate the miniatures for potential big-screen use at the December 1977 meeting. None of the models, particularly Brick Price and Don Loos' *Enterprise*, were finished. And while the work-in-progress status was taken into consideration, the switch from television to feature film ultimately wound up being the final arbiter.

"My basic take was that everything Magicam had done all needed to be replaced," Taylor says. "That wasn't something they wanted to hear, but I prefaced that by saying that we are making a modern motion picture and there are techniques that have been evolved as a result of *Star Wars* that have to be incorporated into the way these models are made, that the look of science fiction had changed as a result of *Star Wars* and *2001* and, if we were going to rebuild the *Enterprise* and modernize it or update it, because it was the hero of the movie and Kirk's love affair, it had to be really refined."

Taylor's first instinct was to take a completely different approach to the famous starship, retaining the warp nacelles but experimenting with different shapes, but Gene Roddenberry had very specific guidelines. "The *Enterprise* had to retain the general configuration that it always had, that being the saucer, the big dorsal, the lower fuselage, two struts, and two nacelles. He felt that it was a character that was essential to the franchise, so those things had already been incorporated in some ways in the model that was already underway by Matt Jefferies, and there were some things that he had done that I thought were really quite good. I took all the pictures of the one that he'd done and started redrawing over them, and I did the first real drawings of the *Enterprise*, primarily the side view. I wasn't so worried about the saucer—I wanted to make it larger and have a reverse curve when it comes out toward the edge and also make the proportions, the size of the bridge compared to the saucer, smaller."

BELOW: (LEFT) Robert Abel, Robert Wise, Richard Taylor, Gene Roddenberry, and Con Pederson confer over the saucer of the *Enterprise* model at Magicam's shop; (RIGHT) Master airbrush artist Paul Olsen giving the *Enterprise* her signature paint job.

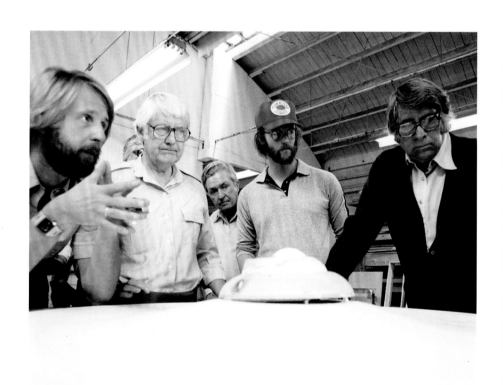

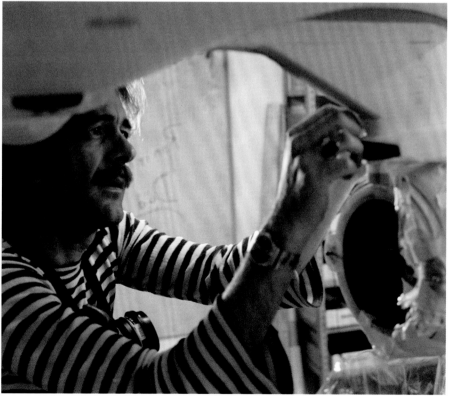

CLOCKWISE FROM TOP LEFT: The heliarced aluminum armature of the *Enterprise,* showing the little-used starboard side mount point; Model maker Chris Crump carving the pattern for the new impulse engine; The *Enterprise* saucer resembled The Original Series with a simple dome on the bottom, but featured new access hatches and docking ports; The *Enterprise* model in the paint shop; Production designer Harold Michelson points out his preferred location for the recreation deck.

Taylor had done a great deal of research regarding space architecture, folding foils, and other methods NASA had looked into regarding zero-gravity construction and the way a large spacecraft might actually be constructed in Earth orbit—research that confirmed that a great deal of the *Enterprise*'s familiar appearance went against the grain of science and engineering into fantasy. "The *Enterprise* is very unbalanced—if you take anything in weightlessness and spin it around, it will find its own center of gravity. On the *Enterprise*, the center of gravity is outside itself—it's somewhere between the nacelles and the nose and up above somewhere. It makes no sense at all other than that it looks cool. And that's what science fiction is all about. The minute you walk into a spaceship in a science-fiction movie and there's gravity, you've crossed a line, and there are physical things happening that you're just not going to explain. You try and make those rules the same for the whole movie once you've set what the rules are, so

obviously when Spock left the *Enterprise* they're in weightlessness, but onboard there's gravity."

Ultimately, this meant that a whole new model of the *Enterprise* would have to be built at additional cost. Brick Price and Don Loos' version of the model was shelved—literally—and it was decided that Magicam would now supply all the models for the feature film, including a new, larger *Enterprise* designed specifically for the big screen.

As the chief representative of Earth and Starfleet's spacecraft aesthetic, the *Enterprise* became a major part of Andrew Probert's marching orders to work on the movie's 'human' spacecraft and vehicles. While Probert agreed with the idea of maintaining the starship's familiar shape, he wanted to add to its scale. "I said 'Let's make the ship larger—let's make it 2,000 ft instead of 960 or whatever,' and Richard said, 'No, we need to make it the same size.' So I said, 'Let's even it out to 1,000'—parenthetically, I'm an even-numbers freak. And he said, 'Okay, we can do that.' But Richard said, 'Before you get

started, I want to design the engines.' Richard set the style for the *Enterprise* as being this art nouveau style with all these parallel lines, a lot of horizontal nests to what we were doing, which I thought was great. I was taking some of my cues from what he was doing—he worked on the engines and had these really complex shapes that he put together beautifully, so I started doing details on everything else—the saucer, photon torpedoes, the bridge structure, and so on."

"The saucer had to be an independent craft itself," Taylor says, "so there's these rectilinear things on the bottom that are actually the footgear, the landing gear that comes down. It has its own engine, the [impulse] engine, and I worked back and forth with Andy to get that right because I wanted to have an effect in that sphere in the middle, a pulsing effect of energy so there was something visual about it. Any time you can add lights to something, it becomes more interesting, and when you could have animation it gets even better."

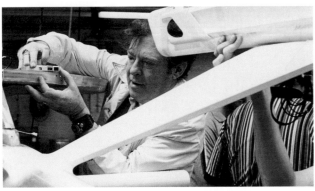
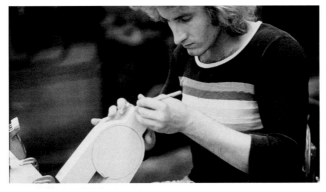
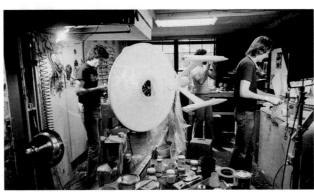
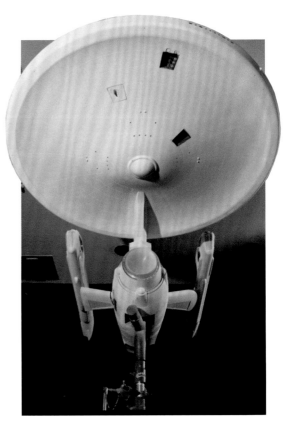

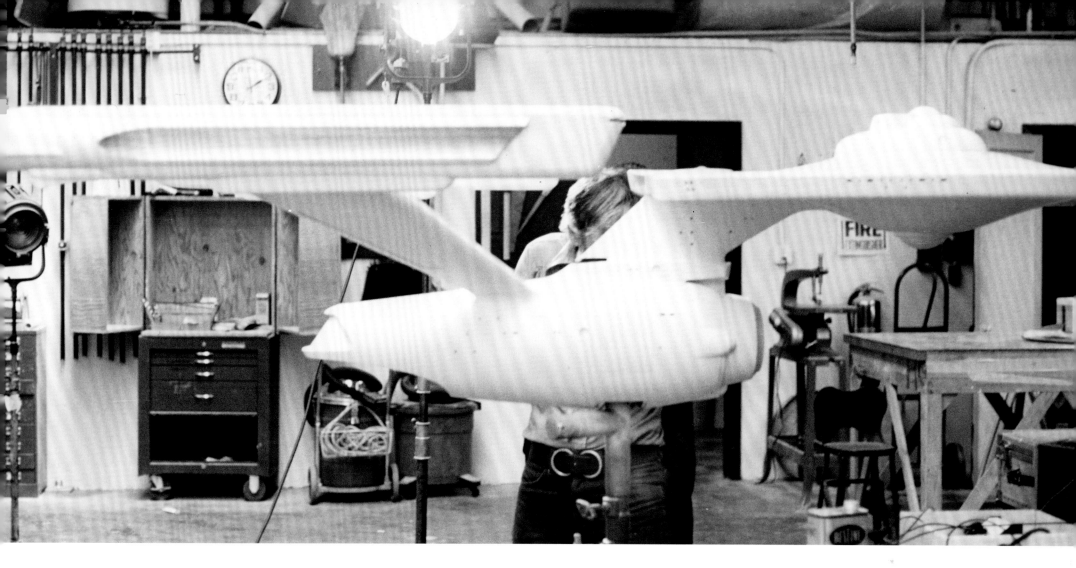

THIS PAGE: (ABOVE) The *Enterprise* takes shape as the remnants of the *Phase II* models are exiled to the attic above; (BELOW) Impulse engine artwork by Andy Probert.

Probert also tackled the question of what allows the *Enterprise* to make small-scale movement and attitude adjustments—pitch and yaw. "I introduced the idea of reaction control systems for the ship because I thought the ship was going to be doing all this finite maneuvering, but we have no way to see how it does that, so let's extrapolate from NASA and put these RCS systems all over the ship."

Taylor brought an art deco look to the nacelles, adding intake grills onto the front inspired by a 1938 Ford. "I'm into cars and hot rods, so the nacelle was a combination of things—the nacelle was really maybe the most critical part of the design: its functionality and the whole philosophy of how the *Enterprise* works, which is basically: there's supposed to be antimatter in those nacelles and, when it's activated, it creates a hole in space, or a disturbance, and the *Enterprise* is riding on the front of that disturbance, so it's surfing. I personally designed the nacelles and went through a lot of versions of it to get it right. I wanted those big raw metal grills on the inside and outside to represent huge electromagnets or something that

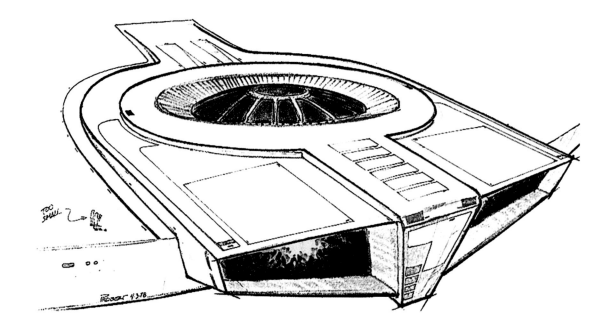

represents a force. It didn't need to be there the whole time, it just could have been there when the engines initially fired and then it could have faded." Ultimately, the warp drive effect was achieved on the model by illuminating the inner warp nacelle grills with blue lighting.

Another major piece of lighting design was incorporated into the front of the engineering hull, which had sported a metallic antenna on the original 1960s *Enterprise*. "That's the deflector that theoretically shoots energy downrange and moves stuff out of the way," Taylor explains. "That antenna had been

eliminated in Joe [Jennings]' model, and there was a dish shape at the front of the fuselage which Andy and myself redesigned." Lighting was integrated into the deflector dish so that it would display an amber look when the starship was at rest and power up to a hot blue when the ship was in motion.

A new miniature was constructed by Magicam under the direction of Jim Dow, incorporating all these features, with Taylor, Probert, and Dow finalizing the ship's details to create the look of an ocean liner in space. Dow knew of Richard Taylor's initial desire to

redesign the *Enterprise* from top to bottom. "I think that would have been a huge mistake, and I think proof of that is the opinion that everybody has of every ship that's been modified since," Dow says. "Nobody likes them, everybody goes back to [the design we built]. It was spectacular."

Dow says many of the ship's contours were dictated by its inner support structure, designed to keep the ship absolutely immobile and to make it easy to mount for motion control photography. "Once I designed and built the armature, there was no going back. It was skin

ABOVE: Artwork for the lettering, insignia, and pinstriping was generated and farmed out to a commercial decal company.

OPPOSITE: Original Series *Enterprise* designer Matt Jefferies worked out the design and dimensions for the revised *Enterprise* model for *Phase II*.

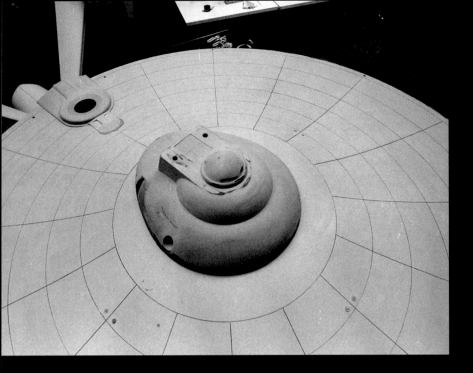

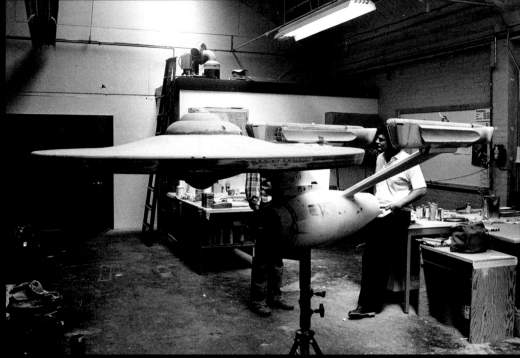

TOP LEFT: Initially, the bridge decks of the *Enterprise* were soft and rounded, resembling the basic shape of The Original Series miniature. Note the updated docking ports on the side and rear. Additionally, the saucer grid lines, which were simply drawn on The Original Series model, are now engraved into the surface.

details from that point on—we could change skin details, but the armature was built out of half-inch aluminum, titanium, all kinds of exotic materials, and it was all machined and heliarced [a welding technique] and fitted together so that it was bulletproof and could be armatured from any one of four or five positions, solidly. Then it was a matter of putting the skin on. The main body was translucent butyrate that was vacuformed. The windows were masked and this was the blockout paint job—first it was painted white, then painted black, and then the final paint job over that."

"The *Enterprise* was about 8 ft long and could be armatured from the rear, the left, the right, and the bottom and the front. It could not be armatured from the top," Taylor points out. "The underlying structure of the *Enterprise* is a big aluminum thing that's very strong, and it has to be because the *Enterprise* is a very unbalanced object. The way the saucer hangs out there on that nacelle, it wants to break off, so you had to build a really solid armature under there and there were lots of lights built into that.

This was pre-LED so all of the lights were either fluorescent, which is what lit all the windows, or incandescent, grain-of-wheat bulbs that were very small."

The elegant surface shapes of the starship were vacuformed with a clear plastic called butyrate. "I don't remember who spun the saucer patterns, I think that was done with vacuform parts out of house, but they were nice," Mark Stetson recalls. "The main lower hull, the secondary hull was also butyrate vacuform, and the pieces on that and the neck going up to the main saucer were a bit thin and they moved around a bit too much. Jim Dow did a really good job designing the access points on all the models. The butyrate vacuform pieces are plastic in the physical sense—they expanded in the heat and flexed and, as they shrink from their forming process over time, they curl a little bit, so we ended up sealing up the port-side hatch on the secondary hull, so that's why you always saw the *Enterprise* shot on that side. We finished up the other side of the ship for one big shot at the end."

Richard Taylor's influence on the design—the art deco look of the ship's engines, its gleaming surface detail, and the eye-catching color palette of lights (the blue deflector and impulse crystal, amber impulse engines, and purple warp engine grills) reflected the vibrant, Candy Apple Neon colors of the Robert Abel TV commercials, giving the *Enterprise* a zippy, disco-era coloration that meshed perfectly with its sleek, art nouveau contours. "Paul Turner was our electronics guy," Jim Dow recalls. "He wired everything and, after we closed down on *Star Trek*, he went to NASA and applied for work and was in charge of wiring the space shuttle at Vandenburg [Air Force base]."

The finishing touch on the model as it was completed by Magicam was a spectacular, multifaceted, pearlescent paint job rendered across the hull via airbrush by artist Paul Olsen. Since *2001: A Space Odyssey* and *Star Wars*, audiences had been acclimated to a new level of detail on spacecraft in movies, but Gene Roddenberry and the film's artists still wanted the *Enterprise* to retain its clean, futuristic look on the big screen.

"Originally, Richard wanted the ship to be white," Andrew Probert says. "The classic *Enterprise* was kind of a gray-green color and Richard thought 'we have a brand new ship, it should be white.' In some of my drawings and some of our discussions, I mentioned the fact that the *Enterprise*, the original one, had these red pin stripes down the spine, and I said we could do some detailing like that but expand it more. I knew that the saucer from the original separated from the engineering hull, so I created a specific separation line on the dorsal; part would go with the saucer, part would stay with engineering. So we did red pin striping around that, we did red stripes around the RCS system, and red pin striping around the phaser banks, which I placed all over the ship so it could totally cover itself instead of just having phasers come out of the bottom like the original. Then we had pin stripes around the upper part of the saucer—they were all over the place."

The combination of white hull coloration and red striping led Richard Taylor to suggest some blue accents in order to create a red,

white, and blue starship. "So all the leading edges, like on the dorsal and on the pylons, the warp nacelles, had blue leading edges," Probert says. "Then I came up with the idea that jet engines on today's aircraft have a totally different feeling from the rest of the aircraft, so let's do that around the engineering section. We came up with this engineering green, a light gray-green color that would cover the top of the engineering hull between the warp engines and go all the way up to the front."

The pin striping ultimately became a victim of miniature photography and time. The striping was achieved through the use of silkscreened water-slide decals. But unfortunately, the decal film was just thick enough that its application was visible on camera, robbing the miniature of a convincing sense of scale under certain conditions. "The modelers started complaining about how hard it was to put the pin striping on and, by that point, Doug Trumbull was in charge and he said 'just forget about it,' so we lost that additional level of spiffiness because of that," Probert adds.

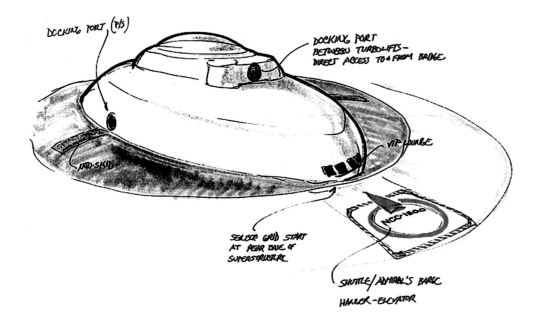

ABOVE: The initial bridge model featured a miniaturized set of the officer's lounge. After it was completed, it was felt that the bridge decks didn't match the art deco look of the rest of the model and they were redesigned and constructed by the ASTRA model team. They were further revised at Future General after Doug Trumbull introduced exterior lighting to the model.

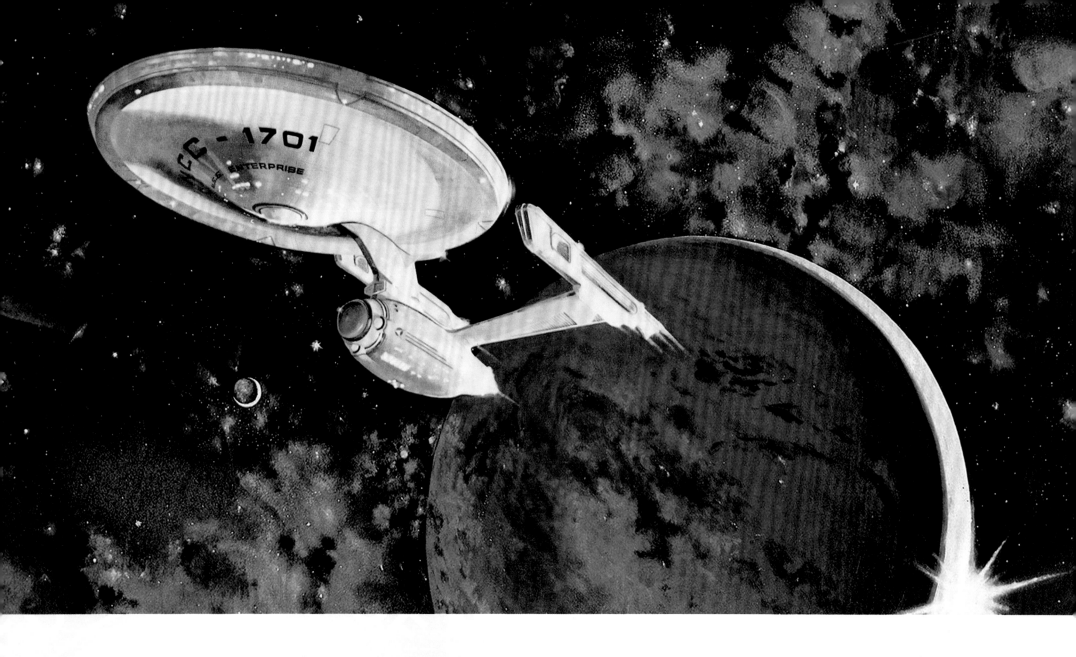

ABOVE: Mike Minor painting of the *Enterprise* done for *Phase II*. Note the pinstriping on the edge of the saucer.

OPPOSITE TOP RIGHT: Material from early camera tests using the unfinished *Enterprise* model were combined with shots of the actors to make up early PR photos.

Ultimately, another approach would add both scale and the ship's unique, iridescent look. "Richard said, in order to understand the scale of this thing, it should have panel lines," Probert says. "I said the original was smooth, as far as I could tell, and he said, 'Yeah that's true, but we're going to see this on the big screen so the ship should have panel lines.'"

"I think one of the most beautiful things about the model was its finish," Taylor says. "It was very carefully designed and created because the *Enterprise* is supposed to be more modern, smooth, sleek, and we couldn't put greeblies all over the outside of it. But we needed something

to give it scale—the windows did that, and I had horizontal lines inscribed around the edge of the saucer and, wherever I could, linear lines that were parallel, that were part of body paneling or part of the structure. Wherever we could have an etched line into the surface, we did that, but the overall surface wound up being a paint job done with pearlescent paints and different specularity with a tiny difference in color temperature."

Jim Dow notes that the paint used ground oyster shells as an ingredient. "It's pearlescent and it's an old material that guys used on their cars in the 1950s. It has wonderful qualities

because it's translucent and, depending on how you lay it on, it will refract color in different ways. In growing up watching *Flash Gordon* and so on, the models always looked one color, there was no scale. But you look at an aircraft carrier or any ship of anything of great size and you see panel breakup—you see differences of paint from one gallon to another, so it was really important to me to help indicate size and help bring this thing into reality through panel breakup. The idea of using the pearlescent paint was to give it another layer of believability from surface glare and so on, trying to break it up even further."

Dow needed a highly skilled specialist to execute the elaborate paint job. "Charlie White was the premier airbrush artist in the world and he was doing Rolling Stones album covers, chrome and neon with an airbrush, and it was very believable. Charlie's an old friend of mine, and I called him and said I wanted to paint the ship myself but I have more than I can handle and could you come and paint the *Enterprise* for *Star Trek: The Motion Picture?*"

White was flattered but also overbooked, and recommended a young artist named Paul Olsen. "Charlie sent Paul Olsen over and I walked him to the spray booth where the ship was in white primer and it was ready for paint, and he just took one look at it and said, 'Okay, I want this job.' I'd worked out an initial pattern that would be repeatable on the saucer and he then did a section like an eighth pie shape, and proved to me that he could do it. I said 'go for it' and he then spent months and months working on it."

Richard Taylor cites what would later be called the 'Aztec pattern' as something worked out by himself, Probert, and Jim Dow, who was instrumental in creating an approach for the areas outside the repeatable saucer pattern, as well as model maker Zusanna Swansea, who spent hours cutting out masks and assisting Olsen with the airbrushing chores. "Jim Dow had a lot to do with that because it radiated out on the saucer, but how it was patterned on the fuselage and the nacelles and so on had to be worked out. We had to make the decision about the patterning, and then masks had to be made and cut and adhered. Then one whole set of panels would be sprayed that would be taken off, another mask put over it, and it was very delicate...It really looked beautiful. It was very time consuming and they put a lot of work into it, and you knew if it was ever damaged in any way you had a major repair job, so moving... and taking care of the *Enterprise* had to be done carefully."

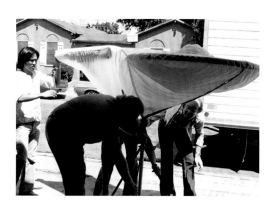

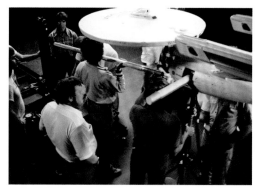

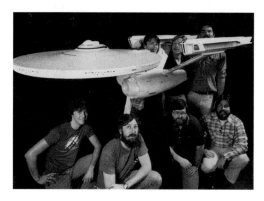

ABOVE: The *Enterprise* was carefully moved from the Magicam model shop to ASTRA's model shop and finally to the Future General shop and stage.

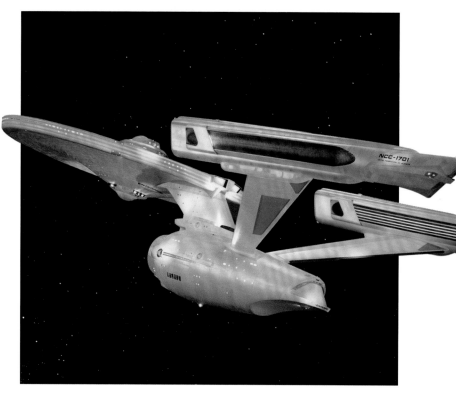

ABOVE: Once completed, a proper still photography session was set up by VFX unit stills photographer Virgil Mirano for PR use.

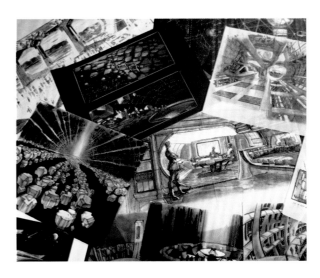

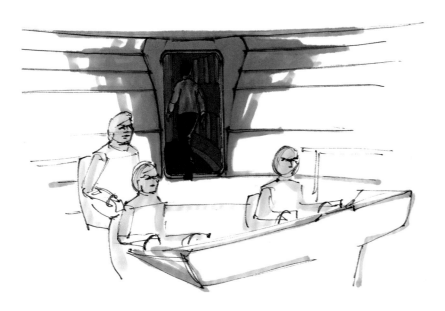
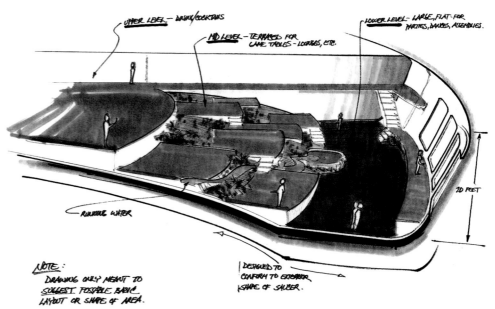

UPPER LEVEL — DINING/COCKTAILS
MID LEVEL — TERRACED FOR GAME TABLES — LOUNGES, ETC.
LOWER LEVEL — LARGE, FLAT FOR PARTIES, DANCES, ASSEMBLIES.
20 FEET
RUNNING WATER

NOTE:
DRAWING ONLY MEANT TO SUGGEST POSSIBLE BASIC LAYOUT OR SHAPE OF AREA.

DESIGNED TO CONFORM TO EXTERIOR SHAPE OF SAUCER.

Taylor says that transporting the elaborate model became a major issue after the delicate paint job was applied. "My greatest concern with it was when it was armatured, especially from the rear, that cracks wouldn't happen. It was a delicate model in that way—it was strong, but it was delicate in its surface."

Probert's rationale for the interlocking design pattern of the painted panels was that it was a futuristic approach to structural integrity.

"I thought that the hull would add some tensile strength to the inner saucer in a way that these big hull plates could interlock with each other and provide strength just by their shapes. That's why I came up with such an odd shape—to interlock one with the other around the surfaces, and we carried that to some degree into the rest of the ship—the warp engines have a very specific patterning, the pylons also have interlocking shapes, and so on."

The resulting finish helped achieve the needed illusion of scale—although Richard Yuricich points out that the 8-ft miniature should ideally have been larger still, to handle the 65mm VistaVision shooting format, employed so that composited elements would lose less detail and not display the heavy grain that gave away effects shots in earlier film and TV projects. "It should have been a larger miniature because it was 65mm format...if you're going to

shoot a miniature...you need a bigger miniature for 65mm, like you would in IMAX. The paint job's where ninety percent of the work really is. With all respect to the people who built it, the worry is the last paint job."

Miniature builder Jim Dow points out that other practical concerns dictated the overall size of the *Enterprise* model. "One of the reasons for the size of the *Enterprise* and the drydock and so on was transportability. It fits in the back of a box truck, it fits through double doors and you have to think about these things when you're designing these [miniatures]."

Even as the model was being built, the design was evolving. The initial version of the saucer featured a bridge deck that mimicked the silhouette of The Original Series filming model (albeit with some windows and docking ports) and a small, featureless dome (dubbed a 'planetary sensor') on the bottom of the saucer. During early lighting tests, in the middle of the pearlescent paint application process, it was felt that these two features of the saucer did not reflect the newer, streamlined look of the rest of the ship. The upper bridge decks were redesigned and, in the process, lowered. Additional details were added to the lower planetary sensor. Andrew Probert had wanted to update the superstructure of the *Enterprise*, which contained the bridge, a rear-facing docking airlock, and the upper decks of the ship (including a visible officer's lounge), to reflect the art nouveau look Richard Taylor had brought to the warp nacelles. "The original bridge structure, all of the superstructure on top of the saucer, was still kind of old school, based off Joe Jennings' design. Very soft, kind of bubbly shape. And I was dying to change that because, if [Richard Taylor] was going to change the engines as radically as he did, I felt like we should get away from the bubble look on the bridge structure and come up with something sleeker."

The departure of Robert Abel and ASTRA (as well as art director Richard Taylor) and the arrival of Douglas Trumbull initiated one final round of modifications to the completed *Enterprise*, as well as an approach to filming the elaborate miniature that would give it a groundbreaking and distinctive look onscreen.

Trumbull devised the idea of the *Enterprise* being self-illuminating, with spotlights on the hull that would flood light across the ship's registry numbers, hatches, and primary hull

BELOW: (TOP LEFT) The view from the Officer's Lounge looked back on the warp nacelles; (BOTTOM LEFT) One concept of the recreation deck featured windows on the ceiling, allowing for a unique view of the arriving shuttle; (RIGHT) The windows on the *Enterprise*'s secondary hull were initially conceived as being a commissary or another recreation area.

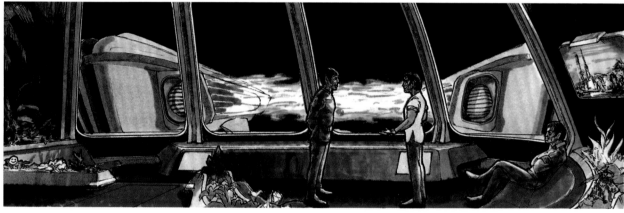

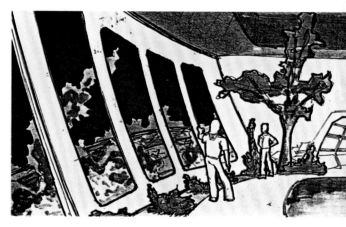

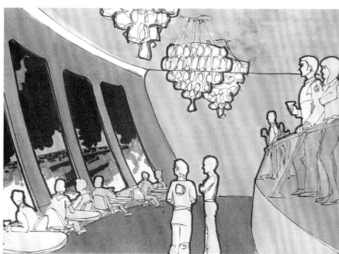

BELOW: Wide shot of the bridge from the viewscreen area showing off the ceiling piece.

disc. Probert designed additional structures on the top and bottom of the primary hull, specifically around the base of the bridge and around the lower 'sensor dome' for lights that could be built into the miniature and shown snapping on as the *Enterprise* 'comes to life' during the drydock exit scene early in the film. Since it was impossible for all of the built-in spotlights to actually illuminate the miniature the way Trumbull intended, Trumbull, camera operator Dave Stewart, and stills photographer Virgil Mirano devised a method of rigging small mirrors to reflect 5K light beams onto the hull.

"Someone made a huge effort to build this miniature and the first question I asked was, 'How do you light this thing?'" Trumbull says. "It's in interstellar space—where's the key light, where's the sun, where's the moon, where's the fill light, how do you justify lighting this thing up? That was the

biggest problem I saw—how do you make this look beautiful? I wanted the ship to look tremendously beautiful, so when the music cue comes on you say, 'Oh, it's important.' I was thinking back to the lights on airplane fuselages from light sources in the tail or the wing so it could light itself up, and then we augmented that with the little dental mirror things to make lots of flecks of light to make it more theatrical. So there was a point where someone had to go in and start drilling holes and taking that miniature apart to put the lights inside, and I would imagine that that probably did massive destruction to the paint job, and we had to go back in and clean it up."

Trumbull's new lighting concept meant that lighting structures would have to be built into the bridge area to illuminate the starship's registry number on the front of the saucer as well as the saucer's sides. "We had to add

additional places for spotlights to emanate from. We did that and then on the bottom, to sort of echo that idea, I came up with the idea of a kind of illumination collar that went around the sensor dome to shine up on the saucer. Then Doug Trumbull was looking at the model and he had this little penlight, and we turned the lights off and he walked around the ship with this penlight, trying to determine other locations for spotlights for self-illumination. He put one down on the dorsal and said we should have one shining up on the dorsal, and then came up with the idea of lights shining up both sides of the pylons, and then one on each side of the saucer to shine onto each face of the engines," relates Probert.

"The design changes on the bridge, and even the bottom piece, have more to do with style than augmenting lighting," Mark Stetson says. "Those changes were initiated by Richard

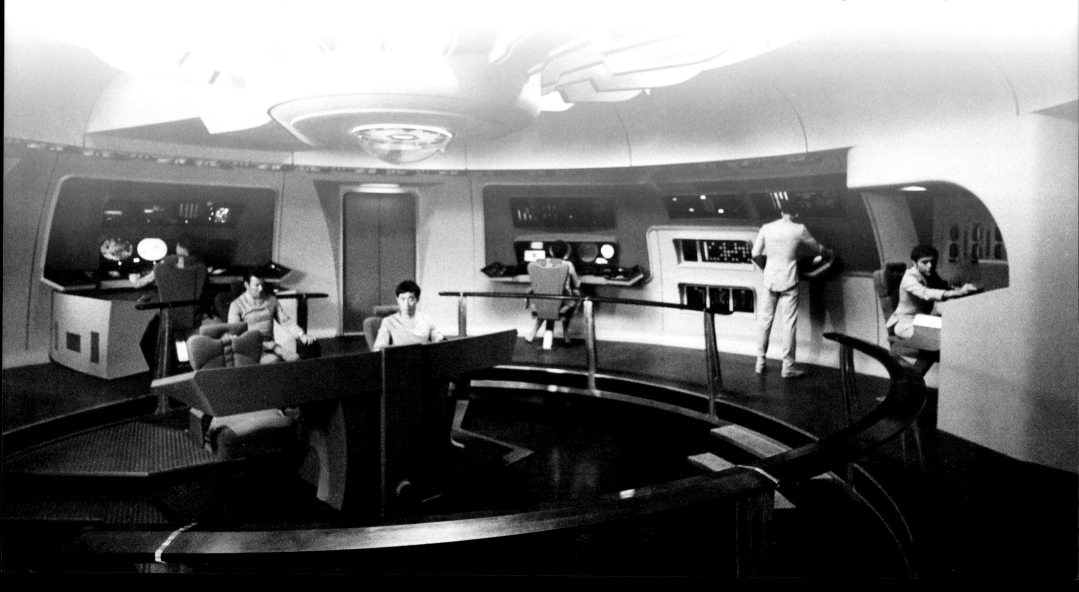

and Andy. And it's as the model was received—by that point, they'd established their model shop at Seward and built themselves a resource where they could keep futzing with them." Some of the final details included additional machinery and coloration on the dual photon torpedo launchers, relocated from their vaguely defined position under the *Enterprise*'s saucer to the base of the dorsal that connected the saucer to the engineering hull. Ron Gress and Zusanna Swansea worked on the photon torpedo area's detailing and paint job. "Ron Gress came up with this lens—he found a big red crystal that he put down inside the photon torpedo tubes to make some light." Gress also painted the engineering hull 'strongback' area, designed by Andrew Probert, to reflect the look of an airliner's jet engine and the different materials and coloration they display with respect to the rest of the aircraft.

For Probert, the self-lighting idea somewhat confused the incorporation of the amber

reaction-control thruster lighting that had been built into the model. "When... people see the reaction-control thrusters power up, they see those are lights shining on the ships because the lights come up at the same time."

Trumbull's lighting concept became one of the most dazzling and memorable visual elements of the film, one that has found its way into almost all later film and television versions of *Star Trek*, right up to the most recent, J.J. Abrams-produced trilogy of movies. Richard Yuricich points out that the effect was so convincing that later effects technicians who inherited the *Enterprise* filming miniature assumed that it really did produce its own lighting. "It was so good that, when ILM came down to pick up the ship when they were doing [*Star Trek II: The Wrath of Khan*], they said 'Where's the switch?'" Yuricich says. "We said, 'What switch?' They said, 'The switch to turn the lights on.' But all that stuff was done with mirrors, and it was tedious and laborious, and

Dave Stewart and his crew, David Harberger, his assistant, shot all that."

Shooting the *Enterprise* model, with its high-gloss, reflective, and iridescent surface, required a different approach than the blue-screen work done on *Star Wars*, where the models had been painted largely in various shades of flat gray. Shooting the *Enterprise* against a blue backing would have resulted in reflections of the blue screen on the model's surface, resulting in what visual effects technicians call "blue spill"—where the blue reflections on the model's surface cause parts of the model to appear to drop out or disappear on screen, ruining the illusion.

Instead of blue-screen, the model was shot with a system called frontlight/backlight, essentially filming passes against a black background as well as a bright white backing to create both lit elements of the spacecraft and its own matte (essentially a silhouette of the spaceship miniature that is sandwiched behind the photography of the miniature to make the

ABOVE: (LEFT) Lee Cole was responsible for the graphic displays on the monitors and much of the button layout and signage throughout the ship; (TOP RIGHT) Rick Sternbach works on some of the graphics and signage that would be created for the *Enterprise* sets; (BOTTOM RIGHT) Colored gels were added to the back of the B&W transparencies before being placed into lightboxes.

image opaque, so that stars and other objects behind it won't bleed through) for compositing. "We wouldn't do blue-screen," Yuricich acknowledges. "We made the decision to do frontlight and backlight, and our mattes could fit a lot better when we needed them. On *2001*, the difference was there was one craft in the shot, the moons wouldn't really cross the craft, and the movement of the stars was shot for the movement of the ship, because the stars move, not the ship."

The *Enterprise* miniature had been updated to achieve the best combination of modern artistry, convincing detail, and, for *Star Trek* fans, the kind of consistent, believable science-fiction technology that had endeared the original starship to viewers. But the interior of the ship had to be updated and enhanced to motion picture standards too. Joe Jennings and Mike Minor had designed new sets for the *Phase II* television series that had were still under construction at Paramount when the project shifted from TV to movie screens. Director Robert Wise had brought in production designer Harold Michelson, whose work ranged back to storyboard illustration on everything from *The Fountainhead*, *The Ten Commandments*, Hitchcock's *The Birds*, and Mike Nichols' *Who's Afraid of Virginia Woolf?* to art direction on *Catch-22* and *Mame*. Michelson's science-fiction work was limited to the period Jules Verne adventure *Journey to the Center of the Earth*, but he was vastly experienced and skilled at just about every other genre in film.

Because the story required interactive lighting and other effects that would have to be filmed live on the *Enterprise* sets, Richard Taylor and Andrew Probert found themselves generating concepts to enhance and sometimes redesign sets that had been started by Joe Jennings and his crew. Harold Michelson oversaw the work while generating his own set concepts, and the artists soon found themselves at odds as Taylor and Probert fought to maintain the believability of the *Enterprise* as a spacecraft while Michelson argued for the practical considerations of shooting and set construction, as well as dramatic license.

"Joe Jennings had pretty much followed Matt Jefferies' original designs for the *Enterprise*, which made sense for television," Michelson said in 1979. "But now we had the freedom of the big screen. In fact, the story, as you know, starts out with the *Enterprise* being overhauled in drydock, which gave us free rein. I figured we could do anything to improve the design for motion pictures. The special effects had been given over to the Abel group, and they got into it real heavily. They not only went for the special effects, they also went for the sets, and they started going great guns. So after a while, it became kind of a battle for me to keep my position. They had some fantastic artists who would do some marvelous science-fiction sketches and everything, but for movies, let's face it: you don't build a spaceship, you build a set. And you build it so that you can shoot it. I told them, Look, fellas, nobody's taking off in this thing.'"

RIGHT: Down angle view of the warp core. Mike Minor laid out Engineering for the aborted *Phase II* and came up with the idea for a vertical warp core shaft, and the idea was held over for the feature.

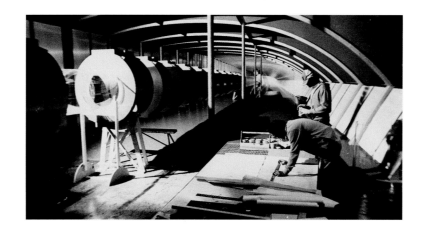

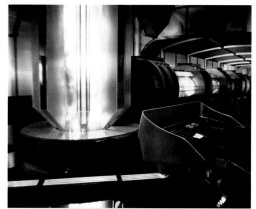

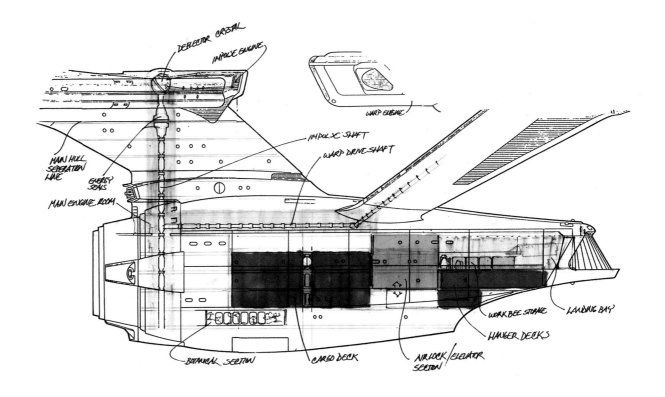

THIS PAGE: (TOP) The horizontal portion of the engineering core used a reduced perspective set to enhance the sense of depth to a limited set; (ABOVE) Andy Probert's illustration of the vertical and horizontal power shafts.

Richard Taylor had found the original *Phase II* sets problematic and had begun suggesting changes after his original review of the sets and miniatures. "It was very rectilinear," Taylor says of the *Phase II* look. "There was no curvature, no rounded corners or anything that looked more modern. That wasn't my part to redesign, but there were parts of the sets that we had to coordinate with the redesign of the *Enterprise* [miniature] and it was essential that the art department and Magicam model shop

communicated pretty well for scenes that had to happen in the movie."

Michelson and Taylor both wanted changes to the *Enterprise* bridge. "The bridge had always been where most of the action takes place on the *Enterprise*, so I very much got into the design of that," Taylor says. "I took pictures of what they had and blew them up, and then did overlays and started redesigning, redrawing, and running concepts by Roddenberry, eventually Robert Wise, Mike Minor, Joe Jennings, and

then, eventually, Harold Michelson. So we would have these regular production meetings at Paramount and I would have meetings privately with Roddenberry and whoever else was needed to be there to discuss the limits of what could be done—how far could we push the design?"

Taylor wanted the technology on the bridge to reflect not only future science, but contemporary advances in instrumentation and materials. Even in this regard, the familiar elements of The Original Series sometimes dictated approaches that, to Taylor, seemed retrograde. "The control con, I had ideas of it being tactile and visually interesting so you could touch it and things would change. That was already starting to evolve in places like Lawrence Livermore [National Laboratory]— they were using tactile screens, which to me was such a perfect thing because it would be graphic and entertaining, and we could do it with rear projection. Roddenberry rejected that; he wanted actual physical switches and things, and that's what got built in. Same way with around the perimeter where Uhura and Spock sat—the screens they saw for information and their controls, he wanted physical things,

keyboards and switches. I wanted to make that one big mono-screen all the way around and have it tactile as well, have them touch it and different things would animate up. He wanted to have oval screens, and I tried to convince him that that was not the most efficient way to see info, but he didn't want info—he didn't want numbers, he wanted more abstract graphics, swirly stuff."

The need for display graphics on the various bridge monitors was identified early on in the Phase II portion of the project. Even though the material would be used on set during principal photography, postproduction supervisor for Phase II, Paul Rabwin, got involved. "It was so unsophisticated. The decision was made to put 16mm projectors, set at twenty-four frames [per second] in these little cubby holes [in the back of the set], and while they're shooting, we would sync them all up at twenty-four frames [per second] and they would have nonsense computer stuff [on them]. So I went to a little company called Image West on Highland [Ave] and we did the most rudimentary stuff. We'd take these sine/cosine waves and take some object and put it in, which would cause the waves to do crazy stuff, and then we'd just record that.

And then they'd do things with flashing colors and changing stuff. It was all futuristic images that may make sense to somebody. I think I had to put together ten to fifteen different loops of those," Rabwin relates.

The upper bridge ceiling had always been suggested as a simple dome in The Original Series (an elaborate miniature composite shot at the beginning of the show's first pilot, 'The Cage,' suggested that the dome was transparent, but this was never otherwise demonstrated, and extensions built into the set ceiling during the show's production showed it as opaque). "We added that whole navigational sphere up above the bridge so it wasn't just open up there," Taylor says. "It brought something down that seemed to have a real function, and I always thought that, at some point, if someone wanted to, you could actually see a starfield on that sphere, so it was like a celestial sphere."

Rick Sternbach had been a well-regarded science-fiction and astronomical artist, creating magazine covers for Analog and other science-fiction magazines, artwork for Astronomy magazine, and paperback sci-fi covers, and had arranged to meet Gene

Roddenberry when the *Star Trek* creator had spoken at Yale University in 1974. Inspired, like Andrew Probert and many other artists, by seeing Ralph McQuarrie's *Star Wars* artwork (in Sternbach's case, a year before *Star Wars* hit movie screens, at the 1976 World Science Fiction Convention in Kansas City), Sternbach traveled to Los Angeles looking for work in film, and interviewed with Joe Jennings for a job on *Star Trek: Phase II*—but at the time, Jennings didn't have a position for him.

That changed just as Paramount prepared to announce the *Star Trek* movie production at a March 1978 press conference. Jennings called Sternbach to ask him to join the design team and work with him and Mike Minor. "Mike Minor was sort of a kindred spirit—he knew science fiction, he knew art, and we bounced ideas back and forth and I was learning a ton of stuff from him as well," Sternbach says.

Sternbach would work on numerous details of the *Enterprise* interior along with graphic designer Lee Cole, who had been hired by Jennings to work on the *Enterprise* bridge during the production of *Phase II*. It was Cole who designed Taylor's 'celestial sphere,' which was more functional than its brief appearances in the finished film might indicate. "If I remember correctly, there were some actual servo motors, and the internal parts inside the bubble were waterproofed, and this thing could actually tilt and rock," Rick Sternbach says. "I was there to see the water being put into the dome, and I know that the graphic of the ship with the little compass points were all backlit and it was set on these servos."

In 1979, Lee Cole noted that the team's biggest challenge was that everything seen in the movie had to be designed and built, rather than bought or rented. "We had to decorate the *Enterprise* sets, but we really couldn't follow the usual route of simply hiring a set dresser and letting it go at that because he couldn't go out and buy furniture. Roddenberry stipulated very early in the pre-production planning that we couldn't use anything already existing. If it existed, it was automatically out. So our challenge was to make every single thing that was on the set."

Lee Cole created the design approach to all of the ship's instrumentation, which she and Sternbach helped execute, along with the movie's set construction and set decorator crews. "I ended up using about a third of the control panels, using the style that Lee Cole had established, working with her stylistic guides," Sternbach says. "We were working with the stage-effect guys who were gelling up the artwork, the kodalith films, and we were supplying all of the color specs—these two buttons are red here, these things blink, these sliders on Chekov's torpedo-launching panel have this particular display, so anything we were directly involved with designing, we were there onstage looking at how things were developing."

BELOW: Lee Cole and the art department came up with a guidebook illustrating the console's functions; (INSET) Reference polaroid of Spock's science station.

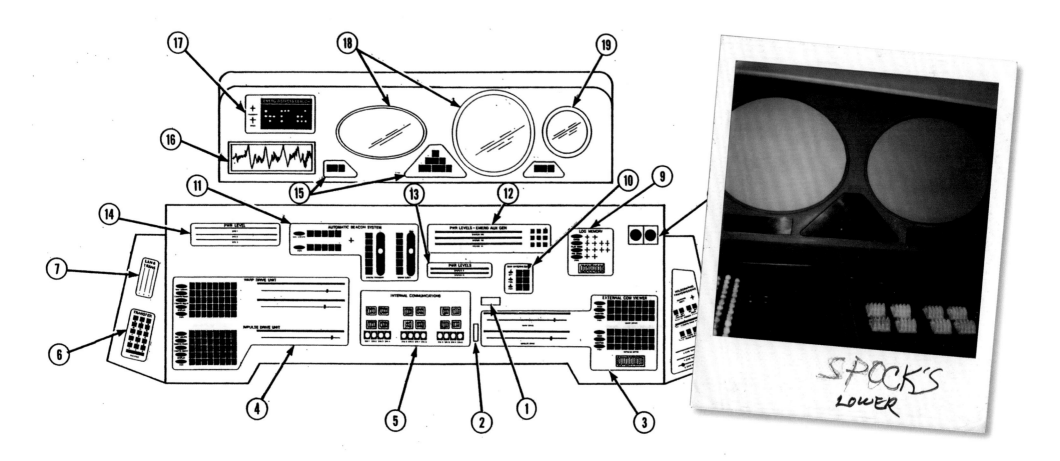

BELOW: A partial
set depicting the
saucer's lower airlock
was built on stage.
The wide angle
version of this shot
was not used in the
theatrical release.
Unfortunately, it was
used in the TV version
of the film and,
because the matte
painting was never
finished, it was seen
complete with a view
of the rafters and
rigging of the set.

In 1979, Mike Minor highlighted Lee Cole's contribution to the film, which included not only the instrument panels but also signage design and reels of animated displays for all of the information screens on the *Enterprise* bridge. "She had to produce something like 200 separate pieces of film, either by original animation or by careful editing of existing scientific or medical data.... Readouts were made up from spectrographic stuff and some really thrilling medical scans of brain and body parts. Lee and I also had to produce Chekov's weaponry images, projected live on stage onto his viewscreen. It was planned that they would be augmented in post-production by the optical personnel, but they had to have images happening in front of the actor when he pressed a button. And we had to do readouts for Spock's science center—we designed Uhura's signals, which bounce off of the intruder and come back to the ship. All this texture, which completes the scene and which the average viewer's eye passes over; but if it wasn't in the picture, you'd notice it. The sets would look plastic and unformed."

One of the scenes that resulted in the most arguments between Taylor, Probert, and Harold Michelson was a meeting of the entire *Enterprise* crew on a recreation deck, where Kirk demonstrates the threat to Earth that V'Ger poses by showing the alien probe's destruction of Federation space station Epsilon IX.

"When it came time to do the rec deck for the *Enterprise*, I said, 'Let's put it at the back of the saucer on the top,'" Andrew Probert remembers. "Harold said, 'Let's put it on the rim,' but I said, 'That's where the impulse engine is.' So he said, 'Let's just put it over to the side.' I gave him cross sections of what the saucer would look like in profile and gave him an idea of what a rec deck could be, and he ignored that and came up with a rec deck so big that it would never fit in the saucer." Science-fiction films often play fast and loose with the laws of interior sets fitting into exterior plans, but locating the rec deck on the rear side of the saucer created a new challenge—what would be seen outside those windows. Because of the rec deck's proximity to the warp nacelle, and desiring to eliminate a costly optical, a large backing with an angular forced-perspective view of the warp nacelle and pylon was created and placed behind the set's windows. Ultimately, and perhaps ironically, when the set was filled with extras on the day of the shoot, the backing was largely obscured, hiding the true location of the rec deck within the *Enterprise*.

Rick Sternbach designed some of the interactive games that Decker plays with the Ilia probe on the rec deck in an attempt to coax some remaining humanoid emotions from her. He also helped create an art gallery of previous ships named *Enterprise*, which included a distinctive Matt Jefferies conjectural design. "The gallery of *Enterprise* ships—I did some of the black and white art for those and I think Leon Harris, who was art director under Harold, wrangled that whole separation of bits of art onto clear plexi. They lit it one way for one scene and differently for other scenes. I did some of the research on the photos from the US Navy and NASA. Gene Roddenberry had stopped me on the lot before we did that gallery and handed me a poster and said, 'could you please include this ship in the gallery?' and it was the big ringship. So we broke the image down into black and white layers and installed it on the set."

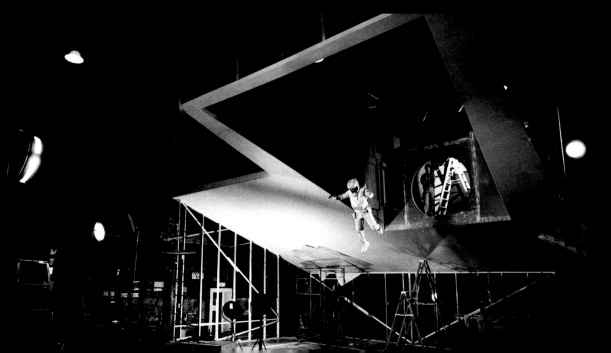

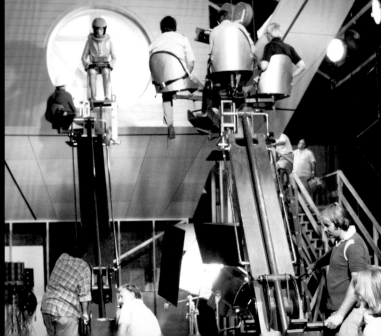

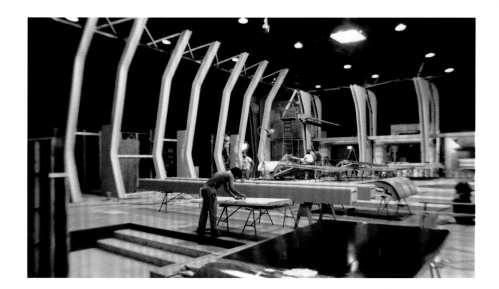

Sternbach, Mike Minor, and Lee Cole also revamped Dr. McCoy's sickbay with a sterile, white, softly curved look. "The medical display over the beds, that little trapezoidal thing with the vertical readings, was an homage to what we saw on the original show, with the little indicators that went up and down," Sternbach says. "The electronic guys equipped them with some blinkies and we changed the locations of the vertical indicator triangles just to make them look different. Mike Minor wrangled a lot of the animation for the Ilia sequence where she's on the bed. And Mike designed that yellow-green examination bed she's on and I did the inkwork on the nervous system diagram she's laying on top of. I think the ink drawing was maybe eighteen inches long and the guys who actually applied the white silkscreen graphic photographically enlarged it so it would fit."

Probert had designed an officer's lounge for an early conversation between Kirk, Spock, and McCoy that was ultimately relegated to a brief miniature shot showing a view of the Vulcan shuttle approaching for its rendezvous through the lounge's windows. The officer's lounge gave the only view that looked back directly between the two warp engines—a view that might have boasted a unique effect of the engines operating as Roddenberry had insisted they did, by creating a warp field between them. "The engines were going to have a visual effect between the two engines, but that never happened," Probert says. "They were going to use a black *Enterprise* with all of this effect work somehow suspended between the two nacelles, this lighting effect and all kinds of cool stuff. They were going to do a pass on that and then the black *Enterprise* would actually be the mask for the real *Enterprise*, but that never happened. So that was the visual behind Spock and Kirk having this conversation in the one concept sketch I did."

Michelson worked out a spectacular, multi-level engineering room set that incorporated forced perspective to show the 'anti-matter' warp core

extending seemingly hundreds of feet back into the ship's secondary hull, with smaller actors and eventually children in scaled engineering gear used to sell the illusion. The horizontal look of the final set contrasted with the more vertical look Mike Minor had designed for *Phase II*, with Rick Sternbach contributing one color study for an intermediate phase that was never built. "It was just a big vertical core, and they had not yet installed the aft plasma conduit hang for the nacelles. I did one illustration of that and then they went and changed the whole thing. There were some suggestions that came from Andy Probert or Richard Taylor to Harold [Michelson]. They had built a warp core that Mike Minor designed for the TV show, that giant segmented donut shape, so they went through at least one version of the core, and then a second version, and then the big conduit heading aft. That was outside what I was responsible for, but I was able to watch it being built."

Michelson also debated with Robert Abel and Probert about the ship's shuttle and cargo bay, which features in several shots after Kirk's arrival onboard the *Enterprise* that demonstrate the starship's interior size and complexity. "I disagreed with some of ASTRA's conceptions and their fetish about not doing anything that would change the model," Michelson said in 1979. "For instance, I'd say, 'I want to open up a certain wall area on the *Enterprise* cargo deck so we can see the Earth back there.' And Abel would say, 'No, no, we can't open it up. There are no big windows on the model.' We did a very big set for the recreation hall, and we put in very big windows, and Abel's group got very upset because we were upsetting the model. But I wanted to see out the windows, to see some of the other parts of the ship, to get a certain sense of scale. So I said, 'Drill a hole.' Simple, right? To them, it was like asking them to commit hara-kiri. But you need to see all of that, you can't just be looking at the same walls all of the time, and I think Trumbull realized this when he took over later."

ABOVE: (TOP) The much debated recreation deck under construction on Stage 8; (MIDDLE) A large scenic backdrop depicting the *Enterprise* warp nacelle and drydock was created for the rec deck scene. While it solved the problem of what would be seen out those large windows, ultimately, in the film, the set was filled with so many extras, it was hardly visible.

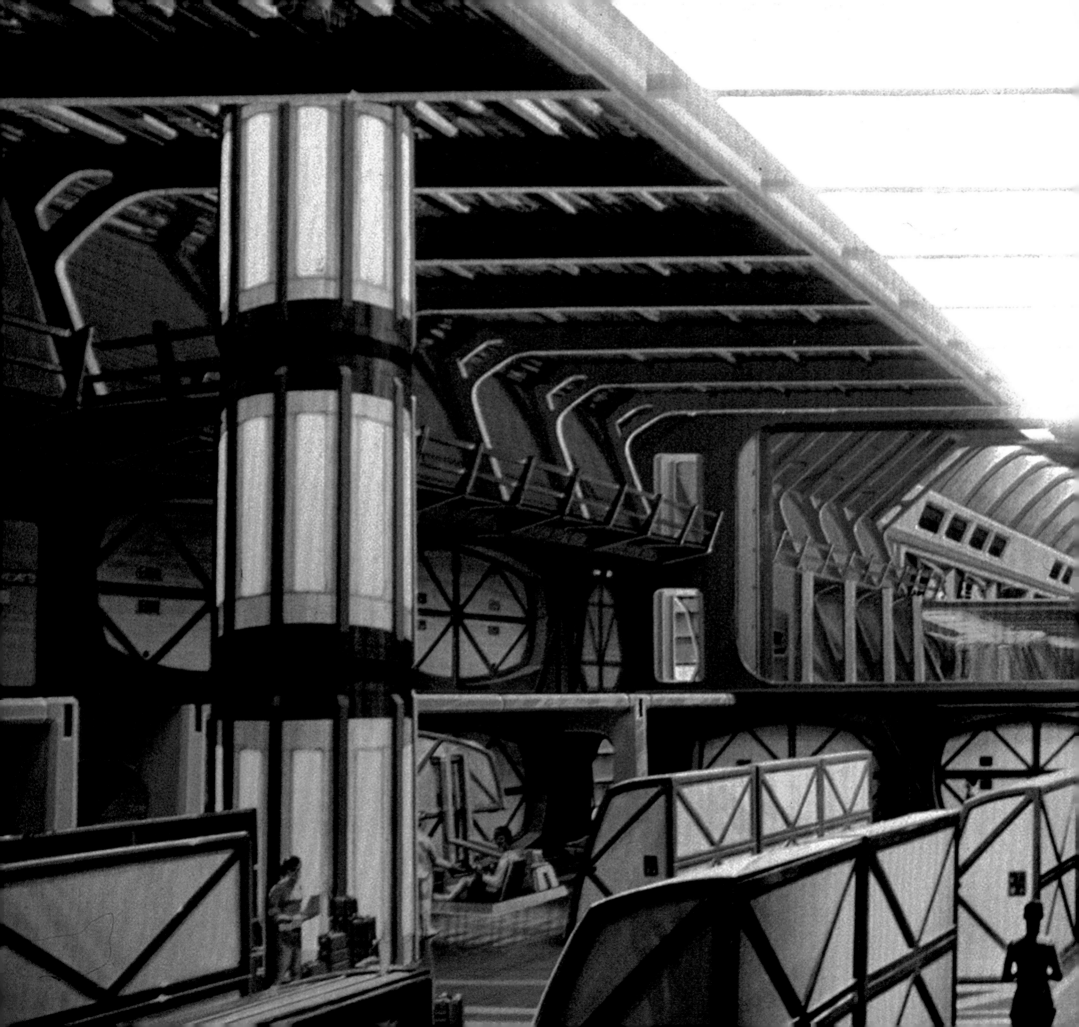

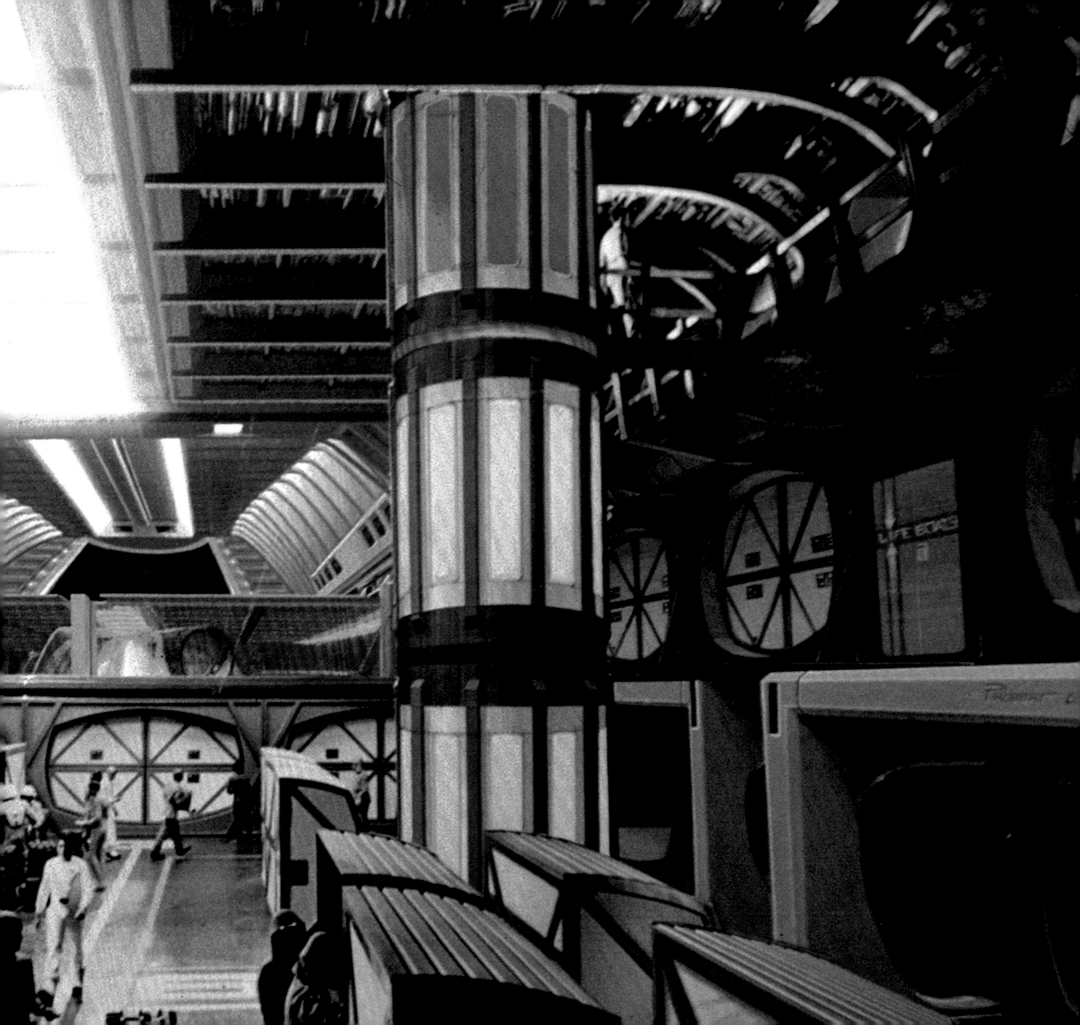

Probert, a die-hard fan of the original TV series, recognized that *Star Trek* fans attending the movie would be eyeing these details carefully. "Michelson would say, 'What are you talking about, are people going to come to the movie with their slide rules in their hands?'" Probert says. "Well, kind of, yeah. Two or three years later, I worked on a movie where Hal Michelson was the production designer and I had to work directly under him, and that's when I realized how smart this guy was. He was really a genius, figuring out camera angles and when to use miniatures, foreground miniatures, all of these tricks and wonderful things that would work on what I would call a standard story, that he couldn't translate into science fiction."

The design of the *Enterprise* and its sets would set a new standard for *Star Trek* and earn *Star Trek: The Motion Picture* an Academy Award nomination for its art direction. All of the workings of the famed starship that had been theorized and argued about by fans would now be able to be shown on the big screen in stunning detail, providing Captain James T. Kirk and his crew with a wholly believable and remarkably beautiful wagon train to the stars.

THIS PAGE: Matthew Yuricich displays an early concept painting for the *Enterprise*'s hangar deck and storage area. (INSET) This early version features a large wall of storage containers and an equally large opening in the side of the engineering hull revealing the side of the drydock and the Earth. After much discussion, the concept of an open-air storage area would be dropped.

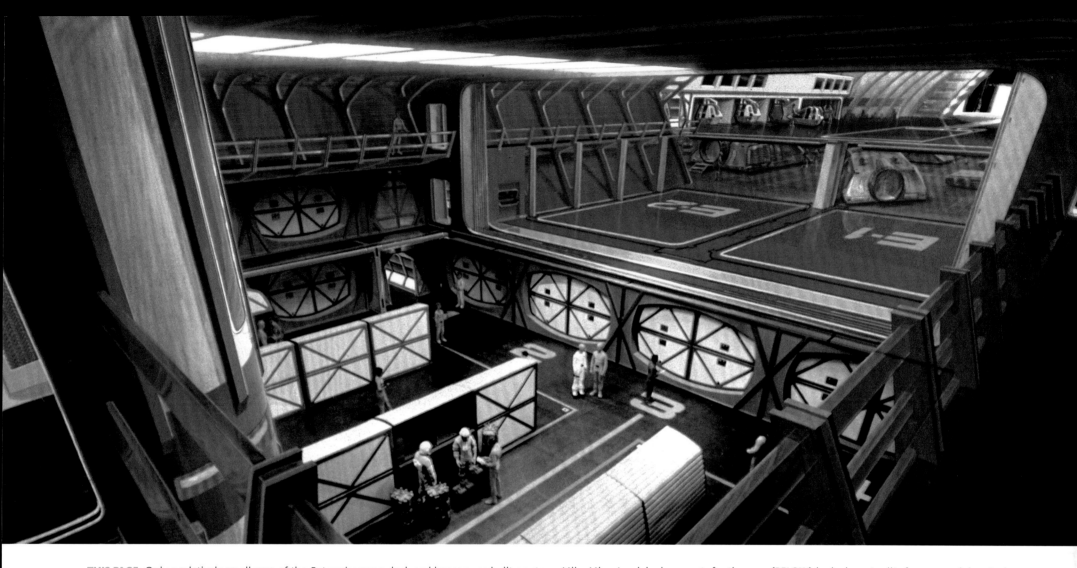

THIS PAGE: Only a relatively small area of the *Enterprise* cargo deck and hangar was built on stage. Mike Minor's original concepts for the area (BELOW) had a large 'wall' of cargo modules. Andy Probert revised that view and expanded it to give the viewer a view running almost the entire length of the secondary hull (ABOVE).

STRANGE NEW WORLDS

DESIGNING VULCAN AND
A NEW LOOK AT EARTH

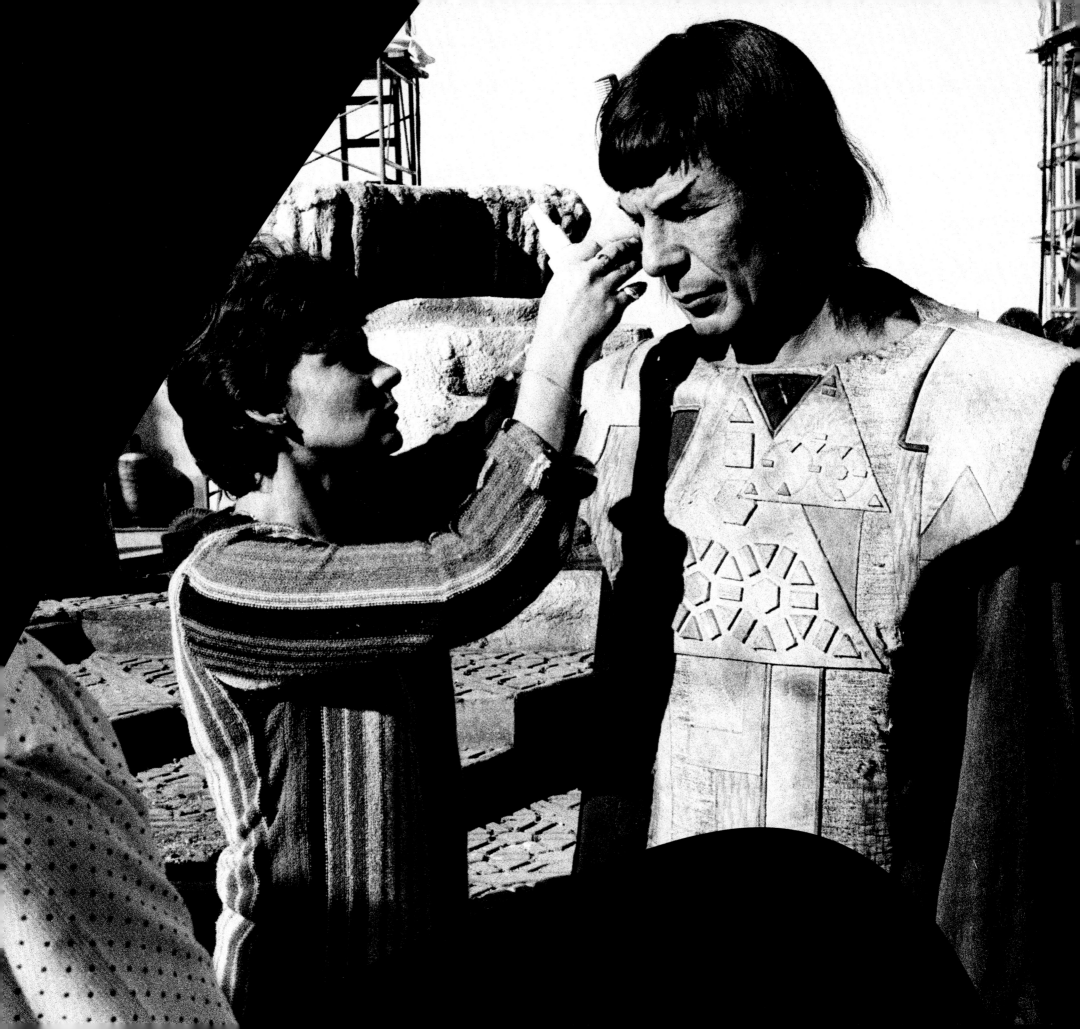

STRANGE NEW WORLDS

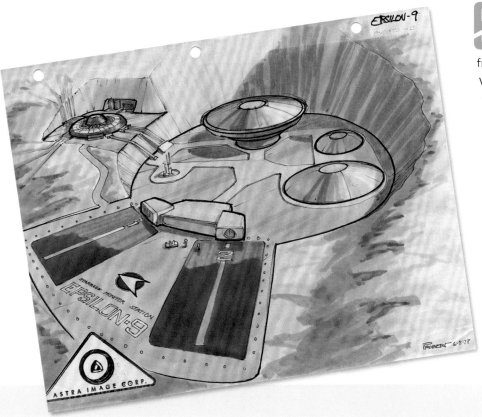

Star Trek: The Motion Picture would spend its opening minutes reintroducing familiar alien races from the TV series, like the Klingons and Vulcans, and shoot around the Galaxy, from V'Ger's location to a Federation deep space station to Spock's planet of Vulcan, before heading to Earth.

The first Earth technology and personnel on view in the film is the Epsilon IX space station and its crew, introduced with a long overhead shot of the incredibly complex space station, something light years beyond the detail of something like the K-7 'The Trouble with Tribbles' space station seen in the original series.

Initially, the design for the deep space listening post was set on an asteroid, echoing the previous Ralph McQuarrie-designed drydock from the aborted Planet of the Titans. Though sketches were made of the outpost and a large dish antenna embedded into the surface of the asteroid, and even though the model appeared on Magicam's 'to-do' list, no construction was begun before ASTRA left the show. The changeover to Trumbull and Dykstra meant that the design for Epsilon IX was up for grabs.

John Dykstra's Apogee group constructed and filmed Epsilon IX, with model maker Grant McCune supervising the station's build. "We wanted to provide something that gave real scale," Dykstra says about the intricate space station miniature. "You have to remember that the miniatures were fairly large scale

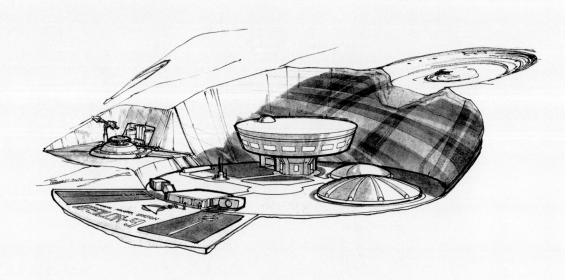

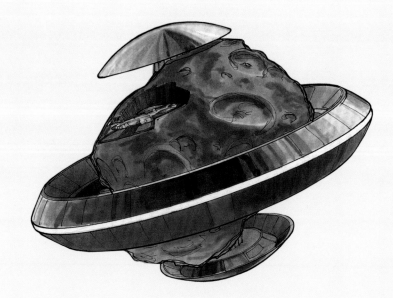

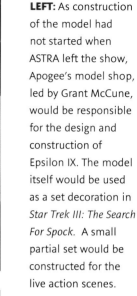

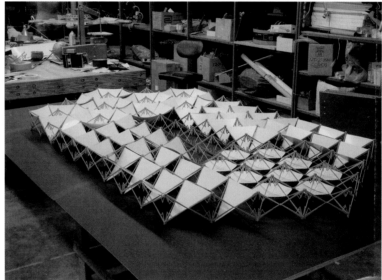

on everything except the Klingon warship, which was fairly small. But the *Enterprise* was a big model and the *Enterprise* drydock was a big model and we wanted to keep the sense of scale that those larger models provide, not just because it's bigger but because the detail is high enough that it gives you the ability to get in close to it. When you show component pieces, the whole idea of the scale of a ship is totally based on being able to relate to something on the surface of that ship that has human scale. At the time, we were doing an awful lot of acid etching to make parts and, as a result, it lent itself to a lot of high-frequency, high-precision detail, so the process to a certain extent informed the design. I think it got outrageously detailed because they had the ability to do that with the laser etching and brass materials they were using. It was maybe 8 ft and it just had so much intricacy, and that's why the modelmakers hated it so much, because it was like putting together this 4,000-piece jigsaw puzzle with catcher's mitts on your hands because everything was so small."

Sections of the station were also reproduced at a larger scale so that the filming crew could cut from long shots to close ups, or even overlay differently scaled sections to create added perspective.

Dykstra and his team also worked to effect Robert Wise's request to bring the human figure into shots as much as possible to provide the audience with a reference point for the size of the station. David Sosalla and John Ramsay developed a miniature figure about 14 inches in height that could be filmed in a to-scale

OPPOSITE: The earliest version of the Epsilon IX listening post featured it being built into an asteroid.

BELOW: The site of Spock's *Kolinahr* ritual was depicted in the concept art as a hostile environment, but with a refined and elegant temple.

BOTTOM: Matthew Yuricich painted several versions of Vulcan, each with a different landscape, but all with a large moon in the sky.

spacesuit and shown jetting around the station. "He was motorized so that his arms moved and his legs could pull up or extend," Dykstra said in 1979. "And those were all individually controlled off a stepping-motor drive system. Faces were sculpted for Spock, Kirk, and an anonymous spaceman. It's real funny, because a lot of the stuff was used interchangeably throughout the movie, which was pretty great because I think you'd be hard pressed to figure out which shots were the little model and which shots were the real guy. The stuff that we did was blue screen, where we used the puppet. Like the one shot where the little guy comes up into frame and turns and shoots off toward the antenna, that's the puppet, and that was shot in blue screen, and then we'd combine it that way."

Vulcan had been depicted only once in the TV series, using a single, Stonehenge-like set and a red sky backing for the episode 'Amok Time.' Recruiting Leonard Nimoy to play Spock had been one of Robert Wise's key demands in taking on the project, and with Nimoy secured, considerable thought was given to giving his character a big entrance in the movie. Makeup artist Fred Phillips, who had created the look for Spock on the TV show, returned to apply the Vulcan's pointed ear makeup appliances and yak hair upswept eyebrows, this time enhanced by a bedraggled, hippy-length wig to show Spock reverting to a kind of primitive state while undergoing the emotion-stripping *Kolinahr* discipline on Vulcan. This story element had been a part of the equation since at least Philip Kaufman's *Planet of the Titans* treatment and, like the *Enterprise*'s drydock sequence, served to illustrate the passage of time since fans had last glimpsed Spock and account for a new interpretation coming from Nimoy.

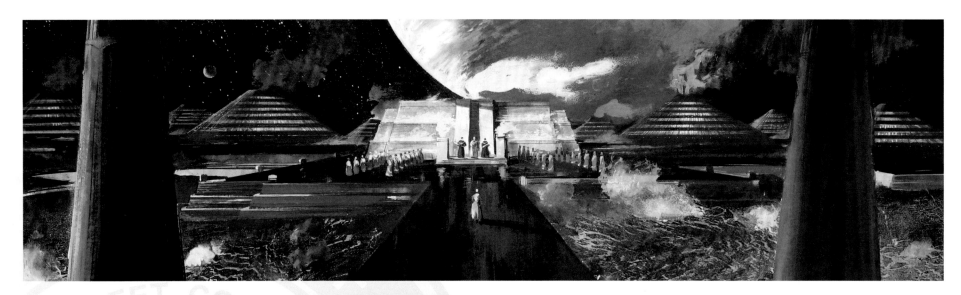

Giving more scope to Vulcan involved location shooting at Yellowstone National Park, where active hot springs could stand in for the volcanic processes and sunbaked, cracked geography on Vulcan. But the initial shooting of this footage, with a hanging miniature provided by Mike Minor to obscure contemporary signage at the park, was ultimately hampered by the limited camera angles necessitated by the rules intended to keep visitors safely away from the open hot springs.

Veteran production illustrator Maurice Zuberano had generated early concepts and storyboards for the film, including the Vulcan sequence, and had introduced the idea of looming, ancient statues on the Vulcan landscape. Mike Minor then designed a series of matte paintings for the sequence. "We planned, I think, something like six mattes," Minor said in 1979. "You didn't see them in the picture, but they were definitely shot as 65mm plates, high angles looking down from the knees of the statue as they climbed the steps. The reverse angle was supposed to feature a number of statues just like that one, all ringing the mountaintop with the sunset, real misty sort of *Lawrence of Arabia* fantasy time."

Matte paintings for the film—an essential element that could provide otherwise unaffordable scope and hide production shortcuts that would otherwise be captured by the camera in live-action shooting—were ultimately produced and overseen by Matthew Yuricich, a veteran matte painting artist. Yuricich had hired a young painter named Rocco Gioffre to assist him on *Close Encounters of the Third Kind*, and had promoted Gioffre to full-time matte painter on *Star Trek*. While Matthew Yuricich had done work on major productions like *Ben-Hur*, he had been largely uncredited until the late 1960s and into the 1970s, where his work on movies like *Logan's Run* became better known.

ABOVE: Fred Phillips would once again be the 'man who made Spock's ears', as well as many of the other Vulcans' during the ritual scene.

BELOW: While a small
crew was dispatched
to shoot scenes in
Yellowstone National
Park, most of that
footage was replaced
by material shot in
the B Tank on the
Paramount lot. The
large foot, painted to
look like a translucent
crystal, was made on
the lot.

"He was a very well-rounded visual effects man, especially dealing with matte painting shots, but he could also do animation and rotoscoping, 2D stuff, and incorporate those into the matte painting shots," Gioffre says of Matthew Yuricich. "He worked on some big epic movies under the visual effects cinematographer at MGM in the late 1950s, Clarence Slifer, and they knew how to do camera moves on shots and integrate human beings into their paintings and have things cross over each other. Matthew was a very talented matte painter and just wasn't as much of a familiar name as Peter Ellenshaw [*Mary Poppins, The Black Hole*] and Albert Whitlock [*Earthquake, The Hindenburg*] in the 1970s. But Matt could paint, I would say, just about as well as either of those guys."

Gioffre began work on *Star Trek* with a matte painting of Vulcan—but not the one finally seen by audiences when the movie premiered. "There were two matte painting shots that I was working on as Matthew Yuricich's assistant, being done in 65mm at MGM's matte department under the payroll of ASTRA Images... One had Spock kneeling down on the planet Vulcan and there was a really pretty orange sunset with a planet in the sky behind it—I think that had a better look to it than what ended up in the movie, personally. I believe it was designed by Bill Sully. Part of Mike Minor's work is in that shot—Mike Minor and Matthew Yuricich were at Yellowstone. That was done outside in the daytime on location, and in the foreground is a foreground miniature with a crystal, ruby-colored statue head." The Yellowstone National Park location, called Minerva Terrace, provided a natural alien landscape of its own, with flowing steps of mineral deposits that look like frozen lava flows.

Richard Yuricich notes that production problems with the live-action shoot, and ultimately a change in aesthetics after Doug Trumbull's group came onto the project, led to a major change to the look of the finished Vulcan matte painting shot. "I believe there were some problems with the stuff shot in Yosemite, but Mike Minor made it possible to reshoot that on the Paramount lot in the tank and then fix it with a painting. That's always a problem, because they weren't designed as paintings, and they were the shots to fit in the movie, not things that Al Whitlock or [Matthew Yuricich] would approve of totally. The dark night part was to tone it down a little—it worked in the film, but it could have and should have been better."

The Paramount tank shoot involved constructing the large, crystalline feet of a massive statue, and shooting Nimoy interacting with three performers playing Vulcan elders.

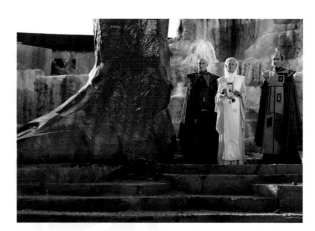

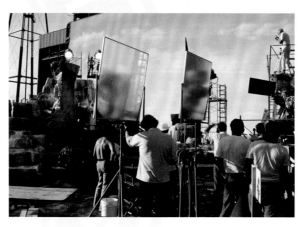

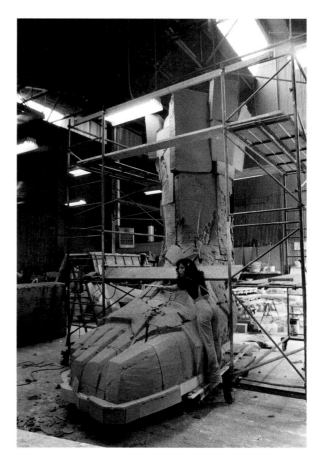

Mike Minor had originally planned a painting with a more familiar-looking, red-orange sky and a bright, daylight look with a single satellite visible on the horizon. Ultimately, Matthew Yuricich executed a different, more nocturnal approach that allowed Trumbull's team to track in moving planets or moons in the night sky above Spock and the elders.

"They had a statue of a foot in the B tank area of Paramount with a scenic backing, and they built a big outdoor set there, and they had a great big ruby, transparent, fiberglass foot to that statue," Gioffre recalls. "The change of the look, I never did find out what the deal was, but Doug Trumbull called in David Negron and he did those drawings that had black and outer space. They were far back and had planets in the sky that were complete planets, and mountains and statues, and you didn't know quite where to look. They reduced that live-action photography a lot, and a lot of other things were drawing your attention. You can reduce live action that tiny if the perspective or the geometry of the scene is pointing toward it—Matthew was involved in some beautiful shots in *Forbidden Planet* where there are tiny people on a walkway, but the perspective in the shot points right to where they are."

ABOVE: Andy Probert created treatments for a BART-like shuttle (CENTER), but ultimately Harold Michelson created a smaller version (TOP) that was easier to build on the lot.

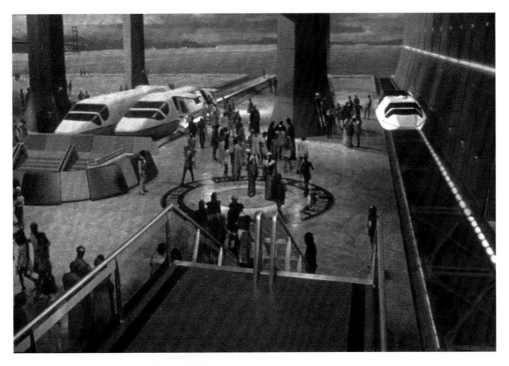

One of Gene Roddenberry's early dictates for the *Star Trek* television series was that the show would never visit the Earth of the twenty-third century. Roddenberry felt that it would be beyond the show's budget and special effects technology to envision a future Earth convincingly, and in any case he felt it should be left up to the imagination of viewers and that everyone would have their own expectations and ideas of what an Earth civilization would look like in this era. The show referenced Earth and 'San Francisco Navy Yards' in its mythology, but kept its actual visualization strictly to planets outside our solar system.

By the time of preproduction for *Star Trek: Phase II*, Roddenberry and his team felt ready to ground the beginnings of their story on Earth, in San Francisco, with scenes of Kirk interacting with officers from Starfleet Command, and of the *Enterprise* being overhauled in a floating drydock in Earth's orbit. The drydock

THIS PAGE: Early and ambitious plans called for a detailed depiction of San Francisco in the twenty-third century – something which had not been seen before. It became clear fairly early on that the schedule and budget would only permit glimpses of the city. One matte painting featured a modified Golden Gate Bridge, while another showed an exterior shot of Kirk's tram arriving at Starfleet.

idea had gone back at least as far as *Planet of the Titans* as a way to justify redesigning the *Enterprise* to give it a more modern appearance. During *Phase II*'s production, there was even discussion of the drydock overhaul as a fallback to explain the unfinished look of some of the project's sets, which would be referenced as still being under construction in *Trek*'s fictional universe, just as they were in the 'real' world.

In the film, the scene shifts from Spock's failure to achieve *Kolinahr* on Vulcan directly to Earth, with a shot of an air tram rocketing over a modified Golden Gate Bridge and landing in a busy station to reveal William Shatner's James T. Kirk. Rocco Gioffre and Matthew Yuricich designed and completed the matte paintings, which were augmented with overhead lighting

effects. "The San Francisco shots with the Golden Gate Bridge and the water; those came out rather nicely for what they were, and involved some crowd multiplication in the interior," Gioffre notes. "When they had the one craft landing on the tracks, I remember animating the shadow next to it on the wall on the matte stand."

Apogee built the air tram miniature, which was about three feet in length. Andrew Probert had generated initial designs of the craft, which combines the look of a futuristic commuter train with the boxy, utilitarian look of *Star Trek*'s traditional shuttlecraft.

The crowd integration in the tram station shot was just one example of a key strategy pushed by director Robert Wise to bring a

human scale to the production. "As fine a job as they did on the series—look at the time and money they had to work with—one of the first things I said we had to do much better was the effects," Wise said in 1979. "We have to get some scale in this picture. Any time we have an opportunity, we must show the *Enterprise* in relation to the human figure. There's nothing that gives scale like that. When we discover the *Enterprise* up in the drydock, we will see around her little spacesuits working and doing things, as well as little work bees and machines flying. Every time we have a chance, we do that: Epsilon IX is another case in point. On the series, they couldn't have that size comparison because they never put the *Enterprise* in relation to anybody or anything. When you see a little

BELOW LEFT AND MIDDLE: Shots of the full-size tram being built at Paramount.

BELOW RIGHT: The miniature tram, seen in only a few fleeting shots, was built by Apogee but filmed by Douglas Trumbull's group. Here, model painter Ron Gress adds some last-minute details to the miniature.

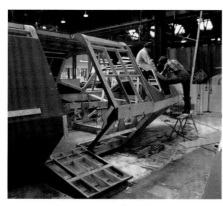

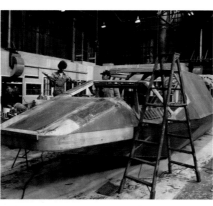

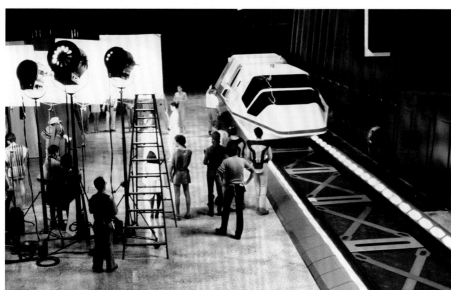

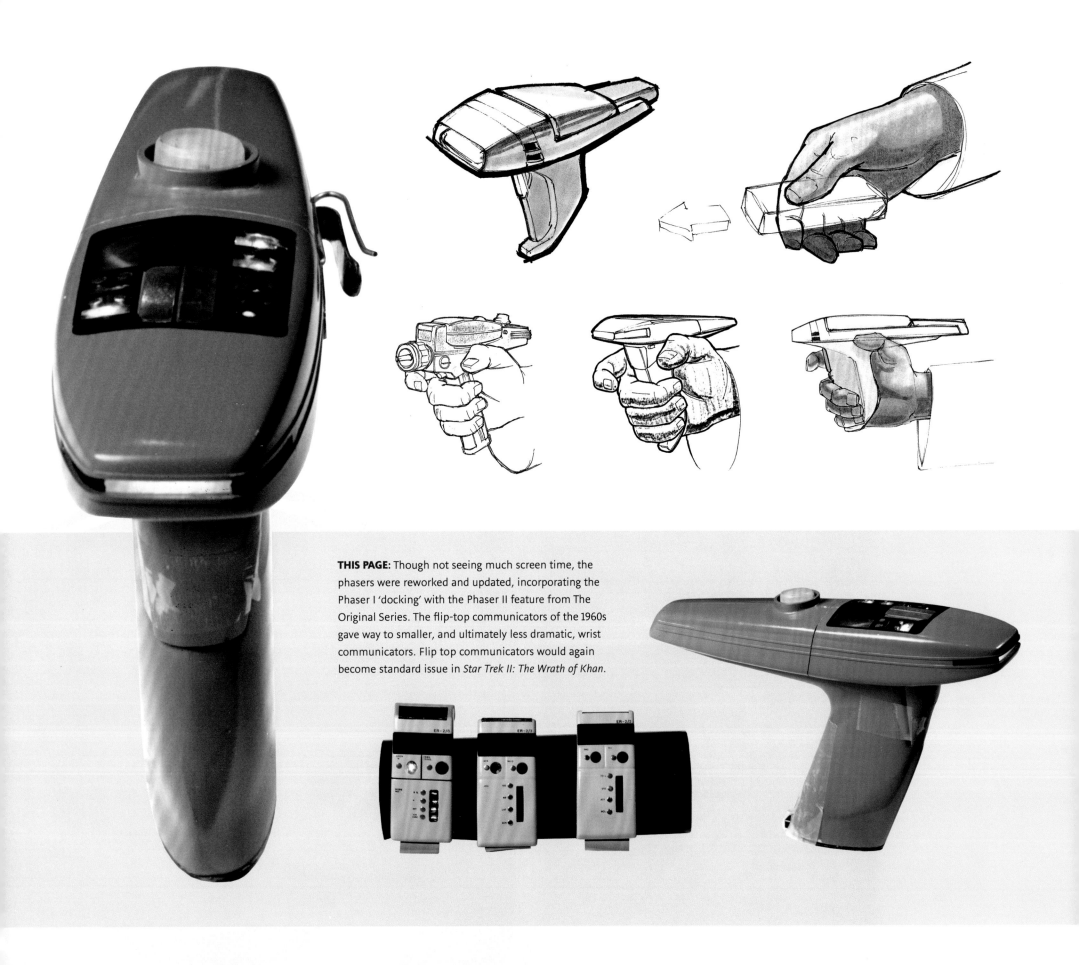

THIS PAGE: Though not seeing much screen time, the phasers were reworked and updated, incorporating the Phaser I 'docking' with the Phaser II feature from The Original Series. The flip-top communicators of the 1960s gave way to smaller, and ultimately less dramatic, wrist communicators. Flip top communicators would again become standard issue in *Star Trek II: The Wrath of Khan*.

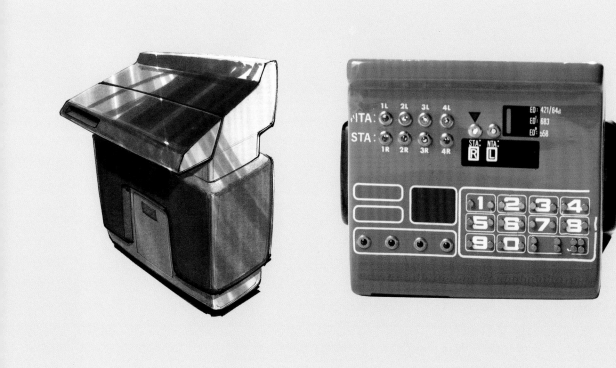

THIS PAGE: The tricorder got an update, losing the little TV screen featured on The Original Series' prop.

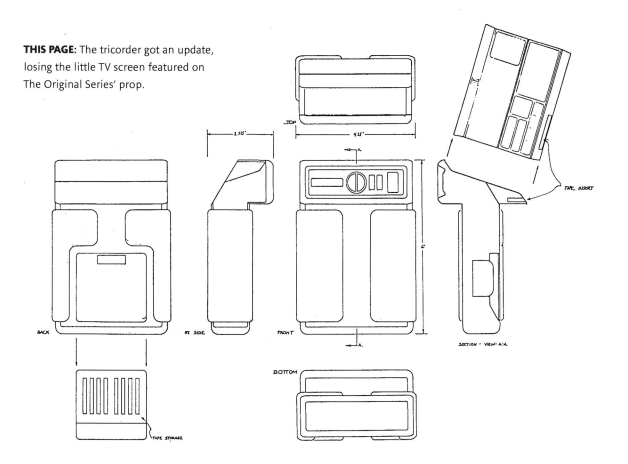

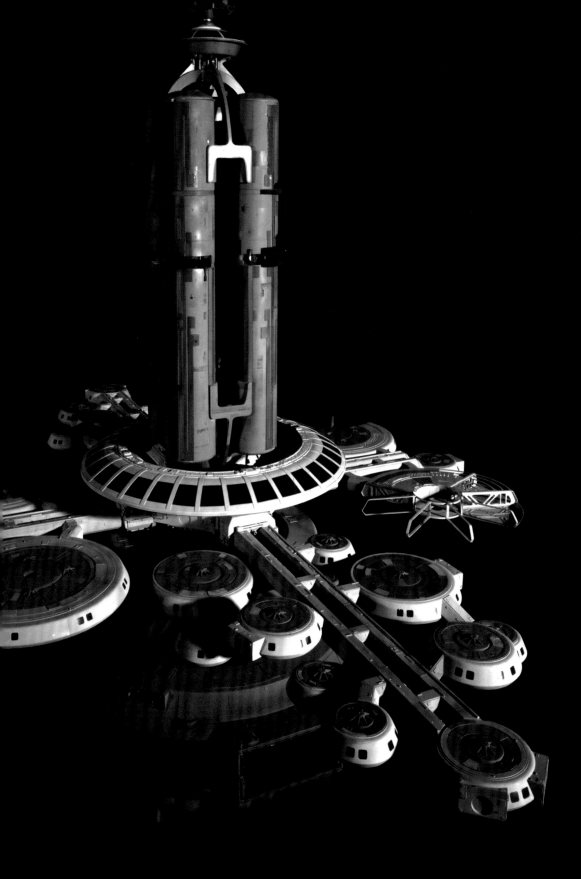

carrier, she's 1,000 ft long. When you see her just flying across the sky by herself it doesn't register." For this one scene, a full-size set piece was constructed by the Paramount mill and filmed on a partial set that would be expanded by a matte painting.

The San Francisco sequence introduces James T. Kirk, emerging from the air tram in a sleek admiral's uniform designed by costume designer Robert Fletcher. Fletcher was walking in the footprints of William Ware Theiss, who had designed the original TV show's striking color-coded uniforms. In 1979, he recalled joining the production after a previous costume designer hadn't worked out. "I looked at the clothes that the previous designer had produced, and they were far too balletic, I thought. I didn't really know what the Paramount people hadn't liked, but I felt, having seen some of the sketches, that they were very imaginative. I was one way of doing the film, but it would have looked more like *Flash Gordon* or perhaps *Forbidden Planet*. What the *Star Trek* people had in mind was a more naturalistic, logical kind of approach. They wanted not so much science fantasy as science fiction, so I felt the costumes had to be science fact. The hope was that I would try to quiet things down so that you wouldn't be looking at the clothes all the time, but that the clothes would simply seem inevitable, natural, and dignified—just as they should in a contemporary dramatic film. Apparently Bob Wise had decided I might be the one who could do it; I really don't know why. I made a lot of sketches that week, and showed them to Bob and Gene Roddenberry. They seemed to be pleased, and apparently they were because I ended up working on *Star Trek* for more than ten months."

To reflect the interplanetary cooperation that one would expect to find at the headquarters of the United Federation of Planets, a wide variety of alien species would need to be featured. Perhaps influenced by *Star Wars*' cantina sequence, *Star Trek: The Motion Picture* would feature the most aliens of any *Star Trek* project to date. Makeup appliances for the aliens in the Starfleet HQ and rec deck sequences ranged from delicate applications of custom-made appliances to full-faced slip-over masks to the old *Star Trek* TV series standby wildly colored makeup. Due to the sheer numbers of extras involved in both sequences, assembly line-like techniques for makeup and costuming would have to be adopted.

The San Francisco sequence follows Kirk from the Earth-based tram station into Earth orbit, on an office complex built to oversee and man the drydock complex that houses the *Enterprise* while it is being redesigned and upgraded. Just as Apogee had done with the earlier Epsilon IX sequence, Douglas Trumbull's team used the orbital office complex and drydock sequences as key opportunities to integrate human figures into the film's visual effects sequence in order to provide scale.

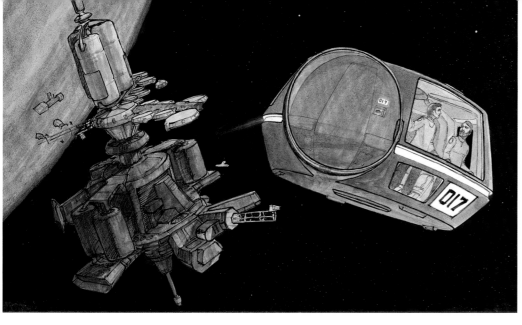

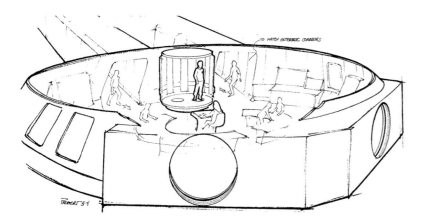

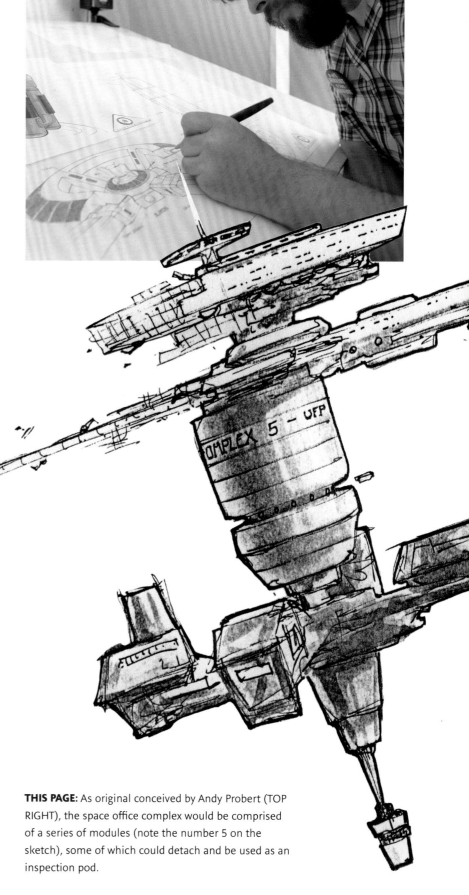

The orbital drydock and office complex had originally been designed by Mike Minor for *Star Trek: Phase II* and built by Magicam. These miniatures were part of the December 1977 review by Richard Taylor, and were found wanting in terms of their ability to stand up to scrutiny on the big screen. Taylor's marching orders to Andrew Probert to tackle the 'human-based' Starfleet designs fell heavily in this section of the film, as Andrew provided new approaches to the drydock, the orbital office complex, and several small, auxiliary crafts that would operate in and around the drydock and office complex. "Mike Minor had done some concept work," Probert says. "He did a concept on the shuttlecraft, the cargo deck, and he did a version of the space office complex and even

the drydock. Magicam had built Mike Minor's version of the drydock and the space office complex, which was this weird kind of spherical, dodecahedron kind of shape that, to me, didn't make any sense."

Richard Taylor generated one early sketch for a redesign of the office complex that shows the lower, cone-shaped bottom of the station and some attached, spherical tanks. "It had these extended arms and these circular pods that could be nested, and the idea was that the space office complex used Starfleet modular architecture so they could build a bigger or smaller version of that thing." Andrew Probert generated the bulk of the design, creating a vertical shape with tower-like tanks and disc-shaped, blunt habitation modules to get

THIS PAGE: As original conceived by Andy Probert (TOP RIGHT), the space office complex would be comprised of a series of modules (note the number 5 on the sketch), some of which could detach and be used as an inspection pod.

away from the very abstract, geometric shape originated by Mike Minor. "One of the things to me in the design of all of the objects, and it's something they dealt with in *Star Wars*, was you could make something that doesn't have some lateral space to it, you can't tell what it's doing," Taylor notes. "You can't see movement. A tube in outer space isn't interesting; a tube with wings is. To see motion, things don't have to bank to turn in outer space, but it looks better."

The office complex was also one of the first miniatures constructed for the film. "I remember a working drawing of the space office complex, and I wound up being the lead on that model," Mark Stetson says. "It started before I got there, and Lee Edelman built the framework for it that included the arms that extended out to the clusters of pods, but I received it as an aluminum framework and those arms as octagonal pieces. I built square stock into the octagonal arms that they could run all the neon into. I don't remember Andy delivering accessory drawings or auxiliary drawings to guide the construction there, it was more like he'd come over periodically and ask

for additional detail to be added."

Like Probert, Stetson had studied at Art Center, but his background in industrial models hadn't fully prepared him for the rigors of detailing models for motion picture production. "The space office complex model was delivered with fairly basic detail like blocks, maybe scribed stuff for solar panels on the main tanks, but I did all the plaster spins and made all the vacuform parts for it to put it together and assemble it to the original drawing as drawn, like the little yokes holding the main tanks together, and stuff like that."

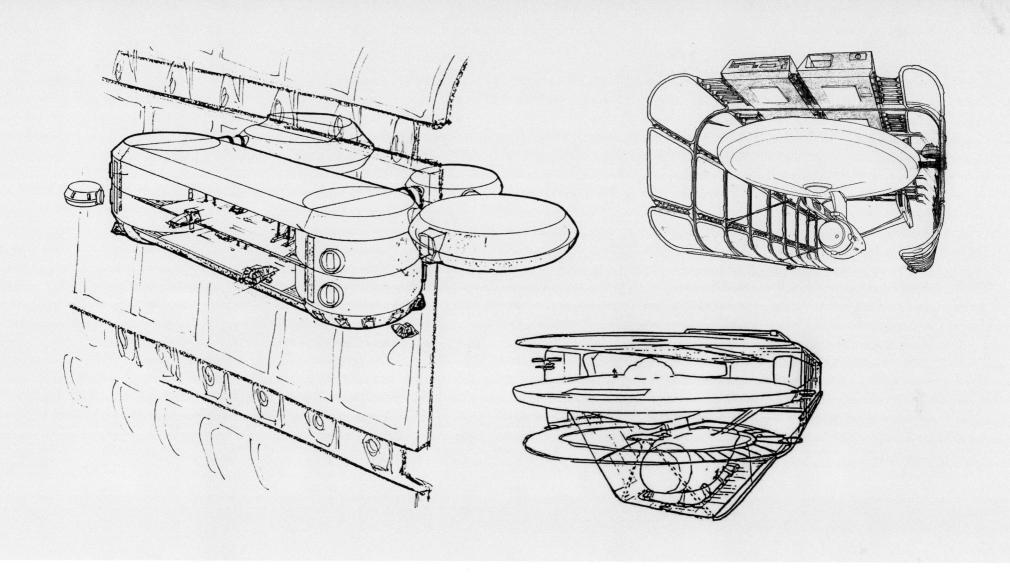

BELOW: Some of the small details of the Drydock built by Magicam. (LEFT) Paul Turner did the wiring on all the drydock lighting panels.

The light panels on the drydock proved a problem for those that had to photograph the miniature. They gave off too much light, making the *Enterprise* look like a model in a car paint booth. The final solution (FAR RIGHT) was to create a graphic that looked like a futuristic piece of technology that would also cut down on the amount of light; (BOTTOM) Harold Michelson and scenic backing supervisor Benny Resella in front of the full-size backing of the drydock.

The space office complex miniature was delivered to Abel's group at Seward and, after Abel left the production, it went to Apogee, where John Dykstra's crew were filming. Apogee had their own model group that did the final layer of detail on the station. "Pat McClung detailed it out a lot before it was shot," Stetson says. "We were putting maybe $^3/_8$-inch-square chips of detail on the space office complex. We were very conscious of the difference between

detailing the *Star Wars* models and detailing the *Star Trek* models, because the *Star Trek* models were so streamlined and stylized. They were design pieces rather than engineering pieces. They were kind of styled, and everybody thought Richard's work and Andy's work on them was beautiful. But it was a very different aesthetic universe from *Star Wars* and I didn't know that we should have been adding bits of model parts and stuff like that onto them."

Probert's approach to the Office complex also influenced his work on the travel pod, another key element that would transport Kirk and *Enterprise* chief engineer, Montgomery Scott, from the orbital office complex to an inspection of the *Enterprise* in drydock. The design ultimately called for simplicity, and had to feature a large, circular hatch of a kind favored by Gene Roddenberry, and an eye-catching forward window that would allow footage of

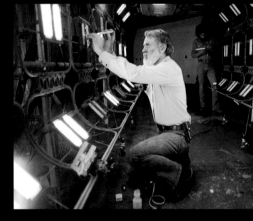

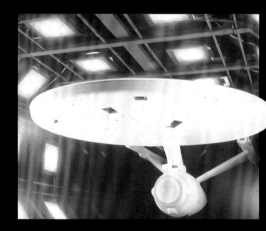

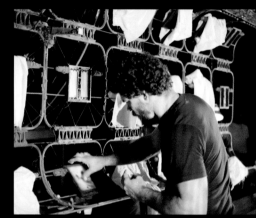

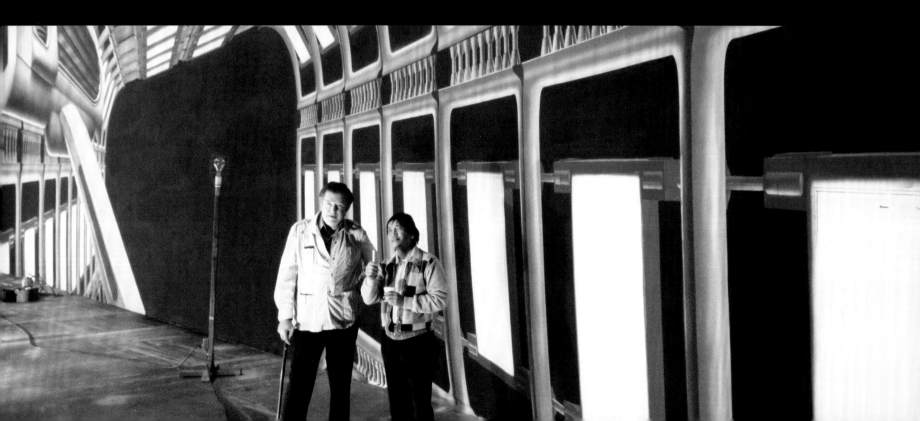

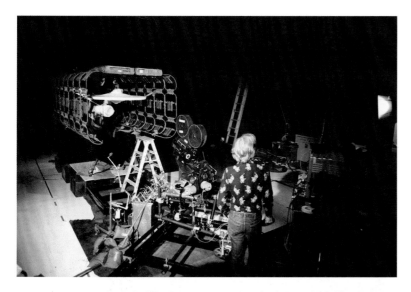

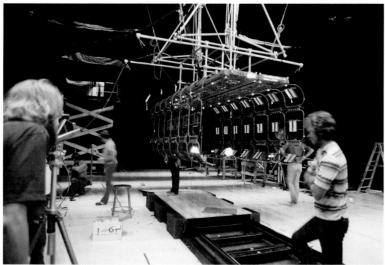

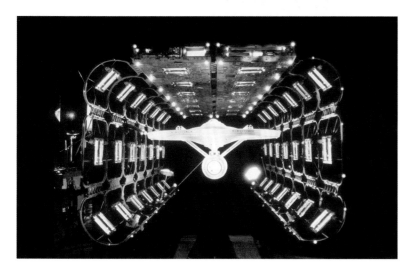

THIS PAGE: Stills photographer Virgil Mirano (RIGHT) hit upon a novel way to add spotlight effects to the *Enterprise* model. Using automobile inspection mirrors, he reflected the light from a stage lamp into smaller pools of light.

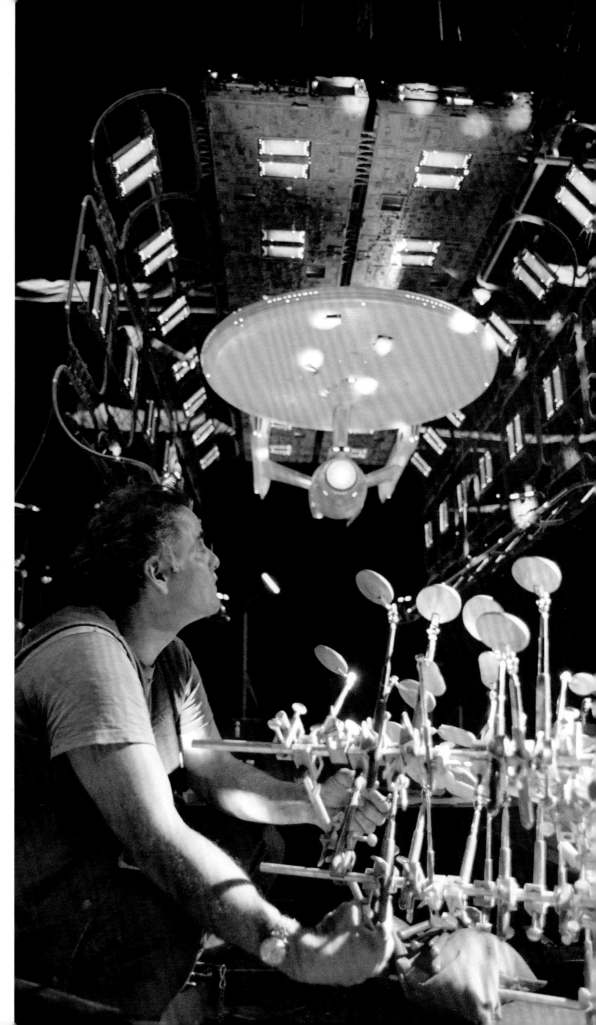

the two characters to be rear projected into the cabin of the travel pod so that Kirk and Scotty would be prominently visible—and moving—during the lengthy scene of Kirk viewing the refurbished *Enterprise* for the first time.

"Gene I don't think had any specific shapes in mind, *per se*, except that he wanted the travel pod to look like one of these office units in the space office complex," Probert says. "He thought that would be a lot of fun to suddenly see one of these office units detach from the station and become this transport over to the *Enterprise*. I started doing some basic layouts and a whole bunch of different versions of this thing, and eventually settled on a layout that incorporated not only offices but domestic units for personnel to live at the station, all predicated on artificial gravity, so there was

nothing that had to spin, just all these double, inverted pie-shapes that became these offices. I did a version of that for the travel pod and it had an off-center docking ring for the *Enterprise*, kind of like the *Millennium Falcon*'s control pod. Then the back, there was no defining feature, it was just attached to the space office complex like one of the offices. Gene said, 'No, take that docking ring and put it on the back, it should only have one entrance.' So I moved the docking ring to the back and kept the front as kind of a stylistic version of the office units, shape-wise. But then the sides tapered back into a docking ring, and that was the shape of the travel pod."

The travel pod miniature became one of the first to be constructed, because a matching interior set had to be made for Shatner and James Doohan to perform in and be filmed for

the rear-projection photography that would be inserted into the pod's window. To add visual interest to what was necessarily a relatively simple shape, Taylor and Probert added a band of lights around the pod's equator and numerous other paint and trim details. "There was a glowing light and a strobe on the top and the bottom, so any time you can add work lights, headlights, it helps," Taylor says. "The typeface on there we designed from scratch, the alphabet and numeric system for Starfleet; we did the same thing for the Vulcans and the Klingons; we came up with the Klingon typeface and numerology, and the actual Starfleet logo we redid, so that's some of the detail work we did at the Abel studio, and all of that stuff was what we did to give continuity to anything that was Starfleet."

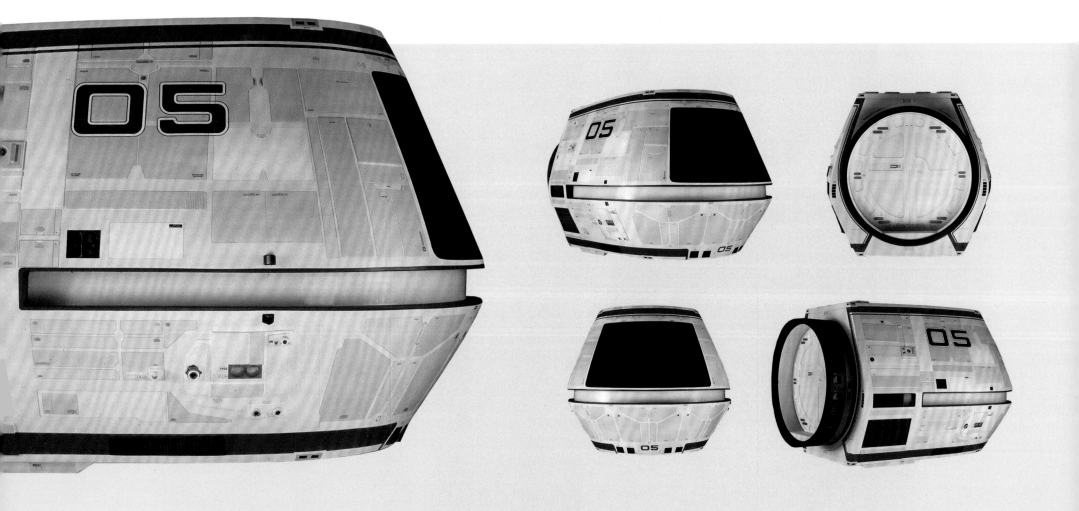

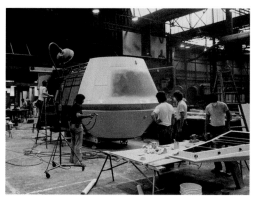
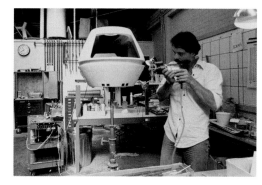

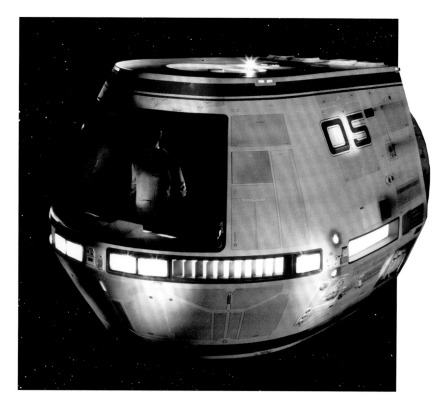

Probert was involved in detailing the final model even further. "Another thing we did was use decals from airplane model kits and put these little tiny details over these panels, especially the travel pod, because we thought it was going to be seen close up, and in most of the scenes, you probably can't see the details. It was like those 'no step' signs on an aircraft wings or 'electrical equipment in this panel,' because military aircraft, especially, are loaded with this nomenclature, so we put that all over the travel pod."

Mike Minor's *Phase II* drydock design had been rectangular but relatively sparse in its details; the most distinctive elements were elaborately-constructed hexagonal lights, spaced evenly around the structure, and the miniature was built to scale with the 6-ft *Phase II Enterprise* miniature. With that model rejected and a new, 8-ft *Enterprise* under construction, the drydock too had to be rebuilt and reconceptualized.

"The drydock was another thing Gene Roddenberry had specific views about," Richard Taylor says. "He wanted it to be rectilinear, and the one being built at Magicam was rectilinear, but it was too small and we needed to build a bigger one to fit the bigger model. I wanted it to be a hexagon cylinder, and the whole idea I wanted to [story]board from the beginning, that he nixed, was, when you very first saw the *Enterprise*, it was all upside down and the whole thing is rolling around, so when they come around with the pod, when they finally get out in front, is when you finally see it right-side up."

"I always thought there would be like five drydocks sitting up there, around one space office complex controlling them, just like in a real navy yard," Andrew Probert says. "You could do that just by putting still images up there, it wouldn't have cost a lot. My drawings always had more than one drydock in there. I came up with all kinds of different designs for the drydock and a lot of them were very form-fitting to the *Enterprise* because it was supposed to be a work platform to get the ship ready, like a gantry on a rocket."

Some of ASTRA's early concepts for V'Ger featured orifices that would conform closely to the *Enterprise* as it moved through them, an idea Roddenberry liked, so Probert's idea of a form-fitting drydock was rejected as detracting from the later V'Ger imagery. "My original take was, 'Well, how do you build this thing?'" Probert says. "NASA had come up with an idea of actually extruding trusses, three-sided trusses, out of the orbital shuttle with this machine that would just continue to somehow extrude these beams and wrap them in something that would actually make a triangular truss of indeterminate length. I don't know how that worked, or how they did it, or if it was a conceptual idea they'd been testing, but I thought 'Let's start with that.' My initial thought was that, instead of a triangular truss, we would go with a tubular shape on all of the drydock structures and they would be extruded, and if you looked really close at it, it would have a very detailed structure showing how this thing had been grown. That disappeared very quickly and they became solid tubes."

ABOVE: The travel pod was built as both a full size set and a miniature. (CLOCKWISE FROM TOP LEFT) A rendering of the interior of the travel pod; Model maker Chris Ross works on the miniature; Final version of the miniature. Note the figure of Scotty used for long shots; 65mm film clip of William Shatner and James Doohan in the full-size travel pod set; The full-size travel pod under construction in the Paramount mill.

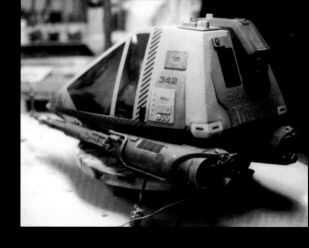

ABOVE: (LEFT) The workbee miniature would be crewed by a 12" G.I. Joe (with kung-fu grip); (MIDDLE) Zusanna Swansee details the workbee miniature; (RIGHT) Gripper arms and other accessories could be added to the single miniature.

Richard Taylor contributed the idea of a 'paddock' for support craft and personnel as part of the drydock. "I came up with a design for that, that you sort of attached to the side of the drydock and then, later, for whatever reason, I took that off or just added on top this full-length structure where all of that could take place," Probert remembers. "It would be up above, a huge cargo thing or living quarters or whatever was needed to attach to the drydock. [The paddock] vanished once I came up with that thing on top."

Probert also designed a track system of work cranes that could be operated near the hull of the ship inside the dock. "My initial idea was that these cranes would be manned individually and then I thought, 'Why don't we take these work bees and plug them into the crane?' and now the bee is controlling the crane. Then it was, 'How do you keep the ship registered in the drydock? We'll have four tractor beam emitters at the base of the drydock to keep the ship stable and in relative position to the drydock.'"

Practical lighting had always been a part of

the drydock design but, once Doug Trumbull took over supervision of the film's effects, the approach to lighting the *Enterprise* within the drydock took on added importance, as Trumbull had a specific look in mind for the Earth orbit scenes. Probert had initially designed large and prominent lighting fixtures for the drydock that would surround and illuminate the *Enterprise*. Ultimately, these would become more subdued, illuminated blue panels with patterned detail that would supply additional color to the drydock structure without adding significant

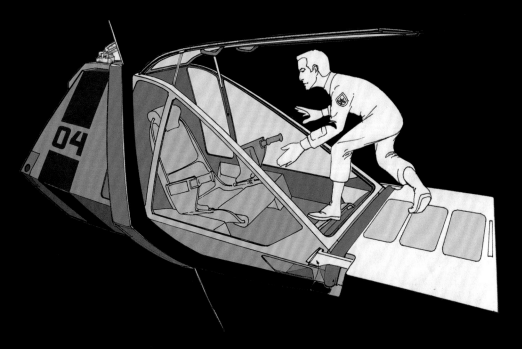

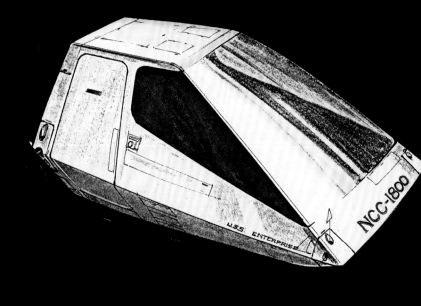

illumination. "The one thing that I really liked that they had at Magicam on the original drydock model were these hexagonal lights," Taylor says. "Those were really beautiful, and they just needed to be repositioned and put into the new drydock, but I really loved those lights. Then there are lots of other, smaller lights that were put on the final drydock."

"The drydock's going to be orbiting the Earth and it's going to be in absolute direct, blinding sunlight, or it's going to be in Earth's shadow," Probert explains of his rationale for the original look of the drydock lighting structures. "When it's in sunlight, there's going to be all these shadows from the drydock, so I came up with this full lighting system that would illuminate that ship and negate any shadow problems. We even did lighting tests early on to see how that would work, and I thought it looked great, but when Trumbull came onboard he said, 'That's too much light and it's going to make it look like a toy. We'll neutral-density all of those light panels way down and we'll use spotlights.' So he dredged up those hexagonal things from the other drydock to use those as these giant spotlight things in the drydock."

The five-minute-long inspection sequence of Kirk and Scott traveling alongside and into the drydock structure to view the *Enterprise*

ultimately became one of the visual highlights of the film, especially once the sequence received a majestic, spectacular musical accompaniment by composer Jerry Goldsmith. The addition of support craft, other travel pods, and a space-suited worker floating down past the starship's open shuttlebay achieved director Robert Wise's stated goal of bringing a human scale to the *Enterprise* and the film's visual effects as a whole. "There were parts of the model that we knew we were going to come by on the reveal, with workmen on some of the beams to give scale," Taylor says.

As the *Enterprise* exits the drydock later in the film, effects director of photography Dave Stewart and Trumbull added a moment of humor that involved an astronaut figure literally 'flipping out' as the *Enterprise* moves past the drydock structure. "He did a backflip and we reduced him incredibly with special lenses and incorporated the shot," Richard Yuricich says. "It was filmed with a guy in an astronaut suit and it could have even been Doug because Doug used to do that stuff—you'd see him out back jumping up and down on a trampoline behind MGM studios when we were doing *2001*. I don't think it was Doug, but Dave made it quite humorous and legendary, all tongue in cheek."

THIS PAGE: Early concepts of the workpod used a sphere, (RIGHT, TOP AND BOTTOM art by Rick Sternbach), before Andy Probert developed the angular look of the work bee (ABOVE).

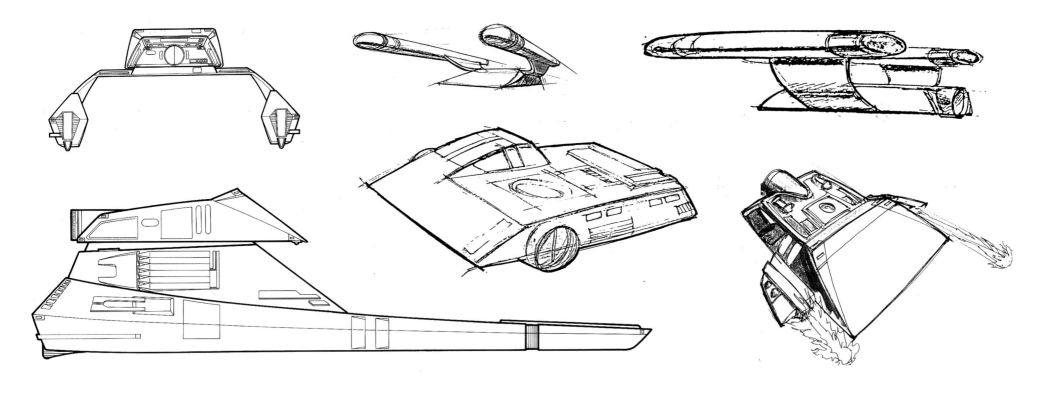

ABOVE: (TOP RIGHT) Long range shuttle concepts featuring different treatments for the warp nacelle packages; (TOP LEFT) Line drawings by David Kimble; (BOTTOM) The miniature under construction.

In 1979, John Dykstra pointed out that the flipping astronaut was actually portrayed by stuntman Tom Morgan. "That was shot on a stage at Paramount, but it was shot with a front-projection blue-screen process that we've been working on and making work well. I think we're probably the only people who are doing front-projection blue now, but it's neat because all you need is a front-projection machine and a big front-projection screen, and you can make it as big as you want. And the blue is really pure, you can get a really nice matte off of it. We've

had really good results from that technique."

Some of the vehicles seen moving around the orbital office complex and the drydock are one-man pods called work bees. Andrew Probert provided the concept for the vehicles. "As I was reading the script, I told Richard, 'What we're missing here is some little working craft that are servicing the *Enterprise* because they're trying to get this thing ready to get out of drydock, and we need to show a lot of activity.' I said, 'What about these little things scrambling around like bees around a hive—let's call them work bees.'

So I came up with these little yellow work bees that got built."

Probert incorporated the modular cargo pods designed by Harold Michelson for the cargo bay set, with a 'train' support structure that the work bees could be plugged into, as well as manipulator arm harnesses that would lock around the work bees. Richard Taylor notes the designs were inspired by one-man submarines. "You can change the operating arm systems on them. They're maneuverable and they also work as a tug; you can put containers behind them

and they can pull them along." The model for the work bee, like many others, passed through many hands, beginning at Magicam, having detail added at Abel's own Seward street facility, and continuing at Apogee where the gripper arms were made, before finally being finished and filmed at Trumbull's facility in Marina del Rey.

The movie's other Starfleet spaceship is a long-range shuttlecraft—a 'courier' that delivers Spock in the nick of time to the *Enterprise*, just after the starship leaves the solar system and is momentarily crippled after the wormhole incident. The Vulcan shuttle evolved from a standard, but enlarged, shuttlecraft concept into a unique vehicle that would bear the design imprint of Spock's Vulcan culture. "Spock had to catch up to the *Enterprise* in flight with this shuttlecraft and Gene said, 'It's got to have really big engines on it so it can catch up to the *Enterprise*,'" Andrew Probert says. "I started doing these sketches with these double engines—Gene said right away, 'There are no odd-engine starships because the engines are codependent—they work on powering each other and they create a warp field between them, so there are no single-engine ships, there are no three-engine ships; they're all even-numbered.' Part of that was [a reaction to] what they'd done with the [*Starfleet Technical Manual*]. So the ship had to have two warp engines, but be able to dock with the *Enterprise*. I thought 'Why don't we make it a sled that pulls the shuttlecraft, that the shuttle is mounted on,' and that could separate and therefore dock with the *Enterprise*—have a docking ring on the back and dock just like the travel pod."

BELOW: Andy Probert concept art of the long-range shuttle.

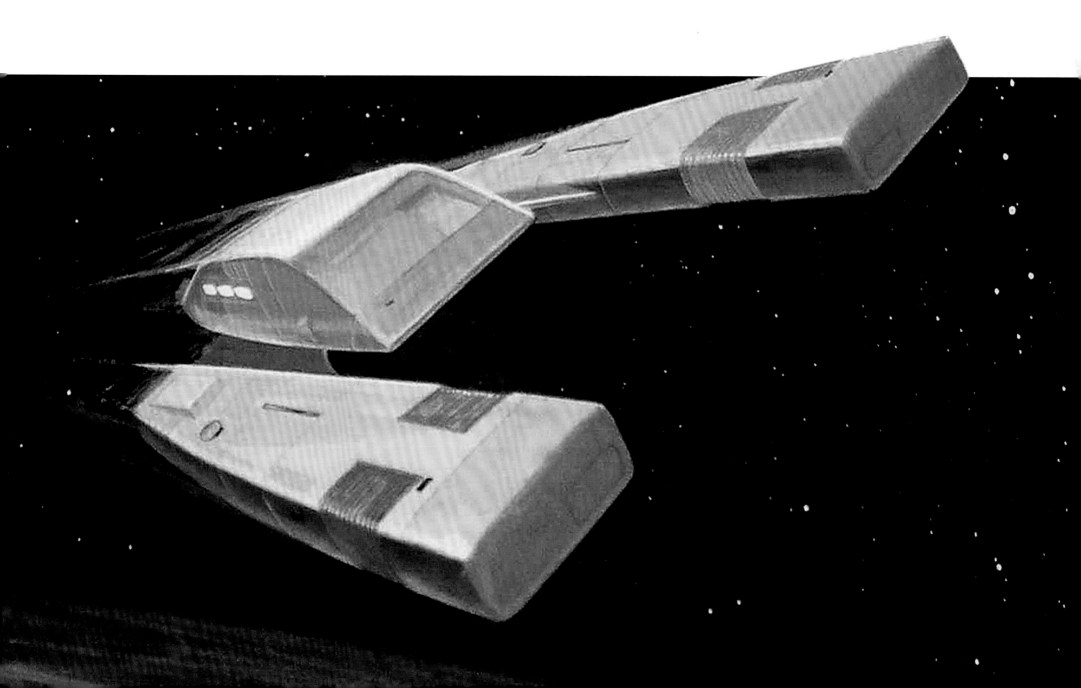

While some of Probert's early sketches show the traditional, tubular warp engines seen on the original TV *Enterprise*, Probert eventually went in a different direction, one that rendered the Vulcan shuttle—named the *Surak* after the Vulcan leader depicted in The Original Series episode 'The Savage Curtain'—as a distinctly Vulcan vessel. Probert took a Vulcan prop seen in 'Amok Time' as inspiration for the Vulcan shuttle's engines. "I started with the gong in that original *Star Trek* episode where Spock goes back to Vulcan. They rang it, and all these people came out and Spock was challenging the guy. I took that as what I thought would be a typical Vulcan shape and I started basing a lot of my design work on that, starting with those warp engines."

Probert also recommended the ship's unusual, mauve/magenta paint scheme after tiring of the gray-on-gray look of spaceships in movies like *Star Wars*. "I said, 'Vulcan has this red sun or atmosphere,' and I said, 'If you took gray with a red light, it would turn out to be more magenta than anything.' So when the time came to paint the model, I was over there working with the modelers—I was dirtying up the Vulcan ship and there was [Zusanna Swansea], who was an absolute artist when it came to painting models. I wouldn't do any of

the primary painting because that was not my forte, but the ships could not look pristine."

Probert created a windowless, wedge-shaped shuttle that would separate from the warp drive sled, and designed a smaller, standard-sized *Enterprise* shuttlecraft based on the same look, although these were only briefly glimpsed in the film as painted elements in a matte painting of the shuttle bay and cargo deck area inside the *Enterprise*. "[The shuttle] was a simplified shape, but we knew it had to have that 12-ft door on the back and we knew it had to dock behind the bridge," Richard Taylor says. "That docking bay didn't have a lot of room underneath it, so you couldn't have anything vertical, any fins or anything below it, so that capsule on the top is pretty minimal—it could have as much horizontal as we wanted, but you couldn't have much vertical."

Mark Stetson credits modeler Tom Pahk with building the final Vulcan shuttle miniature. "That was Tom's project at Magicam and it was delivered as a pretty clean model, but Andy directed all this additional detailing on it, and he used that as an opportunity to teach me and Zusanna Swansea about aging spaceships *Star Wars*-style. Doug [Trumbull] shot it—it was one of the first things they shot at the Future General stage."

Trumbull's motion-control shot tracked the shuttle as it approached the *Enterprise*, with the shuttle then separating and performing an aerobatic, flipping maneuver to finally dock at the rear of the *Enterprise* bridge. According to Mark Stetson, the shot was executed after Stewart and Trumbull saw John Dykstra's shot for the opening Klingon sequence (which had the camera itself seemingly flipping over the bridge of one of the Klingon ships) and wanted to do something equally audacious: "That was called the Doug Beats Dykstra Shot."

Because of the difficulties in maintaining focus on the *Enterprise* bridge structure when shot from the edge-of-the-saucer angle the scene required, matte artist Rocco Gioffre executed a remarkably realistic side view of the bridge and superstructure area of the *Enterprise* that is virtually impossible to spot as a matte painting in the movie.

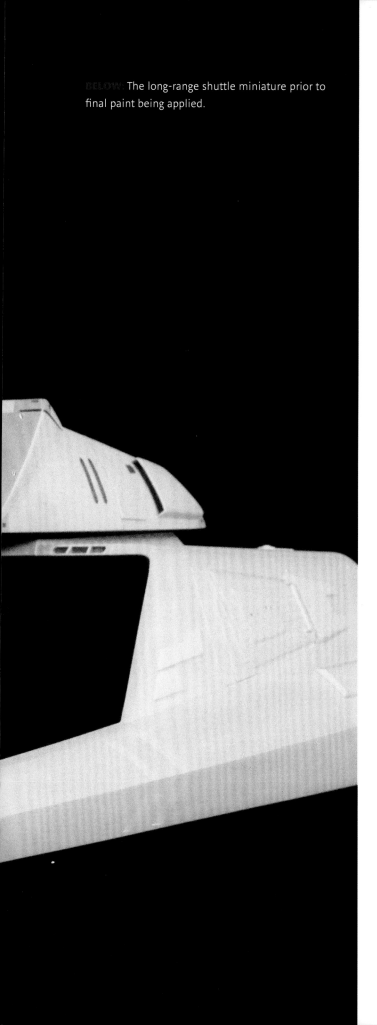

"The Vulcan shuttle is a motion-control stage miniature and the *Enterprise* is a matte painting I did," Gioffre says. "They could pull focus and get a tight shot of the *Enterprise* model bridge, and they had another shot of it where they were focused on the ship's nacelles. So they actually gave me a few different photos that had the focus shifted from one point to another. I think, at the time, I'd project it up on a transparency or film print images like slides onto the glass that I was painting on, and traced those basic shapes, each one with their own specific focus, because they wanted some depth-of-field enhancement that they couldn't get with the closeup photography, and they knew I could turn it around real fast and it was easier to manipulate in post. If they'd done it with a photo, they'd just have somebody come in and retouch the photo so it was in focus, but it was a matte painting on about a 3 × 7-ft frame. It was on glass because we had some little window areas and some ship lights that were going to be backlit and others that were blinking."

Between the work of artists like Andrew Probert, Richard Taylor, Jim Dow, Mark Stetson, and many others, *Star Trek: The Motion Picture* updated the familiar look of the *Enterprise* and Starfleet to create a lavish, sleek, and highly believable look for the big screen. But the film's other design challenge called for something utterly unfamiliar— and utterly alien.

BELOW: The long-range shuttle approaches the *Enterprise*'s upper docking port. The *Enterprise* in this shot is a matte painting by Rocco Gioffre.

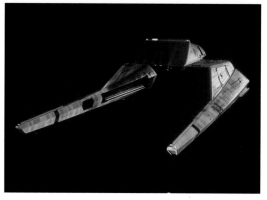

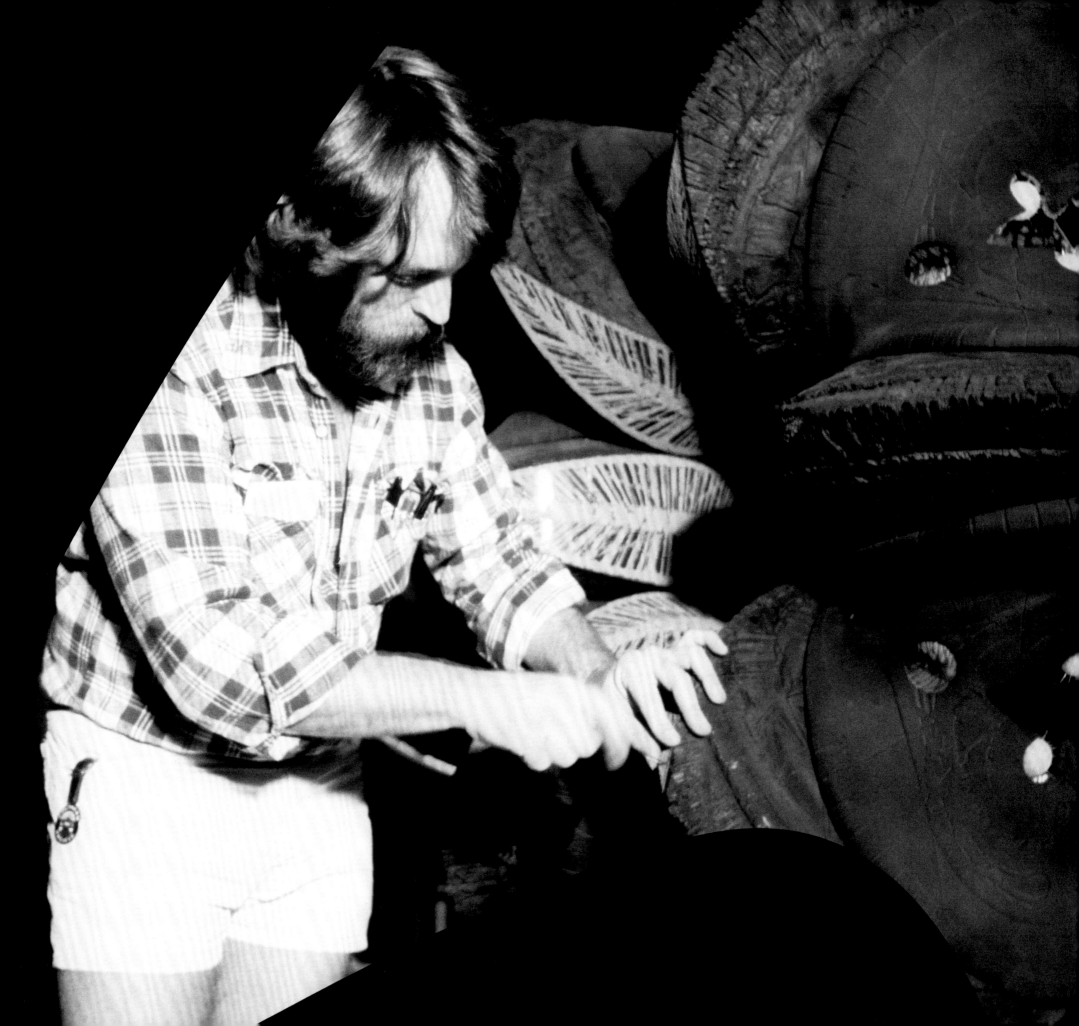

DESIGNING V'GER

As far back as the 'In Thy Image' *Phase II* television pilot, the realization of V'Ger had been the biggest challenge of the production and, apart from the update of the *Enterprise*, the final depiction of V'Ger in *Star Trek: The Motion Picture* remains the film's most startling and unforgettable element. Originally called N'sa, the gigantic, sentient object was always intended to be something unlike anything that had been seen before—bigger than the original show's 'Doomsday Machine' and ten times as unfathomable. Ultimately, V'Ger would become, at the time, the largest artificial object ever conceived for a motion picture, making its design and execution a landmark endeavor.

Science-fiction author Alan Dean Foster, working on the teleplay for 'In Thy Image,' was one of the first to tackle even a description of the entity. "The original thing that I wanted was the kind of spaceship that the French artist [Philippe] Druillet draws," Foster said in 1979. "A lot of his stuff has been in *Heavy Metal* comics, and he's done a number of books. He works on a grand scale, with tremendous detail, and you get that feel for his work from a statue, or a sailing ship, or any of his stuff that you pick up. Basically, if I remember the words right in the treatment, I didn't say 'a Druillet spaceship' because I didn't think anybody there would know who Druillet was. So I said that the kind of feeling I wanted was 'like a Gothic cathedral lying on its side.' Again, I was thinking in 1977 television terms; what could they be capable of doing?"

Ultimately, Mike Minor came up with a lengthy, ladder-like shape and a box-like forward section broken up by saucer-shaped, eye-like structures, a concept simplified further in construction. Minor also designed a 'maw' through which the *Enterprise* would pass—another important story element. "This was another Mike Minor concept," Jim Dow recalls. "It was described as being a 'maw,' and they entered through the maw into the body of it. We vacuum-formed the panel sections of it and sent them out and had them gold plated, and this was all Mike Minor's idea of what it was going to be. I was never involved in any of the discussions of how it was going to be shot, so I have no idea what he was thinking, and at this point, we were just following orders." The Minor-designed miniature, derisively described by some as a cross between a gold-plated stepladder and a crocodile, was another victim of the redesign effort when *Star Trek* switched over to a feature film.

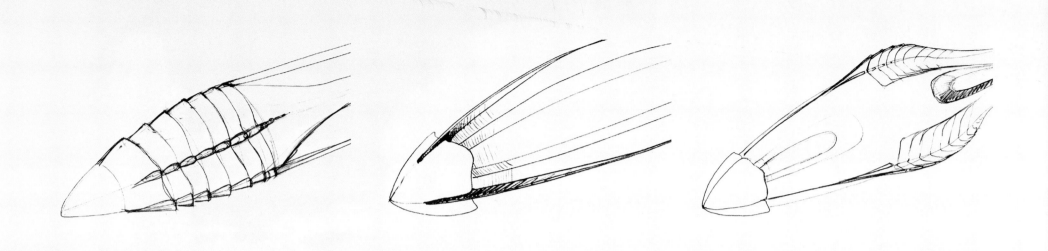

ABOVE: Different versions of V'Ger's closed "maw."

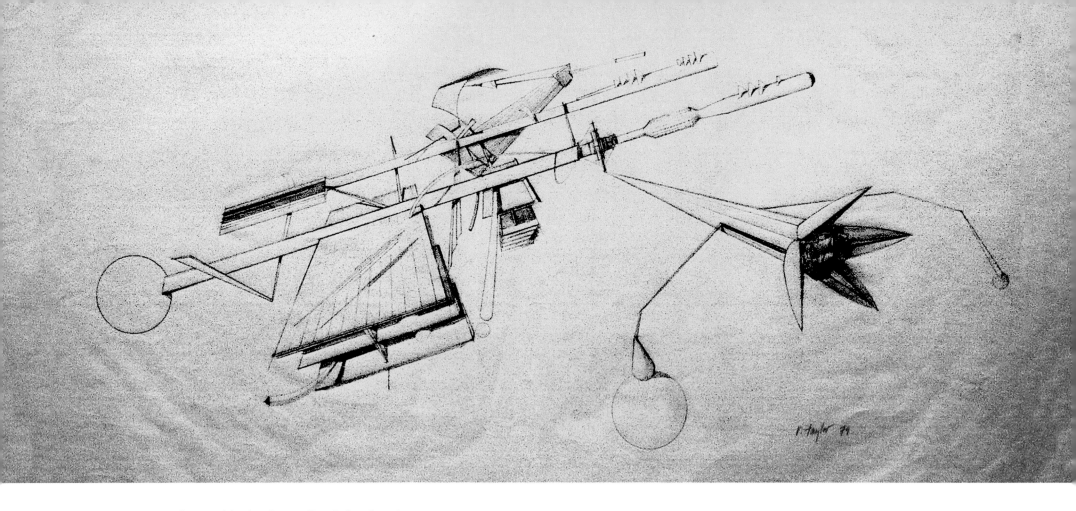

THIS PAGE: ASTRA art director Richard Taylor's earliest designs for V'Ger.

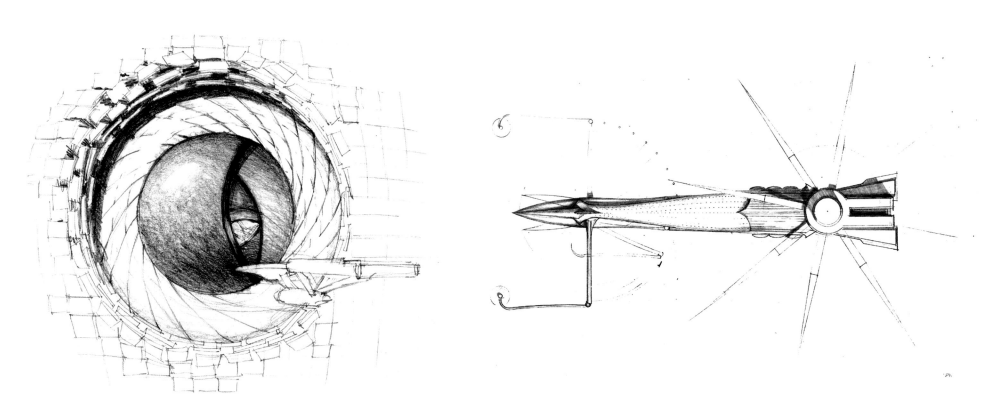

A *Time* magazine article previewing the film described V'Ger as looking like "a cloud of electrically charged whipped cream"—a distinctly Robert Abel-esque image. Quoted in the article, Abel himself stated his team would be giving the entity a "throbbing, ominous personality. It's so big you can't make a model of it. It's so awesome, so powerful, and has so many unique identities..." The article described the techniques Abel would be using to create V'Ger as "filmed layers of high-speed light streaking, chemically milled metal, animation, liquid crystal, and half a dozen other gimmicks." In fact, all these techniques were being explored by ASTRA to create V'Ger, but Abel and his company would never employ them.

Elaborate plans for V'Ger were being designed by artists David Negron and Tony Smith, Richard Taylor, and others on Abel's team. "I had this whole philosophy for the designs we were doing for V'Ger: that, inside V'Ger, everything was made of molecular stuff, so that everything could break into pieces and go and reform someplace else, and the basic modules were these bits or little spheres that could fly around," says Richard Taylor. "V'Ger was always reacting, so if you touched it, there were things that would happen along the surface. The *Enterprise* was going to fly down through it on its way to the *Voyager*'s site and was going to be continually analyzed, and you'd see versions of the *Enterprise* being built next to it basically out of jelly, like V'Ger trying out anything."

Mark Stetson produced a sleek-looking study model of ASTRA's V'Ger concept that some on the production saw as submarine-like in outline. One design element that virtually all versions of the alien probe needed to have was a massive chamber holding the 'altar' or 'temple' where V'Ger had placed the original *Voyager* space probe that gave it its purpose.

BELOW: Robert Abel and Richard Taylor (RIGHT) wanted to show V'Ger reacting to the *Enterprise* as it flew over the exterior. Heat-sensitive, iridescent paint (the type used in mood rings) was tested, with a heat source tracking along with the camera (LEFT).

Storyboards depicting the *Enterprise*'s penetration of the V'Ger cloud, as well as its approach to V'Ger itself. One concept featured the *Enterprise* entering V'Ger via an aperture that conformed to the *Enterprise*'s profile, while a simpler version featured an enormous maw that opened up.

One of Richard Taylor's plans for showing the surface of V'Ger reacting to the *Enterprise* as it travels along the entity's body involved using some of the exotic materials and approaches referenced in *Time* magazine. "You have the model with detailing on it, and the model was going to be made with photo-etched metal so you could have layers of complex stuff. The final layer on top was going to be covered with this material that was a gel that changed color with heat, and would look iridescent. The camera with motion control was going to have a heater on the front of it, so it would react and light up as it went along—it was so beautiful, we did one test that was great. I was going to do all this projection on the *Enterprise* with lasers and all sorts of things as it was being scanned."

Producer Jon Povill says that the approach to V'Ger evolved back and forth between the hard-edged look originally conceived by Mike Minor to the amorphous concepts of ASTRA's team. "The plan for V'Ger was something solid. Conceptually, we needed to feel like Jonah trapped in the whale in order to have the proper sense of jeopardy once the *Enterprise* was sucked into V'Ger. Yes, it had to be big, but it also had to feel claustrophobic as well. A maze with twists and turns and barriers from which it would seemingly be impossible to escape."

Once Abel and his team left the project, V'Ger had to be reconceptualized and executed in a manner that created predictable results. The idea of a constantly moving, reacting shape, potentially masked in form-fitting mists and layers of light, fell by the wayside, with some of that amorphous quality adapted as a tremendous, layered cloud of energy described as actually being larger than the Earth's solar system. The cloud would precede V'Ger in the film's early Klingon and Epsilon IX attack sequences, and then provide a dazzling environment for the *Enterprise* to journey through on its way to encountering the V'Ger entity itself.

Douglas Trumbull's Entertainment Effects Group generated the ever-shifting cloud environment with multilayered pieces of artwork for long-distance views. "It's based on this idea of a piece of artwork that's moving in an arc and there's a series of exposures to create this cloud," Trumbull says of the effect. "You'd have a single airbrushed shape repeated a million times as the camera goes through an arcing movement against the artwork." A sophisticated version of streak photography created first-person POV shots for the *Enterprise* viewscreen, showing awe-inspiring, three-dimensional environments moving past the *Enterprise* on

its viewscreen or simply enveloping the entire movie screen, putting the audience itself in the immersive environment of the cloud.

John Dykstra and Bob Shepherd of Apogee, tasked with creating exterior views of V'Ger, approached 'visual futurist' Syd Mead to design the entity. Just as Richard Taylor had assigned Andrew Probert to work out the look of Starfleet to give the film's Earth-based vehicles a cohesive look, Mead's work on V'Ger created an equally distinctive, wholly alien counterpart that was as intimidating and mysterious as Starfleet's look was bright and reassuring.

Dykstra says his familiarity with Mead's work inspired him to reach out to the artist for the *Star Trek* project. "Syd Mead is a rock star in the industrial design world. When we started doing the *Star Trek* movie and there were some issues with regard to the designs of the V'Ger ship,

being a futurist and being a technologist also, he was the guy I figured would be best suited to come up with some visuals for what this alien society might produce. It was an alien vessel, and the scale and level of technology was totally different from anything that we might conceive of, and he came up with a gestalt, if you will, for what this was—it was sort of a hive mentality, and my approach to him was to say 'Let's make it geologic, have qualities to it that are almost like Earth's geology if it were a sentient planet,' and some very specific requirements for the ways in which the vessel opened up and closed—it was out there harvesting things, that was the whole premise behind it."

Mead was famed for his industrial design work and for boldly designed, futuristic cityscapes full of gleaming, beetle-shaped automobiles, towering edifices, and curvilinear,

sculpted architecture. Mead was less well-known for space-related imagery but, in 1977, he had created a trio of paintings for a San Francisco company, including one of a massive space colony ('Barrier Attack Colony') and one of a gargantuan, tube-shaped space pierced by some equally massive force ('Disaster at Syntron'). The latter was inspired by Mead reading Arthur C. Clarke's science-fiction novel *Rendezvous with Rama*, which featured a massive alien object being investigated by Earth astronauts as it moves through the solar system—a storyline not dissimilar to the V'Ger one in *Star Trek: The Motion Picture*. "I was fascinated by this, so I thought 'let's do a rendering inside of a huge tube habitat,'" Mead remembered. "It's been hit by a planetoid or an asteroid, and there are spaceships floating through it, making a three-dimensional damage review."

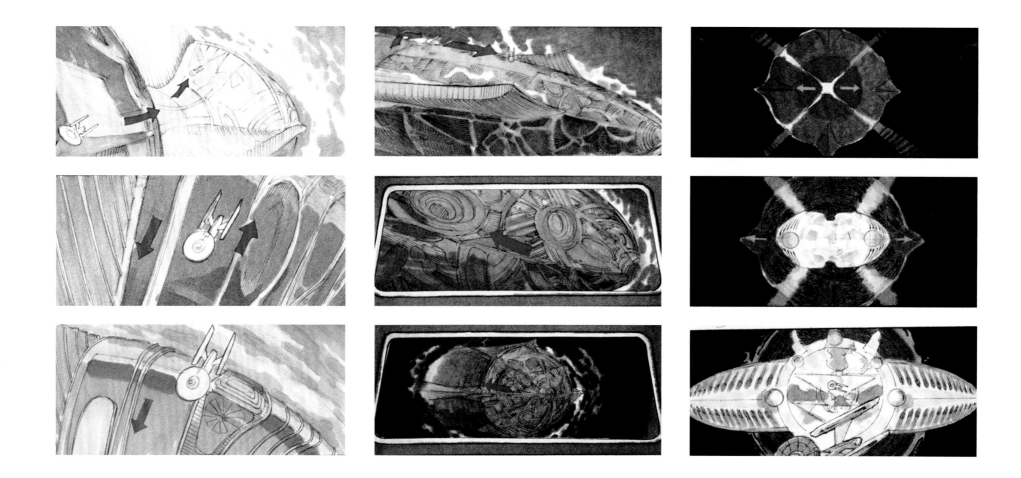

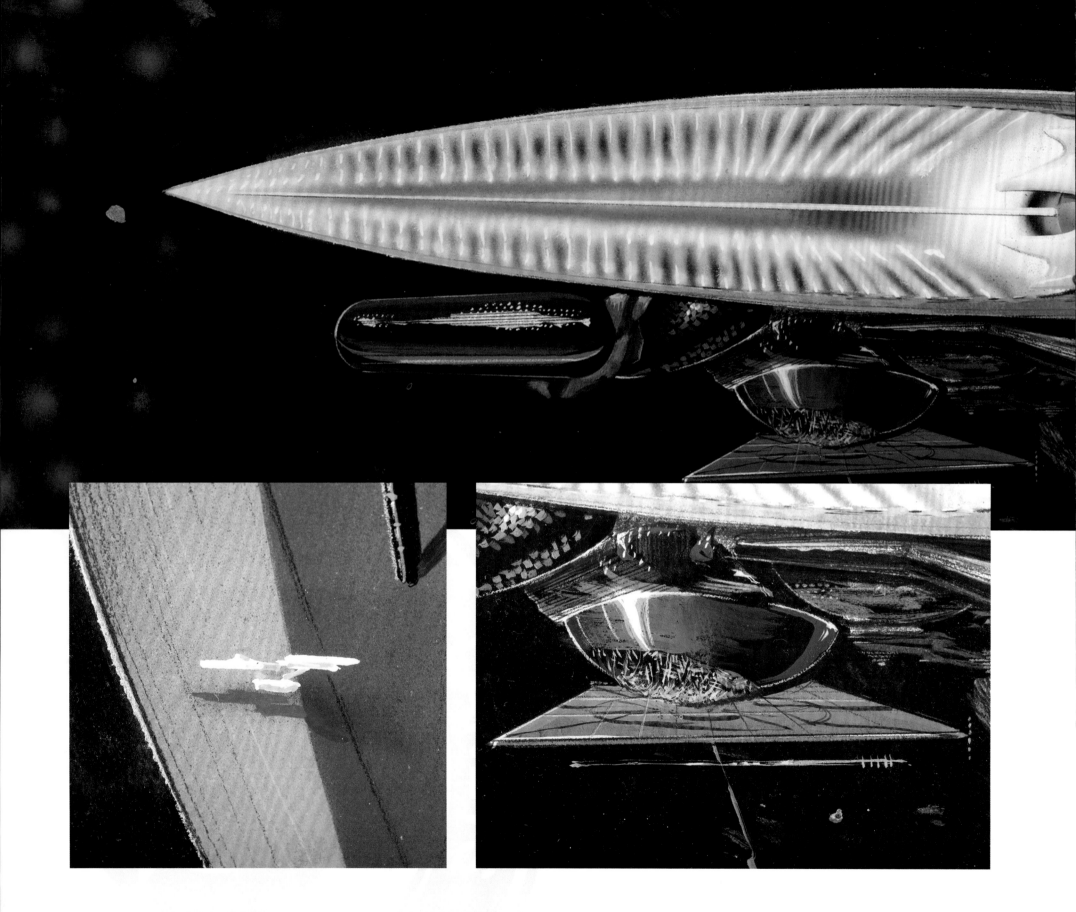

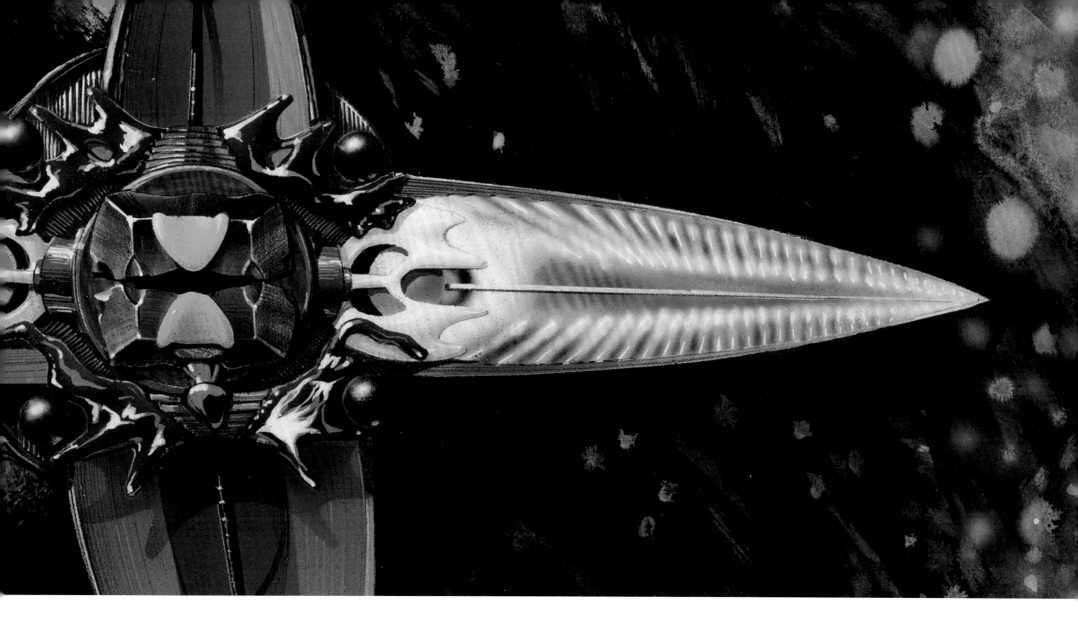

Mead recalled the call from Dykstra and Shepherd asking him if he'd like to work on a science-fiction film. "I had a lot of clients at the time—I had architectural clients and design clients, Raymond Loewey in New York and Paris, and Philips in Holland, so to me it was just another job. I went out to see them and went to lunch and started on the film." Both writers and artists on the *Star Trek* project had struggled to envision just exactly what V'Ger would look like and, in Mead's experience, Robert Wise and the producers on *Star Trek* were no different. "We were in a meeting and Robert Wise handed me a slip of paper from the script and it said, when they come out of the cloud, they're staring at the back end of V'Ger, the terminus, and the script said they were looking at something no man had ever seen before. That was my art direction."

It was the front end of V'Ger—the 'maw' that the *Enterprise* would eventually journey into—that would help inspire Mead's approach to the overall design of the entity. Knowing that the maw was a critical story element, Douglas Trumbull had already recruited someone to design an operating, mechanical maw that could ultimately be detailed and filmed to show it opening to swallow up the *Enterprise*. "We had to split up the work force because we were doing the [V'Ger] interiors and Apogee was doing the exteriors and we had to make those things come together," Trumbull says. "Ron Resch was one of the pivotal elements— he was an engineer and designer from the University of Utah. Ron was this wizard and I tasked him with finding this transitional point, this orifice, and he came up with this crazy geometry—which was really interesting—of these off-center cones that would create a kind of irising effect, so that was the door that would get you from one place to another."

THIS SPREAD:
Concept artwork of the 'maw' version of V'Ger by Tony Smith.

Mead was shown the miniature maw and described it as, "an arrangement of six cams that rotated synchronously, and they created a six-sided maw that would open or close depending on the rotation of these six cams. I thought that was ingenious, but that was all they had so far. It was just an apparatus, but I was fascinated by it, so that started the hexagonal cross-section of the design. Robert Wise gave me a clue about the scale—he said each one of those pie shapes was the size of the island of Manhattan. So that was a start. I had to decide what the whole length of the thing looked like and then how it would generate its power envelope, and that started the rendering series showing the different views as you progressed from the terminus forward to the maw."

A final suggestion from Robert Wise had Mead enhancing the more industrial look of the initial design to something more fitting for what the script described as a "living machine." "I was sitting in a meeting with Robert Wise and Jeffrey Katzenberg and I was going to Holland to work with Philips, and Robert Wise said, 'Mr. Mead, I like what I see very much, but there's one more change I'd like to request.' He said, 'Think of the machine overlaid with an organic texture.' He said he'd like to take a look at that next week. I said, 'Mr. Wise, I'm leaving for Holland next week.' He didn't miss a beat and turned to Jeffrey Katzenberg and said, 'Do we have an office in Amsterdam?' So they had a driver go down from there every day and pick up my sketches and deliver them to Wise. So, I designed half of V'Ger in my hotel room in Holland after I'd worked with Philips during the day designing tape recorders and VCRs and things like that."

Mead's design had to address two important story points: the actual location of the encapsulated 'temple' where the *Voyager* space probe was stored, and the *Enterprise* crew's first real look at V'Ger as the starship emerges from the energy cloud to view the rear of the gigantic alien vessel.

Various earlier concept paintings by Robert Abel's team depicted the temple as the interior of a sphere and, while interior views would not show this explicitly in the final film, the sphere concept largely carried through the final phases of production, and Mead's design for the V'Ger exterior explicitly depicted the temple area as a spherical shape. "That was the big ball at the aft end of the V'Ger entity, and that's where the original *Voyager*, this frail little thing, had been captured, and this alien machine culture was thinking they should return it to its makers, which would be NASA on Earth," Mead says.

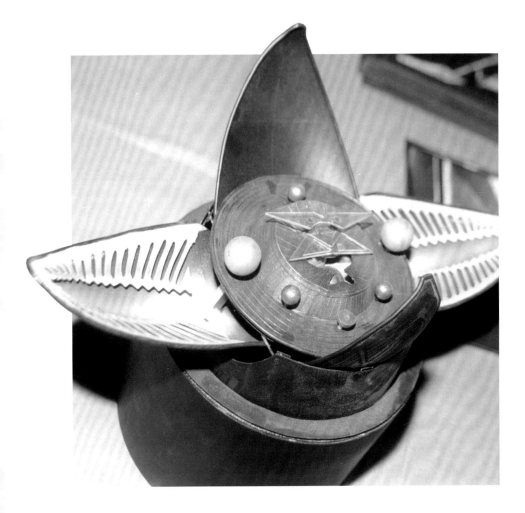

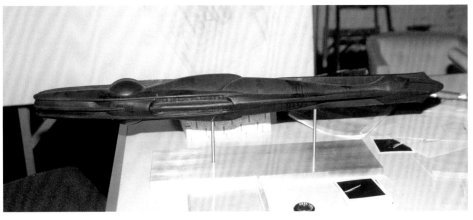

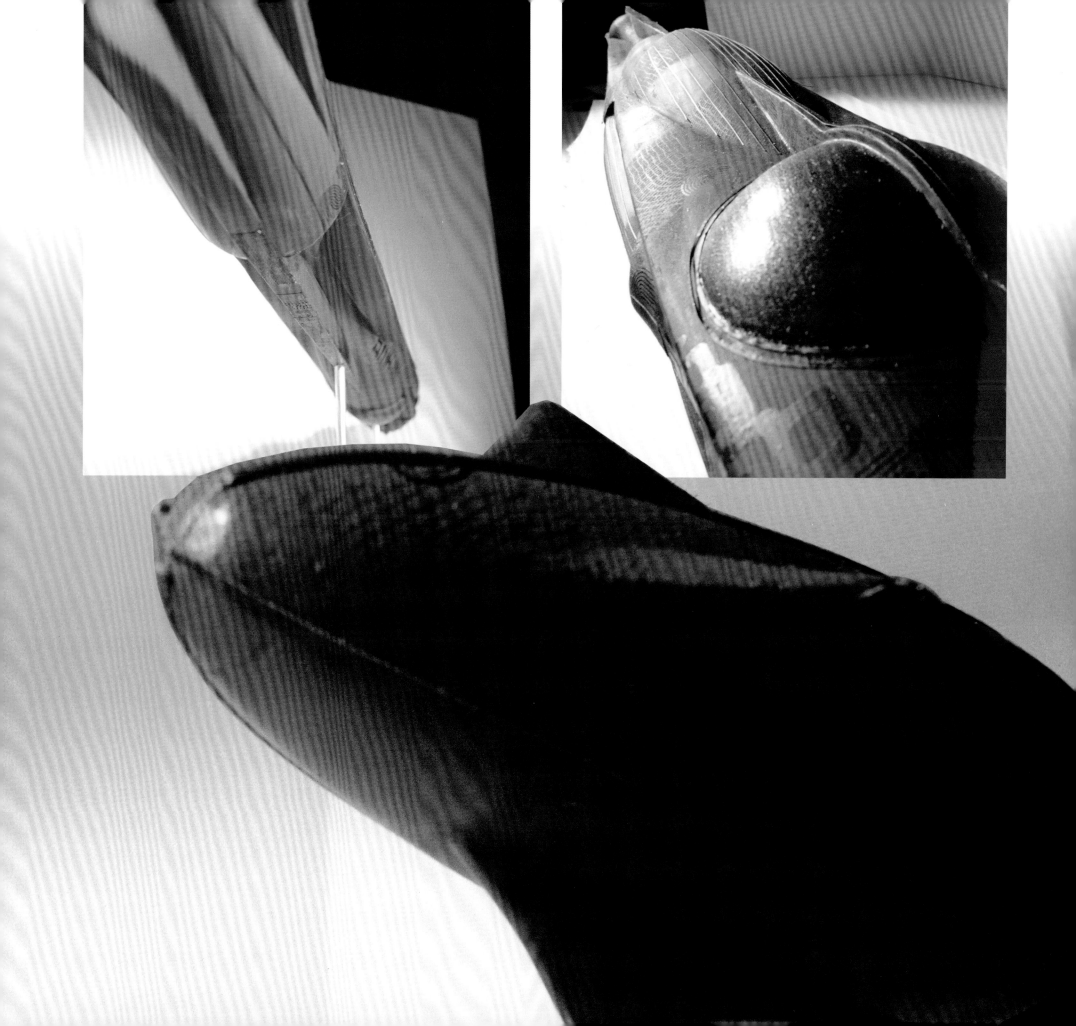

With only the most basic information—a 'maw' at one end, an 'engine' at the other, and some sort of 'heart' somewhere in between—Syd Mead began his first film job with a blank slate. He came up with a roughly cylindrical, segmented shape, using a repeated pattern, which eased the construction process.

The crew's first view of V'Ger is of what Mead calls the object's 'terminus,' a cylinder that flares out into a shape somewhere between a sea urchin and an orchid, with a core of multifaceted, eye-like structures at its center. "The terminus in my mind was, how do you end this thing? I thought how we end it is it comes to a kind of closure of the geometry, and it's a round circle. I wanted the terminus to look like it was looking back at you. It had to look intelligent with all the details, the fenestrations, around the edge."

If merely visualizing V'Ger represented a major challenge, actually building the entity was an even bigger one. V'Ger had to be physically constructed for shots that showed a comparatively tiny *Enterprise* traveling alongside the alien object, apparently across miles of its exterior, then being pulled inside V'Ger's forward maw inside a gargantuan, cathedral-like inner chamber.

"What John [Dykstra] did was to build a 47-foot-long model of just one sixth of the whole thing, which was like one of the six valleys that ran the length of the V'Ger entity," Mead explains. "John had put together a periscope lens that floated over the surface of the 47-ft model, about an inch and a half, to give this immense scale effect in perspective, so they used everything they had in the shop, bits of paper and wire and everything, to give that finished texture."

To add to the exotic look and reflect the surrounding envelope of the massive V'Ger cloud, Apogee projected blue lasers through layers of smoke around the massive V'Ger miniature while the motion-control camera traveled over the model. "Blue is kind of a favorite energy color in science fiction," Mead says. "In my mind, the energy field itself is the propulsion. Those six arms that come out [projected] the energy field that surrounded V'Ger, and it was sort of a protective thing to divert asteroids or things that might attack the entity, but it was an energy field flow, and one of the paintings I did shows the valley of these energy things with this intense field of energy streaming off those six projected points."

ABOVE: The detail of the V'Ger surface would be replicated using etched brass panels.

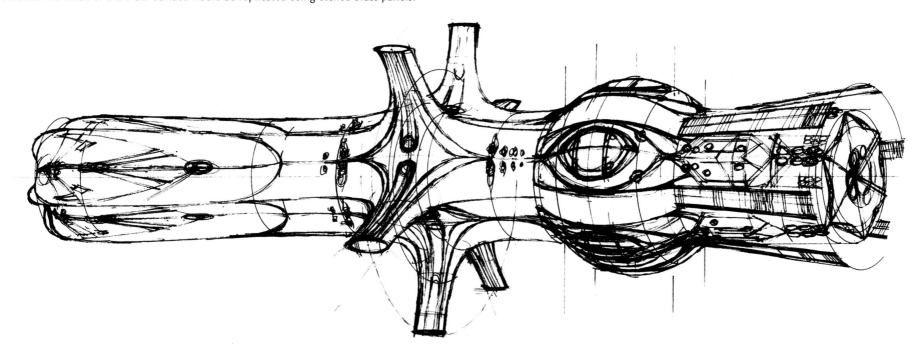

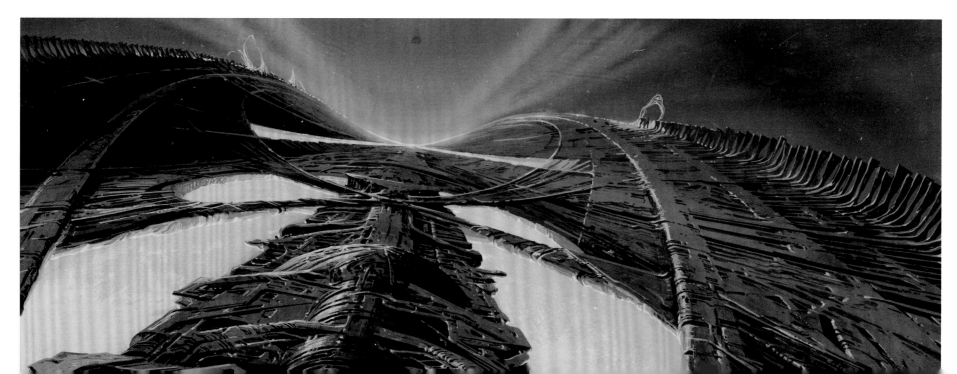

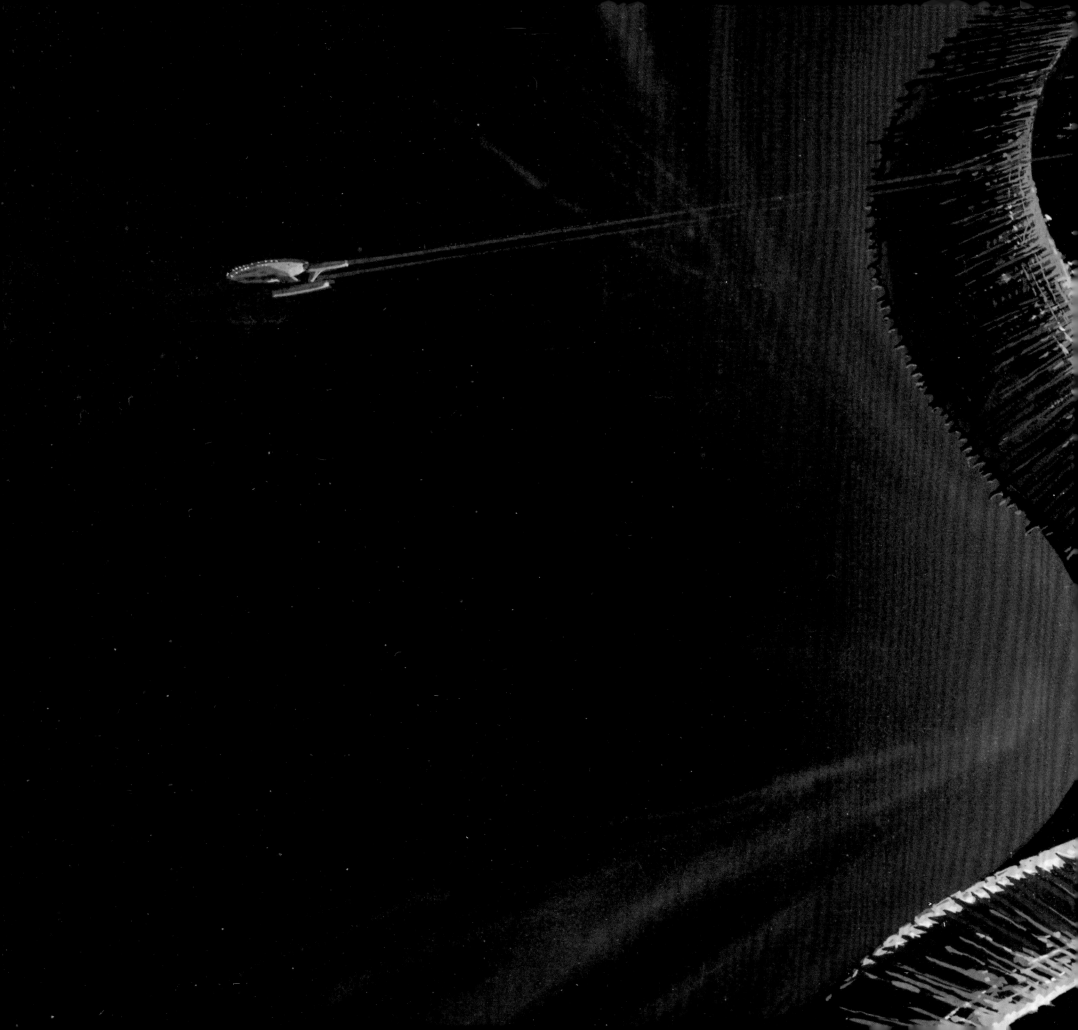

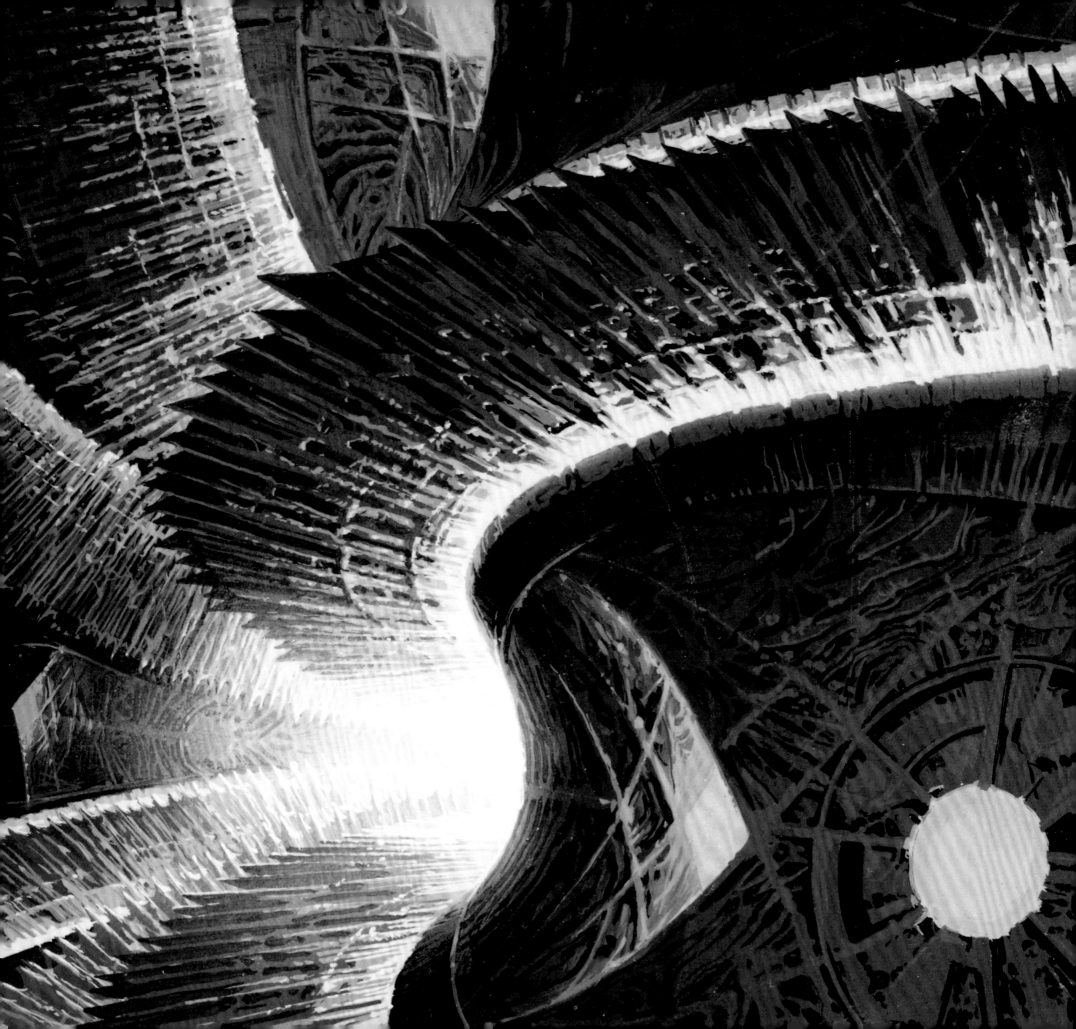

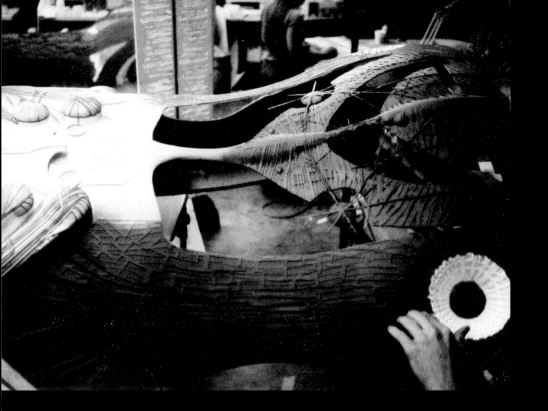

Electrified areas of energy patterns were also projected through translucent areas of the model, and repeated camera passes enhanced those and other illuminated areas on the miniature. "Of course, this was all in postproduction—they'd already shot the movie and Paramount was under the gun," Mead says. "They were on a very tight schedule and you have to hand it to John Dykstra: he chose to do six or seven in-camera passes of the V'Ger model with different cross-lightings and lasers and things. It's very risky because, if you mess up on one pass, you have to start all over. They were working on this twenty-four hours a day. One of the interesting things was this was all film emulsion, not digital. I'd painted a view of the sphere in which the *Voyager* was supposedly sequestered, and I worked a lot to get this evil, acid-gray yellow color. Robert Wise liked that color, and John told me, 'You will not believe what we had to do to achieve that color on film.'"

"All of the features on the vessel itself looked like it had grown in layers like an onion, and the idea was that some of those things had been eroded by its travel through space to produce those things, kind of like Lake Powell," Dykstra says of Apogee's V'Ger model. "There was a mishmash of a bunch of that stuff and then light effects and a lot of smoke. We got lasers when lasers were first around, so we had some big, high-powered lasers that we were experimenting with."

Dykstra says that modelmakers were still working on one end of the V'Ger exterior while the other end was being filmed. "Time was of the essence. They were so constrained by time that one end of the model was being worked on at one end of the stage, a curtain formed a gasket between it and the other end of the stage where the smoke room was, and the other end of the same model was being photographed. It was madness and we ran three eight-hour shifts, so you can imagine the constraints that

placed on the design process and, as a result, Syd and myself were in communication all the time, and then Doug was brought in when we had material that we were ready to review and consult on. It was definitely a collaboration, but for the most part it was Syd's concepts of the ideas that I had generated based on a conceit that Gene Roddenberry had come up with for that story."

A model-making team led by miniature artist Greg Jein helped construct the massive interior chamber that the *Enterprise* is pulled into after it enters V'Ger's maw. Bill George, who would later become one of the key model makers and designers for Industrial Light and Magic, got his first motion picture work helping to build the V'Ger interior. "The interior model was about 6 feet in diameter—it was huge," George says. "I was hired as a production assistant and not a model builder, so during the day I'd be running around picking up supplies but then, at night, Greg would allow me to actually build

THIS SPREAD: Though small in scale (V'Ger's length is measured in miles), the construction of a miniature V'Ger was a large scale, industrial operation. Note the use of computer ribbon wire for conduits and piping.

models and work on them. Greg had built a little mockup, and he broke it down into the structure we were going to build with three or four sections and, because of time, we got rid of one of them that looked like it had surfboards on it. There were Syd Mead paintings we had in the office and I think they were originals, which is crazy but, back in 1979 there wasn't as much ability to scan images. But it was Greg's job to take those paintings, and there might have been a Bob McCall one, and then there was what they were building for the exterior to guide us along."

Achieving the semi-organic look requested by Robert Wise required a radically different approach than the standard method of applying commercial model kit parts from tanks, automobiles, and spacecraft to hard-edged, industrial shapes in order to add detail and create an illusion of scale and futuristic technology. The surface and interior of V'Ger had to suggest a mind-boggling complexity and intelligence, yet also appear to be organic in nature. "We did use model kits, it was just specific ones, and the way they were used is quite different," George says. "A pattern would be made for each of the kind of geometric pieces, so let's say it's like a piece of plywood—that would be covered with clay and then you'd just smash the model kit pieces into that and sculpt it all together, and it's very similar to

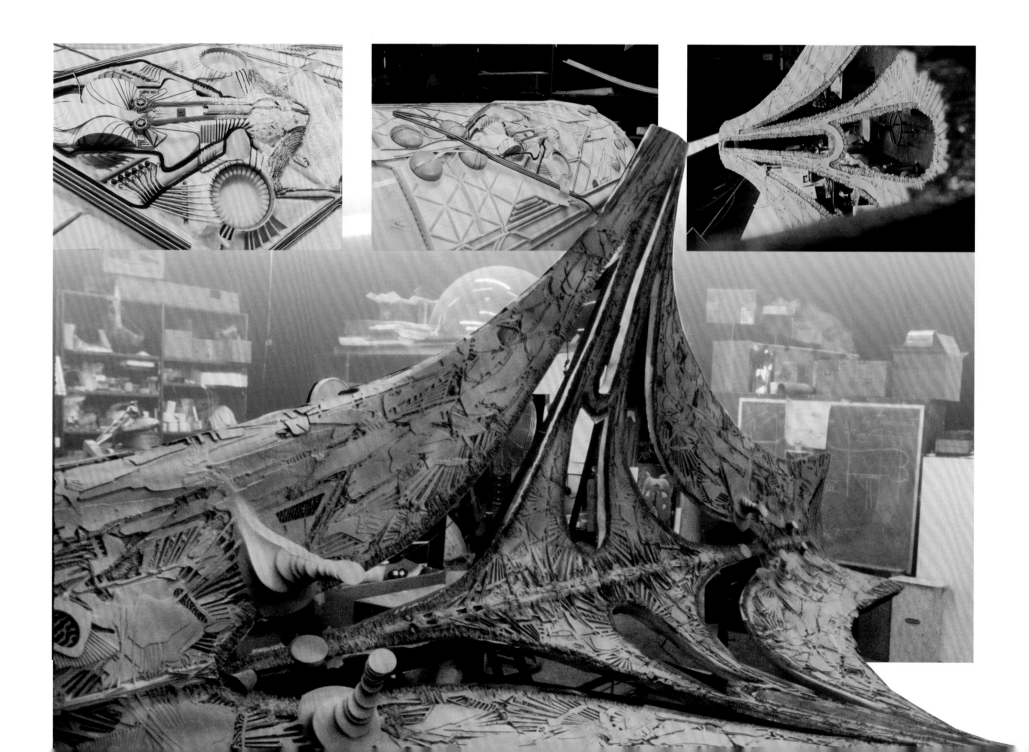

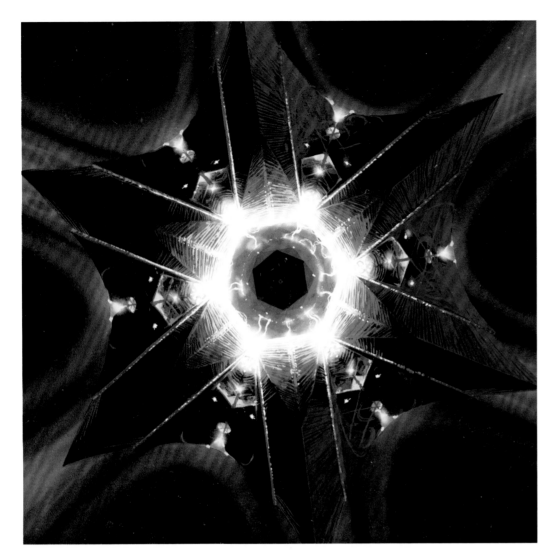

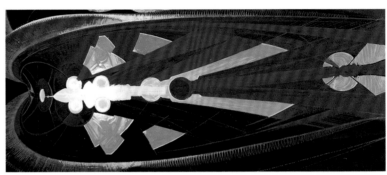

the technique they used in *Alien* to get that biomechanical look. It has some of that hard-edged, mechanical look, but also a very soft look. I think we used the circular Basestar parts from the *Battlestar Galactica* kits and the *Galactica* itself. Greg, who was incredibly creative, found some toy, I think called Ramagon. It was like Tinker Toys, but it was geometric shapes that you could plug together and make your own stuff, and it had a very organic feel to it, and those parts were stuck all over that model." The unusual approach to detailing the V'Ger miniatures didn't come naturally to everyone—model-maker Pat McClung likened the work to "a macramé project."

Trumbull and his EEG crew worked to create the same kind of gargantuan scale for the V'Ger interior shots that they'd created for Spielberg's *Close Encounters of the Third Kind*, which had brought a gigantic, illuminated, alien 'mothership' spacecraft into a realistic Earth environment by filming miniatures in a 'smoke room' to add the kind of softness and diffusion that the atmosphere causes when looking at large objects from a distance. "Trumbull had a lot to do with designing the artwork for when you're moving into V'Ger," Richard Yuricich says of the V'Ger interior photography. "Some of those passes were up to fifty passes, and we had a motion-control system called COMPSYS,

which had stepper motors, and that was Dave Stewart and other guys in the smoke room. Not every pass was done in smoke, just like the [*Close Encounters*] mothership. There must be six or seven [smoke] passes—you'd pump the smoke in at one level, you'd pump it out, and you'd do the matte shot, the light shots, the lens flare shots, the black body matte shot, the white body matte shot—and the methodology suited it. It was easy to just go into what we knew because of the time, and our job was to beat the clock."

"Doug and Richard were very much at the best of their game when they'd have the motion-control shots in a really deep-feeling atmospheric setting," says Rocco Gioffre,

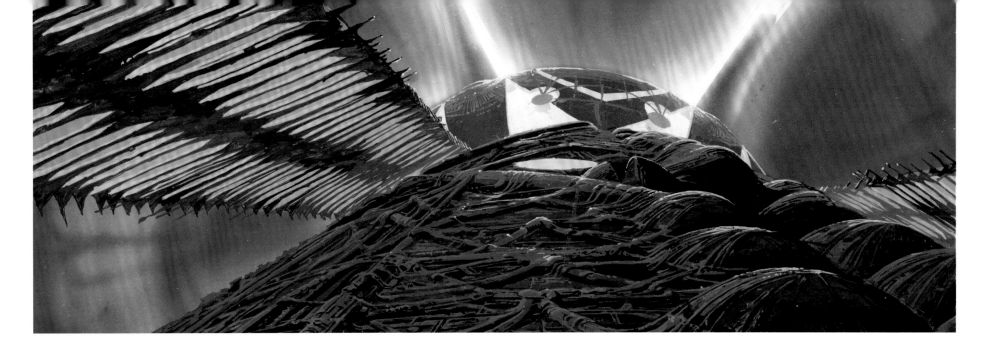

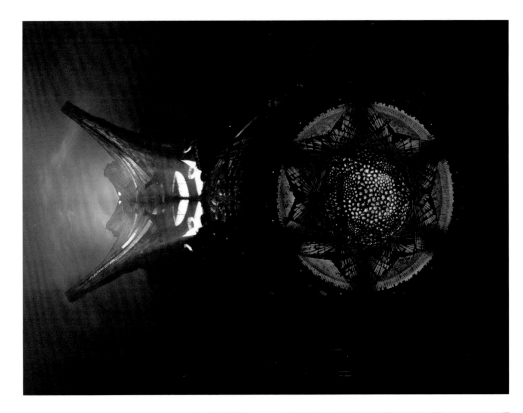

another veteran of *Close Encounters*. "The big moving shape of V'Ger when the ship is so tiny going in there, that was very much David Stewart and Dave Harberger, who was Dave's right-hand man on the motion-control stage."

Trumbull and Dykstra's crew worked around the clock to get enough footage of V'Ger to complete the impression of an awe-inspiring, wholly alien space entity, and Trumbull notes that every shot had to be undertaken with proven methods to avoid having to return to square one. "We were doing the best we could with the time and money we had—it was all about safe bets: that'll work, we can build this, but we can never get all the angles you want and the only thing that can set scale was the *Enterprise* itself and putting that in there against it."

Trumbull had wanted to show V'Ger in its entirety late in the film, and artists including Robert McCall, Andrew Probert, and Syd Mead produced concept images showing Mead's design in context with Earth, the space drydock and office complex, and other objects. "Doug Trumbull had me do a painting showing the V'Ger entity casting a shadow on the moon to show how big it was," Mead says. "He still has that somewhere. But this thing was going to throw a shadow across the whole face of the moon."

Despite the production challenges on the original film, Syd Mead, who would go on to work on science-fiction films like *Blade Runner*, *Aliens*, and *2010*, appreciated the finished film for its serious science-fiction and philosophical concepts. "It became almost mystical because of Ilia and the little red glowing thing on her throat, and the idea that we have to get rid of the carbon units because they're polluting the planet. There's a whole thread that underlies computer technology with human proximity, that the computers go into a loop and you've got to destroy the logic of the loop to the computer, otherwise it'll continue to loop until it destroys itself or possibly you, so they have to invent a rationale that sort of circumvented morality, but still essentially that's what it was. It was a very fascinating dip of my big toe into the movie industry, and to start my movie career working with Robert Wise, one of the grand gentlemen of Hollywood. What a great chance to be involved."

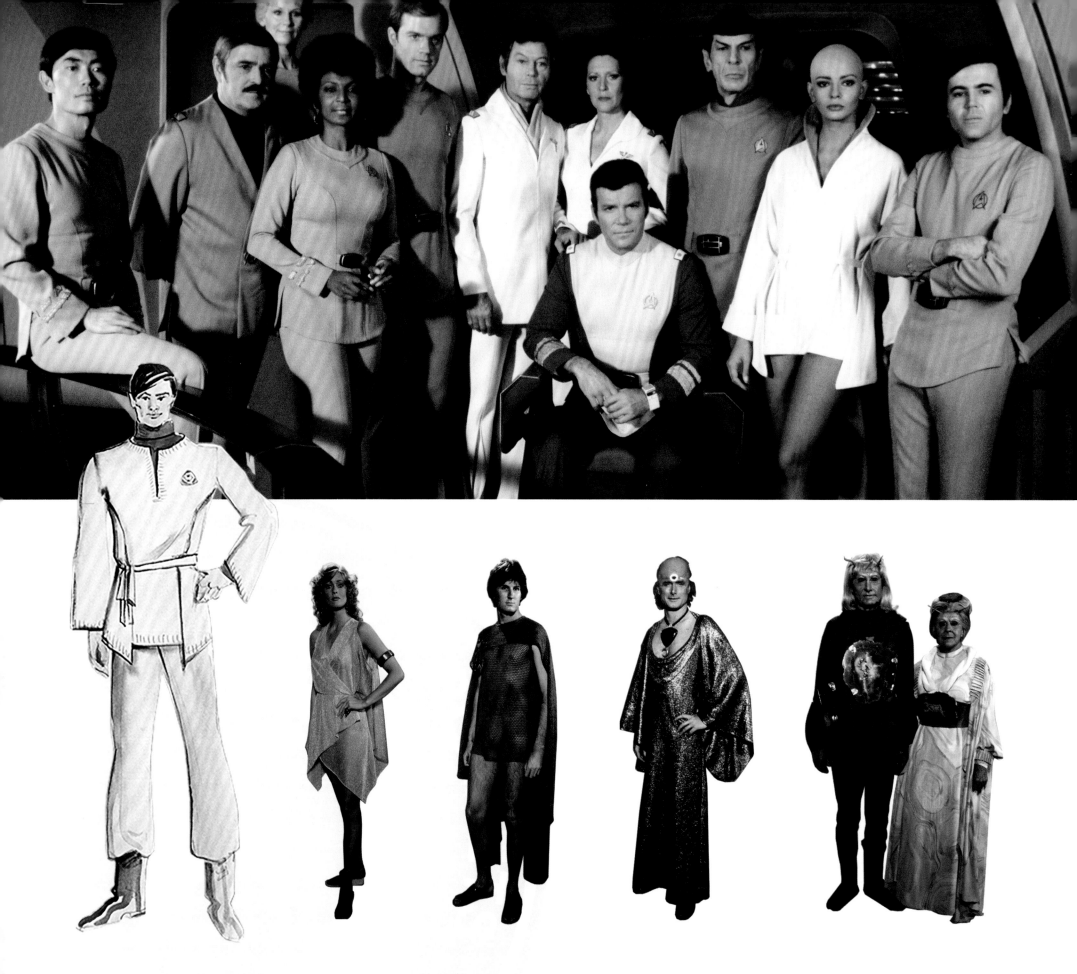

OPPOSITE: (TOP) The subdued hues were specifically requested by Robert Wise and Gene Roddenberry, as they both felt the primary colors of The Original Series' costumes would be too garish for the big screen. Each of the main characters had multiple different costumes throughout the film; (BOTTOM LEFT) Robert Fletcher initially proposed that the crew wear color-coded turtlenecks under their duty tunics to differentiate the different departments. This concept was dropped in favor of having different colored insignia. But the color-coded turtlenecks would return when the Starfleet uniforms were completely redesigned for *Star Trek: The Wrath of Khan.* (BOTTOM RIGHT) The civilian costumes were specifically designed to reflect Roddenberry's personal belief that, in the future, nakedness would not be as frowned upon.

RIGHT: Robert Wise reviews an array of aliens

BELOW: (LEFT) Due to the large number of aliens needed for the Starfleet HQ and rec deck scenes, many of the aliens were fashioned using slip-on rubber masks; (MIDDLE) In the days before personal cellphones, use of a stage telephone for personal calls was frowned upon—regardless of one's planet of origin; (RIGHT) Robert Wise reviews costumes on the bridge set.

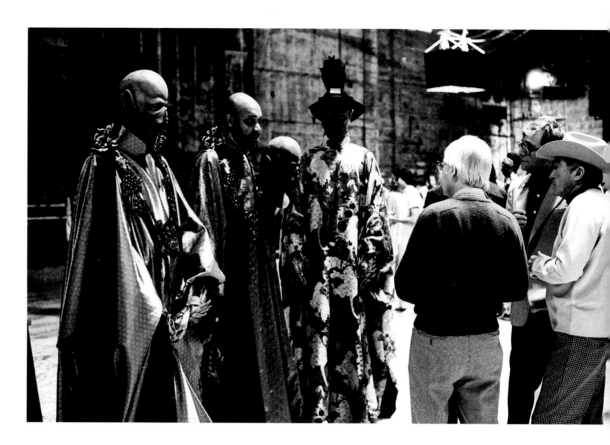

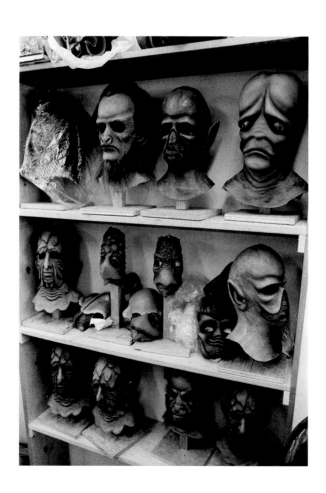

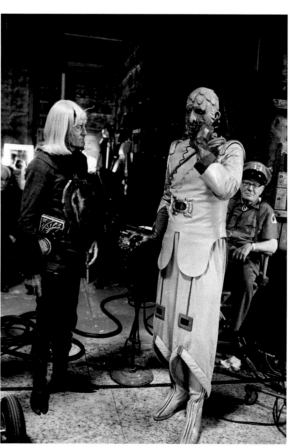

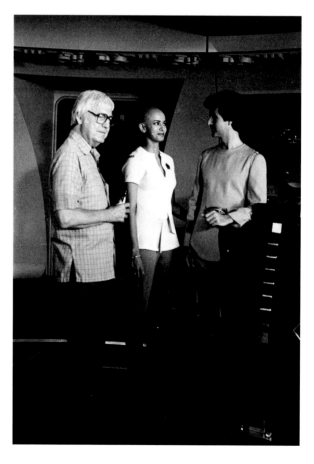

INSIDE V'GER

THE SCRAPPED MEMORY WALL SEQUENCE

AND SPOCK'S SPACE WALK

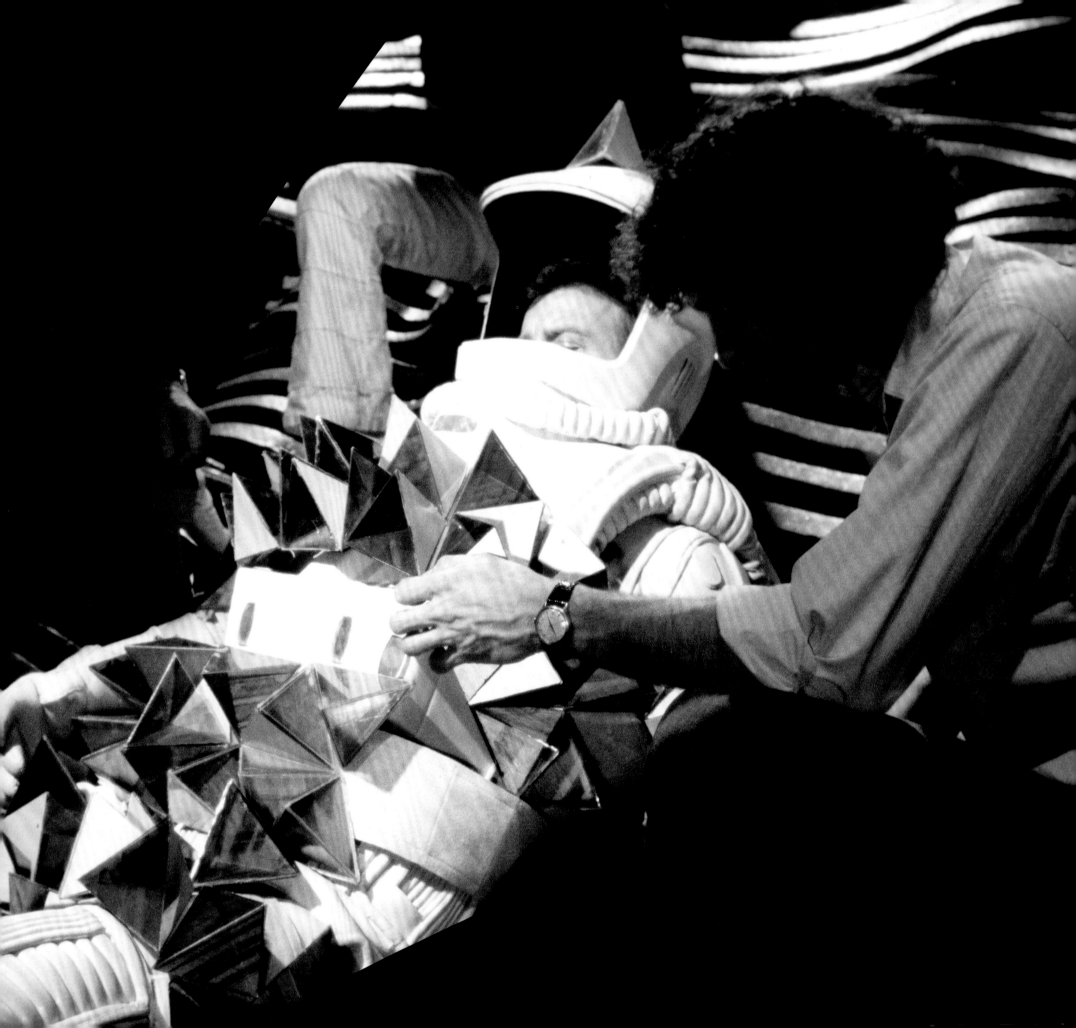

INSIDE V'GER

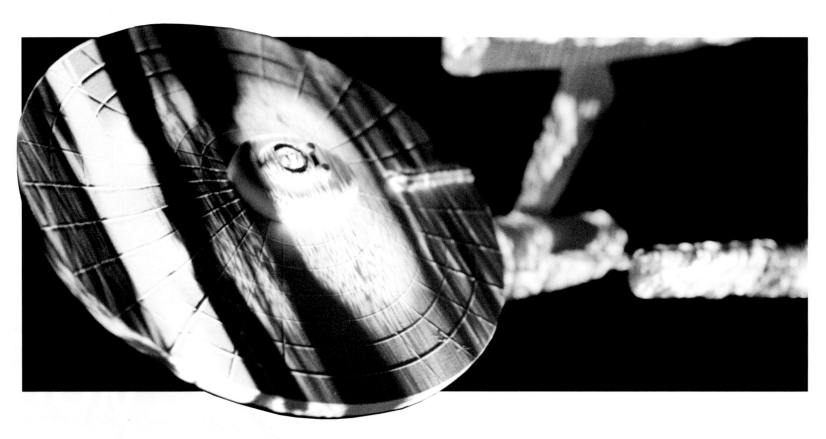

ABOVE: Study model of the *Enterprise* (using a commercial model kit) with a projected moire pattern, depicting V'Ger's scan of the ship.

OPPOSITE: Early ASTRA concept. Once inside V'Ger, the layout would become more organized as we reach the heart of the machine.

Robert Wise's dictate of putting the film's gigantic elements in relationship to the human figure carried over into a potentially spectacular, but ultimately abandoned sequence in which Kirk and Spock don spacesuits and journey inside V'Ger themselves. This hearkened back to the Kirk/Spock action dynamic of The Original Series, in which the *Enterprise* captain and his first officer often boldly went into situations on planets and other locations themselves, risking their lives sans security guards or other support personnel in order to further the starship's mission to seek out new life and new civilizations.

From the beginning, the memory wall sequence was an expensive gamble that relied almost entirely on physical effects, with William Shatner, Leonard Nimoy, and, at times, stunt performers doubling them floating on wires along an immense canyon of pulsating, grilled light fixtures representing the interior of V'Ger. The sequence involved an action scene with crystal-like 'antibodies' attacking Kirk, and Spock driving the entities off with his phaser, as well as the discovery of a grape-sized data device that would tie into the glowing pink sensor/recorder located on the neck of the Ilia probe.

Robert Abel's crew, including Richard Taylor and Andrew Probert, executed numerous designs for spacesuits with their own built-in maneuvering thrusters and futuristic helmets. Although some design elements from the ASTRA spacesuit artwork were used, the sequence's spacesuits were ultimately executed by Robert Fletcher and his costume team, with boxy space helmets not tremendously advanced beyond the simple mesh helmets seen in original *Star Trek* episodes like 'The Tholian Web.' *2001: A Space Odyssey* had demonstrated that zero-gravity effects could be achieved very convincingly by constructing sets upside down or on their sides, or otherwise shooting to obscure physical wires supporting the actors. The Oscar-winning *Marooned*, about an Apollo orbital space mission that goes awry, had likewise showed the limitations of blue-screen shooting of such sequences.

THIS SPREAD: Various concepts and storyboards depicting the *Enterprise*'s voyage through V'Ger.

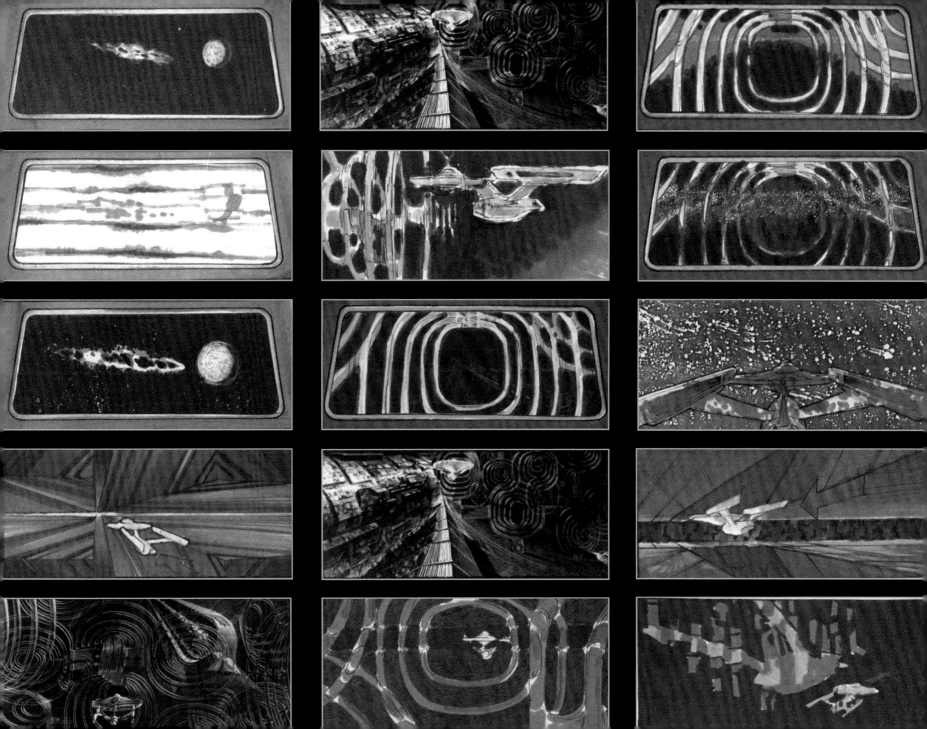

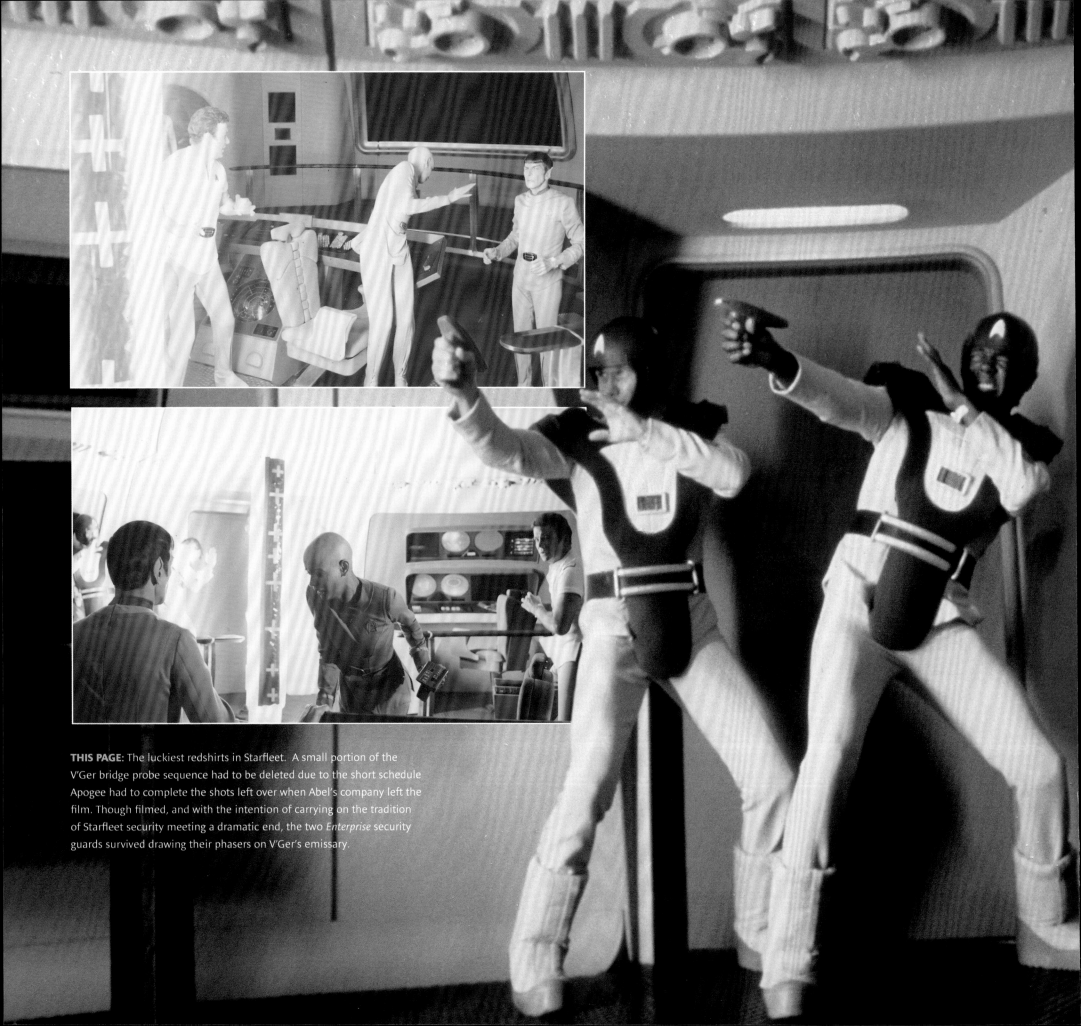

THIS PAGE: The luckiest redshirts in Starfleet. A small portion of the V'Ger bridge probe sequence had to be deleted due to the short schedule Apogee had to complete the shots left over when Abel's company left the film. Though filmed, and with the intention of carrying on the tradition of Starfleet security meeting a dramatic end, the two *Enterprise* security guards survived drawing their phasers on V'Ger's emissary.

THIS PAGE: In order to create the massive amount of interactive light the V'Ger bridge probe gives off, a large light assembly, using aircraft landing lights and supervised by Stuart Ziff, was constructed and filmed on the bridge set. To be superimposed over the top of the strobe assembly would be an animated manifestation of V'Ger's energy.

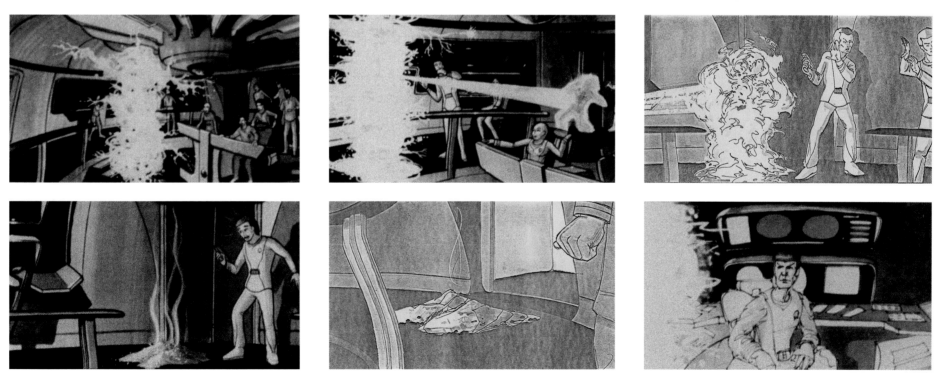

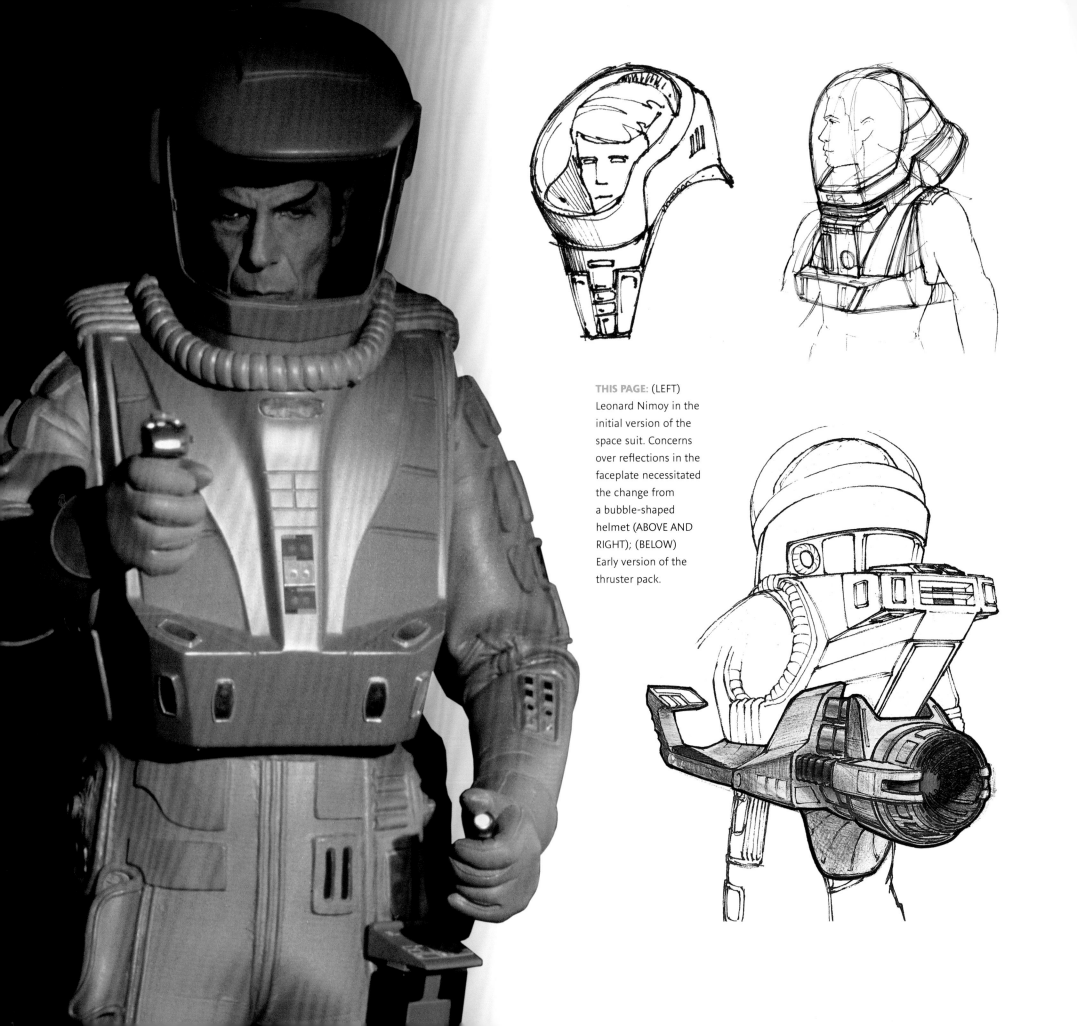

THIS PAGE: (LEFT) Leonard Nimoy in the initial version of the space suit. Concerns over reflections in the faceplate necessitated the change from a bubble-shaped helmet (ABOVE AND RIGHT); (BELOW) Early version of the thruster pack.

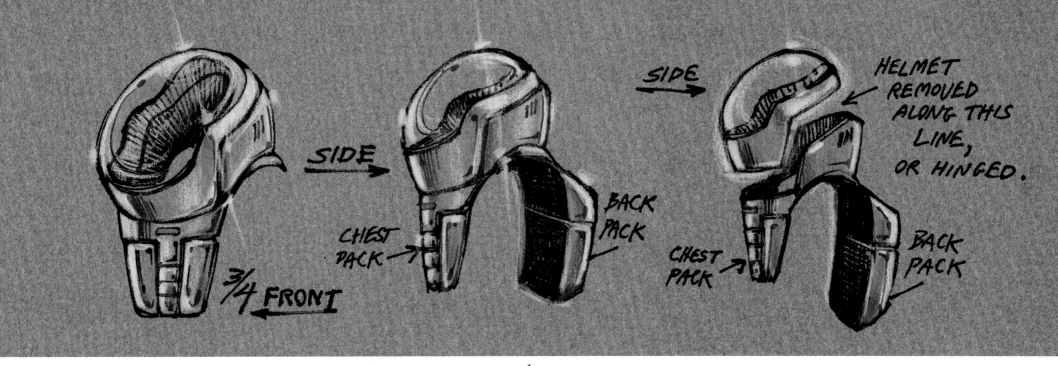

The construction of the canyon-like V'Ger memory wall set was a traditional, vertical façade in which actors would be hung from wires dangling straight down, and even while cinematographer Richard Kline's photography obscured the wires themselves, the limited trajectory and movement of the actors quickly gave the game away.

Andrew Probert had worked on some design elements for the spacesuits that prevented them from looking even more retro. "Originally, Bob Fletcher wanted to use something that looked like water bottles that you'd use in a water dispenser for air tanks," Probert says. Probert also wanted to get away from the boxy helmet design. "I thought, 'Star Trek's 300 years in the future and, if you go back 300 years, NASA had bubble helmets, let's use bubble helmets.' They said, 'No no, that will reflect the studio lighting.' I said, 'Why don't you use masks on the studio lighting that are the same shape as the V'Ger memory crystals, so it will look like it's reflecting V'Ger memory crystals?' So they came up with a helmet that was faceted and they did shoot that in those V'Ger memory wall floating scenes."

Richard Taylor had been convinced from the beginning that ASTRA should not have been as involved in on-set effects, but the integration of interactive lighting in sequences like the V'Ger 'light probe' on the Enterprise bridge often made the presence of visual effects supervisors necessary. The memory wall sequence, however, seemed cursed from the beginning. "I was there for the first filming and doing tests, and the logistics of it and the people who were doing the logistics, they were just not good at it," Taylor says. "They were having problems with everything. I knew it was going to be incredibly problematic shooting it, and it really started with them hanging on wires. I believed they should have been shot against blue screen on armatures and matted in against this wall, and you only build the part of the wall they physically touched, so you didn't have to build

ABOVE: Spacesuit concept art by Brick Price.

ABOVE: The suiting up process was long and involved, and was not that comfortable for the actors, so the helmets would be left off until the last possible moment. For some takes, the glass faceplate was left off.

this whole huge thing. We got drawn into this, and I think it was a big mistake for us to go down this road. The design for all this was all part of the design we were doing for V'Ger and the surfaces inside."

As dissatisfaction with the memory wall sequence shoot reached its height, Abel and his crew bore some of the brunt of the blame for the ill-conceived sequence, and it became one of the reasons for Abel's eventual dismissal. In 2001, Harold Michelson recalled the massive set as being primarily dictated by the visual effects team. "They had designed a set because Spock was supposed to leave his ship and float out in space and get on this V'Ger thing."

The set was built to convey the interactivity that had been part of Richard Taylor and Abel's concepts for V'Ger organically reacting to the *Enterprise* and Kirk and Spock. "They built this whole damn thing and then they hung Spock out there on wires, and it didn't work because you couldn't move the camera. So they canceled the whole thing, and...the special effects people had the stage, and they spent a fortune on this damn thing, and it died."

"They built this whole damn thing and then they hung Spock out there on wires, and it didn't work because you couldn't move the camera. So they canceled the whole thing."

Harold Michelson *Production designer*

THIS PAGE: (BELOW) Spacesuit concept by Ed Verreaux featured a decidedly alien crew member. (BOTTOM RIGHT) Andy Probert modeling the latest in Starfleet spacesuit fashion. The small faceted oval shapes represent small thrusters for maneuvering.

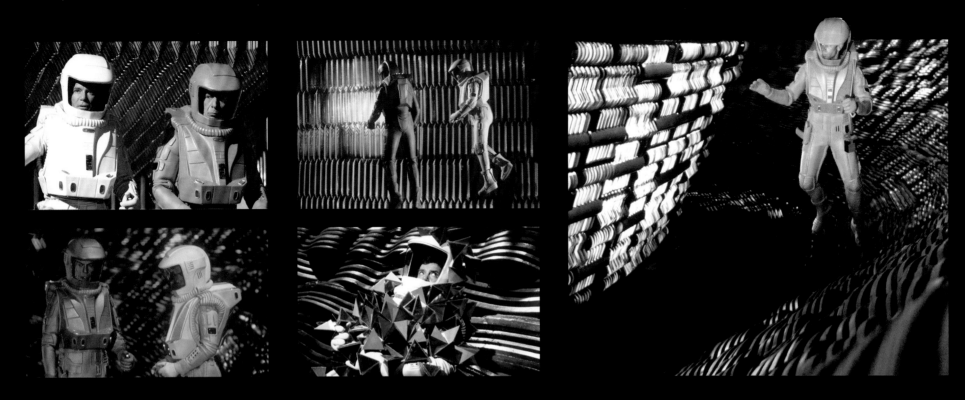

THIS PAGE: The memory wall was originally to be a literal representation of V'Ger's memory system. As Kirk and Spock investigate, V'Ger releases a defense mechanism to deal with the intruders, which attack Kirk and attach themselves to his suit. Spock rescues Kirk by shooting one of them with his phaser. This sequence was only partially filmed towards the end of the shooting schedule. No one was fully satisfied with the results and it was ultimately scrapped.

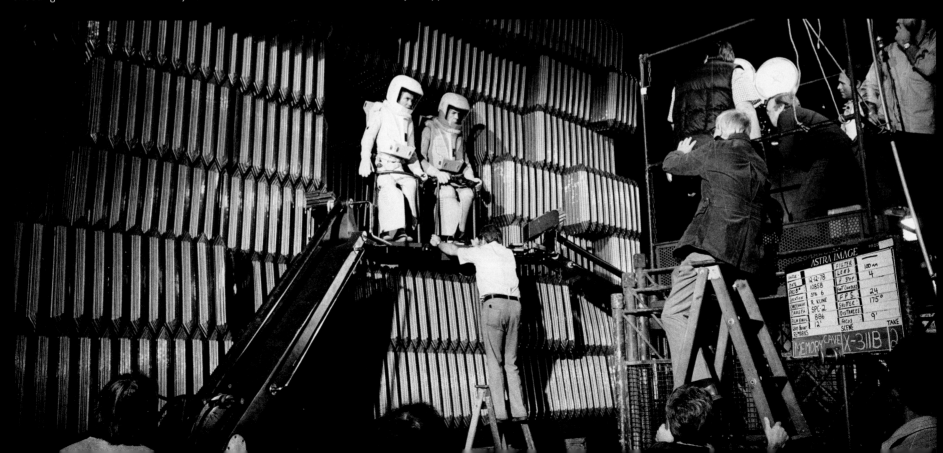

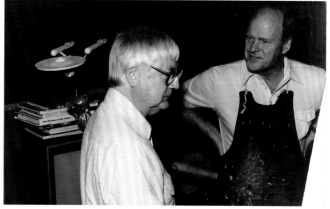

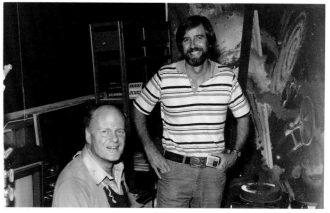

The sequence became, in turn, one of Douglas Trumbull's primary challenges once he came onboard to supervise visual effects in Abel's stead. The obligatory 'we'll fix it in post' attitude common today, when wire removal and digital set extensions are common, was out of the question in 1979. "My first obligation to the movie was to go to Bob Wise and say, 'Bob, this whole sequence has got to go, I cannot fix it,'" Douglas Trumbull says today. "There's no way to enhance it or fix it in post—just dump it and let me start over.' And Bob gave me *carte blanche* to re-envision the whole sequence."

Trumbull came up with the 'Spock walk,' a far more kinetic and immersive sequence that would put the audience in Spock's space boots as he floats outside the *Enterprise* in a rocket pack and launches himself deep inside V'Ger, where he experiences a surrealist light show that would be the modern equivalent of the 'stargate' sequence that Trumbull and Con Pederson had worked on in Kubrick's *2001: A Space Odyssey*.

To conceptualize the sequence, Trumbull reached out to one of the artists behind *2001*'s successful theatrical poster campaign: space artist Robert McCall. McCall had created the famous poster art image of the *Space Clipper* shuttle rocketing away from the double-wheeled Space Station V. Ironically, McCall had been approached early on in *Star Trek*'s development, twice in fact—initially to provide concept artwork and then later to work on poster concepts. Prior commitments to several

THIS PAGE: Robert McCall conversing with Douglas Trumbull (ABOVE LEFT), director Robert Wise (TOP RIGHT), illustrator Tom Cranham (ABOVE RIGHT), and model painter Ron Gress (BELOW).

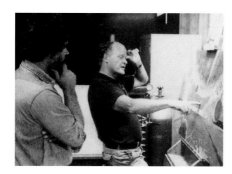

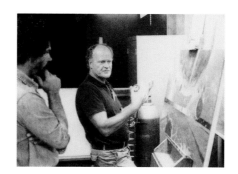

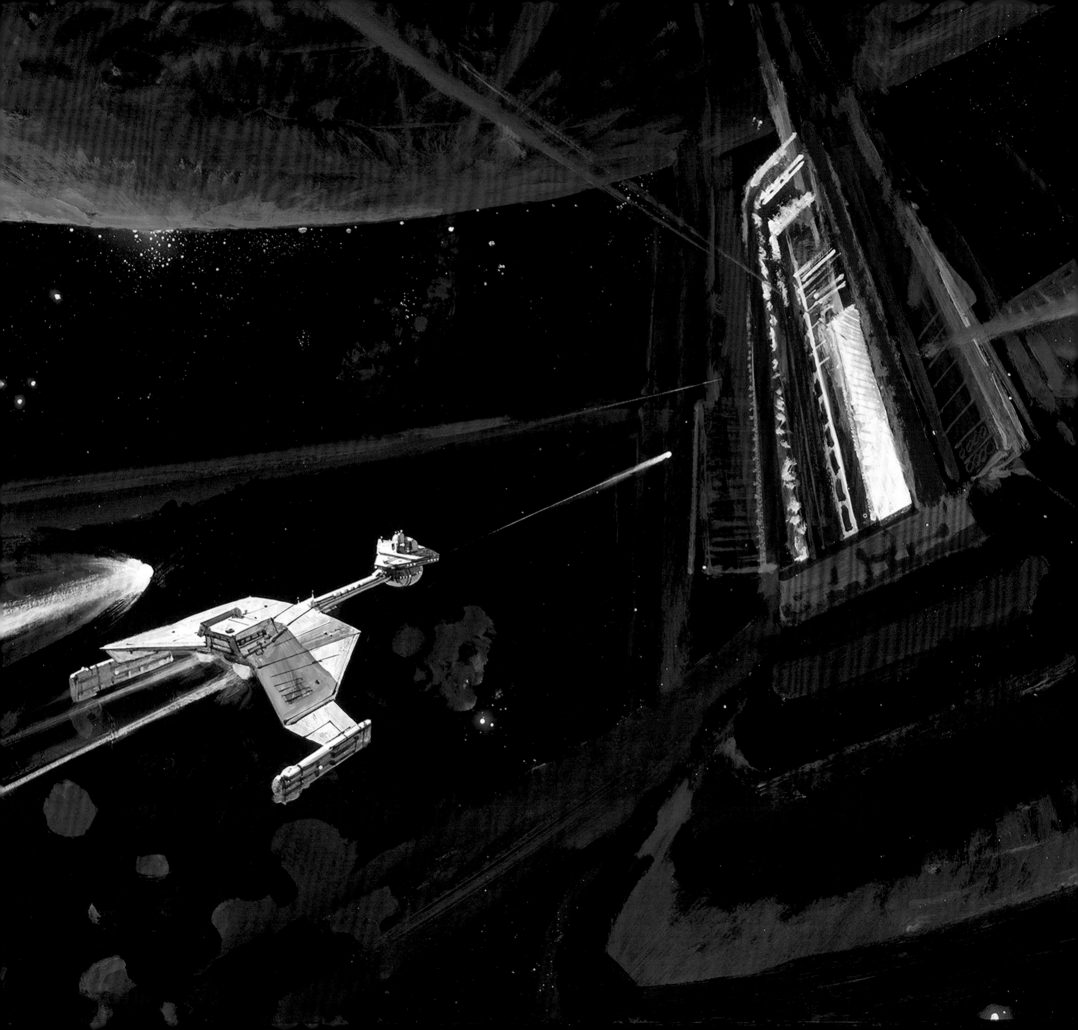

THIS SPREAD: Robert McCall's concept art. There was some discussion about bringing back the Klingons that V'Ger had 'digitized' at the beginning of the film. Ultimately, with the schedule that they had, the idea was quickly dropped.

mural projects prevented him from joining the *Star Trek* crew then but, by the summer of 1979, his schedule had freed up enough to have a meeting with Doug Trumbull.

"I said we had to really think big and go way outside the box and do this fantasy, almost dream sequence of violating all the rules of time and space," Trumbull recalls. "That was what that was about, which was that the whole universe can coexist in different dimensions, and Spock's gotta fly through it. It's a nonverbal trip sequence, so part of the process from my point of view was how to do it quick and cheap."

Trumbull says that McCall's signature style, a mix of hard-edged space technology and abstract, surreal imagery, lent itself perfectly to the look of the sequence. "I would talk to Bob and say 'I want something that's very abstract and symbolic and impressionistic in a way that doesn't make any sense,' and if you look at Bob's work, you would see a lot of that. He's got these huge paintings where there's a billion planets floating in atmospheres and clouds and intergalactic dust storms—a very religious, spiritual sort of thing, and I wanted to get that in this. I just told him to break all the rules—'I don't care about time, dimension, anything.' So I went down to his place in Paradise Valley, Arizona and just sat and did a lot of sketches and drawings. He was really pivotal to envisioning that sequence."

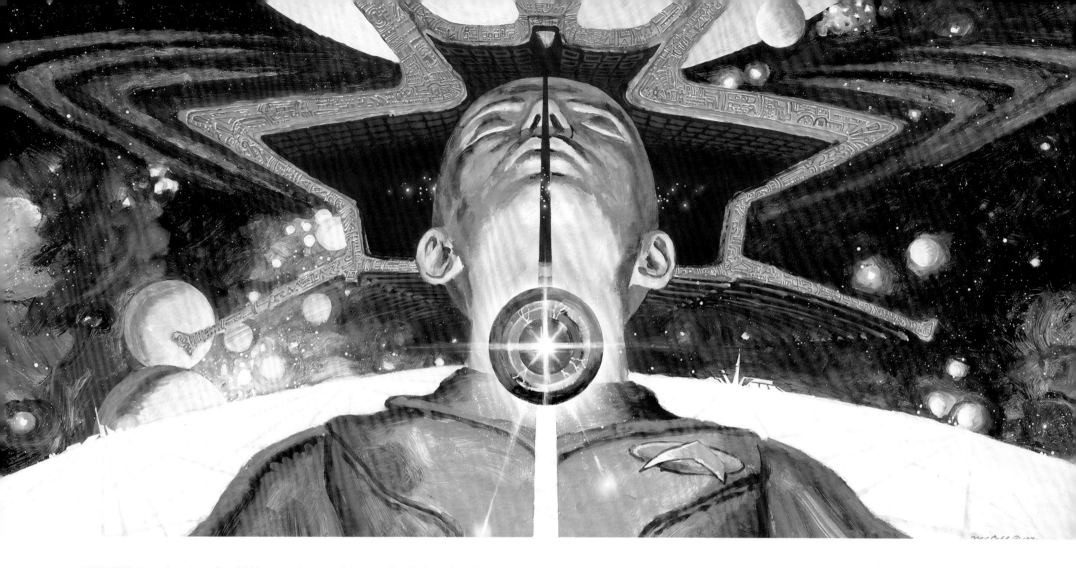

THIS SPREAD: Robert McCall's vivid imagination was firing on all cylinders, though many were left scratching their heads as to how it would all be realized on film.

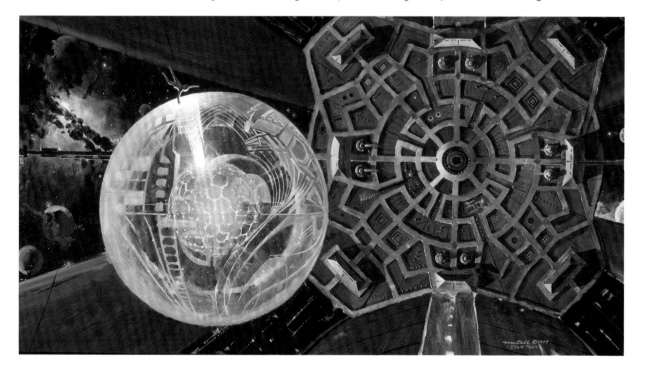

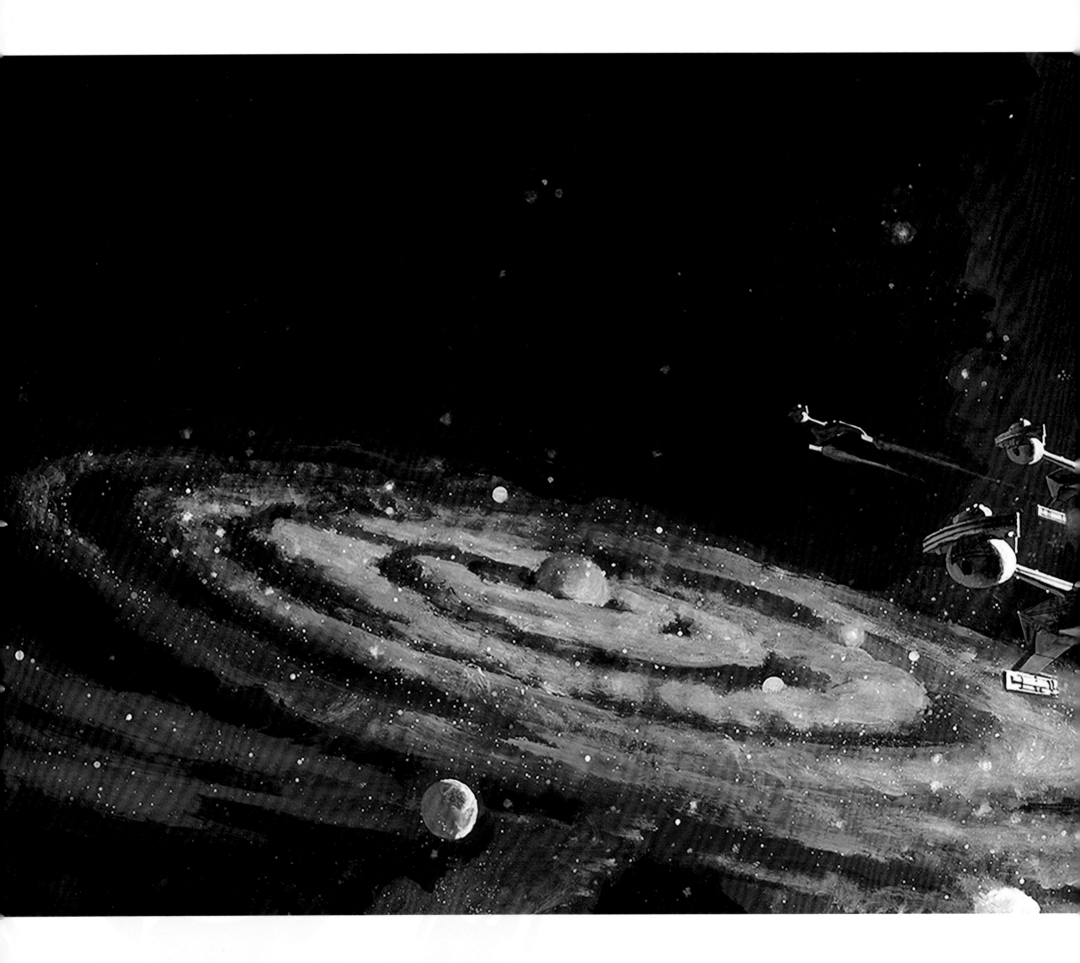

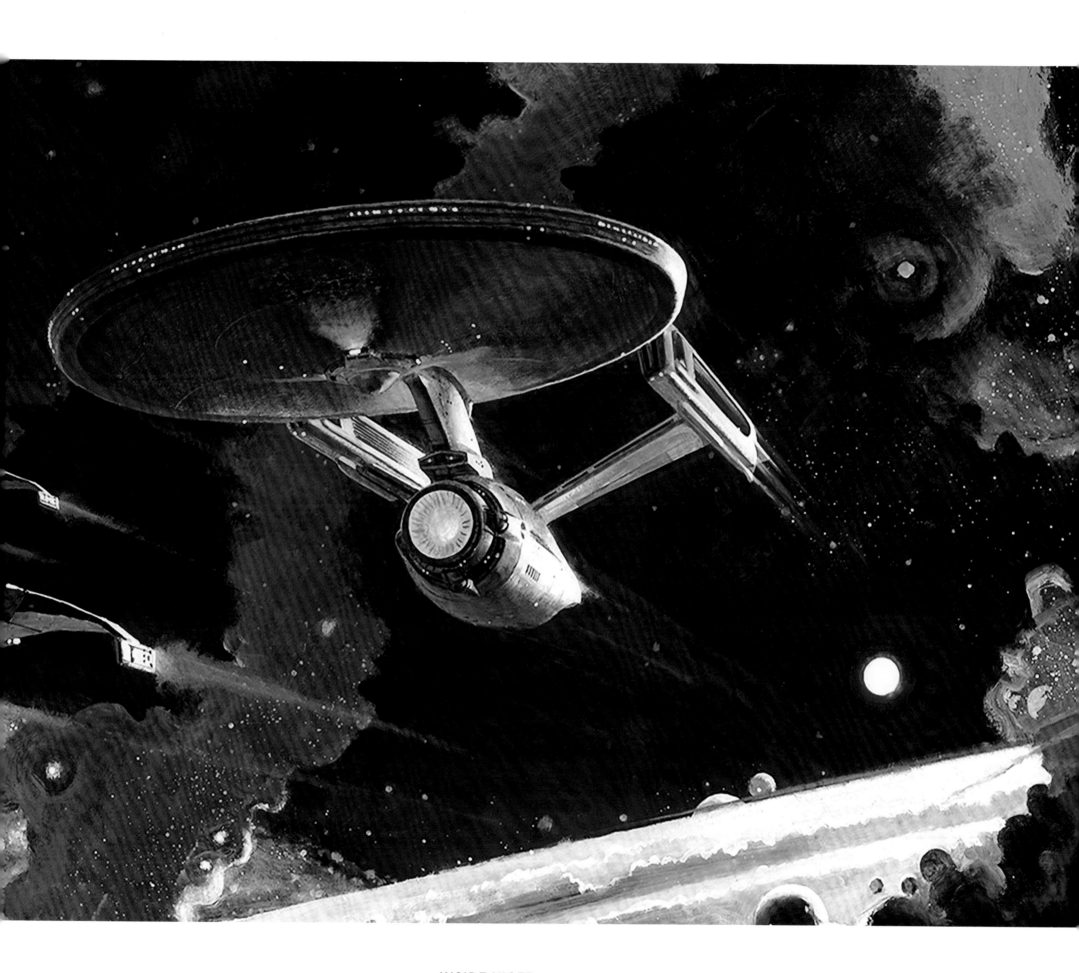

BELOW: This McCall painting (and subsequent model seen on p138) was dubbed 'space lips' by the crew.

OPPOSITE: The reshooting of the Spock walk brought about a change in spacesuits. Doug Trumbull conceived of a way to utilize the original concept for the bubble helmet, and Apogee built the new hard shell components used by both Leonard Nimoy and his stuntman.

McCall would set up a small studio inside of Trumbull's effects facility in Marina del Rey, where he generated a series of large paintings in his signature style, showing images of moons, planets, and abstract shapes like the looming 'space lips' seen in the final sequence. "I'm not being immodest when I say these are kind of powerful images," McCall said in 2001. "I kept thinking, 'they're going to pick up some of these images and design them into posters,' but it never happened. That was a little disappointing, but what I was really doing was creating other worlds and especially other universes that could be part of that trip that Spock takes when he leaves the *Enterprise* and goes out with this power pack on his back. He approaches several of these maws or doorways to other worlds, other universes. My concentration in many of my paintings really had to do with that kind of thing. I had the

script and I had read it and I knew that Spock is going to go out. I just provided them with a profusion of ideas. They were fully painted and very spontaneous; I would spend maybe just two days on some of them. I was kind of amazed at how successful, color-wise and aesthetically, they were."

"One of the weirdest paintings was of these big lips, because there was the sub-story of Ilia, and we had to actually build that and photograph that and fly through it," Trumbull says. "But I also had to take what he was thinking of and sketch and paint and turn them into physical objects and photograph that, and it was kind of a combination of slit-scan stuff and multiple-exposure stuff. There was this tunnel thing with this sparky, electrical discharge tunnel, and that was just one model photographed fifty, sixty times, over and over. It was just trying to figure out something, and...

shoot it quickly and cheaply and be able to pull off a contrast map and comp it together. That sequence is filled with those kind of things— how could you do as much as you could for as little time as possible. Money wasn't such a big problem, it was time, so I had to figure out what I could do that would work the first time and wouldn't be risky, because that could lose us time. How to take a bunch of stars and do multiple passes, do streaks on stars and all that stuff."

McCall also created large-scale paintings of the *Enterprise* moving through the cosmos that could be used as promotional or poster art for the film, and even painted images of the Klingon ships from the film's opening, now shown as entities forever trapped or projected as part of V'Ger's data files, the three ships floating against the surrealist, cosmic backdrop of V'Ger's mind.

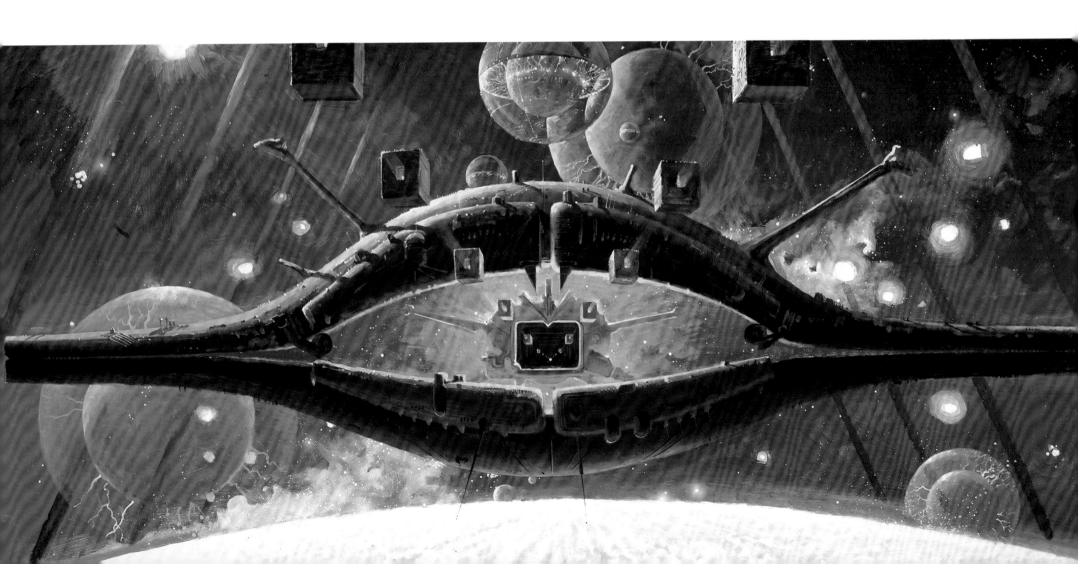

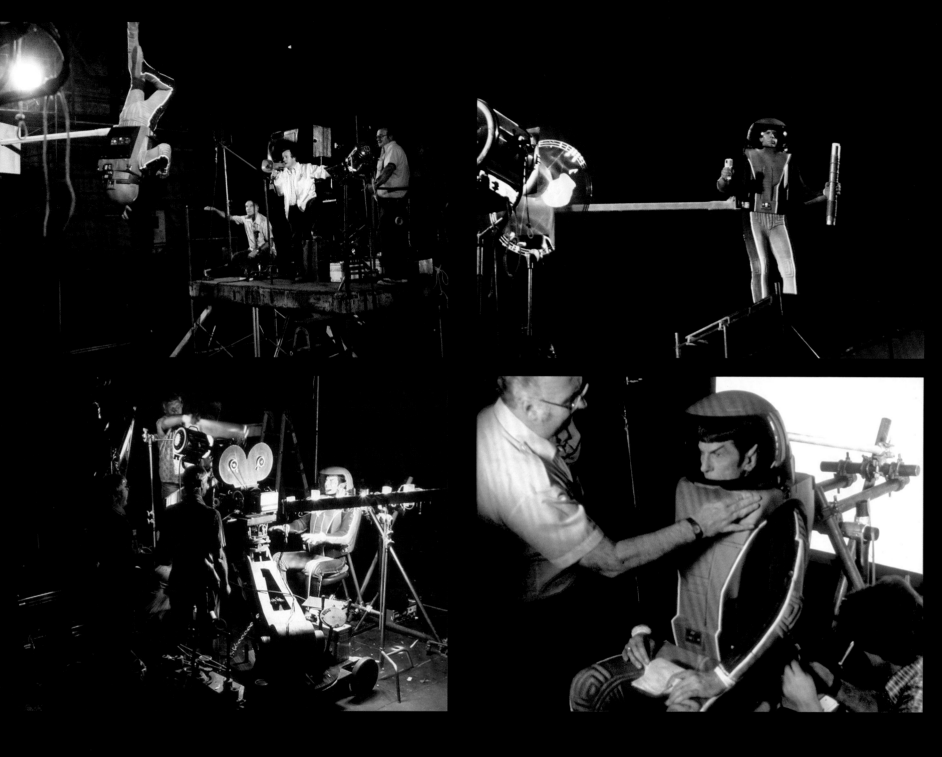

While Leonard Nimoy would don a newly-designed spacesuit built by Dykstra's Apogee with an influence from the red Dave Bowman spacesuit from *2001*, Spock would also be recreated in miniature for the spacewalk sequence, allowing for more dynamic movement and scale as the *Enterprise* science officer is shown rocketing away from the starship and through various regions of V'Ger. (The miniature would also double as Kirk and an unidentified Starfleet crewman that cannot outrun V'Ger's digitizing wave when it attacks Epsilon IX.)

Andrew Probert worked on the revised spacesuit design. "I had lighting built into the chest piece to illuminate what was in front of whoever was wearing the suits, and I incorporated the same kind of reaction-control system into the chest piece so they could maneuver," Probert

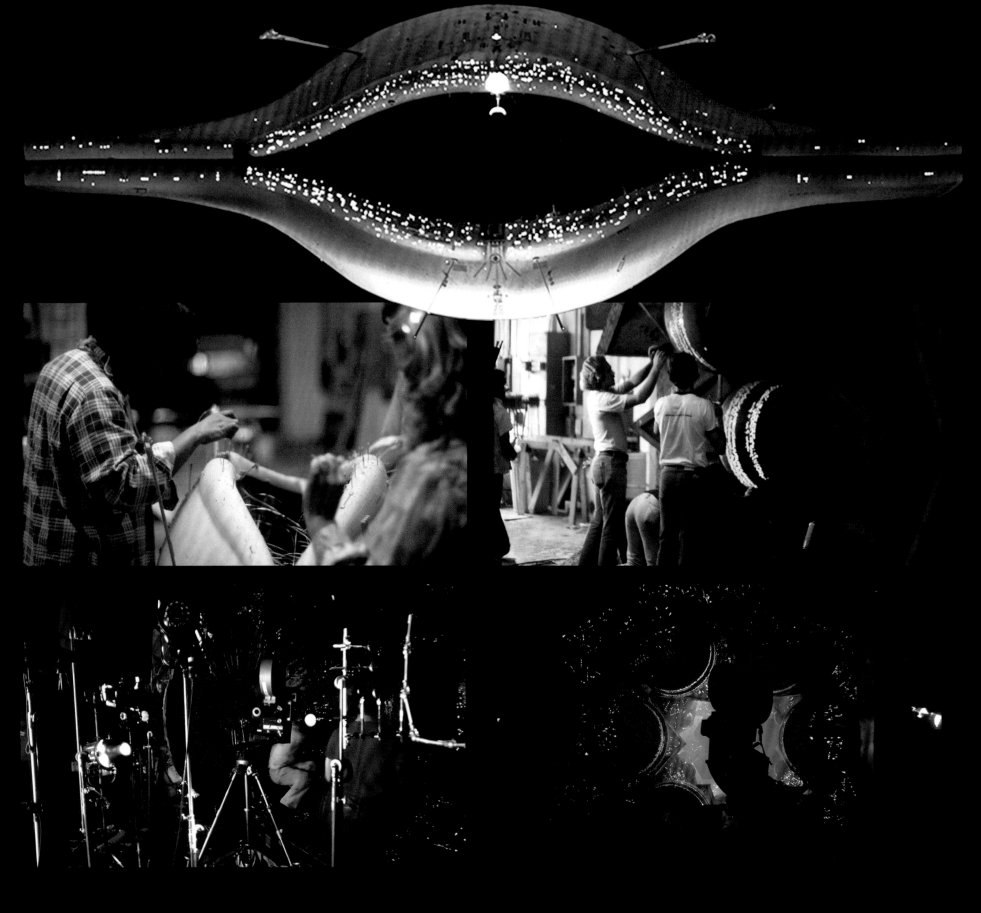

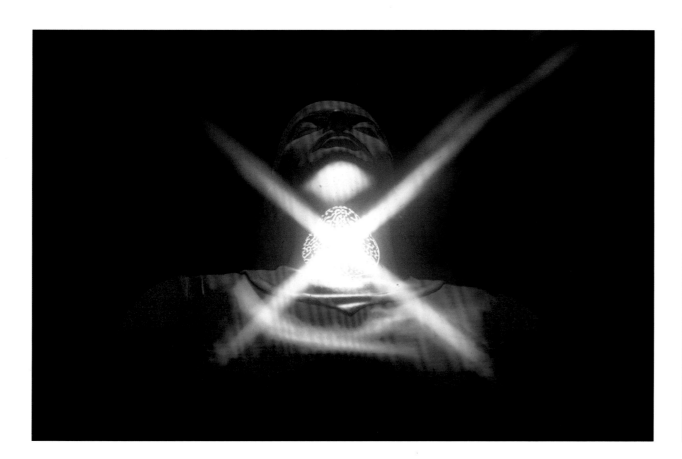

says. "They kept the Fletcher soft suit, I think, but they went ahead and built a version of that backpack and chest piece that I designed, and most of the helmet, although they covered up a lot to avoid those reflections."

Trumbull says that the design of the spacesuit helmet was dictated by the idea that the audience would see the imagery of Spock's journey reflected in his helmet during closeups of Leonard Nimoy inside the spacesuit. "The idea was to be able to superimpose reflections in the face of the character, so it had to be hemispherical to fit—we had no CGI or ability to distort an image other than spherical."

Model maker Greg Jein's shop created physical structures like the space lips, which were painted in neutral grays and then lit and photographed to create the illusion of brilliantly colored, massive objects. Planets, moons, and even a cybernetic homeworld for V'Ger were created by projecting imagery onto blank spheres, and Trumbull added brilliant corridors of light that managed to both evoke a new take on the famous *2001* stargate and something like the original Robert Abel 'painting with light' ambitions for the realization of V'Ger.

"All the things that Spock comes across on his spacewalk that were practical—a number of weird things like rings and squares, and the space egg and the space lips, and planets and planet surfaces and a whole variety of things— that's what Greg and his crew were working on," says model maker Bill George. "There was a really great Bob McCall painting of the space lips, and people like Greg and Bob Shourt had great experience. Greg had just come off *Close Encounters* and—talk about odd models—the models were a thing that you could hold, but they didn't look the way they looked in the film— it was all about the lens flares and weird camera effects. So the things we built really came alive on stage when they shot them with smoke, or they shot them with really long exposures, and it just took it to another world. The interior pieces were more gray than white—we weren't trying to make them look like the Federation, obviously, they were supposed to be an alien civilization."

The Spock walk would become arguably the most visually dazzling and memorable sequence in the film, and a fitting contribution from some of the chief artists behind *2001* and *Close Encounters of the Third Kind*. "It was kind of a miracle that it got done and that it looks as good as it does—they had a release date and that was it," Bill George says. "They had to hit the ground running, they had to split the work up to a lot of different facilities. There was a lot of R&D, the whole V'Ger cloud and the way they were doing that, and a lot of it was in Doug's wheelhouse as far as the whole stargate sequence and the slit-scan and the way that was done. But just the variety of looks and approaches in the film is pretty expensive."

V'GER'S TEMPLE

REVEALING *VOYAGER* AND V'GER'S ORIG

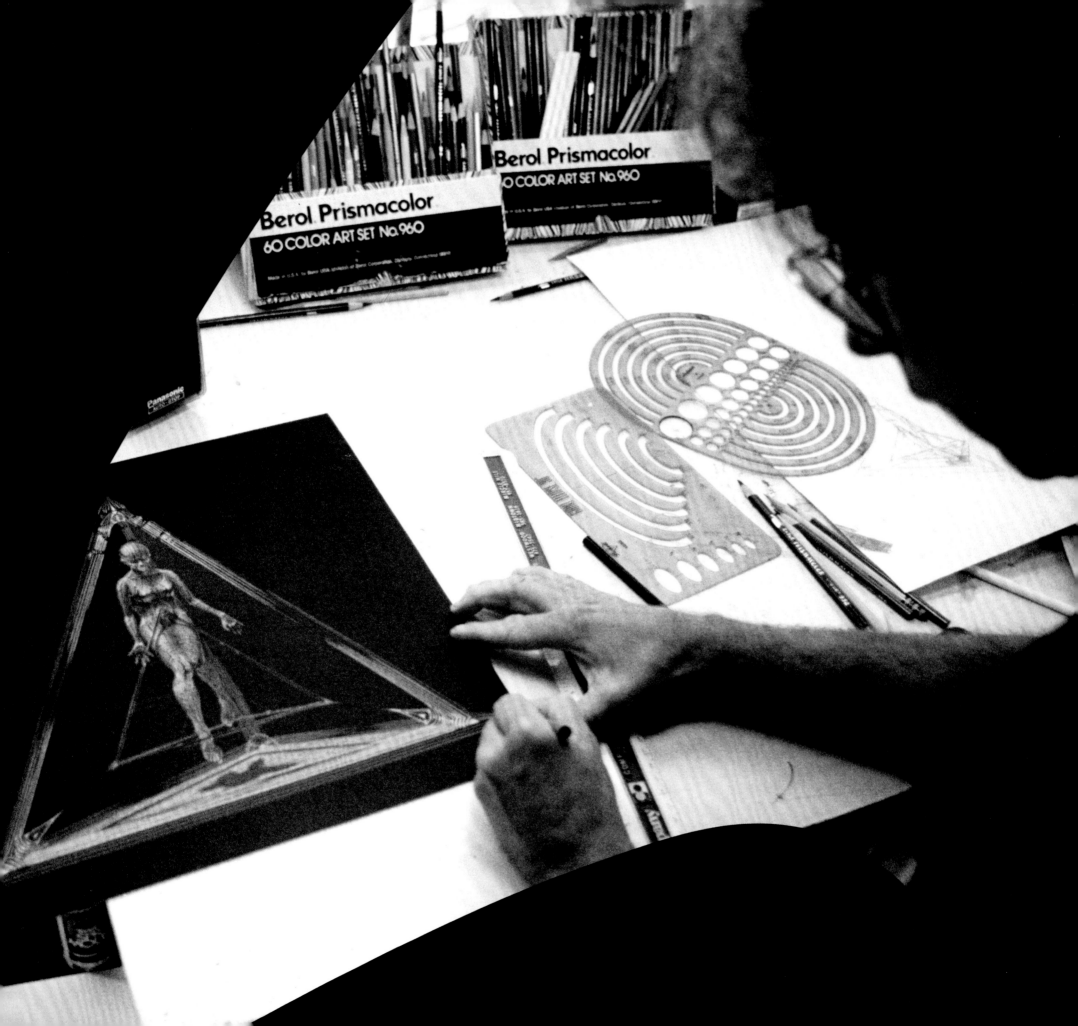

V'GER'S TEMPLE

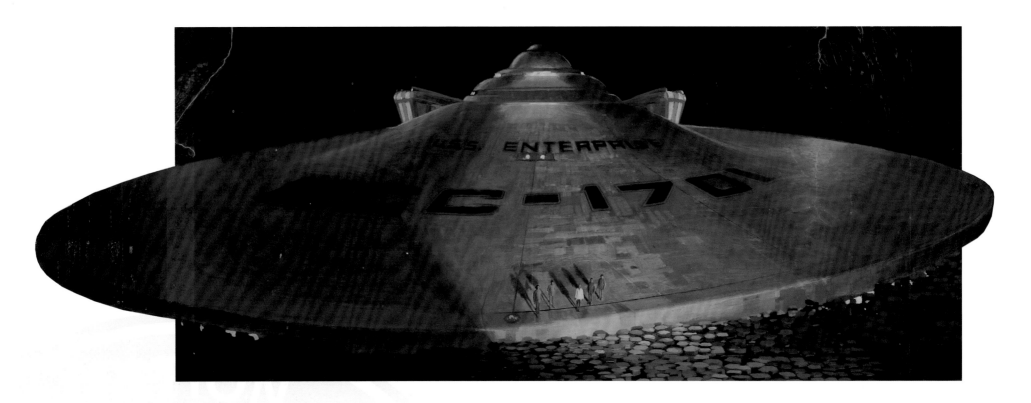

ABOVE: The sequence where Kirk, Spock, McCoy, Decker, and the Ilia probe exit the *Enterprise*'s saucer was referred to as the 'wing walk.' Only a small portion of the saucer was built full-size. The rest of the wide shots were accomplished through visual effects, primarily matte paintings.

From its original genesis as the 'Robot's Return' story idea for Gene Roddenberry's *Genesis II* (and the even earlier Nomad in *Star Trek*'s 'The Changeling'), the revelation of V'Ger's identity as the 'ancient' Earth space probe *Voyager 6* had been the key twist, and integrating the actual design of NASA's *Voyager* space probe into the central 'brain' of V'Ger had been a consistent design element. The idea was always that V'Ger had been constructed around the *Voyager* probe, and that the central location of the NASA probe would be like an altar or temple, an indication of V'Ger's worshipful view of its creator, NASA, and of *Voyager* as its guiding light and connection to the entity that

gave it its reason for being—"to know all that is knowable."

The V'Ger temple set, and the realization of the physical journey from the *Enterprise* to V'Ger's brain center by Kirk, Spock, McCoy, Decker, and the Ilia probe represented the climax of the story's drama and a key element of Robert Wise's early dictate to give the film's visual sequences a human scale.

The sequence required the construction of a large section of the *Enterprise*'s saucer hull, with an airlock elevator that raises the crewmembers and the Ilia probe up onto the surface of the hull. From there, the characters traverse a suspended walkway of geometric, interlocking shapes to a

high-tech, Stonehenge-like temple, where the *Voyager 6* NASA probe is revealed. The sequence begins with the *Enterprise* being pulled into a chamber with an atmosphere envelope that can sustain human life. Kirk and the others emerge onto the edge of the *Enterprise*'s saucer from an elevator airlock, a moment that combined live action—using a set reconstruction of part of the *Enterprise* saucer—with a matte painting of the rest of the ship, and searchlights emanating from the bridge area. This shot has always been jarring for its extreme perspective but, like the earlier shot of the Vulcan shuttle docking, it was produced using a photo of the *Enterprise* miniature for reference.

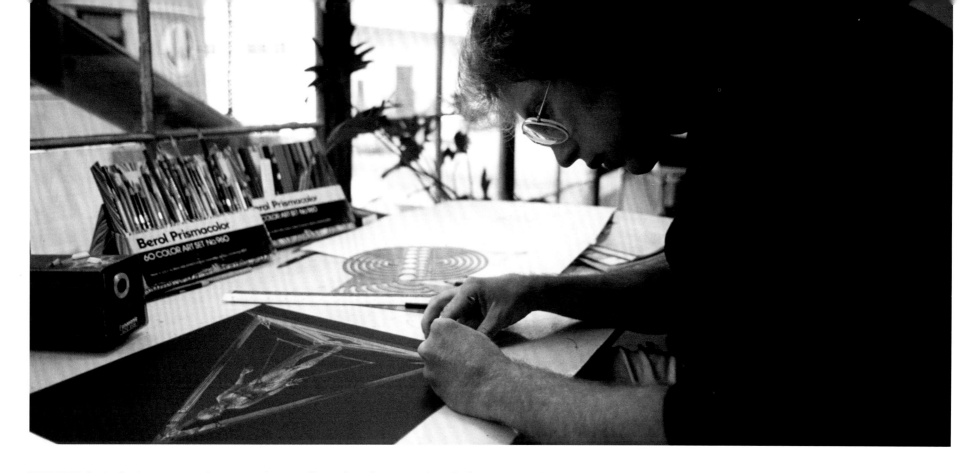

THIS PAGE: (ABOVE) Ed Verreaux works on an early ASTRA illustration of a 'captured' Lt. Ilia (detail below); (BELOW) ASTRA concepts of the *Enterprise* approaching the heart of V'Ger.

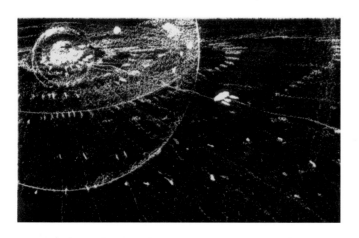

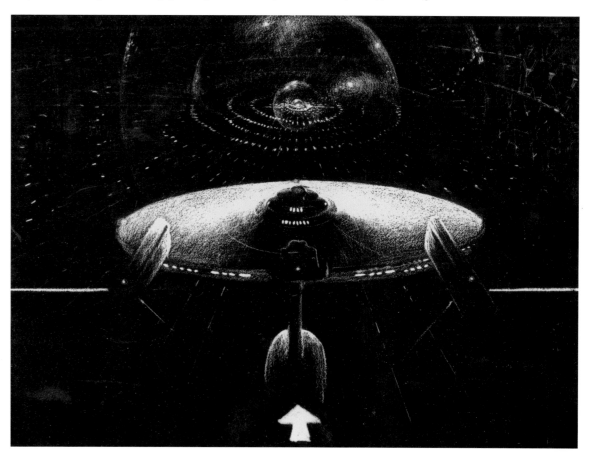

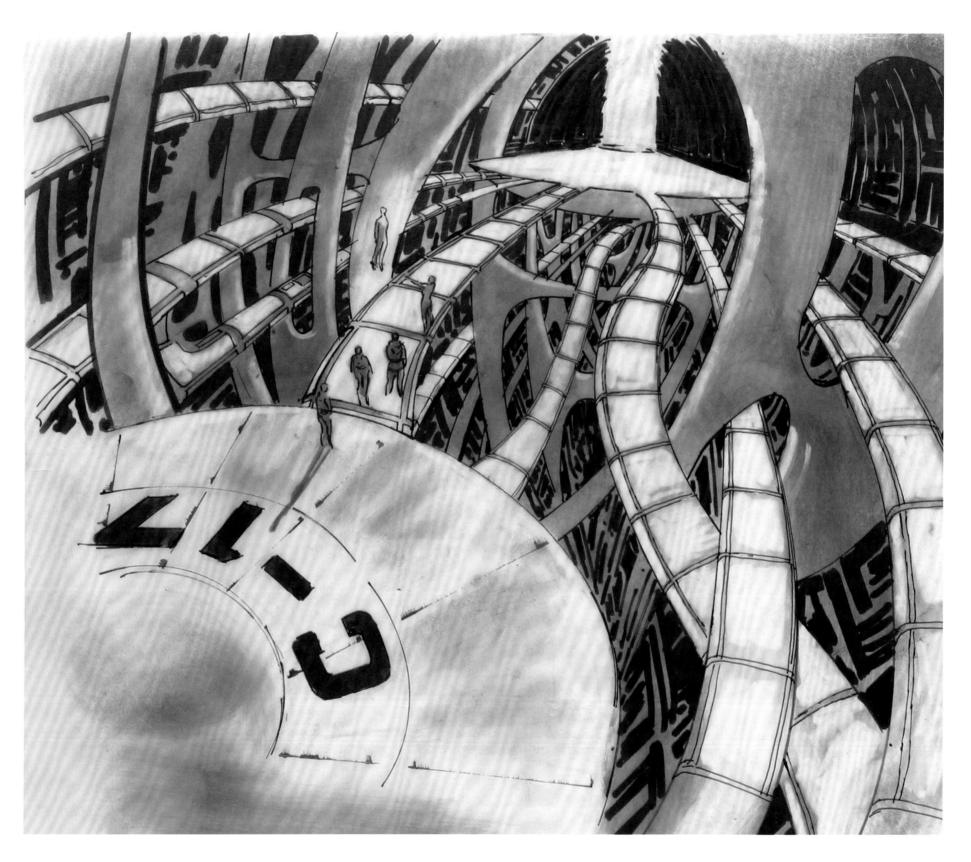

THIS SPREAD: While the final part of the journey to V'Ger was always accomplished on foot, the pathways varied wildly – from a curving set of paths resembling neural paths in the brain, to individual stepping stones. Both concepts were generated by Harold Michelson's art department.

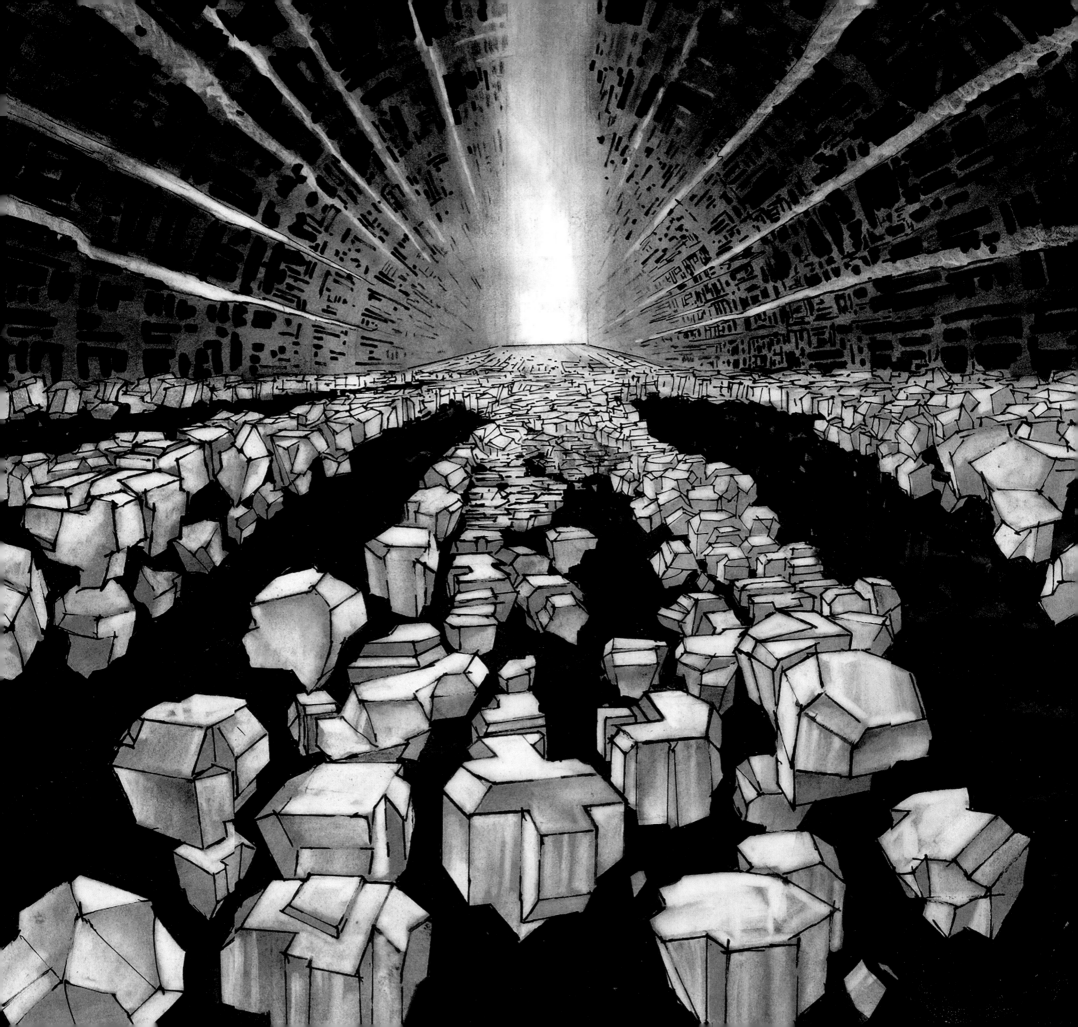

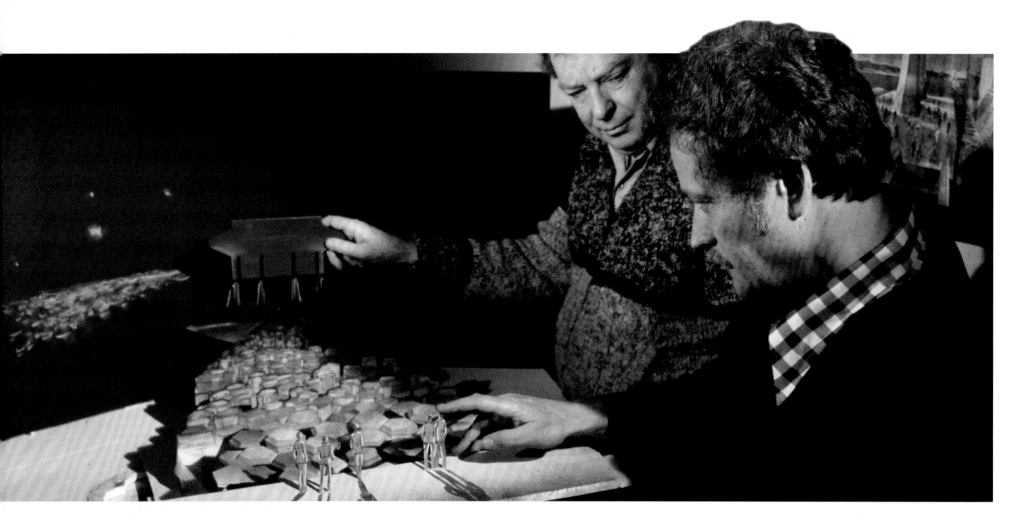

THIS SPREAD: Eventually, a pathway of hexagonal stepping stones was settled upon. A small section was built full size for the actors (including Persis Khambatta in high heels) to walk on, supplemented by a miniature. (ABOVE) Production designer Harold Michelson and art director Leon Harris review the study model of the wing walk and stepping stones set (OPPOSITE TOP).

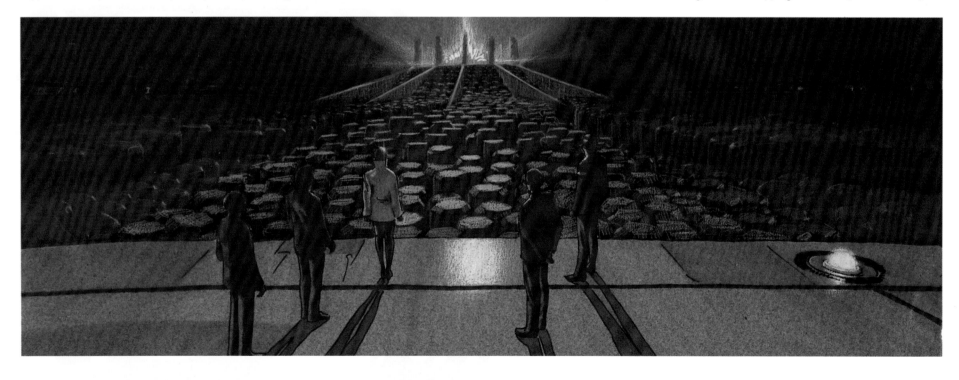

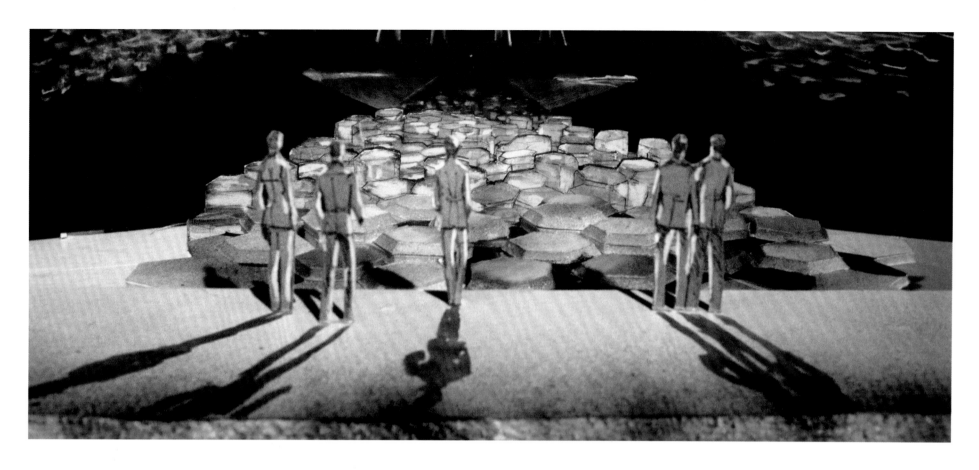
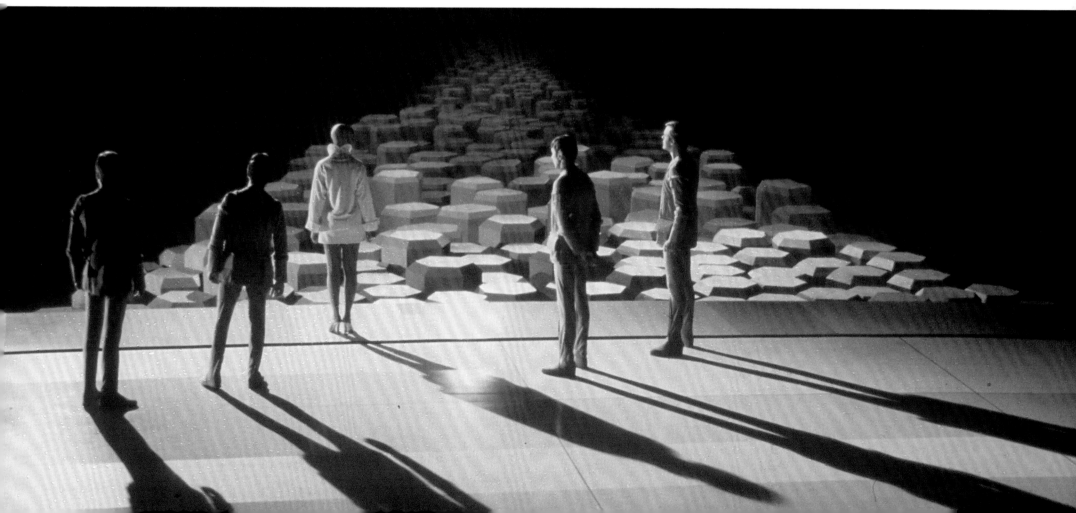

THIS PAGE: ASTRA generated artwork for the V'Ger altar. The objects surrounding the wrecked NASA probe represent special items that V'Ger collected along the journey home.

"It's got screwy perspective," matte painter Rocco Gioffre says of the wide shot matte painting, showing the *Enterprise* officers emerging from the ship's hull. "The visual effects were being done in great haste and, in some instances, the matte paintings were too. I can't answer for Matt Yuricich, but I do know that shot was giving him problems and he was struggling with it."

Gioffre says part of the problem was the necessity of shooting the actors on a soundstage with a wide-angle lens. "When you take a wide-angle shot that's full-frame, and you reduce it to an extreme, and you put it small in the middle of a geometric design, whether it's a cityscape or the interior of a building or whatever, you're forcing it to become a fisheye lens, and it's always going to have a weird warp to it. Nowadays, they've got tricks like lens-warping tools in CG, where they can actually vacuum that out of there and get it back to normal perspective lines and make it look less like a wide-angle shot. But in fact, the right way to shoot a plate like that is to get as far away from it as you possibly can and shoot it with a normal lens, so that, when you do reduce it, you don't have these strange wide-angle perspective lines that are reduced now even further."

Robert Abel's crew had executed a number of concepts for the V'Ger temple, and the original ideas for the geometric walkway were far more colorful and elaborate. In the film, they are simple, gray shapes, but the original art concepts would have had a more crystalline appearance, with internal lighting and color changes. One version of the sequence had Ilia's original body, spirited away from the *Enterprise* bridge during the

initial probe's entrance on the bridge, now encapsulated—and lifeless—in a transparent pyramid discovered by Kirk and the others on the walk toward the V'Ger temple. The concept was to show Ilia as simply a part of V'Ger's limitless collection of alien artifacts accumulated on its journey across the Galaxy.

One of Richard Taylor's concepts for the V'Ger temple showed other space probes and artifacts clustered around *Voyager 6*, as other found objects from V'Ger's trip.

Like the geometric walkway, the V'Ger temple evolved from a more amorphous and trippy light show aspect to a more solid, hard-edged construction: a set of vacuform and other shapes radiating out from the *Voyager* spacecraft replica rented for the production. Fluctuating light effects were projected underneath, designed by Sam Nicholson and Brian Longbotham, who had devised similar light effects for the engineering set on the *Enterprise*.

THIS PAGE: Early ASTRA storyboards featured the crew using spacesuits as they approached V'Ger. Note the 'captured' Lieutenant Ilia in the panel below.

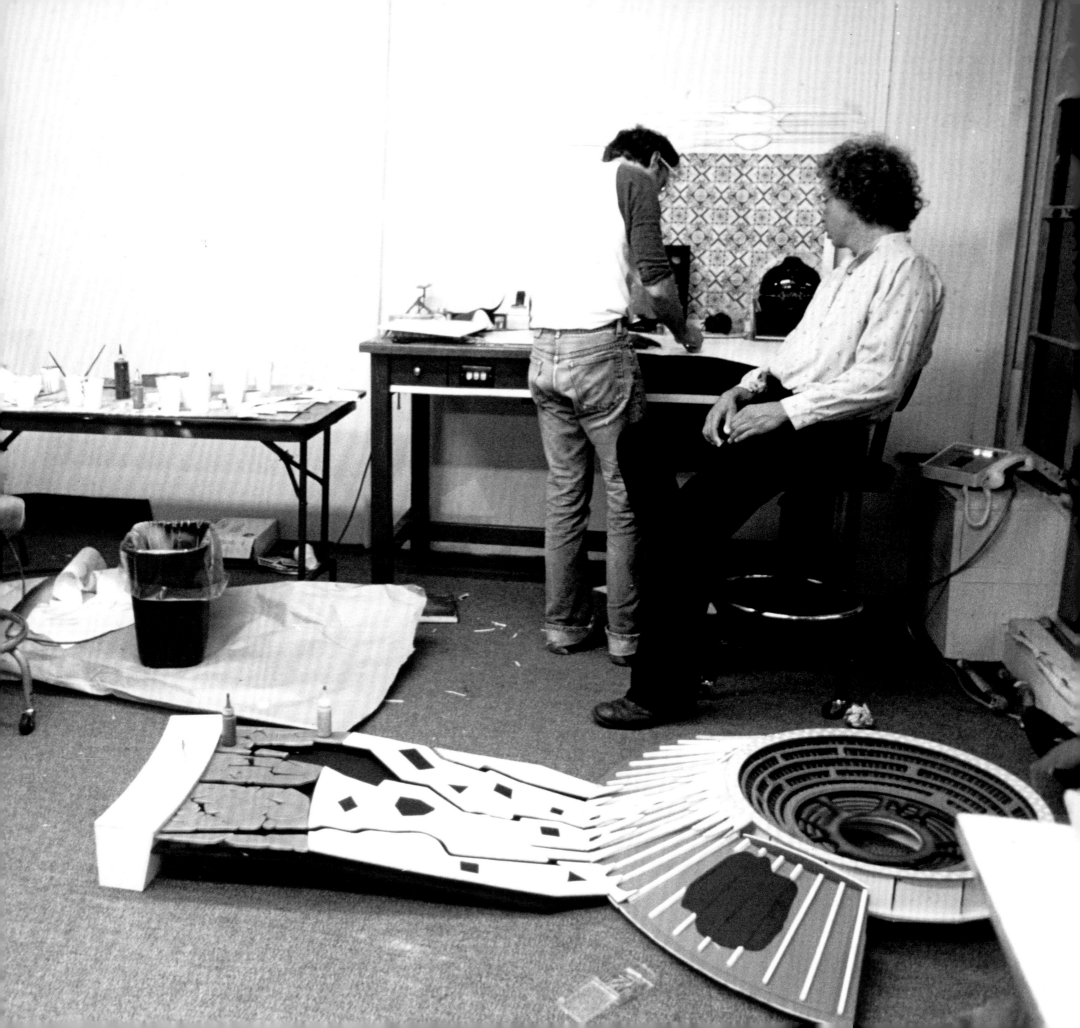

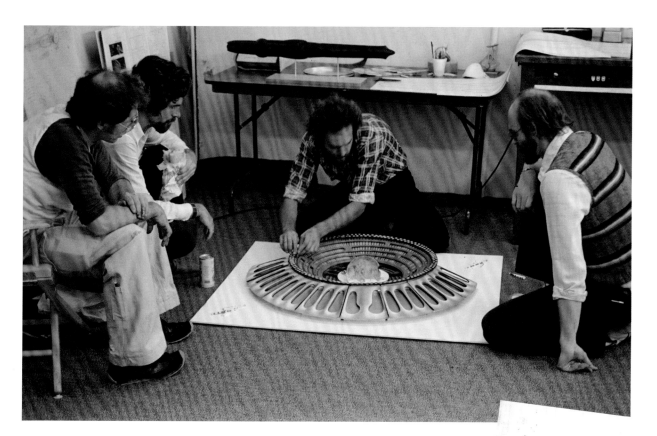

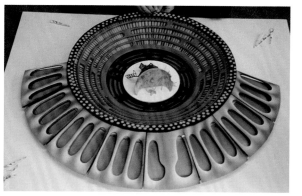

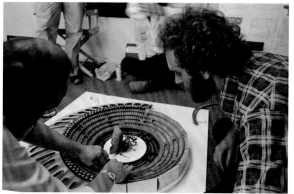

"When it came time to think about designing the heart of V'Ger for the last scene, I started with the description in the script," Harold Michelson said in 1979. "It was spelled out that the characters had to walk out on the wing, go up a ramp, and then down into the form of a bowl. Again, my thinking carried over from the *Enterprise* interiors: I wanted to combine architecture with light. Because you can get fantastic effects and really not see the architecture but feel it. We lifted the floor of our set seven feet off the floor of the stage so that we could have tremendous light underneath. We also built big fins that towered above the edge of the bowl and went way up into the grids. These crossbar fins were plastic so that the lighting inside them could radiate and pulse. While I was designing the set, I'd be telling young Sam Nicholson what we were doing so that he would know where and how he could give us light. He was very cooperative, leaning back sometimes in deference to us because, after all, the set and the action were the important things. He was absolutely marvelous, creating illusions with light."

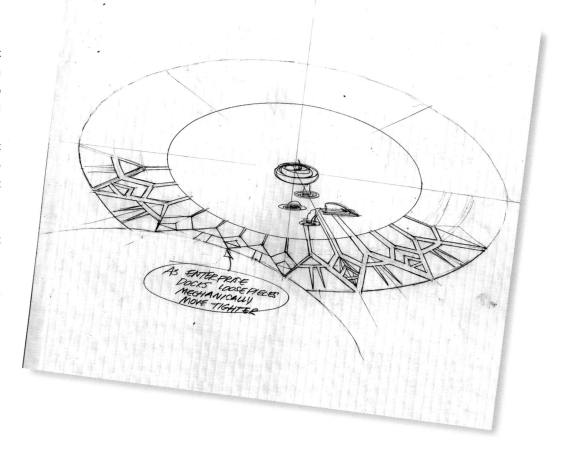

AS ENTERPRISE DOCKS LOOSE PIECES MECHANICALLY MOVE TIGHTER

THIS SPREAD: ASTRA's art department built a scale model representing the edge of the *Enterprise* and the path that the crew would have to take to get to the altar. A wrecked version of the *Voyager* probe would be found at the bottom of the 'bowl'.

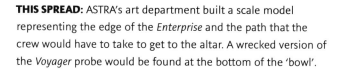

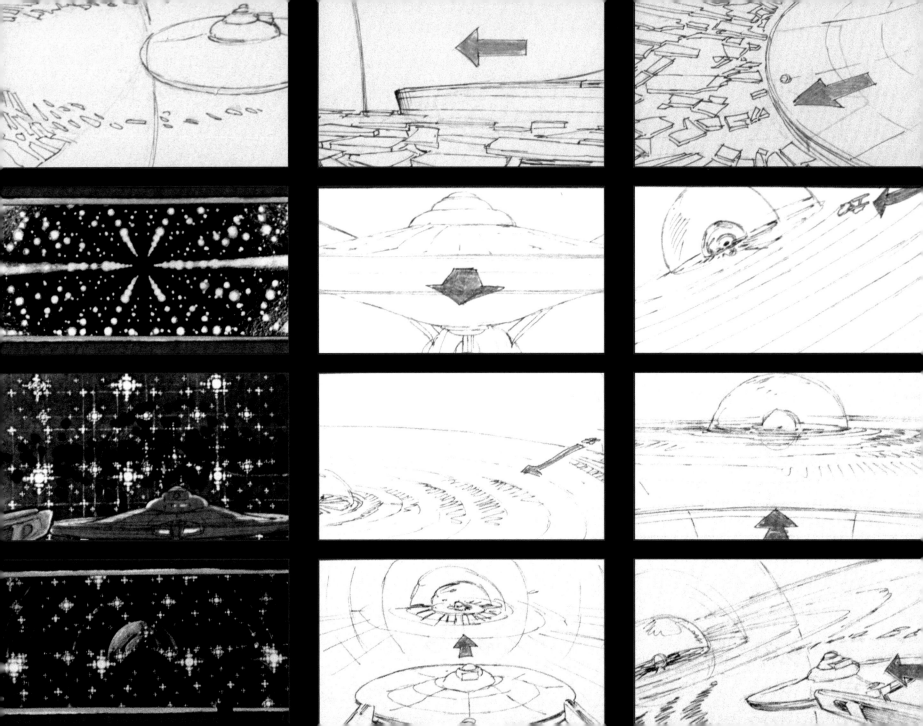

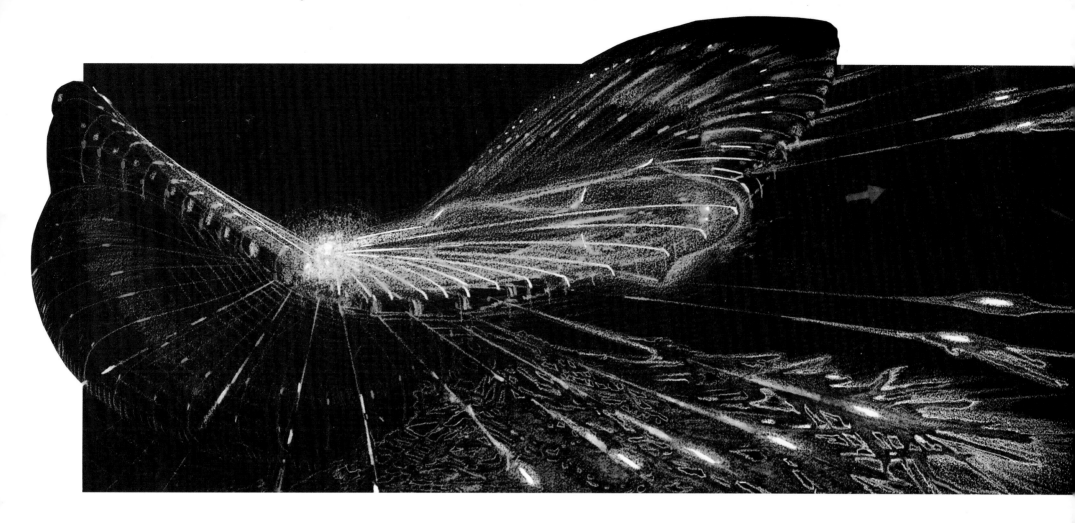

"My thinking carried over from the *Enterprise* interiors: I wanted to combine architecture with light. Because you can get fantastic effects and really not see the architecture but feel it."

Harold Michelson *production designer*

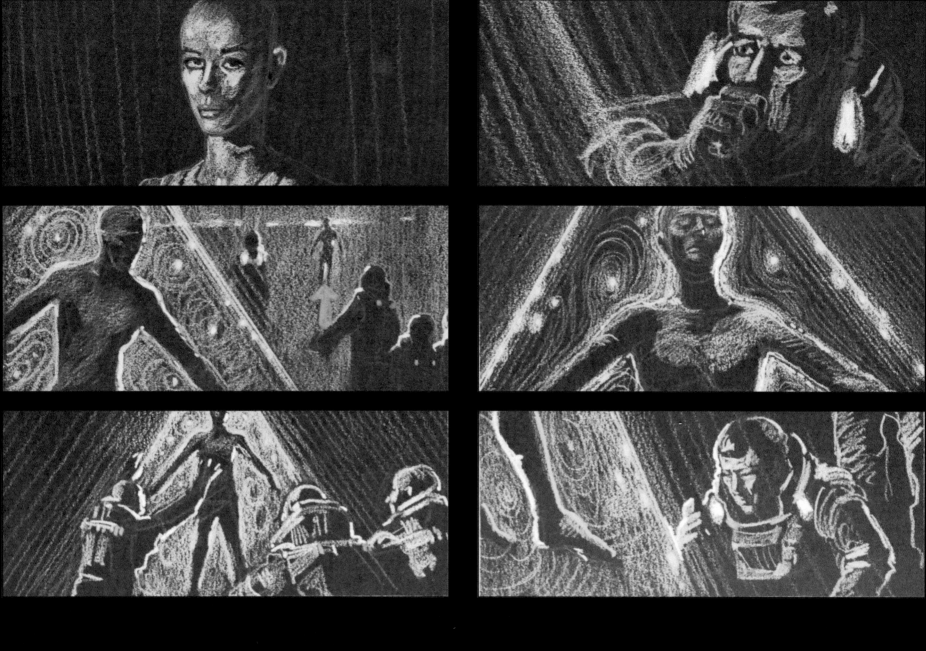

THIS SPREAD: Early ASTRA storyboards had the crew discovering the lifeless body of the real Lieutenant Ilia confined to a crystal pyramid (ABOVE) and the revelation that V'Ger is a NASA probe gone awry (OPPOSITE). Dr. McCoy takes a reading and pronounces Ilia "lifeless" as Decker displays a look of shock. After Robert McCall reimagined the Spock walk sequence, the fate of the real Ilia was never explained so bluntly.

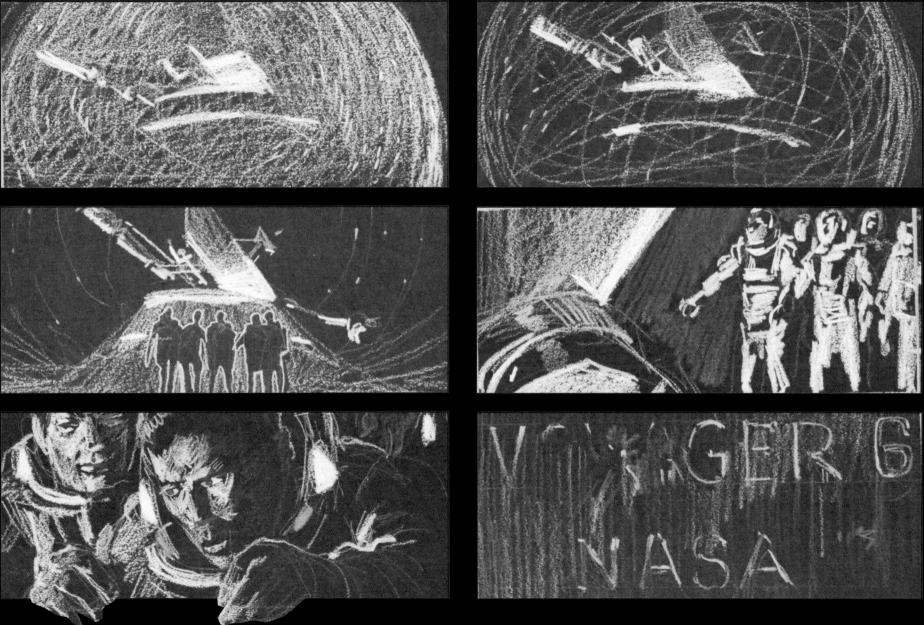

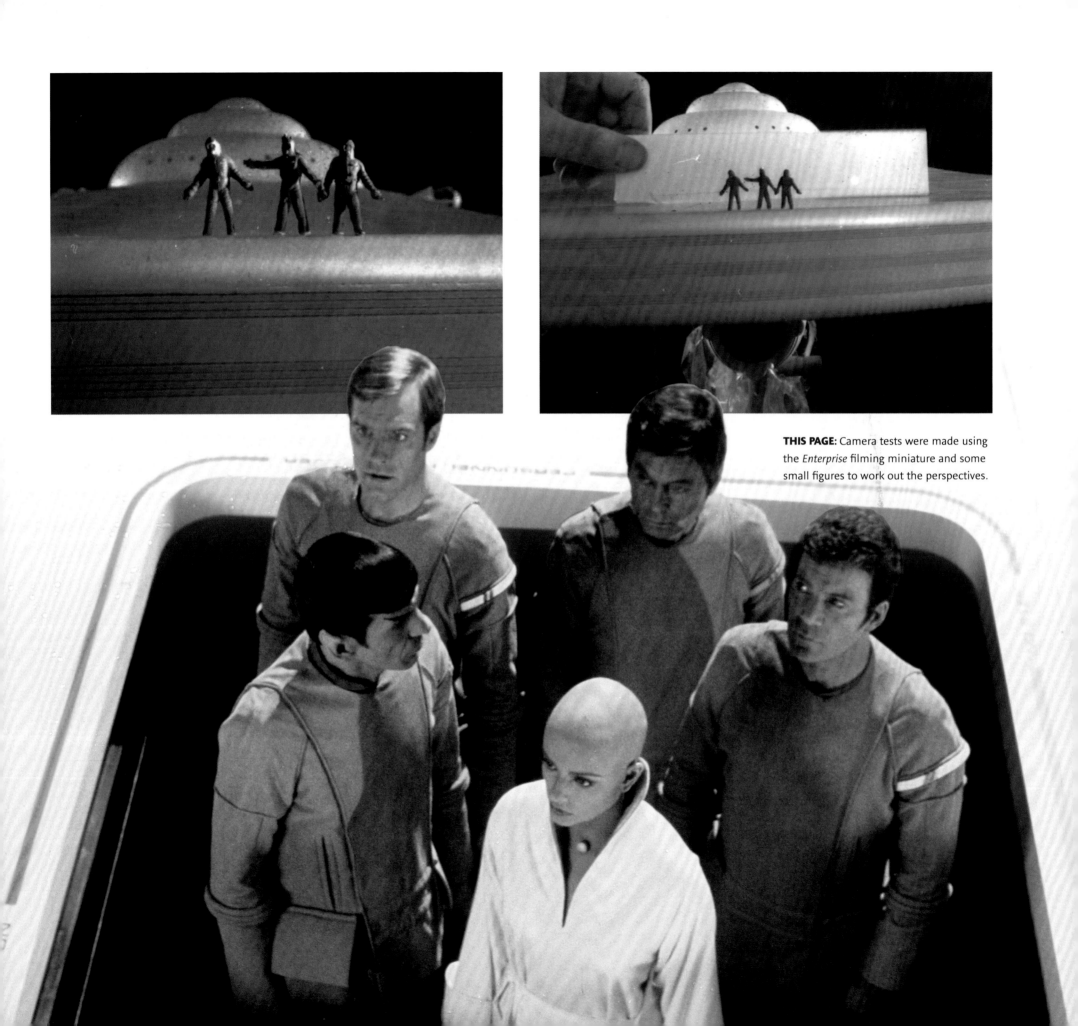

THIS PAGE: Camera tests were made using the *Enterprise* filming miniature and some small figures to work out the perspectives.

Miniatures and matte painting extensions enhanced the size of the already considerable temple set. "I made a little tiny miniature of the altar site," Mark Stetson recalls. "There was a set built for that and then I built a replica of the set at a very small scale. The wrecked *Voyager* in the middle wasn't required for that, it was just the columns, and it was shot in very dense smoke with very low detail."

Matte painter Rocco Gioffre worked on three shots of the walk to the V'Ger temple, helping to extend the sets to give a more epic scale.

"[Animator] Robert Swarthe is still in possession of the closest angle of that, which looks like Stonehenge, where the pillars are standing up and the people are relatively close to the camera and are ascending a slight incline to go down into the dish where the V'Ger remnant is," Gioffre says. "There are probably about three of those shots I got to do completely."

Swarthe and his animation team created the sparkling, cascading light effects that eventually envelop and seemingly merge Decker and the Ilia probe at the climax of the movie. Exactly what Decker, the Ilia probe, and V'Ger 'evolve' into is left deliberately vague in the finished picture, but artist David Negron had created concept art of V'Ger spreading out into a bird-like, winged shape to depict its evolution while Robert Abel was still involved in the production. Ultimately, V'Ger seems to spread itself thin into a kind of nothingness, like the ancient god Apollo describes in the The Original Series episode 'Who Mourns For Adonais?'—apparently moving into a realm beyond human instrumentation or senses.

BELOW: Drawing showing the scale and markings of one of the *Enterprise*'s navigation beacons with a space-suited Kirk for scale.

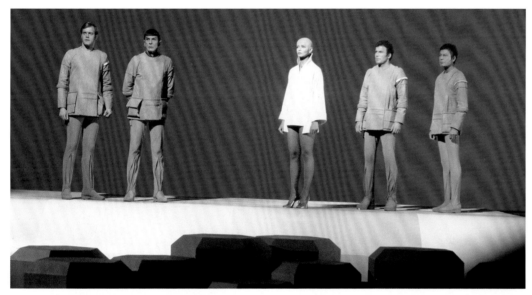

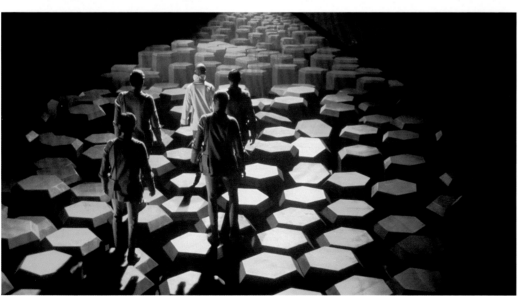

LEFT: The partial set of the *Enterprise*'s saucer and the hexagonal stepping stones were shot against a blue screen in order to matte in the rest of V'Ger's environmental bubble.

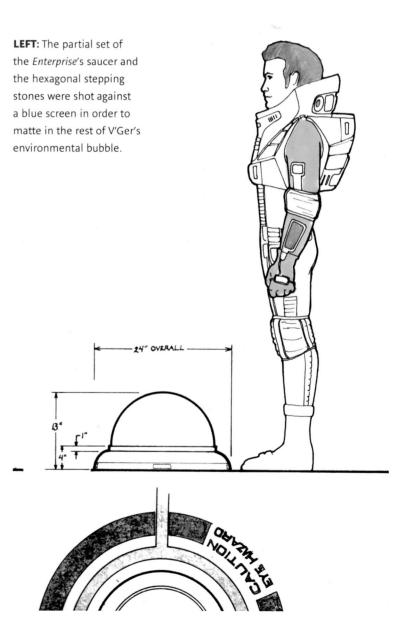

24" OVERALL

13"

1"

4"

CAUTION
EYE HAZARD

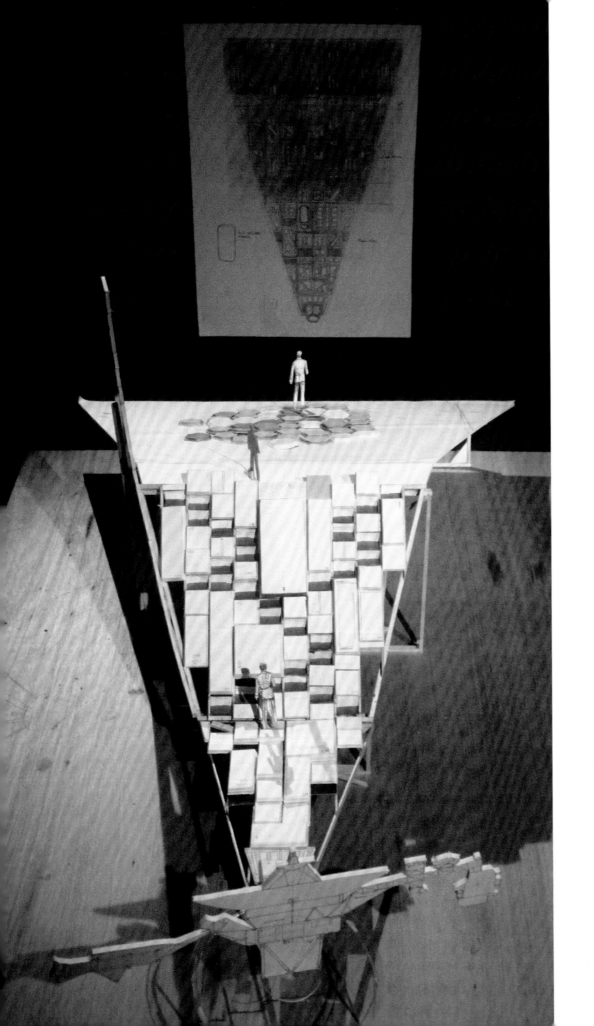

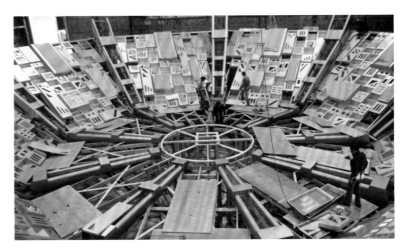

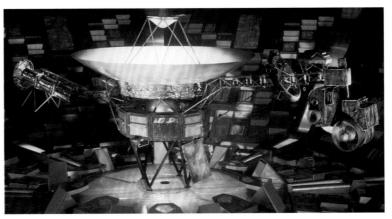

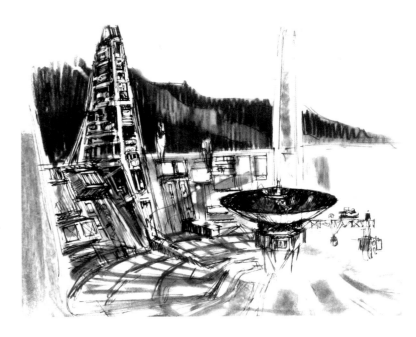

THIS SPREAD: Ultimately, the final design of the V'Ger bowl became the responsibility of the Paramount art department, who generated their own sketches and models.

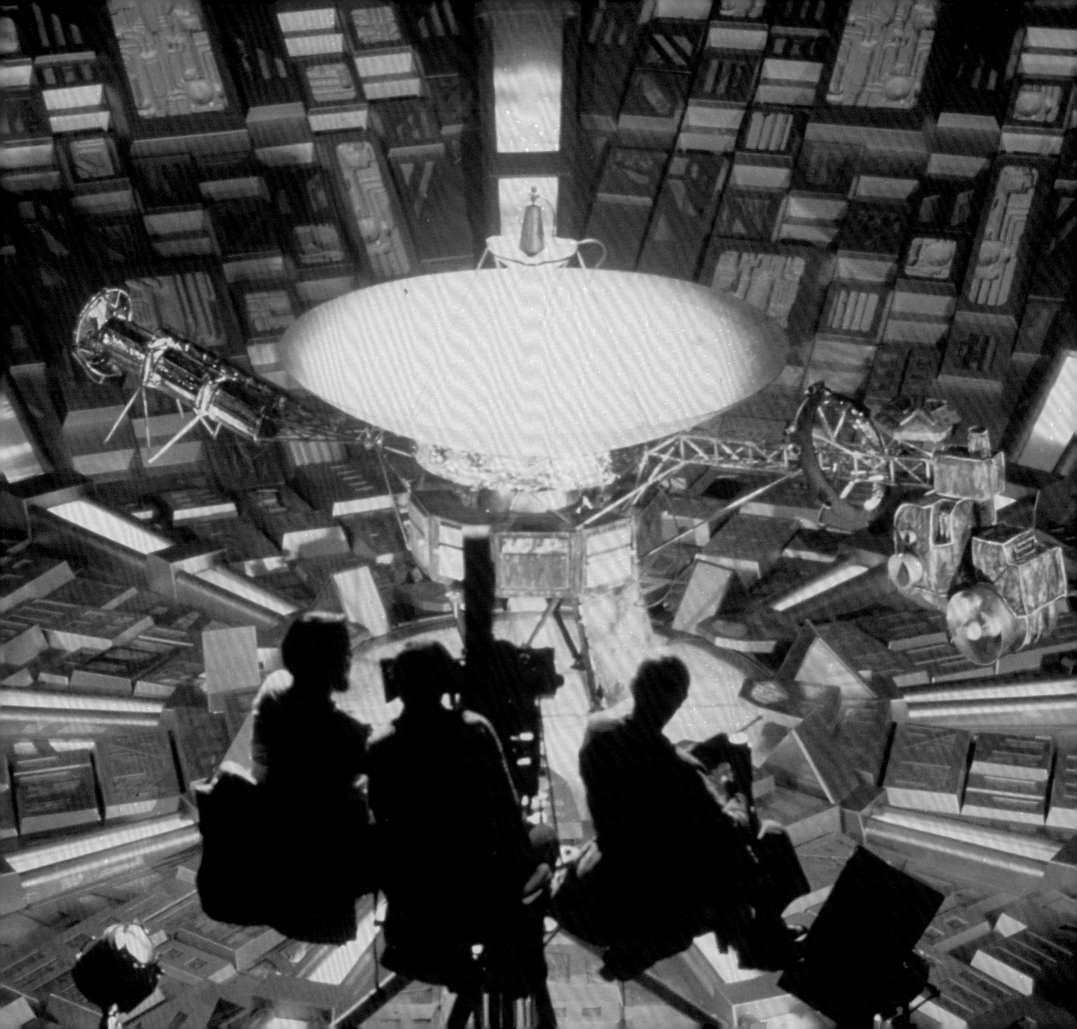

ANGLE OF THE ATTACK

THE KLINGON SEQUENCE

ANGLE OF THE ATTACK

ABOVE: The Klingon ship started out with a very strong resemblance to The Original Series Klingon cruiser with a smooth shape and very few surface details. After a series of camera tests and photos, it was decided that the cruiser needed a massive reworking.

Since the first season of the original television series, the Klingons had always been *Star Trek*'s most audacious and intriguing adversaries, the show's stand-ins for the militaristic threats of the Cold War, who could be counted on to oppose Kirk and Starfleet week in and week out. As early as the development of *Planet of the Titans*, a space battle involving the Klingons had been a key component of any revival of *Star Trek*, and this element had remained in place as a part of Roddenberry and Alan Dean Foster's 'In Thy Image' teleplay for *Star Trek: Phase II*. Using the original Klingon miniature borrowed from the Smithsonian Institution as reference, Magicam model makers made a number of reproductions of the Klingon warship to create early test footage of the ships exploding while under attack from V'Ger early in the story.

Pyrotechnics expert Joseph Viskocil, who had created the crowd-pleasing, zero-gravity miniature explosions for *Star Wars* by rigging explosive charges in the ceiling of soundstages so that sparks, smoke, and debris flew toward the audience instead of toward the bottom of the screen, rigged a number of these small recreations of the Klingon warship, built by Jim Dow and the Magicam crew, to show them being annihilated by V'Ger. "We built it from scratch," Dow says of the first Klingon miniature, noting that the ships were not cast off the Smithsonian miniature as is commonly believed. "There was nothing preexisting that was worth molding off of. We made buck and molds and then did skim molds and fast castings, and provided those to Joe Viskocil and he did what he had to do to explode them."

Even for a television pilot, the two-foot Klingon models were deemed too small, and eventually a more refined miniature of the Klingon ship, around four foot in length, was constructed and painted a light gray-green with some simple interior lighting (the original 1960s television miniature featured only painted windows). The ship's flat, undetailed surfaces were broken up by painted panel lines, and the 'wing' engine support pylons that comprised the largest flat areas on the ship's hull were painted with subtle geometric patterns.

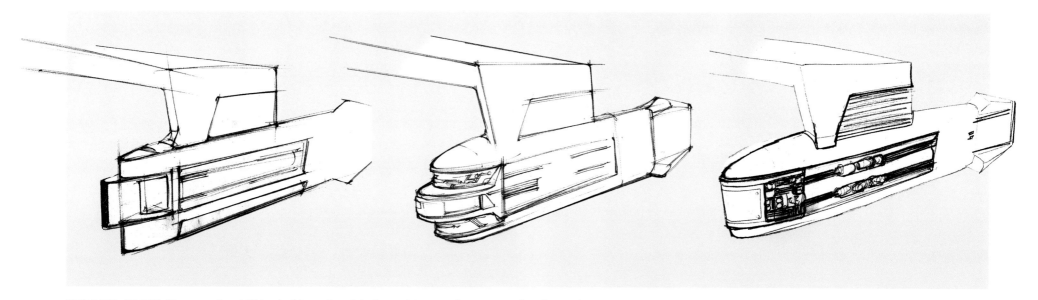

THIS PAGE: (ABOVE) Illustrator Greg Wilzbach did a series of design revisions on the warp nacelles; (BELOW) Andy Probert provided very specific notes to the model building crew.

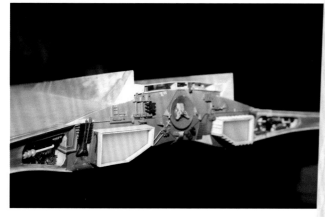

"We built [the Klingon miniature] from scratch. There was nothing preexisting that was worth molding off of."

Jim Dow *visual effects, Magicam*

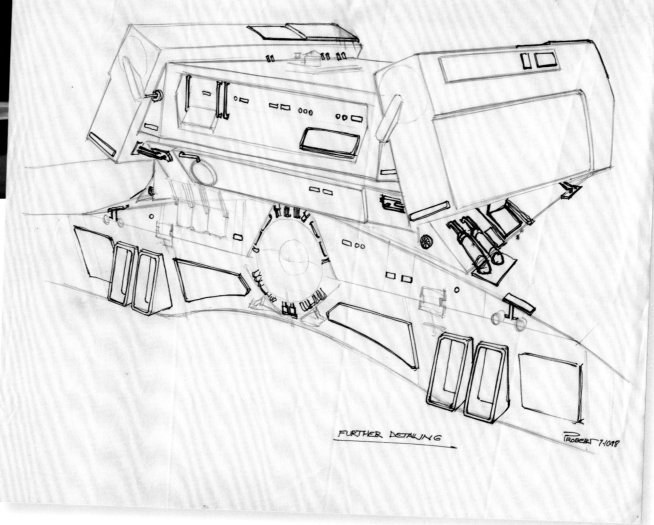

FURTHER DETAILING

When the project evolved into a theatrical movie instead of a television pilot, Richard Taylor and Andrew Probert began to work with Magicam to rework the Klingon model. "We needed to give it more detail and give it a look that really helped emphasize their design style and the colorations [the Klingons] used," Taylor says. "There were parts of that model we had to have more detail on: the bridge at the front and also, because their photon torpedoes came out of the front, we added detail to that. [For] the cladding, one of the things I suggested was we try to give it a bird wing kind of texture. I won't call it Aztec, but we needed to add detail and get lights into it: the lights behind the bridge, the lights at the back for the engines. The coloration of the Klingons was important—I felt the Vulcans, the Klingons, and Starfleet all needed their own color palette."

"It was a matte dark green or olive green, and the detail was basic," Mark Stetson says of the original Klingon cruiser build. "It was redetailed twice after it left Magicam—it went out the door as a matte-green, large-scale replica of the

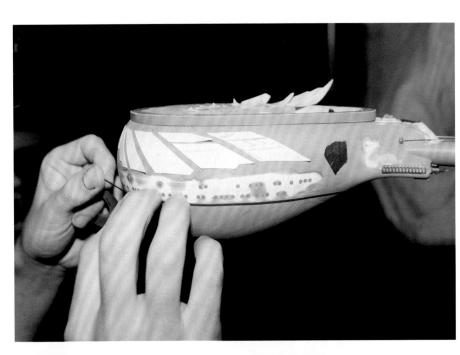

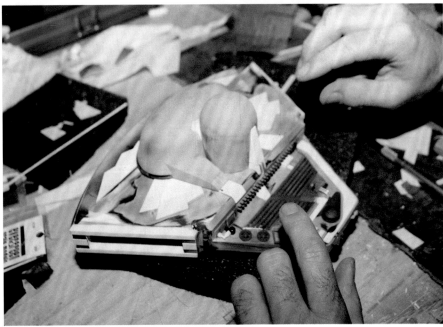

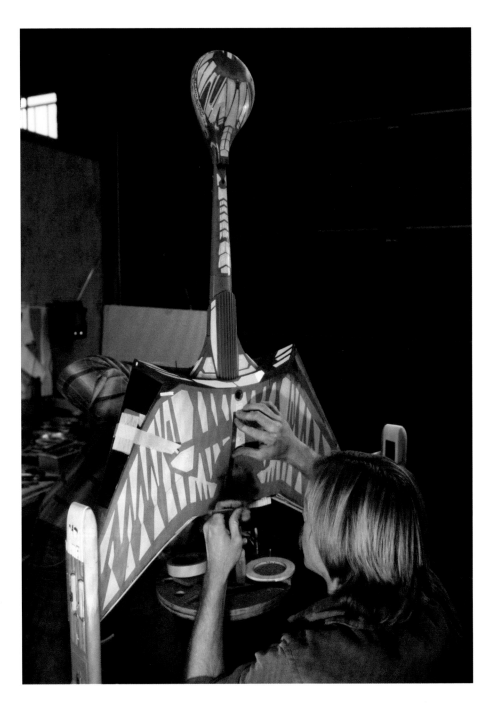

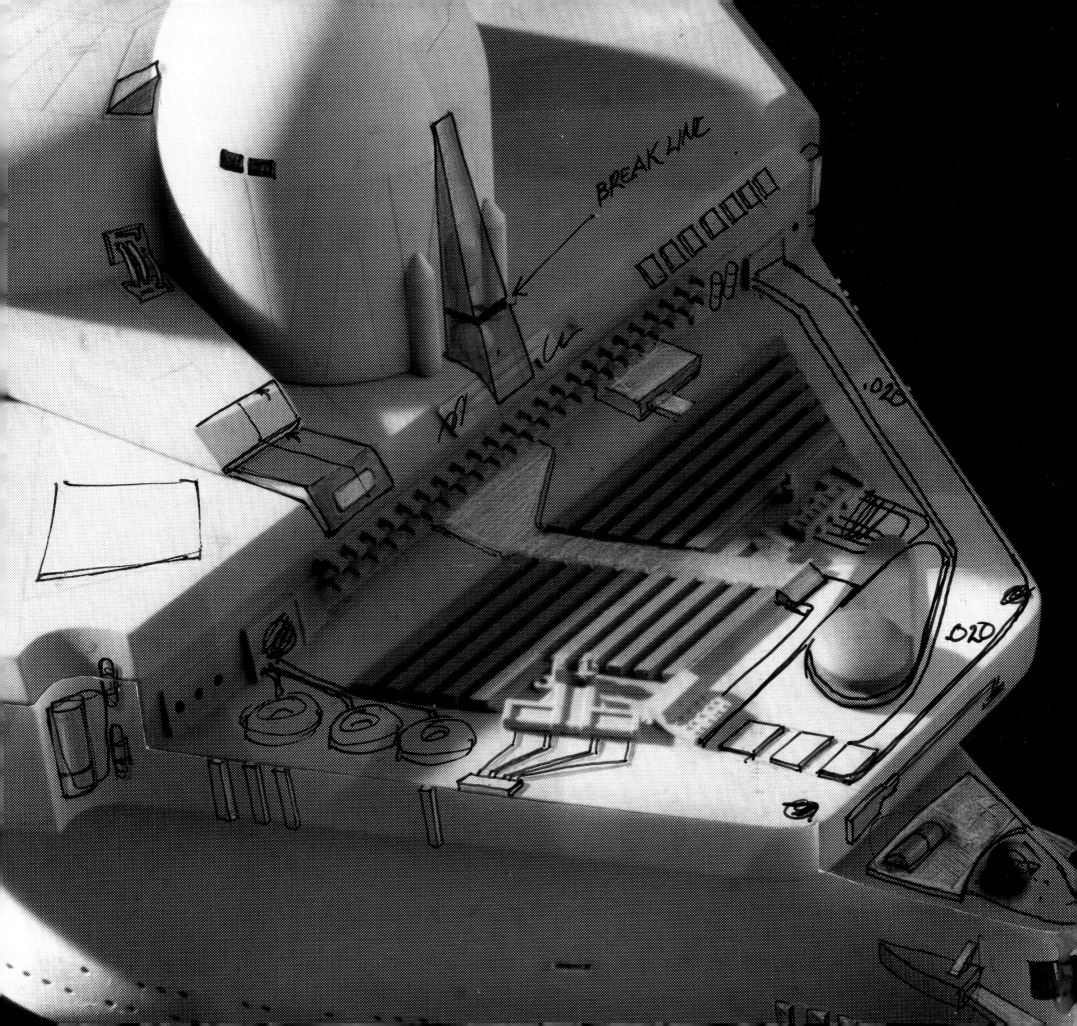

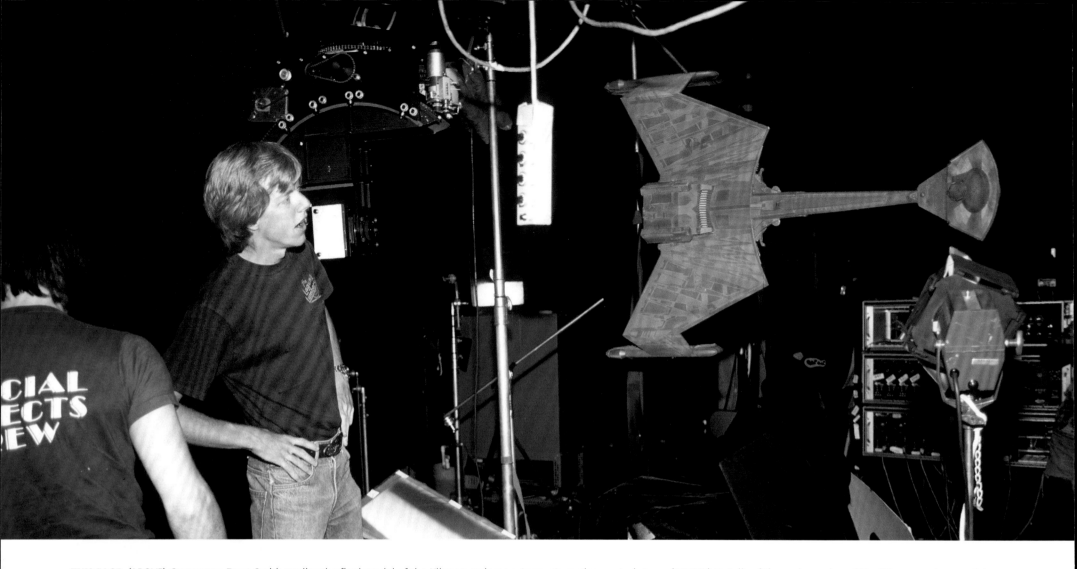

THIS PAGE: (ABOVE) Camerman Doug Smith studies the final model of the Klingon cruiser on Apogee's motion control stage; (BELOW) Details of the early version of the Klingon cruiser model.

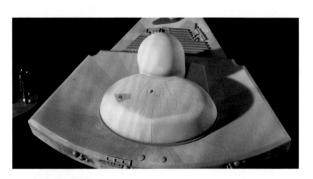
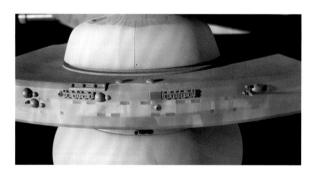
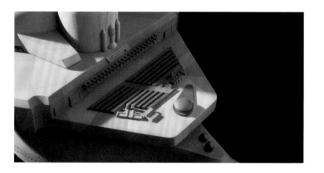

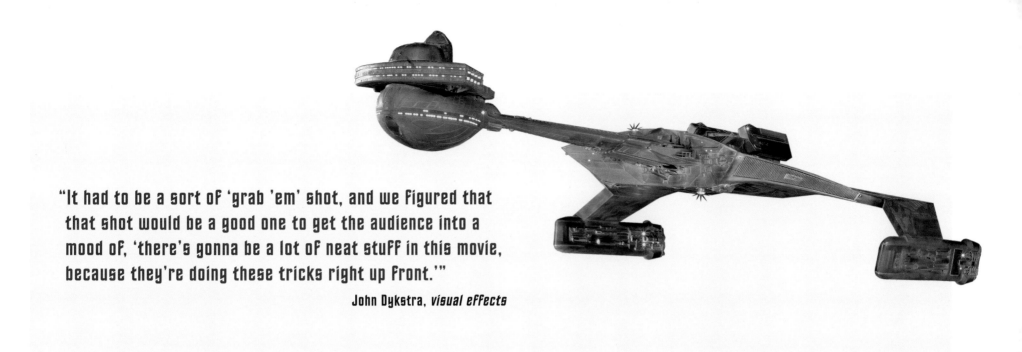

"It had to be a sort of 'grab 'em' shot, and we figured that that shot would be a good one to get the audience into a mood of, 'there's gonna be a lot of neat stuff in this movie, because they're doing these tricks right up front.'"

John Dykstra, *visual effects*

ABOVE: This version of the Klingon Cruiser would later be modified for *Star Trek VI: The Undiscovered Country*.

BELOW: ASTRA art director Richard Taylor studies photos of an early version of the model.

Smithsonian model, the one from the series that they were copying and scaling up. The detail didn't progress much beyond that, but it was finished." Once at Robert Abel's studio, an additional layer of detail was added. "I felt they could have more greeblies than the Starfleet ships," Richard Taylor says of the Klingons. "Their stuff looks more wicked and crude."

As the project was reconfigured from television pilot to feature film, the basic Klingon miniature was retained, but Apogee Effects model makers, with input from Andy Probert, added a wealth of additional detail and an elaborate paint job in varying shades of green, gray, and tan, to give the ship the down-and-dirty Klingon version of the *Enterprise*'s gleaming, pearlescent finish.

Model builder Pat McClung added even more detail to the bulbous bridge area on the vessel's cobra-head nose for a spectacular shot devised by John Dykstra to wow audiences during the film's opening, with the camera sweeping over the nose of one of three Klingon ships in formation, briefly flipping the view (and seemingly, the audience) on its head as the camera followed the three warships on their trajectory toward the V'Ger cloud.

"The opening shot couldn't be *Star Wars*-y. They didn't want a big ship moving in overhead or from the side or anything, so there was no way to get any dynamics into the shot," Dykstra said, in 1979. "We were trying to figure out how to make it exciting without making it so that you just came close to the ship and so on. It had to be sort of a 'grab 'em' shot, and we figured that that shot would be a good one to get the audience into a mood of, 'there's gonna be a lot of neat stuff in this movie, because they're doing these tricks right up front.' I've seen the film with a paying audience and people like it. They get a big reaction out of it, but that's what the shot was designed to do, the same thing as the *Star Wars* shot was designed to do. It's a grandstand shot. My contention initially was that, in order to make people get excited about what

THIS SPREAD: Filming of the interior of the Klingon battle cruiser bridge was among the last scenes filmed, giving Douglas Trumbull and Andy Probert a chance to contribute to the set design.

they're seeing on a screen, image-wise, you need a fluid camera that gives you the sense that it's a cameraman shooting the shot instead of a camera locked off to some god's [point of view] someplace. So I always like to move the camera. I think that gives some dynamics to the screen that you don't get any other way. And that was sort of the ultimate move-the-camera shot. The helicopter-in-space shot."

Mark Stetson notes that McClung brought an entirely new level of detail compared to the techniques Stetson and his team had been using. "Where I was putting on three-eighths-inch squares, Pat McClung was putting on like one-thirty-second-inch squares on the model,

where you'd have to handle the piece by stabbing it with the end of an X-acto knife and adhering it to the model with some MEK [Methyl Ethyl Ketone adhesive]. And he was really good at it, and that made the entire difference in the shootability of the Klingon ship."

Several shots featured sections of the Klingon ship looming in the foreground to add perspective; in particular, a long shot of two of the ships beginning to maneuver away from the V'Ger cloud after coming under attack. "Dennis Schultz made an enlargement section of one of the propulsion pods that went to Apogee," Mark Stetson says. "Dennis was a fine craftsman—he worked in wood and he was like a model

railroad guy. He made that side pod and the new bridge for the *Enterprise* out of wood."

One of the most impressive miniature close-ups in the film was the early push-in on the Klingon bridge section just before the cut to the bridge interior. Remarkably, this was not a specially constructed, oversized reproduction of the bridge section but a close-up of the 4-ft miniature's nose, which was not much more than four or five inches across. The final detailing by Pat McClung, lighting, and photography made this shot easily read like the full-sized command center of a massive spacecraft.

Like the *Enterprise*, the Klingon miniature featured some built-in spotlighting, but the dark

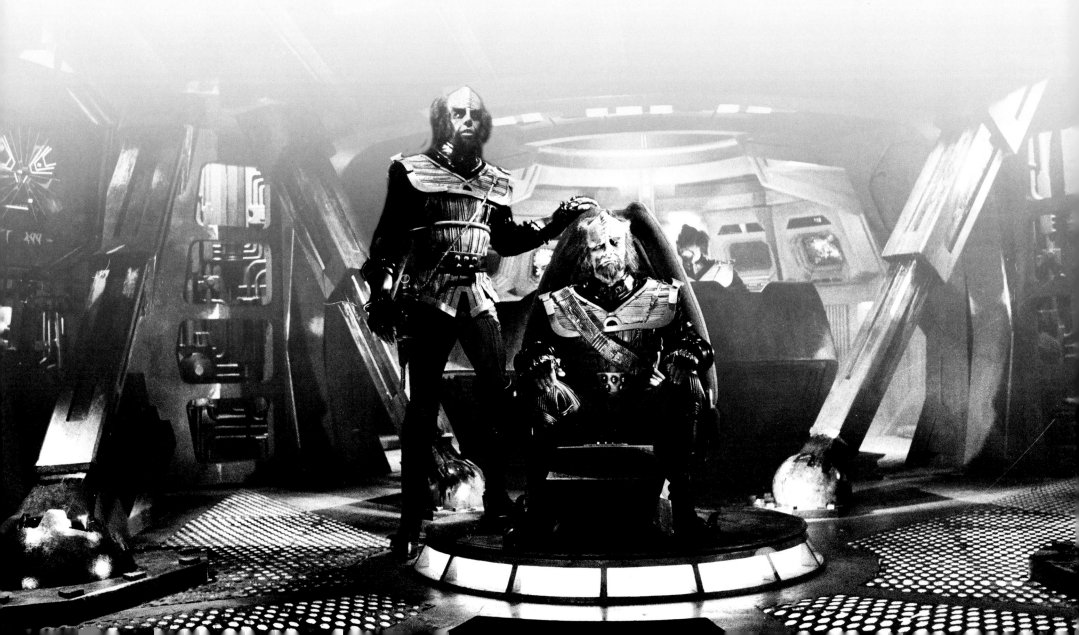

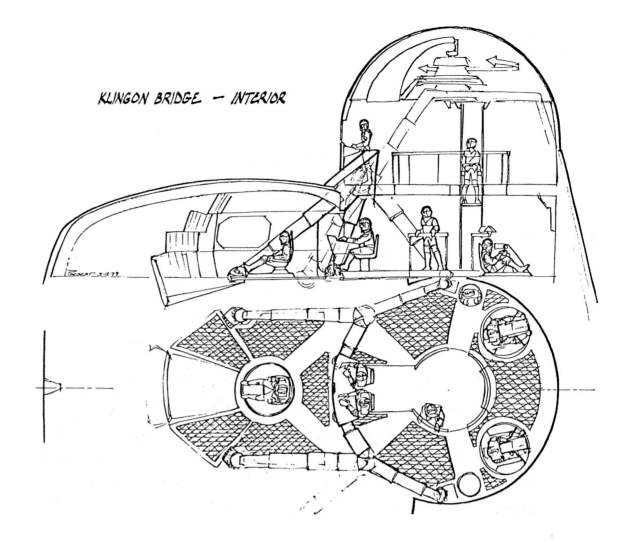

KLINGON BRIDGE — INTERIOR

paint scheme created challenges in picking up the light beams hitting the surface of the ship's wing surfaces. "They were complaining about it during the shoot and I told them I could just airbrush some white paint across those areas where the light was going to hit," McClung recalls. "The white paint wouldn't really show on the model, but it would pick up the light better so you could really see it."

Live action of the Klingons inside the bridge of the lead Klingon vessel, the *Amar*, was some of the last footage shot by director Robert Wise. Doug Trumbull requested that Andrew Probert design an atmospheric set with underlit floor grids for the scene, which featured actor Mark Lenard as captain of the Klingon ship and other actors all wearing updated Klingon makeup by Fred Phillips and costumes by Robert Fletcher

with a heavy, leather-armored appearance.

"They were the last costumes that I did," Robert Fletcher said in 1979. "I took a look at the Klingon uniforms from the original TV series. I tried to keep mine within the ballpark, but make them more exotic, more alien, stronger, more physical, masculine, and a little more primitive-feeling than the other ones as I think their spacecraft is a little more....They have a very effective technology, but it's a little more brutal. Gene, Bob, and I wanted our Klingons to be less human, more aggressive than on the TV series. Kazuaki [Yamamoto] made the Klingons' leather vests, and we achieved the sheen by mixing silver powder into the fabric and using liquid plastic for the armor trim. For the rest of the trim, we took some surgical tubing and dyed it black."

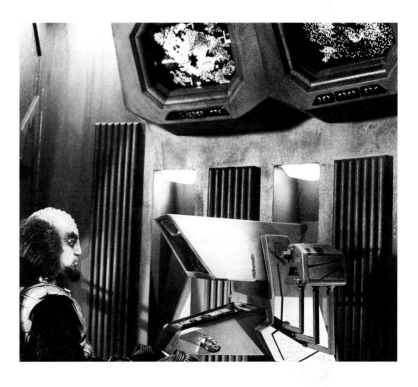

Philips merged the makeup appliance concept (something the original *Star Trek* series could never afford on a regular basis) with the hair and beards of the original TV Klingons and, combined with the heavy-duty costumes, created a tribal, horde-like look for the traditional *Star Trek* adversaries that would redefine the characters for all future movies and television projects. Radically changing the look of the Klingons may have been one of the riskiest moves made by the production, but makeup artist Fred Phillips admitted during the making of the movie that he had been inconsistent with the look of the Klingons even during the original series, painting them with dark greasepaint complexions in some episodes and light skin tones in others—something that had earned him critical letters from fans even back in the day.

The idea of warlike characters with spines growing up across their skulls and foreheads had actually been tested out on an earlier Gene Roddenberry television pilot called *Planet Earth*, with human characters mutated by radiation into barbaric, militaristic 'Kreeg.' Whoever created the makeup for *Planet Earth* received no screen credit on the production. In 1979, Philips credited the look of the Klingons partially to Robert Fletcher, who added "a little suggestion of a ridge" to the top of the Klingons' heads in his costume sketches. Philips had also created a character with a ridge-like forehead and scalp on a Sid and Marty Krofft Saturday morning TV show called *Far Out Space Nuts*. "I decided that if they liked that I'd go the whole route with the Klingons. There was an awful lot to be done to make the Klingons. When I made the test, it was all hand-done. You see here a bald cap and molten mortician's wax, or derma, over the head of this stand-in. That is what I showed them I had in mind for the Klingons. Then I did two or three tests of the Klingons—not because they wanted me to change it, they just wanted to look at it again."

Rather than designing a full-head appliance for the characters, which would have added enormously to the makeup application time for each actor, Philips eventually determined he would create prosthetic pieces for their foreheads and add a thick hairdo, starting halfway back across the top of the head. "There are two reasons for it," Phillips said in 1979. "I could get it over the head, but the edges of a prosthetic piece, when you pick it off, deteriorate. And for a big screen, you're afraid of that. I had to be prepared each day with a whole new head if it was all one piece. So I determined that, if I could put the hair on the back portion, it would always be there, therefore I would only have to do the front head. Because it takes time to put hair on, sometimes more time to put on the hair than the face, unless you want to go through the expense of having full pieces made. Well, that's a little bit too much. So it would save time and money if I could make the front and the back, keeping the hair on the back at all times and just having to put a piece on for the front."

LEFT: To facilitate the visual effects required for V'Ger zapping the Klingons, the set was built on platforms and in sections.

THIS SPREAD: Andy Probert worked to realize Doug Trumbull's vision of the Klingon cruiser as being like "a Japanese WWII submarine that has been at sea too long."

Andrew Probert tackled the Klingon bridge as a concept designer, with the final set laid out by John Vallone based on Probert's design. "Trumbull came to me and described it as a dark, greasy, steamy Japanese submarine, and it would have these giant shock absorbers built into it so it could take all these giant battle hits and not affect the crew in this space," Probert says. "I put that together and they pretty much built it... What was really cool was after the set was built, I was invited to walk down and look the set over, and I hadn't seen Robert Wise in months and I went down there and there he was, and he looked at me and said, 'Well Andy, how do you like your set? Pretty cool, huh?' I was like, wow, how did he remember me?"

After entering the gargantuan V'Ger cloud, the Klingons foolishly launch an attack on the alien intruder with photon torpedoes. Dykstra and Apogee used the same approach Doug Trumbull had designed for the torpedoes, shooting lasers with filters that made them look like brilliant points of light with linear flares spinning around them. The Klingon torpedoes were an aggressive red to match their warrior temperament, and contrasted with Starfleet's blue torpedoes that would show up later in the film. Practical torpedo tube lighting on the Klingon ship's bow was shot with multiple exposures via motion control and combined with the laser elements to create a brilliant look. Dykstra and his team actually shot additional material, including a shot of all three Klingon ships firing torpedoes with red interactive lighting reflecting off the hulls of the ships, as well as additional angles of V'Ger's plasma bolts striking and disintegrating the Klingon ships. These were actually edited out of the final cut of the film to make it appear that only the lead ship, the *Amar*, fired torpedoes.

Lasers were also used to create the effect of the Klingon ship disintegrations, later revealed as a 'data pattern storing' operation by V'Ger. Reflective foils were applied to the Klingon ship miniature to scatter the laser beams into erratic patterns, an effect magnified by filters over the camera. This was then combined with an electrical arc effect and composited into a matte of the Klingon ship's outline while the actual photography of the ship was blocked out frame by frame, so that the V'Ger plasma bolts seem to strike the Klingon ships and spread energy across them that disintegrates them on camera.

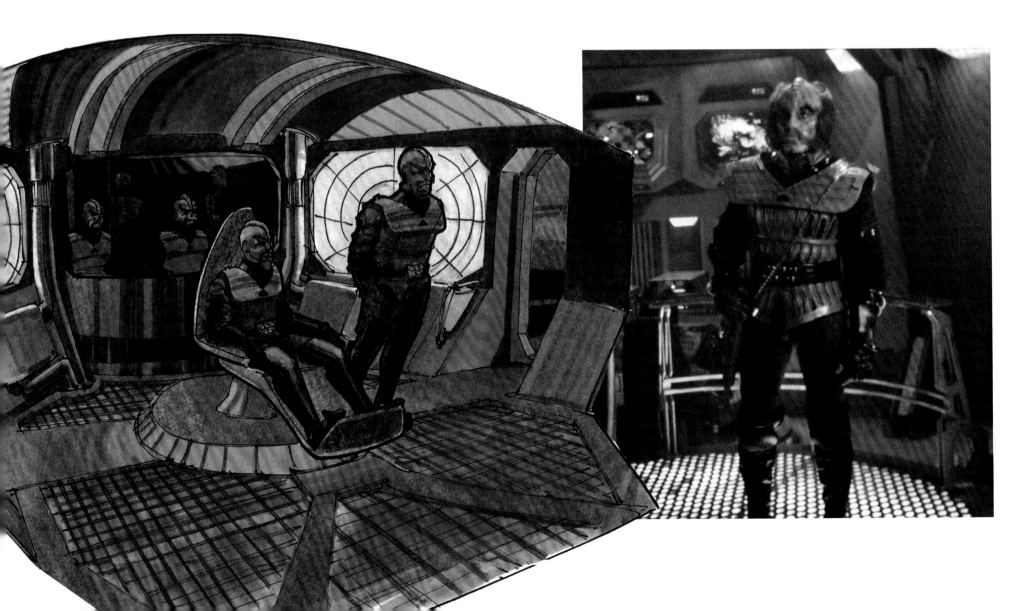

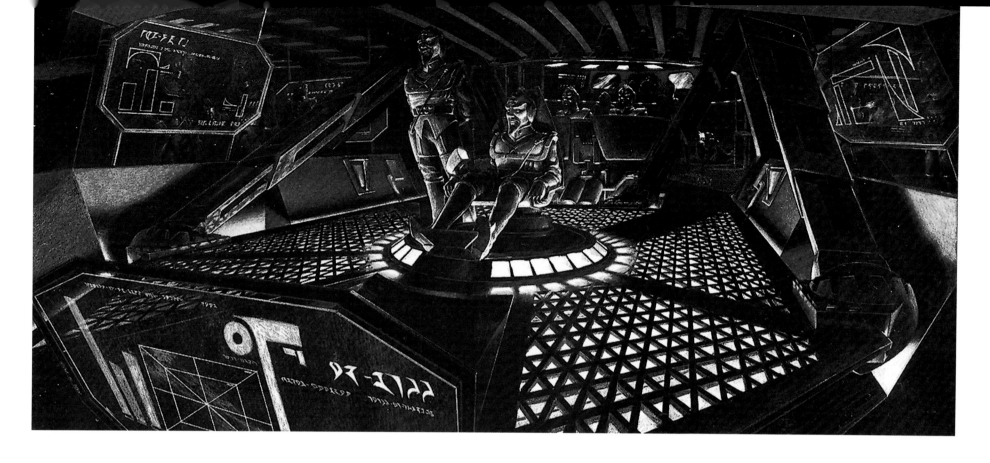

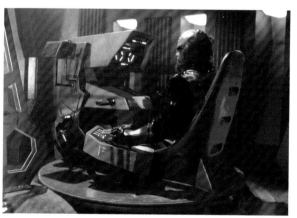

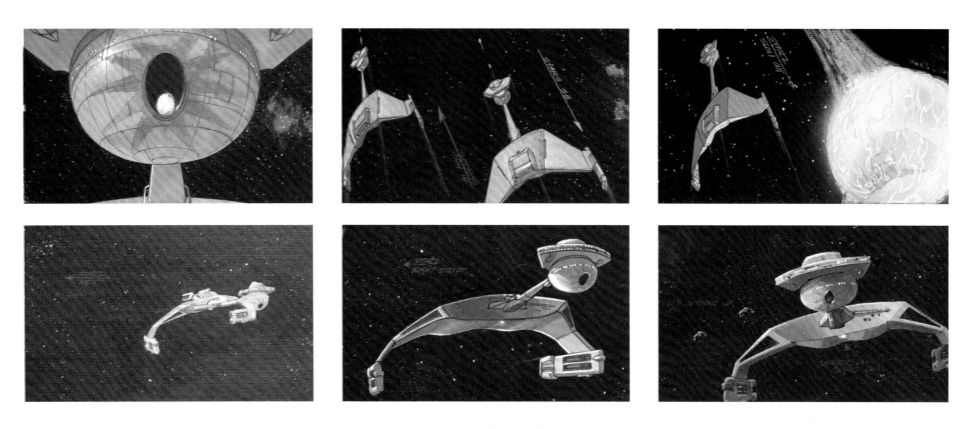

THIS SPREAD: Early ASTRA storyboards showing the opening encounter between V'Ger and the Klingons. This early version had a more dynamic battle, with one Klingon ship having its warp nacelle severed.

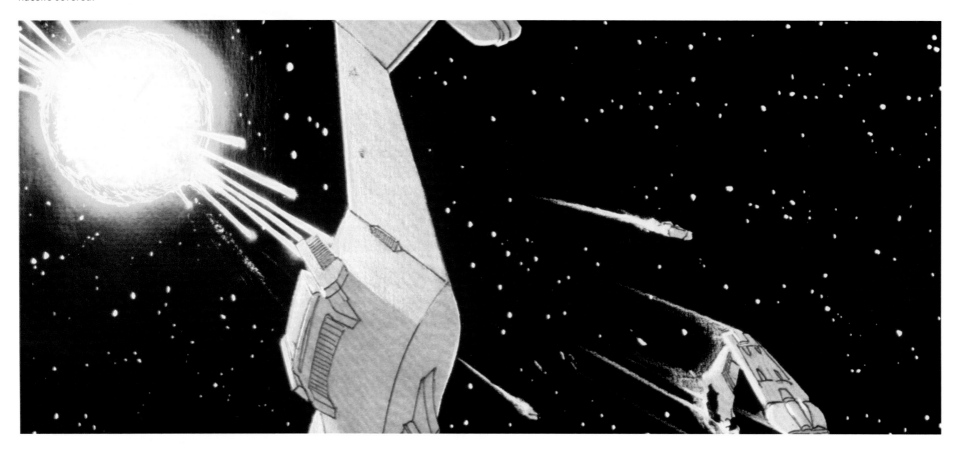

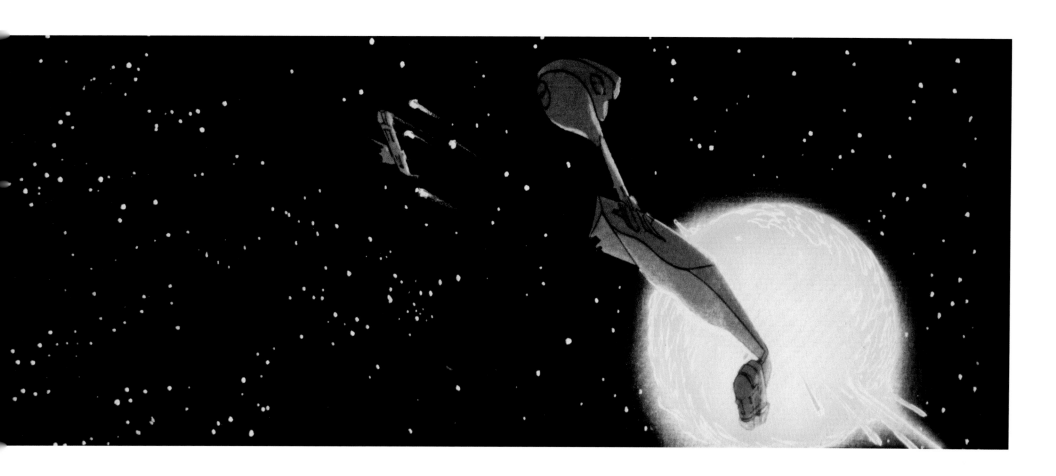

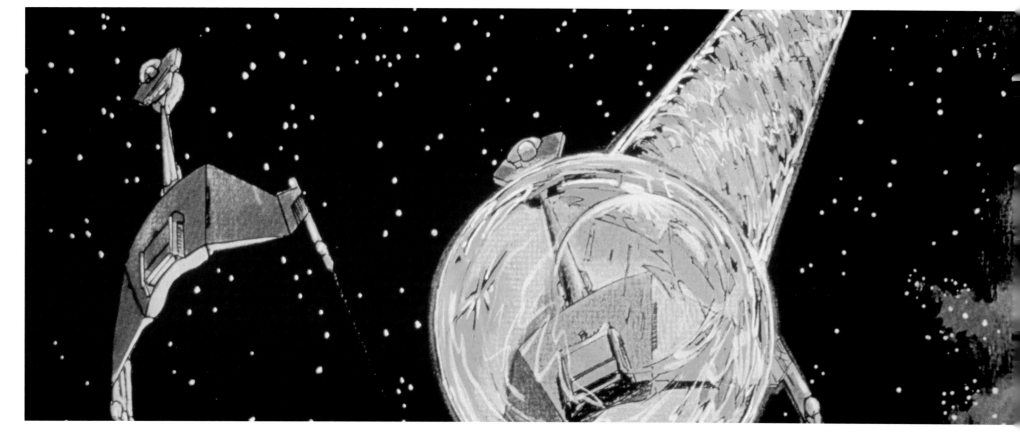

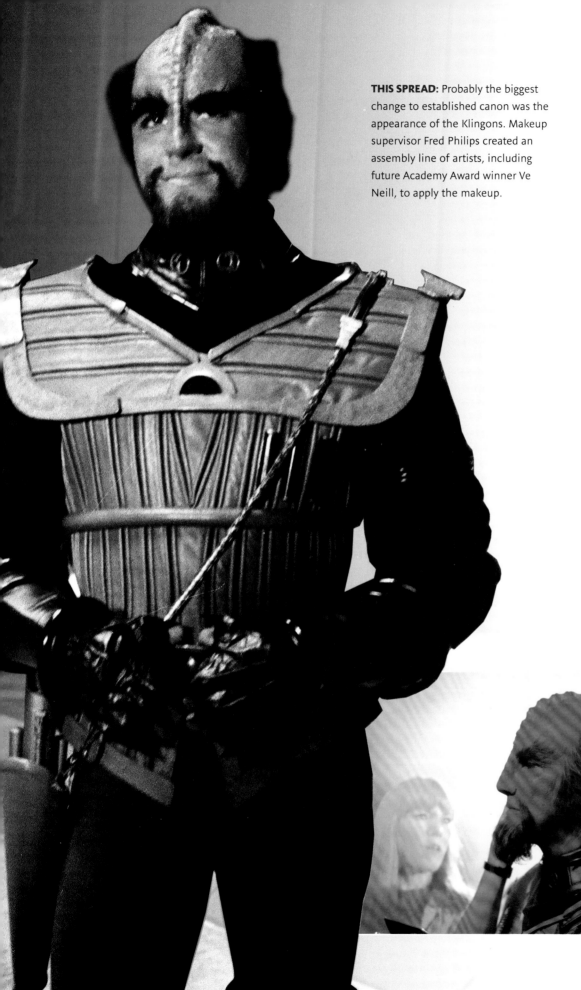

Robert Wise shot some exciting footage of the Klingons being buffeted inside their bridge by V'Ger's attack, and Mark Lenard's Klingon captain desperately issuing orders—all of this footage played out on small screens seen on the Epsilon IX space station interior.

The Klingons disappear after the film's opening scene, but they might have made an even bigger appearance in the film if Andrew Probert and Douglas Trumbull had gotten their way. With concepts for the film's ending still being worked out late in production, Probert sketched out a concept for an ending that would demonstrate his concept of the Enterprise's capability of separating its saucer section from the rest of the ship as an emergency maneuver.

"I wrote an ending where Starfleet wants the *Enterprise* to come back [to drydock]. I tried to put a little play into it where Kirk wasn't satisfied because the ship had really never had a chance to fly because it had to go right out on this mission to V'Ger. I had this dialogue where Kirk was saying, 'Scotty, shouldn't we test the separation system? The separation system has never been tested.' So when they put the *Enterprise* back in drydock, Kirk separates the saucer and flies the saucer away in this kind of rapscallion move."

Trumbull saw the finale as an opportunity to bring even more action into the movie. "He said 'Instead of this, why don't we imagine that, as V'Ger morphs, it dumps all these memory crystals and all these things are floating in orbit and they bump into each other and reconstitute the Klingon battle cruiser?'" Probert recalls. "[The Klingon ship] finds itself 2,000 meters from the *Enterprise* and, in a kneejerk reaction, fires on the *Enterprise* and then tries to warp off, and the *Enterprise* goes to chase them. I came up with four little paintings that show the *Enterprise* being hit in the engineering section, which disables our engines, and then Kirk tries to go off after the Klingons with the saucer."

Of course, none of these possible endings were filmed and, in the end, the movie's conflicts were solved with linguacode, binary communication, and words rather than with photon torpedoes.

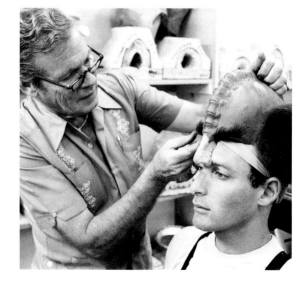

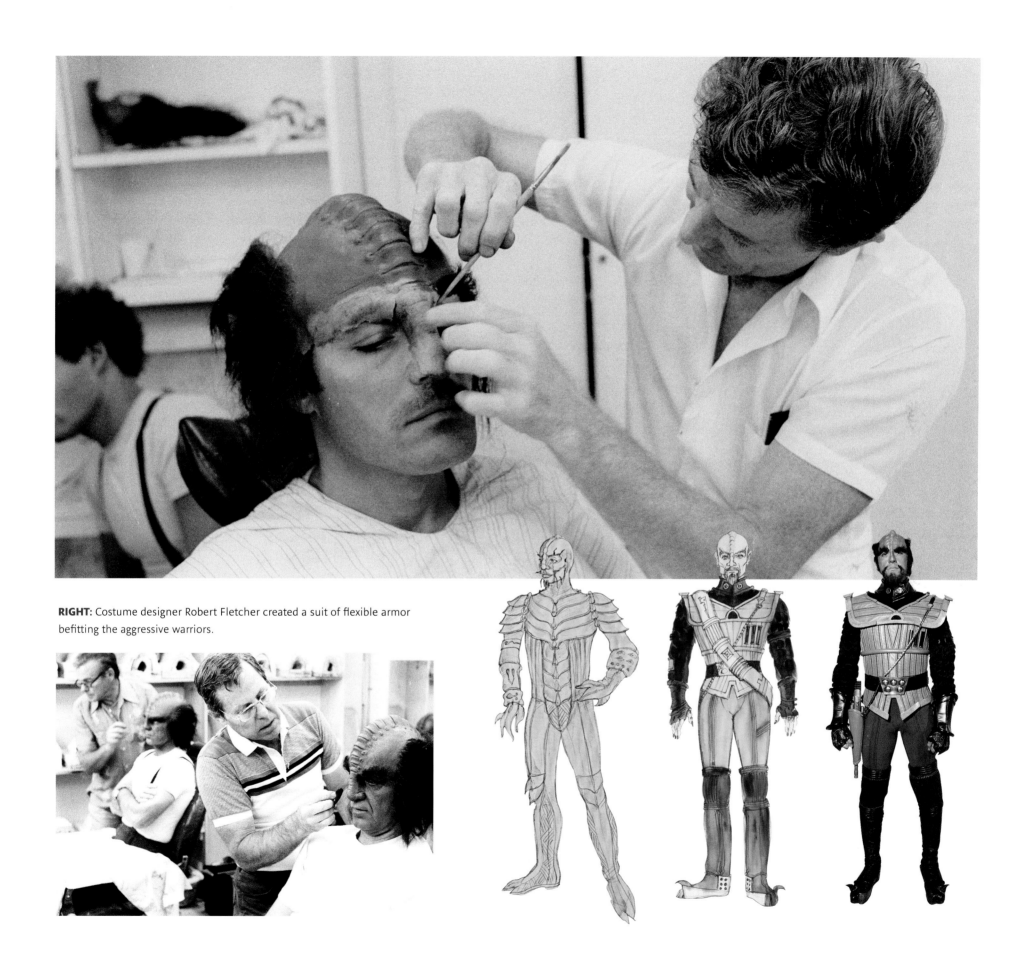

RIGHT: Costume designer Robert Fletcher created a suit of flexible armor befitting the aggressive warriors.

A GOOD BEGINNING

THE CONTINUING EVOLUTION OF *STAR TREK:*
THE MOTION PICTURE

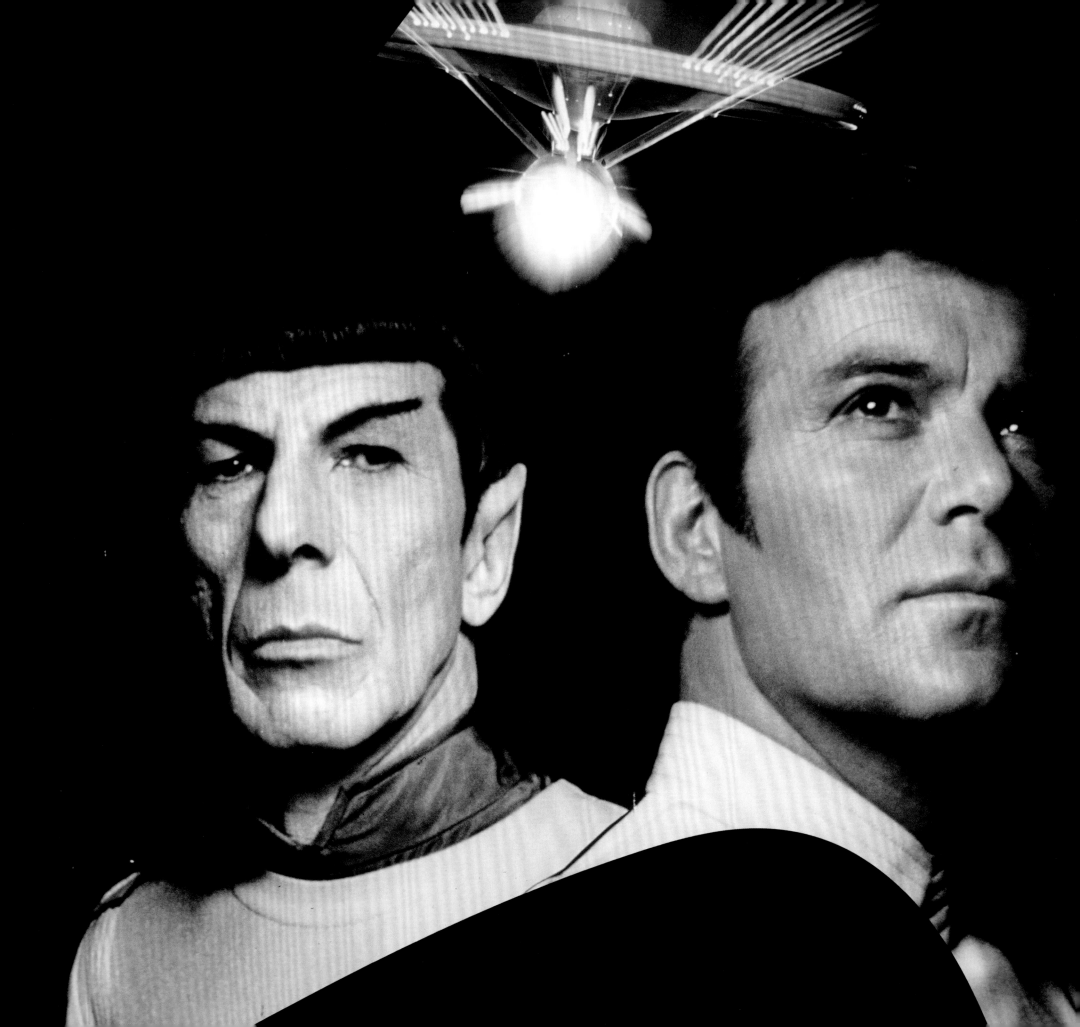

A GOOD BEGINNING

Star Trek: The Motion Picture satisfied a decade's worth of pent-up demand from fans to see the *Starship Enterprise* and its beloved crew in action again. The movie earned Academy Award nominations for its visual effects, art direction, and for Jerry Goldsmith's majestic, varied score. The film's stunning visuals and design work laid the foundations for the visual style of every subsequent iteration of *Star Trek*, from the subsequent movie sequels to *The Next Generation, Deep Space Nine, Voyager,* and *Enterprise* to the rebooted movie series, all the way to *Star Trek: Discovery* and *Picard*.

The movie, much like V'Ger, has continued to evolve and permutate to this day. An *ABC Sunday Night Movie* broadcast of the film added a number of dialogue scenes originally left out of the theatrical cut—scenes lapped up by fans during a period when there were no ongoing *Star Trek* series on the air. Two decades after production wrapped on the 1979 movie, director Robert Wise still regarded *Star Trek: The Motion Picture* as unfinished, so much so that he was initially reluctant to revisit the project for a proposed, expanded home video release.

Restoration supervisor Michael Matessino had gotten to know Wise while working with the director on releases of a number of his films on

home video, including *The Sound of Music, The Haunting, The Day the Earth Stood Still*, and *The Sand Pebbles*. Paramount had released the ABC extended cut of *Star Trek: The Motion Picture* on home video to great success, despite some obvious issues (Wise himself said he "hated" the TV recut) and unfinished visual effects shots, and Matessino and fellow producer David C. Fein were convinced that an improved version, done with Wise's involvement, would be more successful.

One factor that nudged Wise in the direction of revisiting *Star Trek* was the release of George Lucas' *Star Wars* Special Editions, which revised

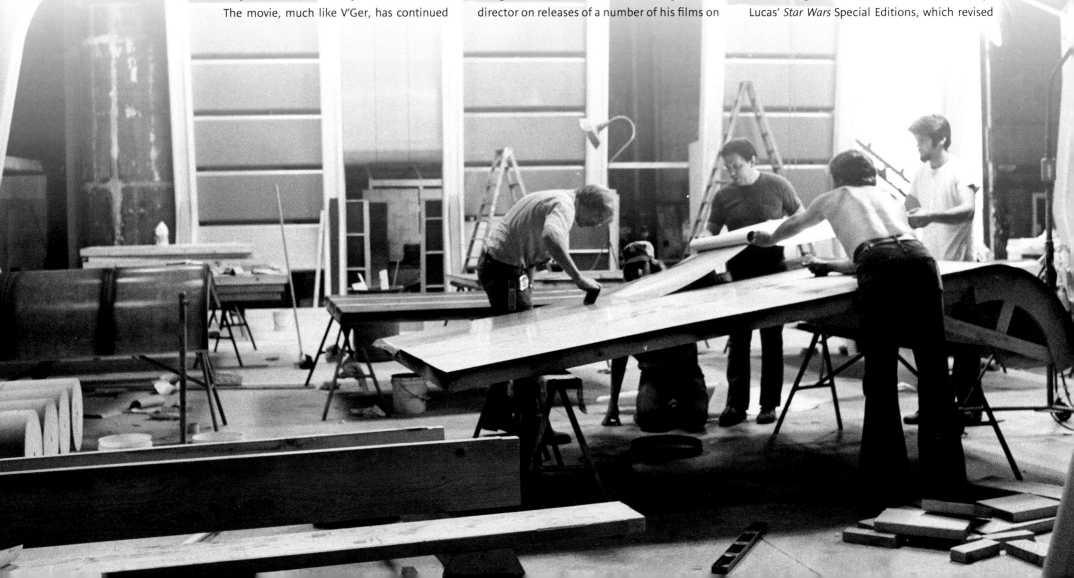

and added visual effects for a very successful theatrical re-release of the original trilogy. The reception of the revised *Star Wars* movies got Wise considering the very real possibility that he might be able to tweak *Star Trek: The Motion Picture* in a way he had never been able to during its rushed rollout in 1979. "Look, the existence of added footage in the first place made such an impact on people that Paramount changed their [*Star Trek: The Motion Picture*] home video release to put it out," Matessino recalls saying to Wise at the time, noting that the original movie, as released, was basically a "first assembly"— the initial, raw cut of a film before it is refined.

"You were never happy with it, you never got to preview it, you never got to do normal trimming or read audience cards, and now we have basically eighteen years of audience cards."

"We had a long talk about the twenty-year test screening," Fein says, "because Bob test-screens every one of his films. There were a lot of moments Gene [Roddenberry] tried to put in. After the film was completed and they had the premiere screening, they went back to [Michael] Eisner and said, 'There's still some time before the theatrical release, let's at least go in and at least fix the most annoying things.' There were still effects elements and sound elements still

coming in after the film was finished, locked, and sent out."

"The showing of *Star Trek: The Motion Picture* in Washington was almost like our first and only preview," Wise said in 2001. "However, we didn't have a chance to have a public preview so, when I finally saw it, I saw a number of things that I would have liked to have trimmed and changed, which is normal for a preview screening. But because this wasn't a preview, and was the world premiere, the studio wouldn't let me do it. They felt that if word got out that after the showing in Washington that we were taking the film back to the editing room, that it would be

THIS SPREAD: The designs of the *Enterprise* sets, as well as the sets themselves, would serve the film series well. Monitor animations and graphics would change, but the infrastructure created for *Star Trek: The Motion Picture* would endure.

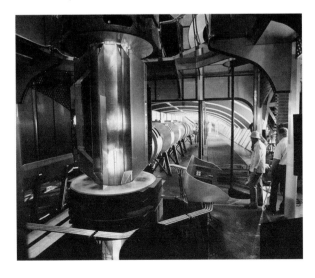
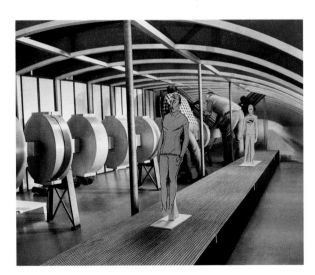

a bad reflection on the film, so they didn't allow me to make any changes. I was unhappy about this at the time because I knew the film could be improved in editing and I hadn't had the chance to have a real sneak preview to get audience reaction, and I think that there were things that would have helped the film. It's the only film I made, and I've made forty now, which I didn't have the opportunity to have a proper preview to know how it worked or played."

Wise was finally convinced that revising *Star Trek: The Motion Picture* was feasible, and wrote to Paramount's Sherry Lansing to lobby for the project. Lansing had studio personnel put it into action. Fein was charged with working out the nuts and bolts of the production and finding an effects group because, after going through Wise's materials, which had been donated

to the University of Southern California, Matessino, Fein, and visual effects supervisor Daren R. Dochterman realized that they actually had a road map for completing a number of visual effects that had been planned, but never realized, for the movie. "We went through *Star Trek* files at USC and found all of the memos from the production that very clearly stated what shots were not going to get finished and what they were going to do about it," Matessino says. "Lots of memos back and forth to Roddenberry, [and] we actually used quite a bit of those comments. Even though it's called a Director's Edition, we factored in a lot of what Roddenberry was saying he wanted, and all the memos would have Bob's handwritten notes on the margin and sometimes he'd write 'no,' and so we'd honor that. And lots of memos with

"The showing of *Star Trek: The Motion Picture* in Washington was almost like our first and only preview... so when I saw it, I saw a number of things that I would have liked to have trimmed and changed."

Robert Wise *director*

THIS SPREAD: The *Enterprise* filming miniature would also go on to serve the rest of the film series featuring The Original Series cast.

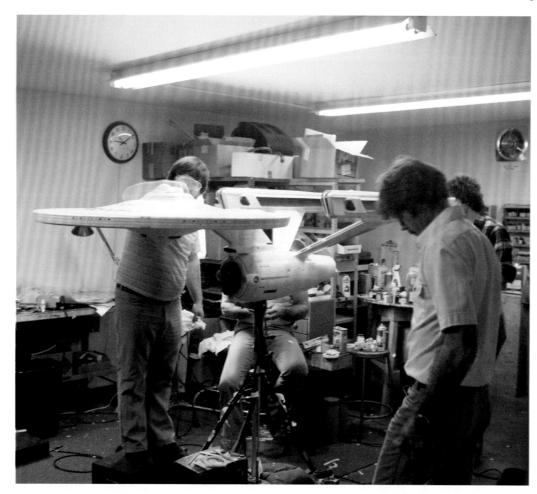

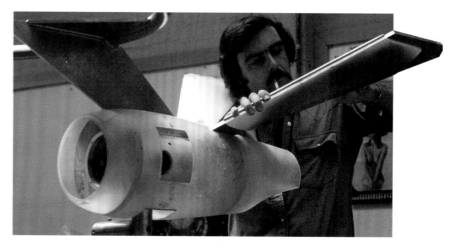

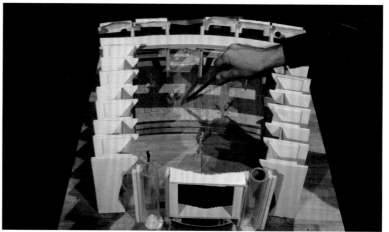

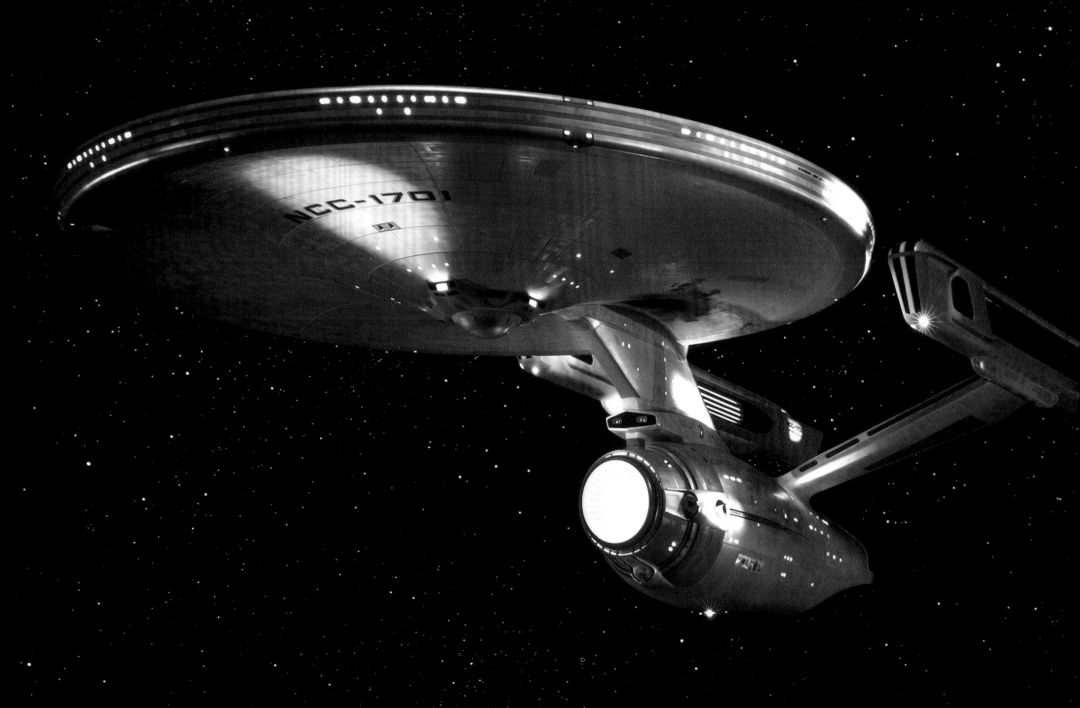

BELOW: One of the chief goals of the Director's Edition VFX was to show more clearly the size and scope of V'Ger in Earth's orbit, as well as completing the original concept for the Giant's Causeway-like bridge from the *Enterprise* to V'Ger.

Trumbull and Dykstra saying 'we can't get this, we can't get that, can we solve this with an edit,' etc. We had all these storyboards and memos, we know what they were trying to do and would have done had they had the time, so it was just a matter of presenting that to Bob and then preparing that, making those decisions in concert with Bob about the fine-tuning of the pacing of the film."

Matessino, Fein, and Dochterman worked with Foundation Imaging, a visual effects company at the time rendering effects shots for the *Star Trek: Voyager* TV series, to create a Director's Cut of the movie for home video.

The original matte painting of Vulcan seen early in the film was one of the first targets for the team, and one of the first test ideas shown to Robert Wise to convince him of the possibility of revising the film's effects. According to Fein, the original film's jarring switch from sunlit, daylight photography to an apparent night shot made for an effective demonstration. "We made up test shots and showed him Vulcan, because Spock is standing there and he blocks his eyes from the sun and the sky is black—it was always supposed to be a sunlit sky."

Visual effects supervisor Daren Dochterman notes that the 'orange sky' matte painting shown in photos being worked on by Matthew Yuricich was being painted for a reverse angle of Spock that was never shown in the movie, since Spock is introduced in close-up. "We saw Maurice Zuberano's storyboards and we saw that he had it all boarded out with the various statues surrounding this temple, and we thought, 'Oh my god, it's gotta be this, this is amazing!' Later on, I think it was Maurice Zuberano and Mike Minor figuring out what this was going to be, because we had drawings by both of them. We took this shot and backtracked and tried to figure out what it would actually look like with the set they actually built, and that way we came up with the six-sided temple. The idea is that perfect logic is actually six-sided. It's interesting that the tiles that are on the ground of the tank set for Vulcan were actually not for Vulcan originally; they were for some other set inside the *Enterprise*, and they grabbed it and used it for Vulcan because it was a quick and dirty thing. In figuring that out, we decided that the whole thing was going to be six-sided and that each side of the six-sided shape was going to be a different statue. We set it up that way so it looked enough like the one that they had drawn in the storyboards, but also made sense in terms of what kind of statues they were and what the whole symbolic meaning of the thing was.

"Dave Morton of Foundation Imaging generated the new Vulcan matte painting

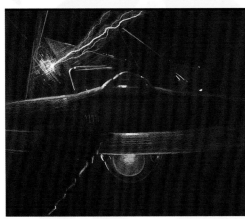

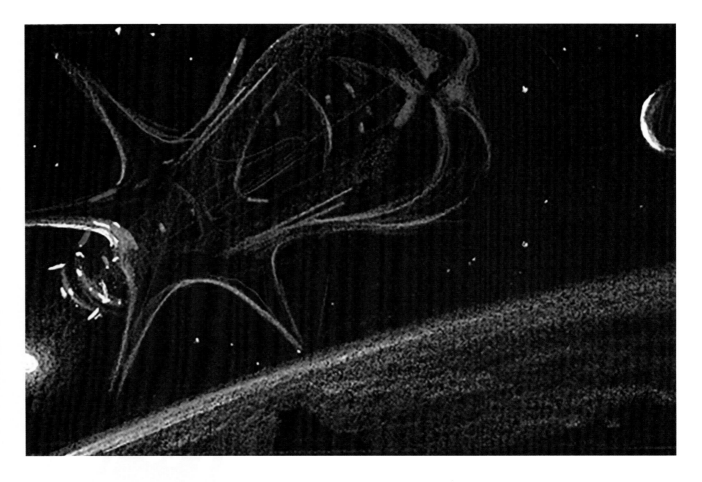

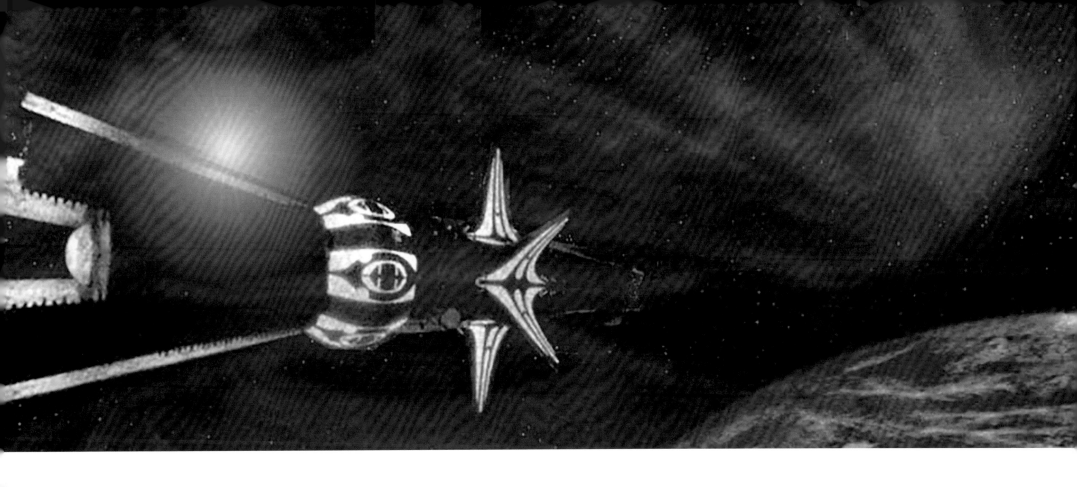

showing multiple statues in a sunlit, orange sky, with one foreground figure even gripping a massive 'lirpa' weapon of the type seen in the 'Amok Time' episode. Dave Morton worked out the matte painting for the view of the statues first and did it using very traditional matte painting methods, starting out with grayscale photo references and bits and pieces, and put it together and painted over it, and it turned out pretty darned good. It's augmented with CG elements and live-action fire, and of course the digital Spock walking up to it."

The ensuing San Francisco air tram sequence was updated to add scope and movement to the original matte painting shots. "The original film has the Golden Gate covered with two lanes of what looks like aeroshuttle tubes," Daren Dochterman says. "We wanted to make sure that the pace of that sequence remained the same, but we wanted to get rid of the filler shot of the United Federation of Planets seal on the ground, which was just a shot they dropped in because they didn't have an extra shot to put in

there. The scene was [a set length] and it had already been scored, and they didn't get a shot so they had to drop that in. We saw something that Andy Probert had drawn outside the tram station looking toward it, and it's a much closer view of that shot that is in the theatrical version, so we can see the two slots for the terminal itself, with the bridge next to it, and we wanted to get as close to that as we could. That was a combination of myself and Doug Drexler executing that. The first establishing shot showing the bridge was based on photos done by a photographer we had in San Francisco who was one of the creators of LightWave, and he took those photographs for us to base the angles of the painting on. The first establishing shot of the bridge and the whole city was actually Mike Okuda working with Doug Drexler."

Another angle showed the tram landing. Dochterman and the Director's Edition team opened up the tram station to add additional tram cars and landing tracks, as well as a shuttlecraft from the original *Star Trek* taking off

in the background. "That shot inside the tram station was just me, with the TOS shuttle in the background," Dochterman says. "Working on that was based on Bob Wise wanting to open up things a bit and get some air in it—in that shot there was just that huge brown wall on one side that blocked off everything, and it was annoying. Originally, I thought we could eliminate that wall altogether and, for those two previous shots of Kirk getting out of the tram, we could open up the wall behind him and behind the tram to show a continuation of the station, but that was just way too much roto and time so we decided to just cut the wall off at the top end."

After the extensive revision of the San Francisco sequence, the Director's Edition team elected to leave the film's iconic drydock tour of the *Enterprise* largely untouched—except for one subtle but important addition. "One of the good things we were able to do tying the people into the ship with scale was in Scotty's tour of the *Enterprise*," says Daren Dochterman.

ABOVE: Due to the size of the V'Ger filming model, Apogee was never able to get the full model in frame. CGI would finally allow that; (ABOVE) An early test to block out the shot of V'Ger in orbit.

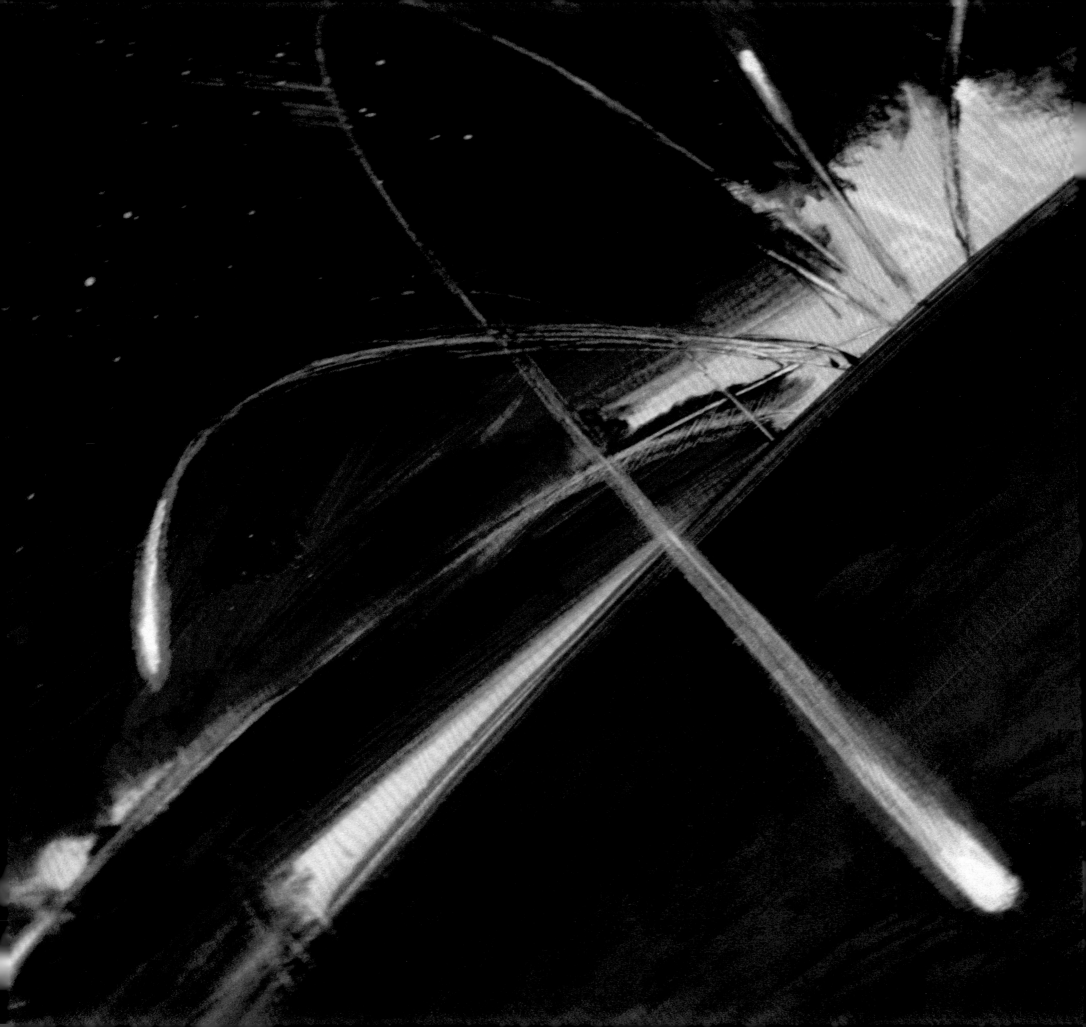

"There's one shot where we were able to project the reflection of the *Enterprise* onto the surface of the pod, and so you have Kirk looking at the *Enterprise* and the *Enterprise* there all in one shot. That is one of my favorite moments of the Director's Cut because it tells the whole story right there."

Fein cited the moment as one of Wise's favorite additions. "There's always one key moment in Bob's movies that blows me away, and *Star Trek* didn't have one of those," he says. "I think, for Bob, it's the reflection in the glass with Kirk looking at his *Enterprise* because what he really got—and *Sand Pebbles* did this a lot too—was the relationship between a person and their vehicle, and he really got that the *Enterprise* was Kirk's woman, and to see Scotty looking at Kirk and Kirk just staring with that reflection just sums up so much of *Star Trek* and Bob—there's nothing else like it in the other *Star Trek* films."

Possibly the highest-stakes addition to the movie is a full reveal of V'Ger as designed by Syd Mead, whose sketches laid out the entity's entire structure. Building a complete, forty-plus-foot miniature of the intruder would have been beyond the film's schedule and budget, and in any case would likely have been impossible to capture through soundstage cinematography, while a matte painting would have limited what could be shown of the vessel.

Modern computer imagery made a full-scale V'Ger reveal possible—but also had risks. Visual effects supervisor for the Director's Edition Daren Dochterman says that the buildup to V'Ger afforded by the film's original views of the entity set a high standard for any attempt to visualize the intruder in its entirety. "We've just spent an hour and a half traveling over this huge thing and now to reveal it in one shot, it could be a letdown. There were several storyboards that were done for this in the original version, and a couple of paintings—the one I remember is looking at V'Ger with remnants of the cloud around it, and it's backlit by the sun so you can see this big shadow and dissipating cloud material as V'Ger is revealed, and that was an interesting thing we were thinking about. But at this point, the cloud had been established and it's so big that a view showing the Earth and V'Ger in orbit, you couldn't go to that sort of detail level. You had to have it more or less be a gentle dissolve from the cloud dissipating to revealing V'Ger. We did several angles and speeds of V'Ger approaching Earth and we showed them all to Bob Wise and went back and forth, and finally figured out that the best way to show V'Ger was where it almost all fit in the frame but not quite. Bits of it are off screen because it's too big to fit into the screen visually."

THIS SPREAD: While working on the Director's Edition, restoration supervisor Michael Matessino came across a roll of film from 1979 that contained footage of these pieces of artwork. The purpose for filming the art—perhaps to be used as a temp for editorial purposes or as an element for a VFX shot—has been lost to time. But Director's Edition producer David C. Fein, VFX supervisor Daren Dochterman, and Robert Wise were so impressed with the find, they decided to use some of the art as the basis for their reworked VFX shots.

Dochterman says it was a challenge to find the right angle and diminishment in perspective to make the gigantic object look big enough. "We realized that this is probably 400,000 ft long—if you guess that the *Enterprise* is 1,000 ft long, 400 *Enterprises* stacked up on each other—so we sort of based it on that assumption and going by that, it's not undoable. We needed to match the detail on the surface of V'Ger and the detail of the energy towers and static electricity going on inside those. With the dissipation of the cloud, we were able to put a nice Trumbull lens flare of the sun behind V'Ger and give that impression of that painting we'd seen before, with the nice colored rings of the lens flare tying everything together. As we follow V'Ger over, the Earth sort of slides in just at the bottom of the frame and then we're out of the shot. You've been looking at V'Ger mostly, and then, when Earth comes in, you're done, that's the story—V'Ger has entered." Foundation Imaging's Steve Burg built the V'Ger digital model and John Teska textured it and did the finishing detail work to prepare it for filming.

Dochterman and the Director's Edition crew focused particular attention on the movie's 'wing walk' sequence of Kirk and his fellow officers emerging onto the hull of the *Enterprise* and making their way to V'Ger's temple. The entire sequence was one where the time limitations on the 1979 production took perhaps their largest toll, as the elaborate plans for depicting a bridge of moving, perhaps even illuminated polygons forming between the *Enterprise* and the V'Ger temple fell by the wayside, leaving the bridge to be depicted almost entirely as a soundstage set with a few matte painting embellishments. "We worked hard on the V'Ger climax where they do a wing walk on the *Enterprise*," Mike Minor said in 1979. "There was a matte shot involved, with them stepping out onto a floating causeway of crystalline forms that group together into a bridge for them to walk across an abyss, which is apparently the mind of the intruder, V'Ger. They had about a quarter-mile walk in scale. Well, we had scale-model, theatrical forced-

THIS PAGE: The field of hexagonal stepping stones from the feature film was replaced with a more elaborate—and dangerous—pathway to V'Ger. Storyboards by Steve Burg.

perspective set pieces do it live on stage, later to be enhanced and augmented by Trumbull's optical work and miniature extensions."

The Director's Edition effects team added an important transitional shot, showing the *Enterprise* from below and at a fair distance, traveling through the final, tunnel-like section of V'Ger before reaching the temple area. "That was one of the shots that Steve Berg did right at the beginning, and he was able to take some of the shape language from Syd Mead's designs for the interior and make a cohesive view of what it would have been at a wider angle," Daren Dochterman says. "We do see some of it in the theatrical version, but it's just shapes going past the viewscreen, and we had to figure out what that would look like from an outsider's point of view."

While at least one concept painting shows a similar angle of the *Enterprise* moving through V'Ger, Dochterman explains that actually generating such a shot in 1979 would have involved a number of technical challenges. "It would have been incredibly difficult for them to do this shot. Shooting the full-scale *Enterprise* model; first of all, they probably wouldn't have been able to get it that small and, because they were shooting on 65mm for the *Enterprise* and VistaVision for the V'Ger stuff, it would have been a major problem to...integrate the two shots into one shot. There are shots from the two different companies, but those are simple dissolves and superimpositions in the film."

BELOW: The Director's Edition allowed the team to expand the scope of the matte painting establishing shots at Starfleet HQ (TOP) and Vulcan (BOTTOM).

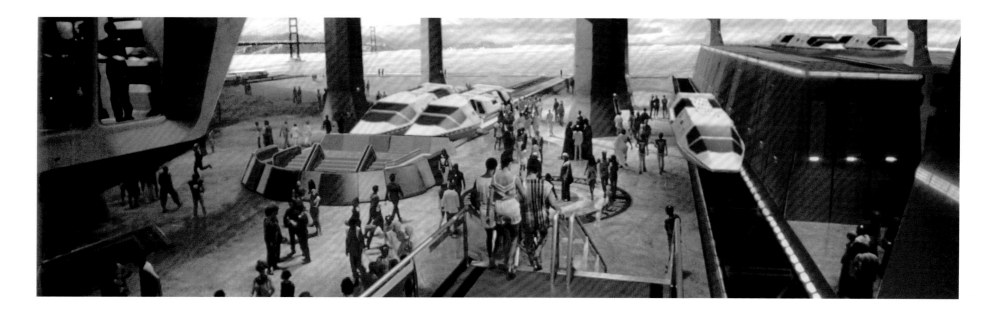

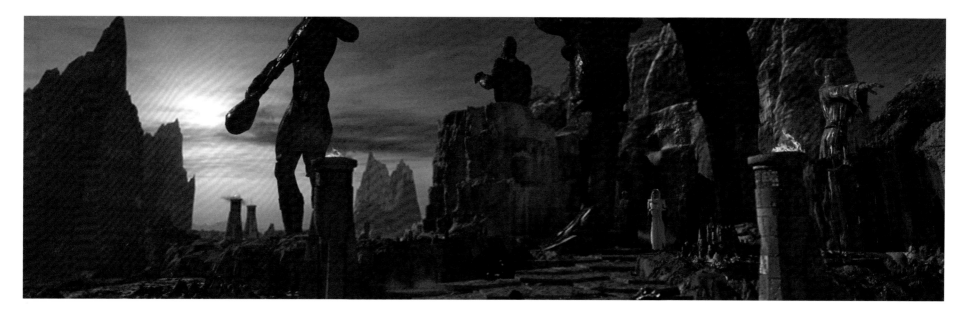

In 1979, the bridge of polygons had just been shown as a dimly lit plain of blocks sliding toward the *Enterprise* on the main viewscreen. Dochterman and the Director's Edition effects team were eager to demonstrate what Wise and his crew were originally aiming for in the sequence. "The [story]boards showed very clearly that it was supposed to be a floating island and not just a sea of these blocks that they pull up to like a loading dock," Dochterman says. "I remember reading in the novel Roddenberry's description of this stuff actually happening, and I had actually read the novel before I saw the film, so I had an idea in my mind as to what was going to happen. When I saw the movie I thought, 'Oh, that isn't what happened at all.' But in seeing the boards, what Roddenberry was describing had been figured out and this stuff had been drawn. There was one shot I remember seeing, basically a three-quarter view of the *Enterprise* looking up at it with part of the bridge up in the foreground, and [the bridge] bows and ducks down and swoops up to the edge of the *Enterprise*, and you see the tiny figures walking

across. That was drawn as a storyboard and we were able to match that exactly."

For the Director's Edition project, the team was even able to find unused footage of the original actors walking across the polygon bridge. "That was nice because we were able to use low angles," Fein says. "Obviously you wouldn't have low angles if it was just a flat plane of objects they're walking on, but we have low angles and they weren't generated, they were actually shot for the sequence."

The Director's Edition also allowed for the actual formation of the bridge of polygons to be depicted. "As the *Enterprise* enters V'Ger, we see what look like stars surrounding the V'Ger island," Dochterman says. "As you go in, the stars start to come down and sort of swirl, then they become these little four- or five-pointed lens flares that then change into the building blocks. We figured they certainly would have done the little lens flares on an animation stand and there would have been no motion blur on them, and they might have done the blocks as motion-control models. That was one of the things where we tried to figure out how they would have done

it, and in the end it turned out to be probably a combination of animation stand and minimal motion control for the stuff that happens in the foreground. So we were able to come up with the idea that the stars come down and they're still stars, and it's only at the last moment that they become these six-sided blocks."

While a number of exotic concepts had been considered for the final evolution of V'Ger during the film's original preproduction, the Director's Edition crew elected to just slightly modify the shockwave-like lightshow disintegration of V'Ger created by Trumbull for the denouement of the movie. "The final slit-scan lens flare explosion that reveals the *Enterprise* coming toward us is such a beautiful and iconic shot, we figured 'Why mess with that? Let's just integrate our shot into that shot,'" Daren Dochterman says. "So we actually added a little bit on that existing shot, so in the distance you can see a tiny little V'Ger in front of the lens flare. The moiré pattern is happening all around it and it kind of implodes on itself and then explodes when we get to the beginning of that existing shot."

ABOVE LEFT: After working on The Original Series, *Star Trek: The Motion Picture* would be the only *Star Trek* feature makeup artist Fred Phillips (left, with Leonard Nimoy) would work on, retiring in 1981.

ABOVE RIGHT: Many of the model crew would go on to work on such films as *Close Encounters of the Third Kind: The Special Edition, Escape from New York*, and *Blade Runner*. Mark Stetson (lower left) would become an Academy Award-winning visual effects supervisor.

"I think that the Director's Edition has finally allowed me to do what I wanted to do in 1979," Wise said in 2001, noting that he'd avoided the subject of *Star Trek: The Motion Picture* for many years because of his frustrations with the process of finishing the movie for its original release. "I didn't want to talk about it much, and I kind of got down on the picture because of all of the difficulties, and I started thinking it wasn't a very good picture somehow. Then when I saw it again in the theater before we started the Director's Edition recut, I thought it was a damn good picture, and one that I'm even more proud of with the final changes we made to it as the Director's Edition. I'm really proud of the film, and especially the hard work of everyone who worked on the film twenty years ago, and my outstanding team today. This is the film I would have put out in 1979. At least I got more sleep this time."

"It was unfinished business," Fein says of Wise's experience on the film. "People talk about in your life you have a lot of things that are unfinished business and you're not really at peace until you get those things handled, and he was resigned to this assembly that he would be remembered for because *Star Trek* was so big, and it always frustrated and upset him. So when we came back and said there's a possibility we could do something better, he liked the idea."

Fein credits Wise for the amazing success of the original movie. "It was his vision that helped elevate it, because if you look at the [*Phase II*] test footage and everything they were doing, it was some evolution from classic *Star Trek*, but it was Bob's vision of this being something naval and real, a real vessel and real existence, brought it up to more of an effective style that dramatically increased the way the film looked, and it carried on into everything that's been done since on *Star Trek*."

The 1979 movie remains unique in its focus on mystery, on alien intelligence, and its expression of Gene Roddenberry's pacifistic, exploration-oriented philosophy. It was a movie in which the only space battle derived from an antagonistic culture misunderstanding its adversary, and its human (and Vulcan) heroes strive to comprehend and communicate with an overwhelming threat, rather than attack it. Director Robert Wise's film represented a titanic challenge to meet a deadline and a herculean, and ultimately successful, struggle by hundreds of artists and technicians to create a finished, visually dazzling work of art. Today fans, artists, and Hollywood professionals still seek to explore and interpret the movie for a new generation of viewers.

BELOW: *Star Trek* fandom has allowed the franchise to live long and prosper.

Interview material from 1979 with Robert Wise, John Dykstra, Mike Minor, Fred Phillips, Harold Michelson, Robert Fletcher, Lee Cole, Alan Dean Foster, and Matthew Yuricich is derived with permission from the book *Return To Tomorrow: The Filming of Star Trek: The Motion Picture* by Preston Neal Jones, published by Creature Features and Taylor White and Lukas Kendall. Kay Milam Anderson interviewed Michael Minor for *Return to Tomorrow*. Interview material from 2012 with Robert Wise, Robert McCall, and Harold Michelson courtesy of Ben Robinson and David C. Fein.

Thanks to Douglas Trumbull, Richard Yuricich, John Dykstra, Syd Mead and Roger Servick, Andrew Probert, Richard Taylor, Ben Robinson, Jim Dow, Mark Stetson, Greg Jein, Rick Sternbach, Mike Okuda, Jon Povill, Rocco Gioffre, Bill George, Paul Rabwin, Pat McClung, Brick Price, John Eaves, Bob Kohl, David C. Fein, Mike Matessino, Neil S. Bulk, and Daren R. Dochterman. Thank you to Profiles in History for providing photos of some of the artwork. Thank you Susie Rae and Natasha MacKenzie at Titan Books, whom we pestered with images and notes up till the last minute. And very special thanks to John Van Citters and Marian Cordry at CBS Consumer Products, who went above and beyond to locate and facilitate imagery for this book.

GENE KOZICKI is a visual effects production manager with over thirty years' experience, and serves as a visual effects archival consultant. Perhaps prophetically, he began his career as an intern on the third season of *Star Trek: The Next Generation*. Over the years, he's had the pleasure of getting to work with and become friends with many of the people that have worked on the films that influenced him as a kid. He hopes these books serve as a tribute to and a thanks for their hard work and artistry. He would like to dedicate this book to the memory of his mother, who, early on, recognized how important *Star Trek* would be in her son's life, but still made him wear socks with his sandals.

JEFF BOND is a freelance writer, author, and magazine editor living in Los Angeles. He has written books about Danny Elfman, Irwin Allen, *Star Trek*, *Planet of the Apes*, *The Orville*, and other nerdy topics.